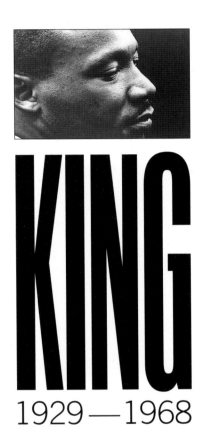

KING

1929 — 1968

KING

The Photobiography of Martin Luther King, Jr.

Charles Johnson & Bob Adelman

Photo Editor & Historian Robert Phelan • Editor Mary Beth Brewer
Designed by Will Hopkins & Mary K. Baumann

A Bob Adelman Book
VIKING STUDIO

This book is dedicated to
Martin Luther King, Jr.,
to his dream of a beloved
community, and to the selfless
activists who brought that dream
closer for all of us.

VIKING STUDIO
Published by the Penguin Group
Penguin Putnam Inc., 375 Hudson Street,
New York, New York 10014, U.S.A.
Penguin Books Ltd, 27 Wrights Lane,
London W8 5TZ, England
Penguin Books Australia Ltd, Ringwood,
Victoria, Australia
Penguin Books Canada Ltd, 10 Alcorn Avenue,
Toronto, Ontario, Canada M4V 3B2
Penguin Books (N.Z.) Ltd, 182-190 Wairau Road,
Auckland 10, New Zealand

Penguin Books Ltd, Registered Offices:
Harmondsworth, Middlesex, England

First published in 2000 by Viking Studio,
a member of Penguin Putnam Inc.

10 9 8 7 6 5 4 3 2 1

Copyright © Bob Adelman Books 2000
Introduction and essays © Charles Johnson 2000
All rights reserved

Library of Congress Cataloging-in-Publication Data

Johnson, Charles Richard, 1948-
 King : the photobiography of Martin Luther King, Jr. / Charles Johnson &
Bob Adelman; photo editor & historian, Robert Phelan; editor, Mary Beth Brewer;
designed by Will Hopkins & Mary K. Baumann
 p. cm.
 ISBN 0-670-89216-5
 1. King, Martin Luther, Jr., 1929-1968—Pictorial works. 2.
Afro-Americans—Biography—Pictorial works. 3. Civil rights workers—
United States—Biography—Pictorial works. 4. Baptists—United
States—Clergy—Biography—Pictorial works. 5. Afro-Americans—Civil
Rights—History—20th century—Pictorial works. 6. Civil rights move-
ments—United States—History—20th century—Pictorial works. I.
Adelman, Bob.

 E185.97.K5 J57 2000
 323'.092—dc21
 00-033389

Printed in Hong Kong

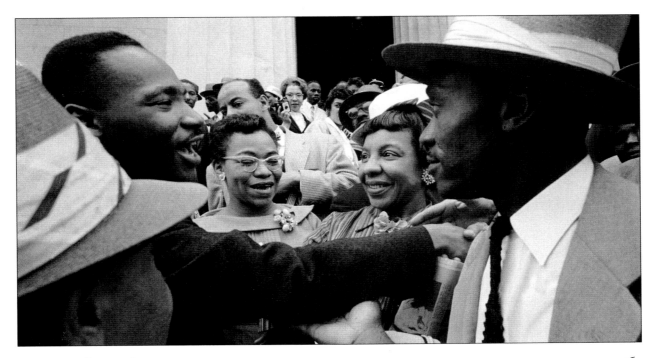

INTRODUCTION

The life and legacy of Martin Luther King, Jr., permeates—in ways great and small, direct and indirect—every facet of our social and political world. Although he was assassinated thirty-two years ago, his hypnotic voice and unique vision linger, ghostlike, in the background of every conversation that touches upon race, the state of black America, and this nation's multiracial future. His name, an eponym given to streets and community centers, is invoked these days with the piety (and emotional distance) reserved for this republic's Founders, and well it should be, for King was a revolutionary whose deeds created the structure, the texture, and the tone of the society in which we live.

Yet in some ways his posthumous visibility renders his life—and the high drama of the noble, world-altering move-ment he symbolized—largely invisible to the generations born after 1968. This, of course, is the price of canonization. Vaguely, we remember a little something of his many southern campaigns (but seldom all the principal players) and his ever-broadening agenda for global peace and economic justice, but with each passing decade the details grow a bit fainter. Indeed, some are forgotten entirely, lost as King is airbrushed,

reinterpreted, packaged, and repackaged by those on the left and right (even those terms have a different meaning than they did during King's era), by liberals and conservatives, by everyone from Afro-centrists to those who use his memory to oppose programs, such as affirmative action, that he would approve. How soon we forget that King was not only a civil rights activist, but also this country's preeminent moral philosopher, a spiritual aspirant, a father and a husband, and that these diverse roles—these multiple dimensions of his too brief life—were the foundations for his singular "dream" that inspired millions worldwide.

It is our hope that this beautiful collection of images taken by some of America's leading photographers will serve readers eager to time travel, to project themselves back into the most transformative decades this country has experienced after the Civil War and to better appreciate the complexity, genius, and memorable public ministry of Martin Luther King, Jr., as he journeyed from Montgomery to Memphis. Each and every photo on the pages that follow is a portal—a doorway—into a watershed life produced by America's ongoing, unfinished experiment in democracy.

Enter, enjoy, and be enlightened.

~Charles Johnson, Seattle, July 2000

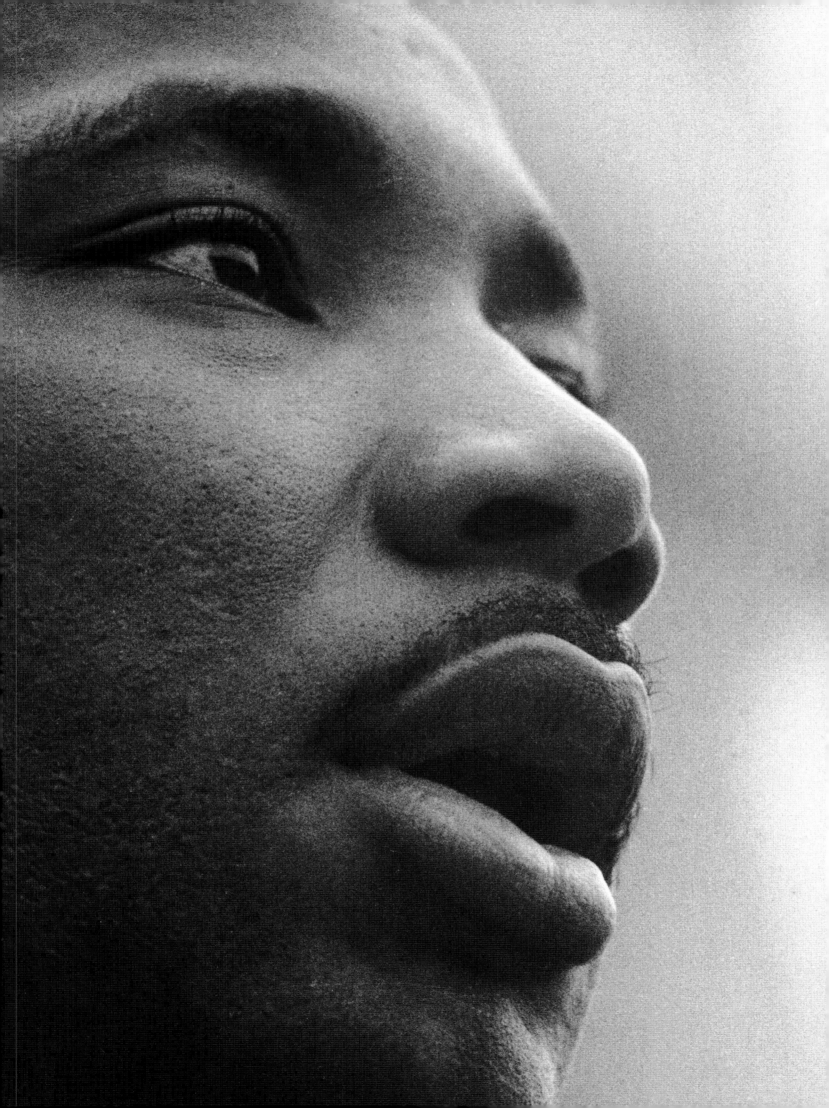

EARLY YEARS

It is quite easy for me to think of the universe as basically friendly mainly because of my uplifting heredity and environmental circumstances.

~MARTIN LUTHER KING, JR.,
AN AUTOBIOGRAPHY OF RELIGIOUS
DEVELOPMENT, 1950

Twenty-one-year-old Martin Luther King, Jr., often spoke glowingly of his childhood and youth as years of fulfillment when "I had no basic problems or burdens." His was "a family where love was central and where lovely relationships were ever present," and he would have no doubt identified his predecessors and peers with the dedication in the late writer Ralph Ellison's second novel, *Juneteenth*: "To That Vanished Tribe into Which I Was Born: The American Negroes."

They were a different breed.

When King was born on January 15,

1929, only nine months before the stock market crash, at 501 Auburn Avenue N.E. in a two-story Queen Anne-style home in Atlanta, he entered a family only sixty-four years removed from the devastating experience of slavery—a family that could boast of producing three generations of black preachers before his birth. His grandfather, Adam Daniel (A. D.) Williams (the son of a Greene County slave-preacher), transformed a struggling little church, Ebenezer Baptist, into a prominent institution with nine hundred members, wed in 1899 Jennie Celeste Parks, a gentle woman who briefly attended Spelman Seminary, and led numerous organizations dedicated to political and racial progress. No less an activist was King pére, a man who knew and inveighed against injustice and racism his entire life.

In the home of these pious black men and women, who deeply valued education and whom he saw indefatigably engaged in social work and spiritual practice (the social gospel), young Martin—a child of the black church— found it "quite easy for me to lean more toward optimism than pessimism about human nature." By his own admission, he was "precocious," a questioning boy who at age thirteen "shocked my Sunday School class by denying the bodily resurrection of Jesus." He felt uneasy with the uncritical fundamentalism of the Baptist faith, only joined the church at age five because his older sister did so and he did not want her to get ahead of him in anything, and he never experienced the "crisis moment" associated with religious conversion.

Of course, he saw poverty and hard-scrabble lives during the Great Depression. And he knew prejudice as a child. His first exposure to a "race problem" occurred when the father of one of his white playmates broke up their friendship, an event that made

six-year-old Martin "determined to hate every white person" until he went away to college and met Caucasians of good will—as well as liberal professors like Benjamin E. Mays, president of Morehouse, who provided him with the intellectual example of a modern minister he hoped to adopt as his own model.

In 1944, when King was fifteen, he won a contest for a speech entitled "The Negro and the Constitution." Even then, the ensorceling orator he would become can be glimpsed in the acuity of his conclusion, where he said, "My heart throbs anew in the hope that...[America] will cast down the last barrier to perfect freedom. And I with my brother of blackest

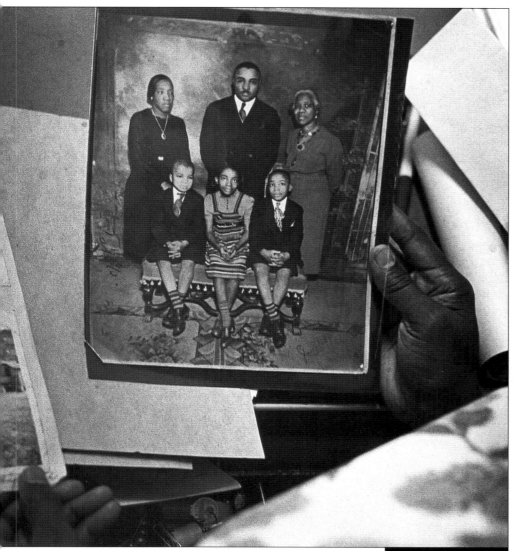

when he began. But by his senior year Martin, who had considered pursuing careers in either law or medicine, sparked to his studies; he was ordained as an associate pastor at Ebenezer at age nineteen, his calling being "...not a miraculous or supernatural something; on the contrary it was an inner urge calling me to serve humanity. I guess the influence of my father also had a great deal to do with my going into the ministry."

Martin struggled to find his path at Morehouse, but by the time he reached Crozer Theological Seminary in Chester, Pennsylvania, he buckled down. He wrote to his beloved grandmother that "I never go anywhere much but in these books." His diligence paid off. He became the president of the student body, delivered the valedictory address at his commencement ceremony, received a J. Lewis Crozer Fellowship of $1,200, and the Pearl Plafker Memorial Award as the student who "in the judgment of the faculty, has been the outstanding member of his class during his course in the seminary."

At Boston University's Graduate School, he studied with Edgar Brightman and L. Harold DeWolf, pursuing the philosophy he later would say he found more persuasive than any other, Personalism, which emphasized personality as the supreme value and the key to the meaning of reality. By the time Martin earned his Ph.D. on June 5, 1955, his pansophical education was complete (according to Julian Bond, King could recite whole passages of Plato from memory); he had married a beautiful New England Conservatory student named Coretta Scott; and he had accepted the pastorate at Dexter Avenue Baptist Church in Montgomery, Alabama (with the highest salary, $4,800 yearly, of any minister in the city). Beyond all doubt, this remarkable, disciplined, profoundly spiritual young man knew at the age of twenty-five that "Religion for me is life."

Leafing through the King family album, we see, on the right, an early photograph. Standing are, from left to right, King's mother, father, and maternal grandmother. Seated are, Alfred Daniel (A. D.), Christine, and Martin.

hue, possessing at last my rightful heritage and holding my head erect, may stand beside the Saxon—a Negro—and yet a man!"

Yet Martin's academic record at Morehouse was, as his teacher George D. Kelsey put it, "short of what may be called 'good.'" Mays was even less enthusiastic, stating in a letter of reference for Martin and another pupil that "they are not brilliant students but they have good minds." King's gradepoint average was 2.48, between C+ and B. That less-than-stellar performance was most likely due to the social distractions he found and a desire to cut loose a little when he started college—he was, after all, only fifteen

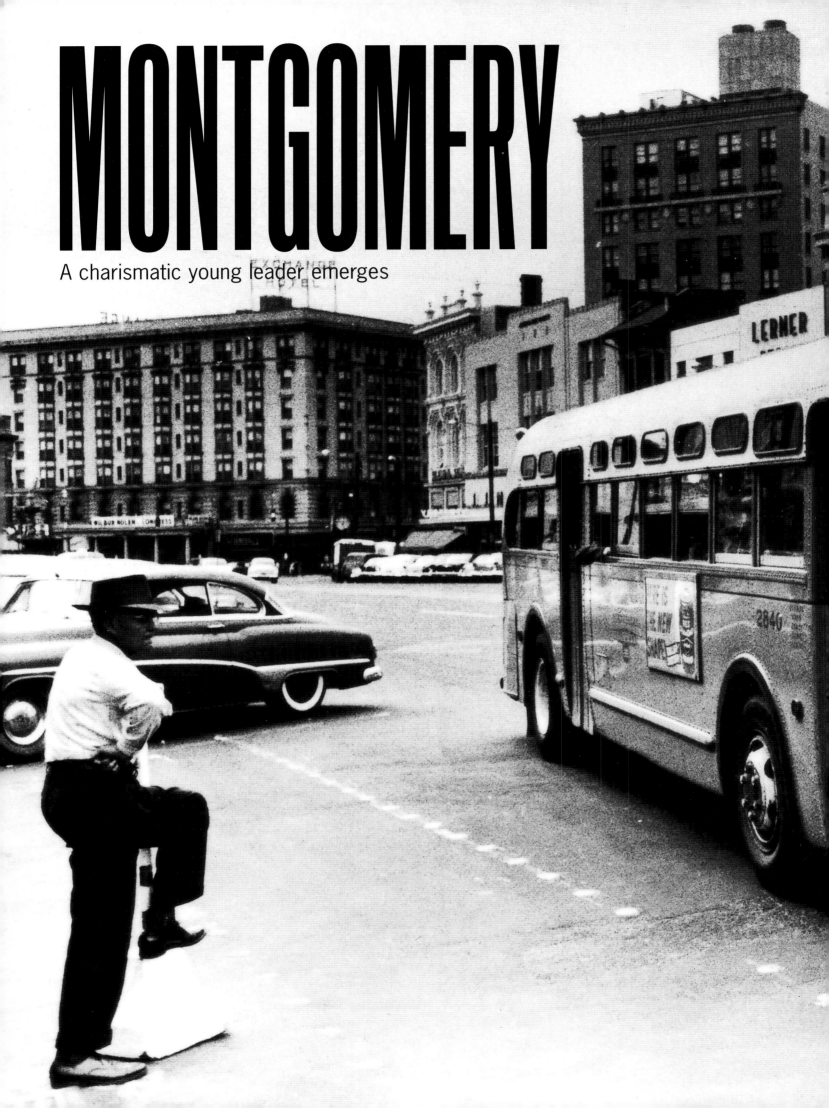

MONTGOMERY

A charismatic young leader emerges

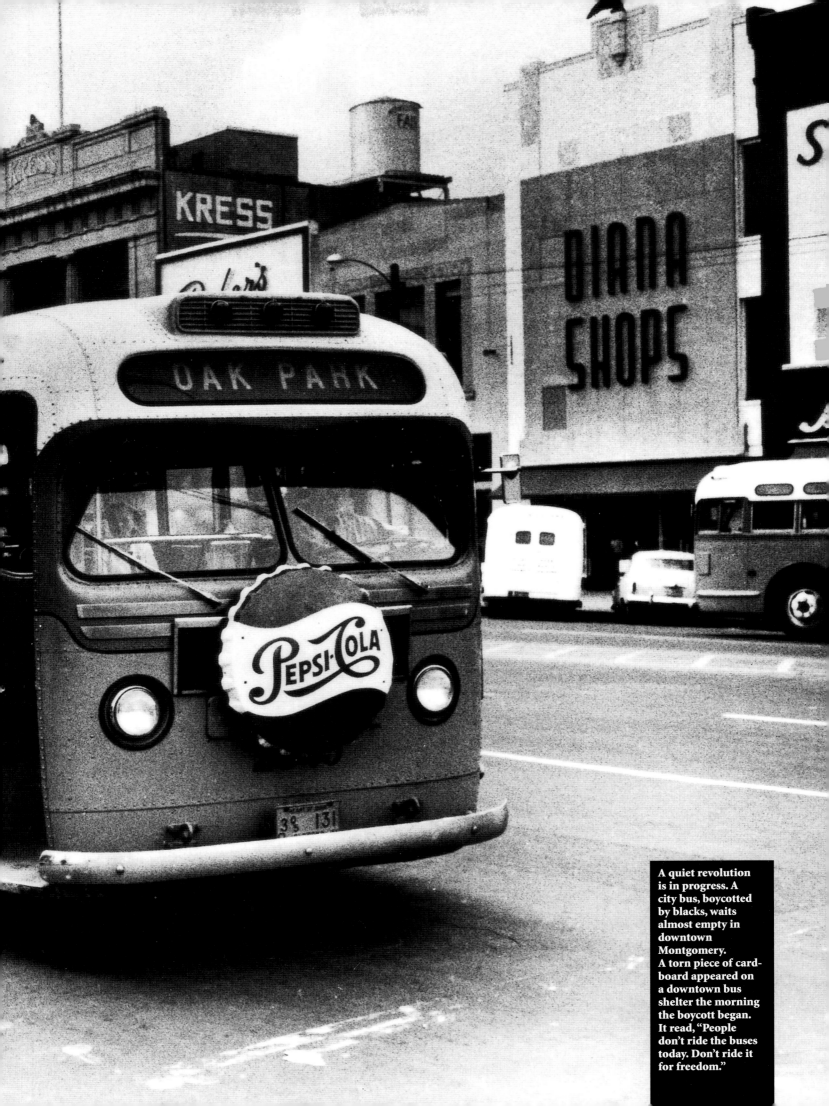

A quiet revolution is in progress. A city bus, boycotted by blacks, waits almost empty in downtown Montgomery. A torn piece of cardboard appeared on a downtown bus shelter the morning the boycott began. It read, "People don't ride the buses today. Don't ride it for freedom."

MONTGOMERY

Christ gave us the goals and Mahatma Gandhi the tactics.

~MARTIN LUTHER KING, JR.,
MONTGOMERY, 1955

The watershed event for which King's entire life had been a hurtling preparation arrived on December 1, 1955, when a 42-year-old seamstress and secretary of the Montgomery branch of the National Association for the Advancement of Colored People (NAACP) named Rosa Parks refused to give up her seat to a white man in the black section of a crowded bus. One year earlier the U.S. Supreme Court had ruled in *Brown v.*

Board of Education of Topeka that racial segregation in public schools was unconstitutional, but it took Parks's arrest to electrify and unify the fifty thousand black men and women in Montgomery around an epic 382-day bus boycott.

King, who had been in the "Cradle of the Confederacy" for only twenty months, was elected president of the Montgomery Improvement Association (MIA), which spearheaded the boycott, although later he replaced that term with a more Thoreauvian and philosophically expansive phrase, "massive noncooperation with evil." On the boycott's first day, King thundered to five thousand people at the Holt Street Baptist Church, "If you will protest courageously, and yet with dignity and Christian love, future historians will say, 'There lived a great people—a black people—who injected new meaning and dignity into the veins of civilization.'"

Inspired by their ministers, who held two mass meetings weekly, and by the unleashed genie of their own power to turn city buses into empty, ghostlike shells rumbling down roads at an eventual loss of $250,000 to the city, black people walked wherever they had to go. Some rode mules. Or turned to horse-drawn buggies. Students at Alabama State College hitched rides. Three hundred cars were donated and ten black churches helped purchase station wagons to create a car pool, each with the name of a church emblazoned on its sides.

Their example inspired people worldwide. Donations to bolster the boycott poured in from across America, as well as from Tokyo and Switzerland, but Montgomery's whites, who at first expected the boycott to fail, refused to honor the MIA's demands, which had been drawn up by Rev. Ralph Abernathy. In a show of racial solidarity, the mayor and his commissioners joined the White Citizens' Council. City officials declared mass rides in black cabs illegal. In retaliation, King was arrested twice,

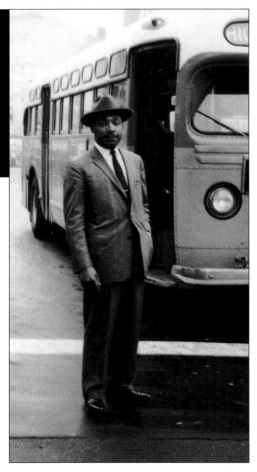

More than a year after the boycott began, the U.S. Supreme Court ruled that Alabama's bus segregation laws were unconstitutional. Martin Luther King, Jr., waits to board the city's first integrated bus.

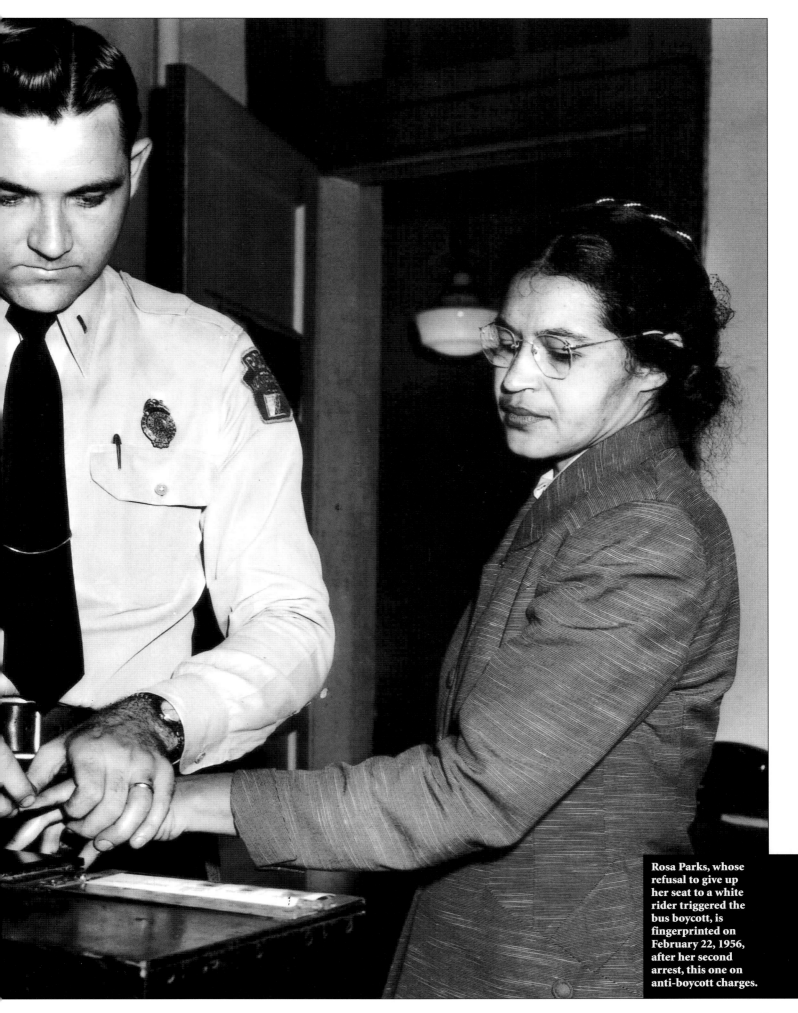

Rosa Parks, whose
refusal to give up
her seat to a white
rider triggered the
bus boycott, is
fingerprinted on
February 22, 1956,
after her second
arrest, this one on
anti-boycott charges.

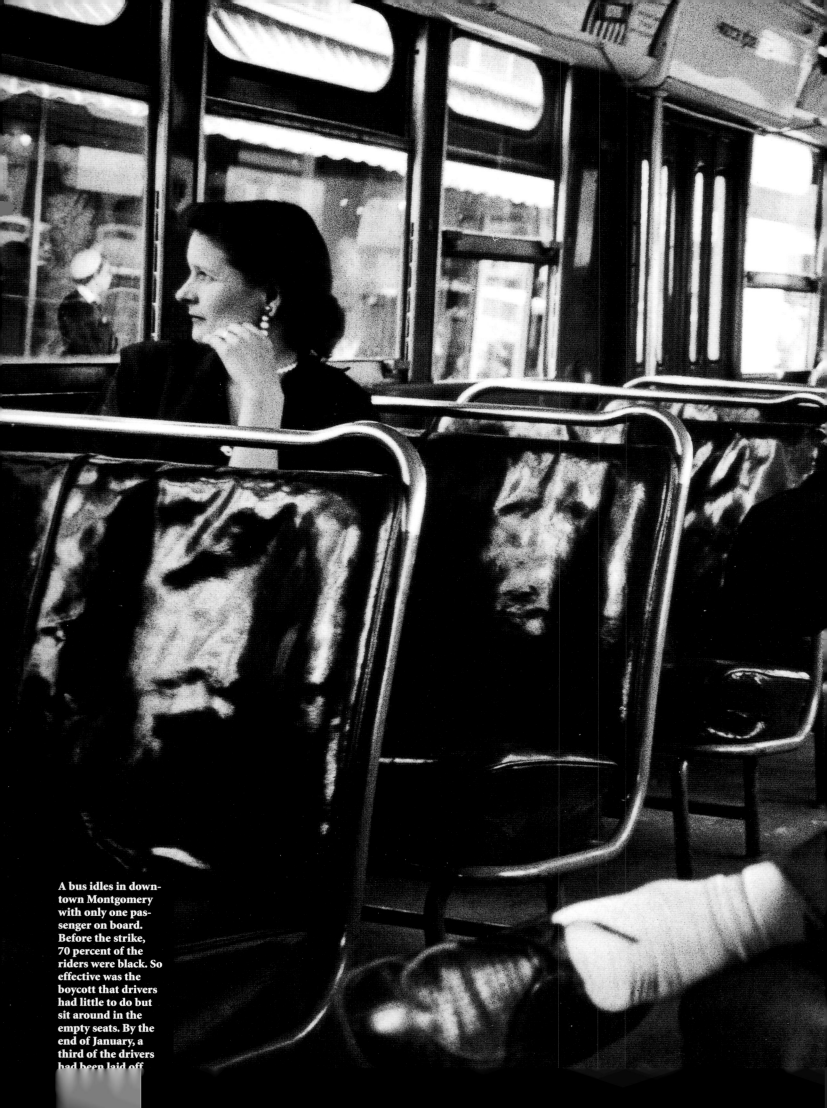

A bus idles in downtown Montgomery with only one passenger on board. Before the strike, 70 percent of the riders were black. So effective was the boycott that drivers had little to do but sit around in the empty seats. By the end of January, a third of the drivers had been laid off.

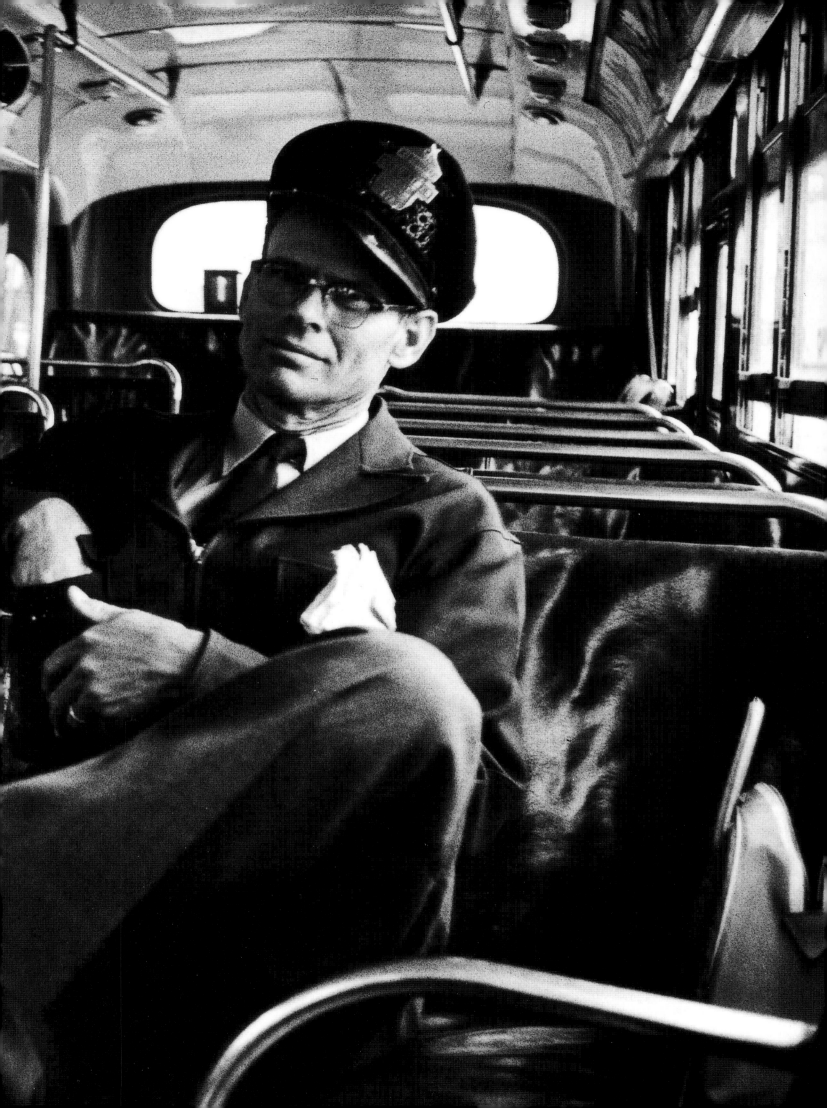

for speeding and for his participation in the boycott. On some days the telephone at his home rang thirty or forty times, with callers spewing obscenities at him and his family.

One such vicious call proved to be of pivotal importance for King. His phone rang in the middle of the night. The caller said this: "Listen, nigger, we've taken all we want from you. Before next week you'll be sorry you ever came to Montgomery. If you aren't out of this town in three days we're gonna blow your brains out and blow up your house." Right then he almost despaired. King walked to the kitchen and made himself a cup of coffee. He sat down at the table and prayed, "Lord….I am at the end of my powers. I have nothing left. I can't face it alone." Then, in the stillness of the night, in the mounting "crisis moment" that was Montgomery, he felt the divine, transforming presence that had eluded him since childhood. When King stood up he was renewed, certain of the righteousness—and successful outcome—of the cause.

His famous "kitchen conversion" came none too soon. On January 30, 1956, while King was at a meeting, his home was bombed. He rushed there, found Coretta and their baby, Yolanda, unharmed, and outside an angry, armed black crowd spoiling for a showdown with white policemen at the scene. The situation was edging toward violence. He raised one hand to quiet the crowd. Said, "I want you to go home and put down your weapons. We cannot solve this problem through retaliatory violence. We must meet violence with non-violence….We must meet hate with love."

Later the policemen would say King saved their lives, for the crowd heard his counsel—indeed, King's Gandhi-esque

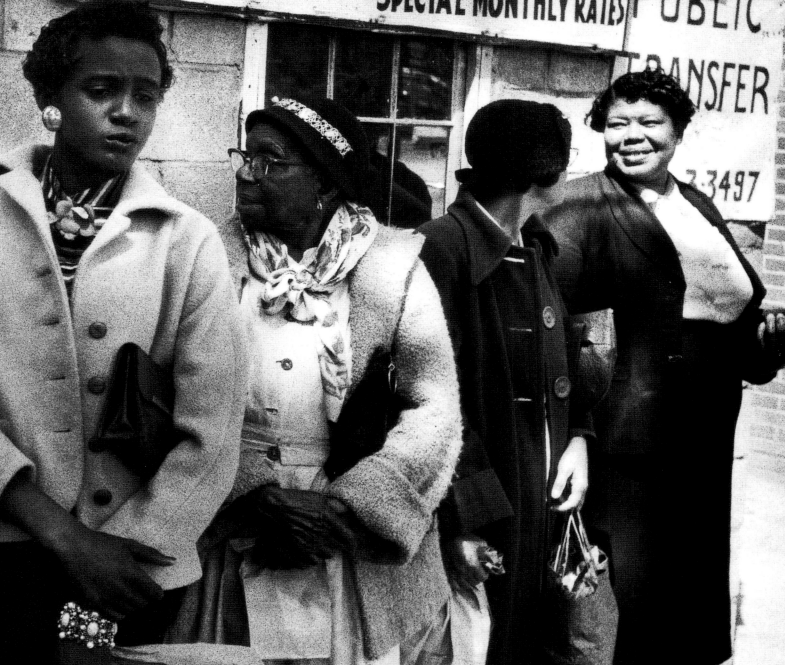

The police take a mug shot of a stony-faced Dr. King, arrested for the second time in his life for his boycott activities (the first was less than a month earlier on a minor traffic violation as part of the city's "get tough" policy). Under an obscure state anti-labor law, a grand jury indicted ninety boycott leaders, including ministers and car-pool drivers. The arrests were a futile effort on the part of the city to end the boycott and only helped unify the black community. The prosecutions also brought increased attention to the boycott by the national press and more financial support to the boycotters.

7089

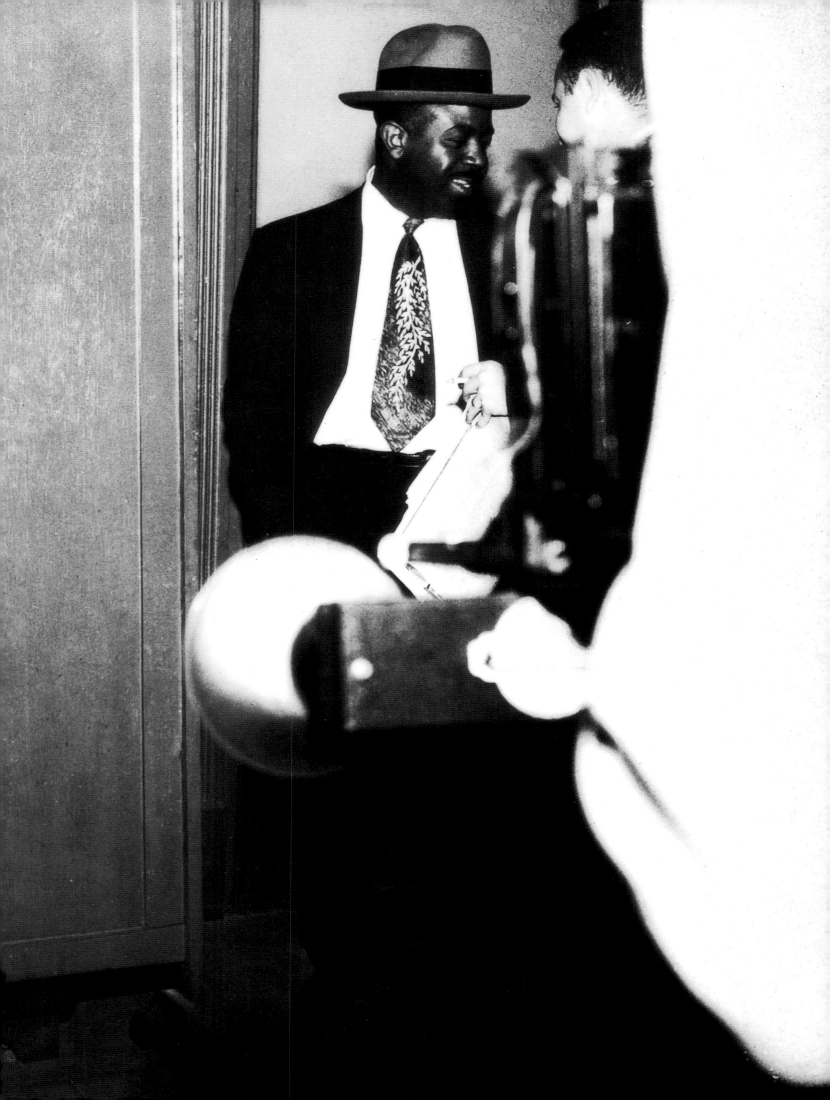

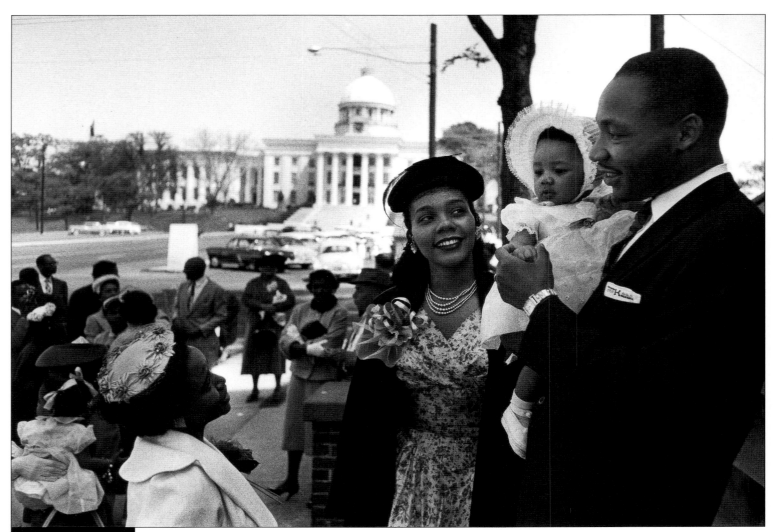

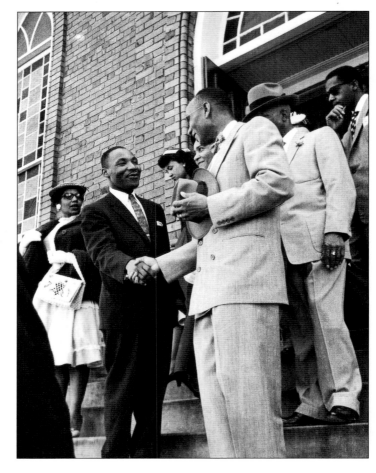

Proud pastor and new father, Dr. King, accompanied by his wife, Coretta, shows off his daughter, Yolanda. He greets members of his congregation outside Dexter Avenue Baptist Church.

stance, his agapic vision, were heard round the world as something uniquely redemptive in the bloody, centuries-long struggle for black liberation in America.

However, after a year of sacrifices, after a war of nerves that included blacks beaten and dragged from MIA vehicles and the bombing of black gas stations, the protesters began to tire. King and ninety leaders were indicted by the Montgomery grand jury, which resurrected a hoary state law that prohibited boycotts. The MIA responded by expanding its demands to a call for complete integration, and it was aided by Bayard Rustin and Stanley Levison—the beginning of two long and fruitful friendships for King. In August of that year he testified with three hundred others before the Platform and Resolutions Committee at the Democratic National Convention in Chicago that "The question of civil rights is one of the supreme moral issues of our time."

The protesters suffered a major setback on October 30, 1956, when the city's

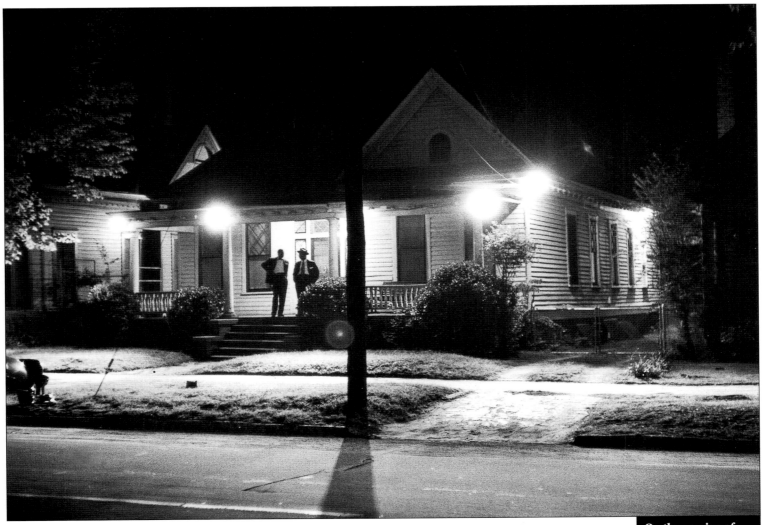

On the evening of
January 30, 1956,
King's house was
bombed. Fortunately
his wife and baby
daughter were unin-
jured. Afterward
floodlights were
installed and guards
stationed to prevent
any recurrence of
the violence.

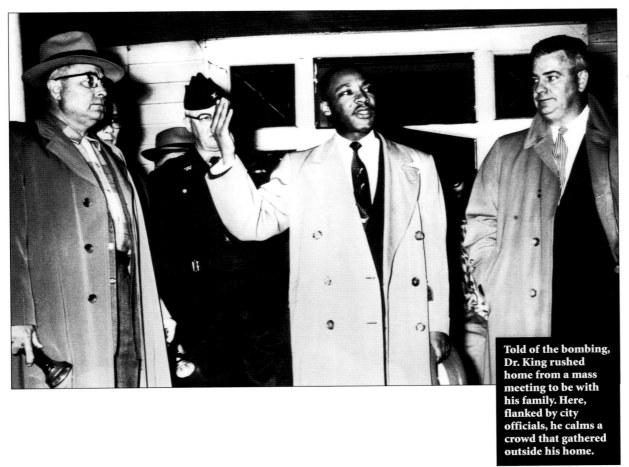

Told of the bombing,
Dr. King rushed
home from a mass
meeting to be with
his family. Here,
flanked by city
officials, he calms a
crowd that gathered
outside his home.

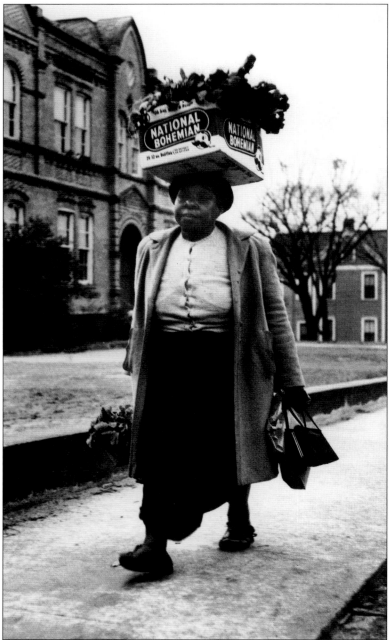

"Sole power" carried many blacks to and from work and around the city. Here a woman carries a box of turnip greens on her head. Others enter one of the cars run by the organizers of the boycott.

legal department stopped carpooling by blacks. Many feared that move might unravel the resistance; in fact, it did demoralize many. But on November 13, the U.S. Supreme Court ruled that segregation on buses was unconstitutional. To be sure, that victory by Montgomery's black citizens triggered more violence—blacks were attacked, buses were shot at, and Abernathy's home and church were bombed—yet when the city's white leaders denounced these criminal acts they ended. On December 20, King declared that the boycott was over and once again provided the language needed to heal wounds on both sides: "We must seek an integration based on mutual respect. As we go back to the buses, let us be loving enough to turn an enemy into a friend."

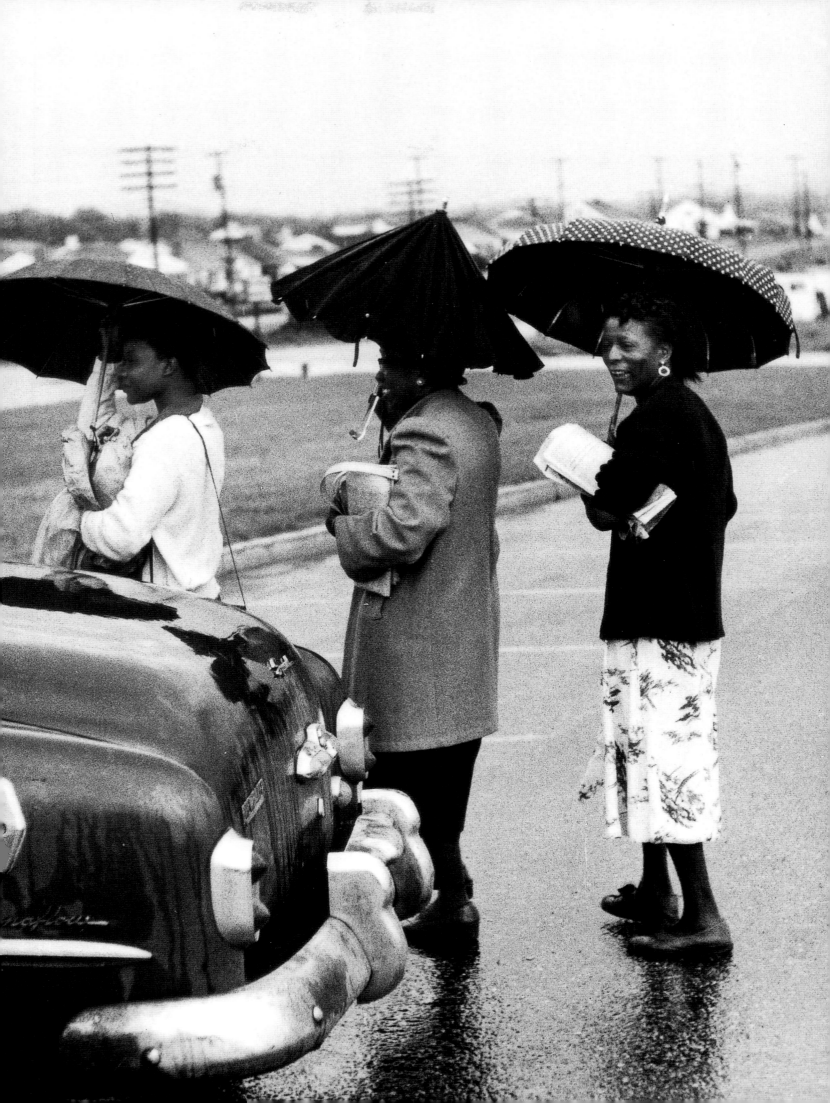

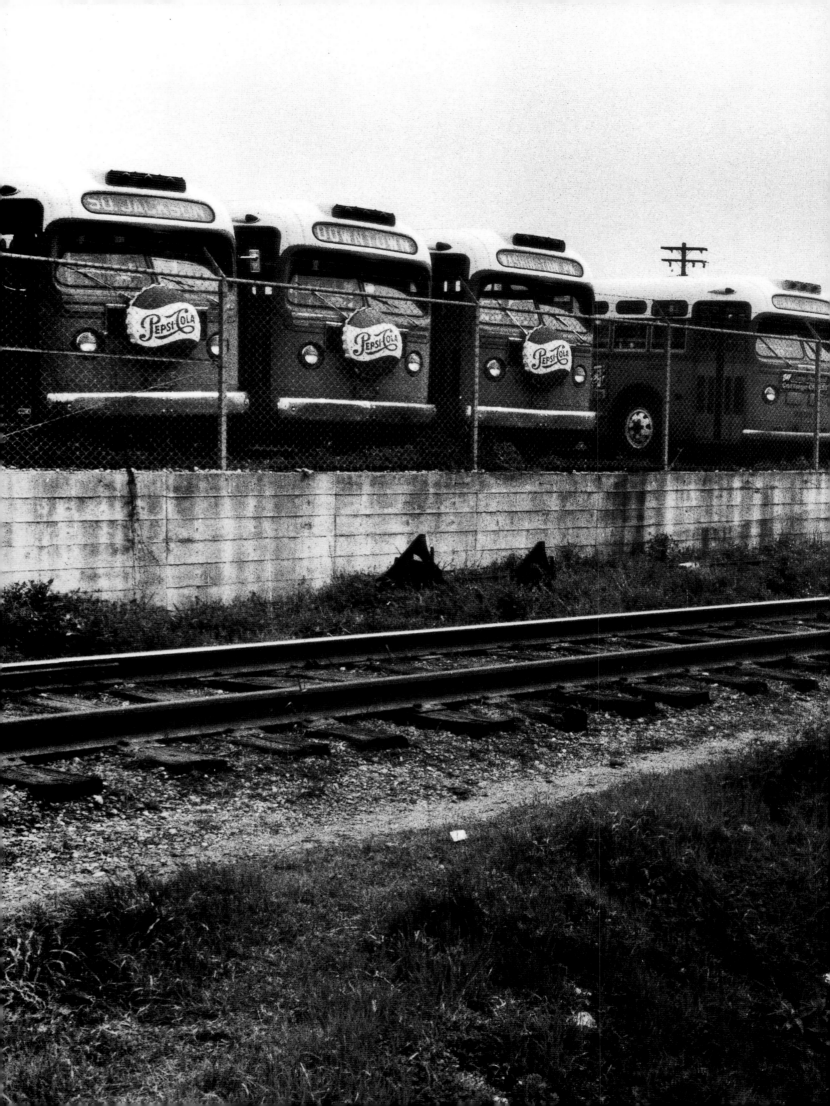

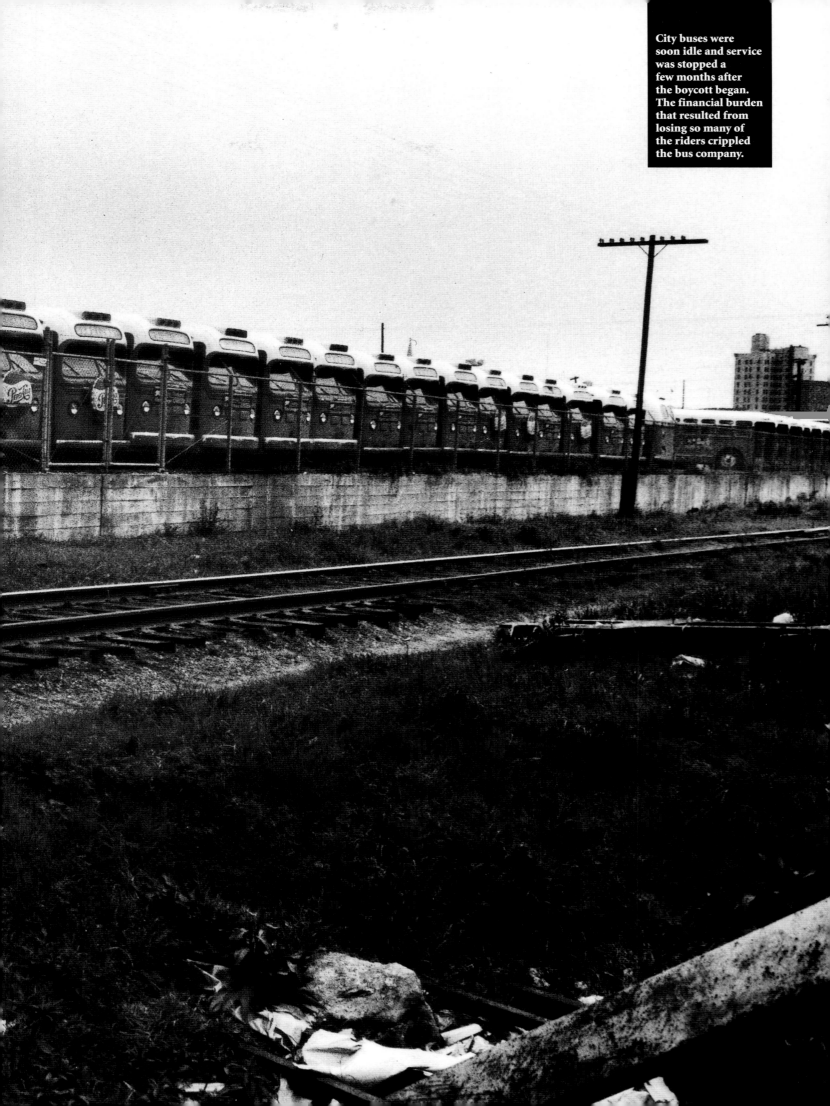

City buses were soon idle and service was stopped a few months after the boycott began. The financial burden that resulted from losing so many of the riders crippled the bus company.

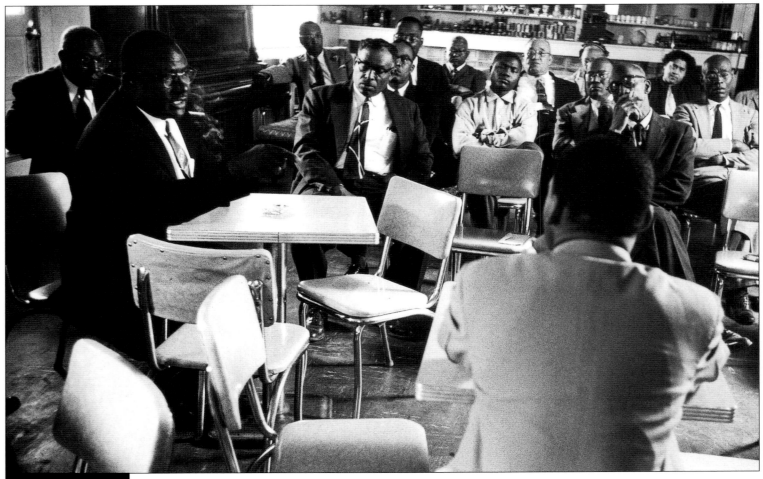

King met often with other MIA leaders to avert violence, solve transit problems, and work out strategies to counter the city's efforts to stop the boycott.

The police often harassed car-pool drivers as part of their "get tough" policy to pressure an end to the boycott. They routinely stopped blacks to check for car-registration papers and drivers' licenses and for any small infraction that could result in a ticket or an arrest.

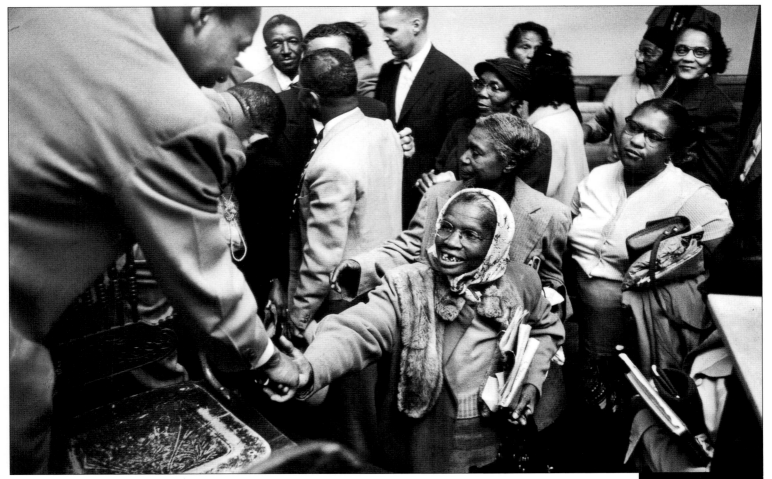

King's eloquence and pacific, dignified bearing served as a model for the protesters and lifted their spirits. Here he greets a supporter. One elderly woman who walked every day told King, "My feet is tired but my soul is rested."

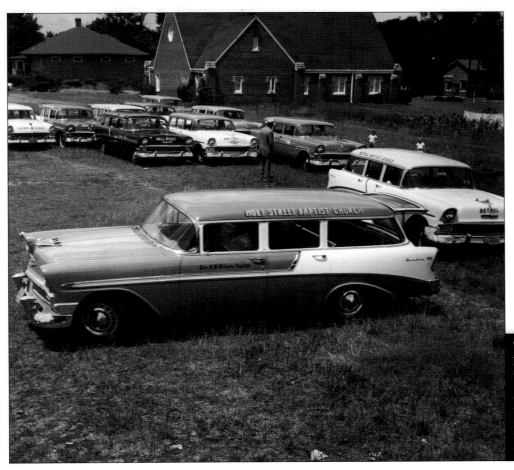

The MIA helped purchase a fleet of station wagons (nicknamed rolling churches), each with the name of a congregation on its side, to transport blacks around the city.

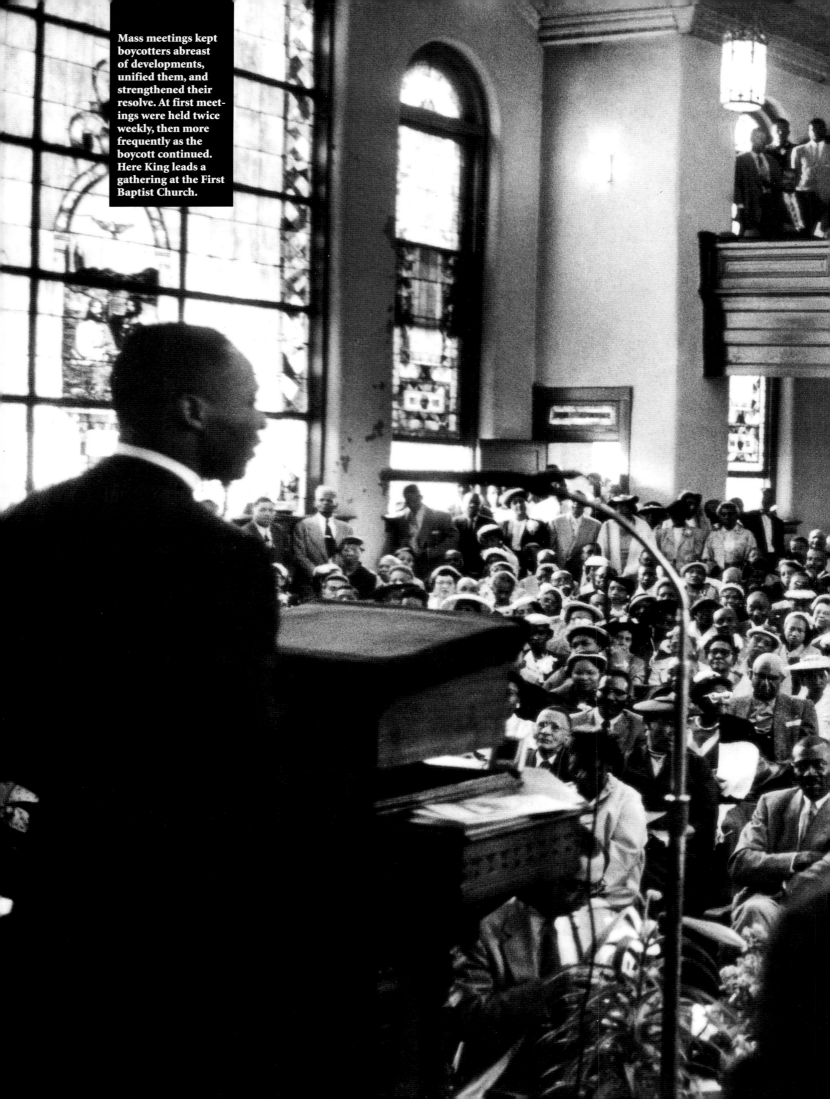

Mass meetings kept boycotters abreast of developments, unified them, and strengthened their resolve. At first meetings were held twice weekly, then more frequently as the boycott continued. Here King leads a gathering at the First Baptist Church.

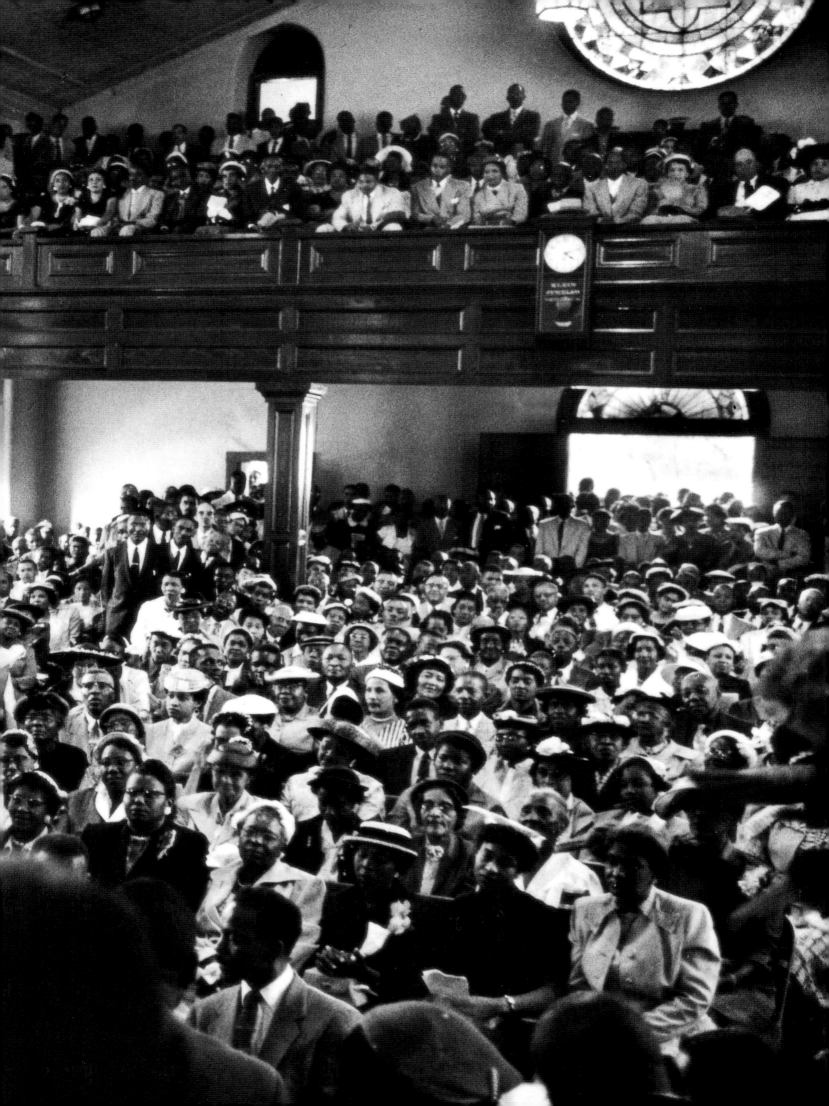

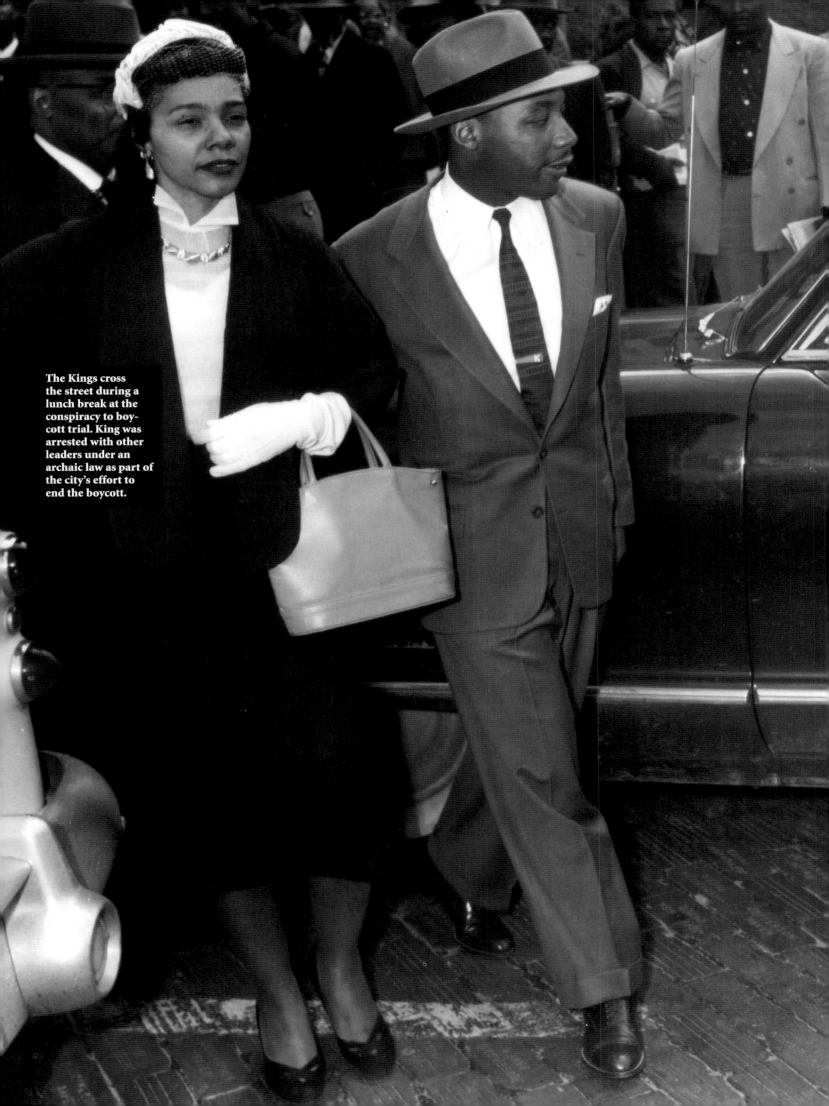

The Kings cross the street during a lunch break at the conspiracy to boycott trial. King was arrested with other leaders under an archaic law as part of the city's effort to end the boycott.

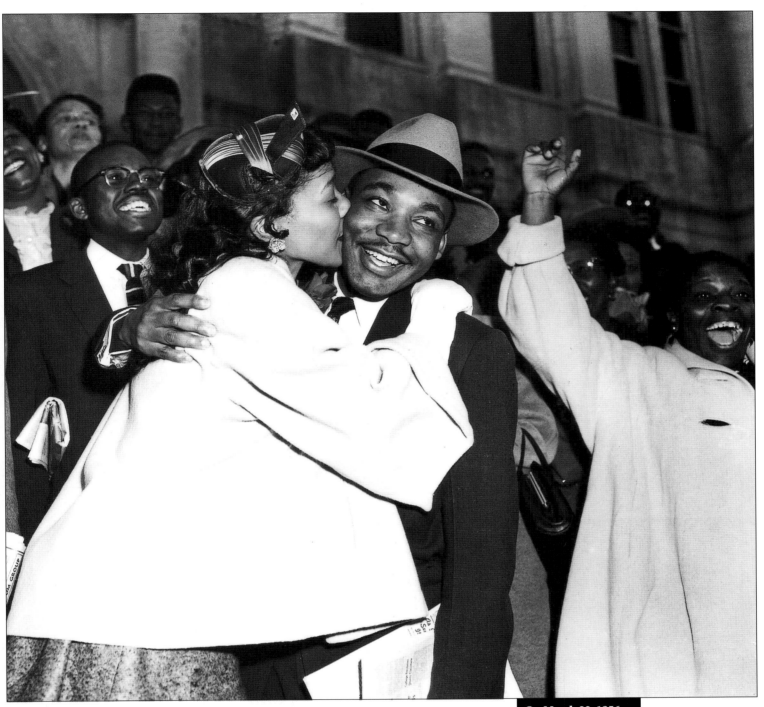

On March 22, 1956, King celebrates his conviction. He believed it was right to disobey unjust laws. Explaining his buoyant mood, he said, "Ordinarily, a person leaving a courtroom with a conviction behind him would wear a somber face. But I left with a smile. I knew that I was a convicted criminal, but I was proud of my crime."

On December 21, 1956, when the boycott ends, King and others wait to step onto the day's first bus.

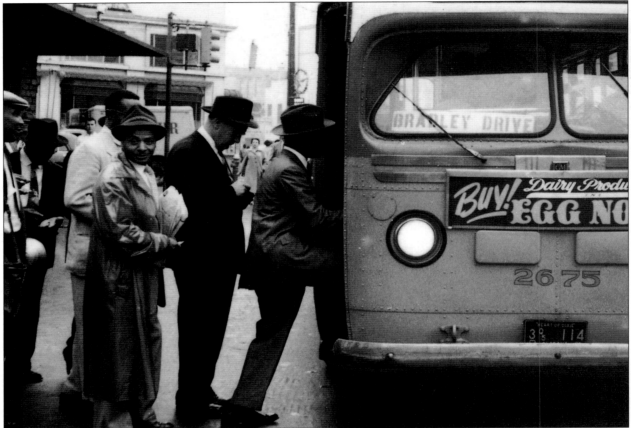

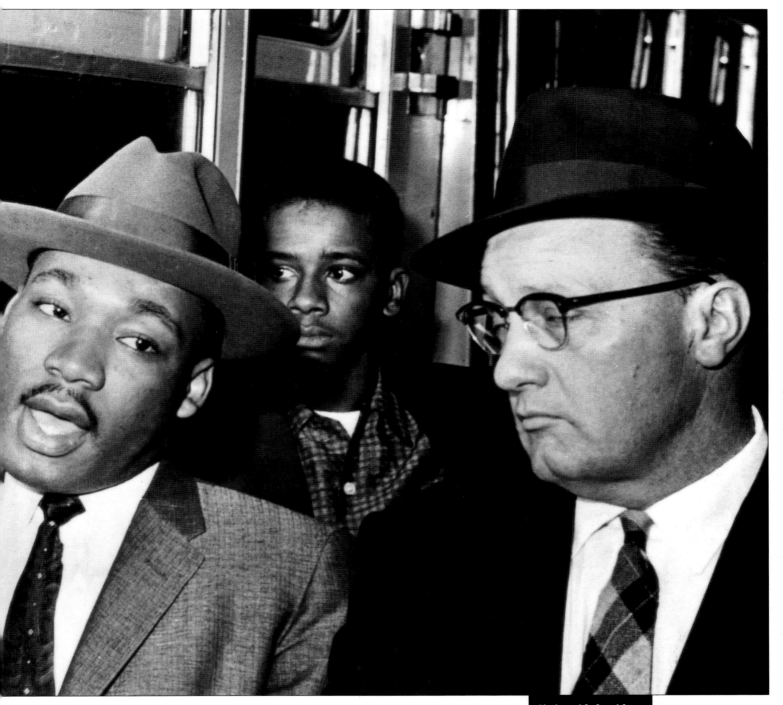

Sitting side by side in the front of the bus, Dr. King and Rev. Glenn E. Smiley, a fellow nonviolent activist, enjoy the fruits of the victory—color-blind service on the city's buses. The time had come, as King had said at the mass meeting the previous night, "to move from protest to reconciliation."

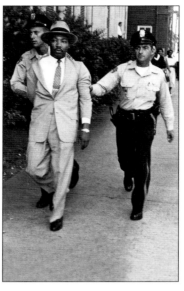

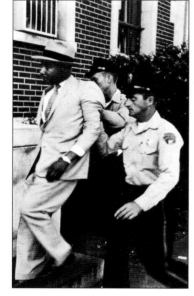

While a concerned Coretta looks on, her husband is booked. King later said the policemen had "tried to break my arm; they grabbed my collar and tried to choke me, and when they got me to the cell, they kicked me in." Once King's identity became known to the police, he was released on his own recognizance. Later he was tried and convicted, and he resolved to go to jail. The police commissioner paid his fine ($14) to keep the incident out of the news, and a frustrated King was once again released.

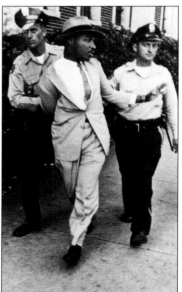

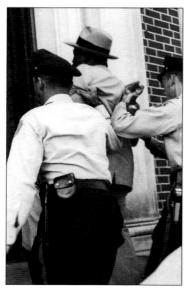

Almost two years after triumphantly leading the battle to end bus segregation in Montgomery, King is wrongfully arrested outside the city's courthouse for loitering as he waits to attend a trial and is then manhandled down to the police station. He raises a hand to warn off supporters from intervening.

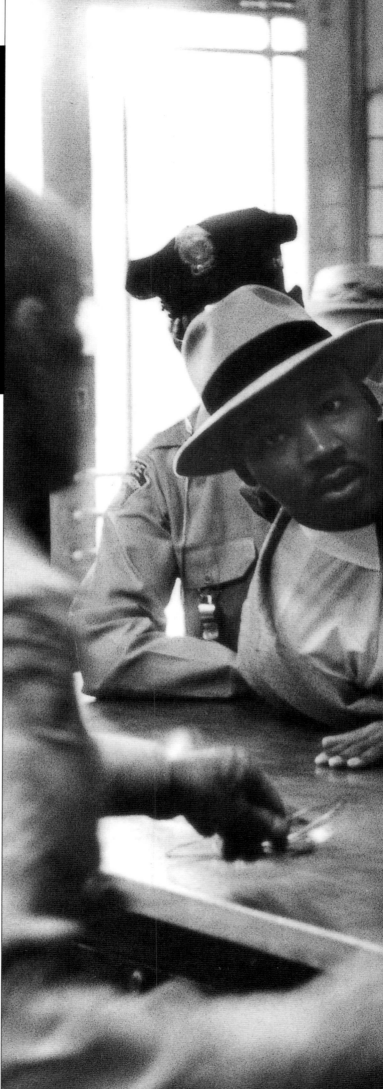

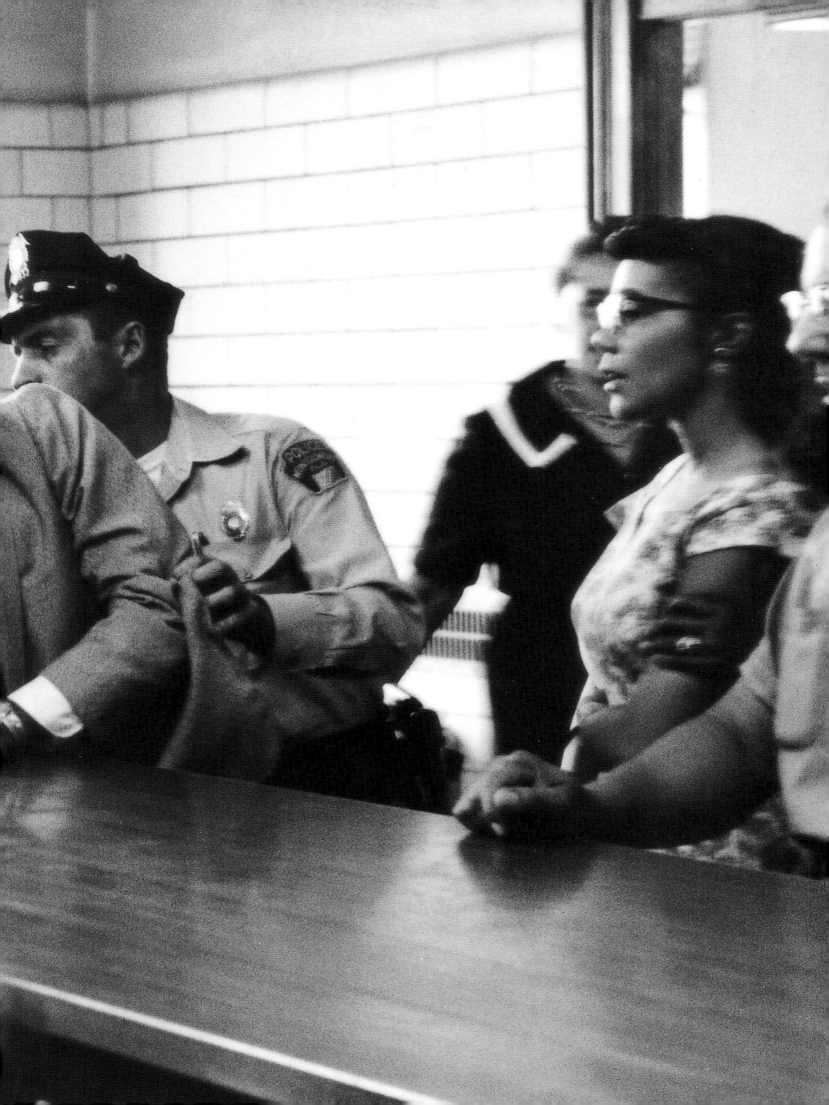

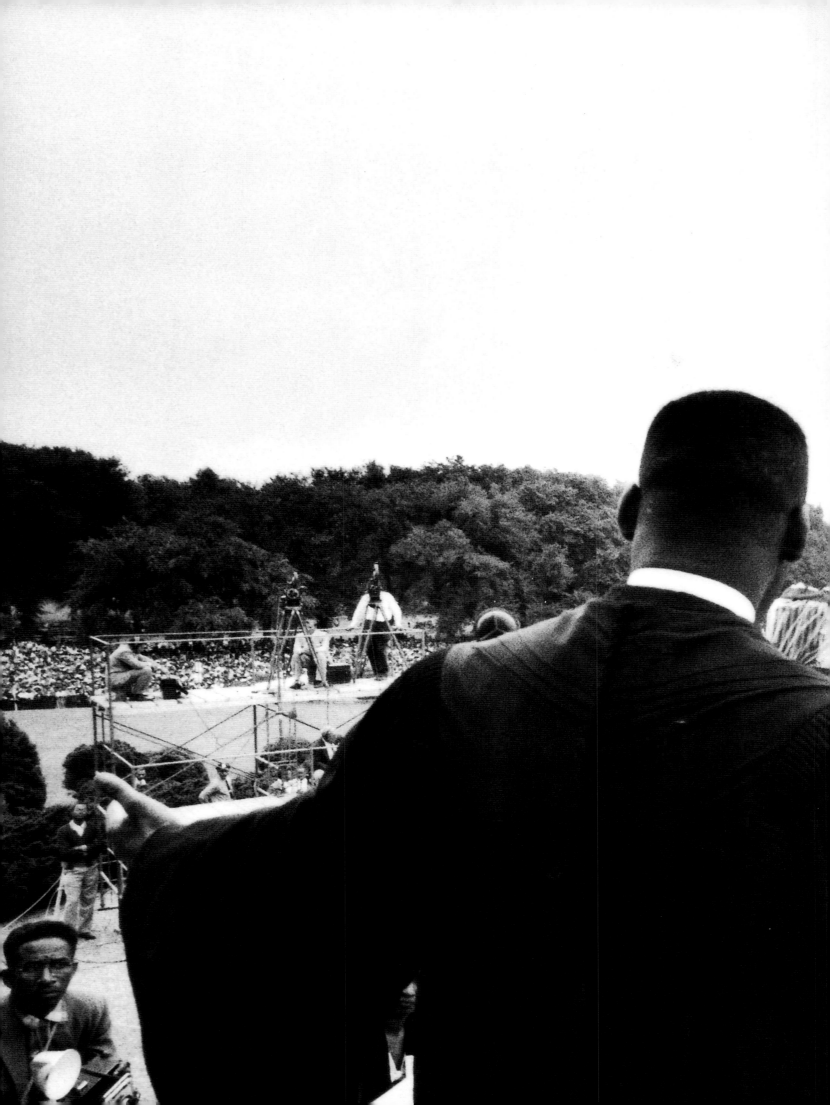

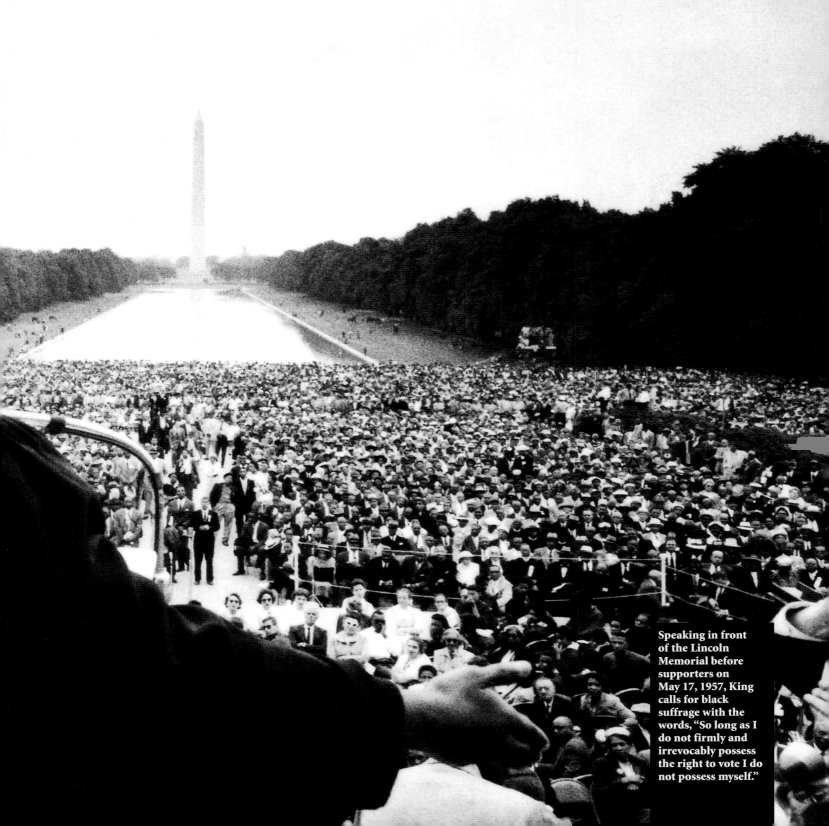

PRAYER PILGRIMAGE

King steps onto the national stage

Speaking in front of the Lincoln Memorial before supporters on May 17, 1957, King calls for black suffrage with the words, "So long as I do not firmly and irrevocably possess the right to vote I do not possess myself."

PRAYER PILGRIMAGE

A man who hits his peak at twenty-seven has a tough job ahead.
~MARTIN LUTHER KING, JR.,
NEW YORK POST INTERVIEW,
APRIL 14, 1957

People from thirty states gathered to celebrate the third anniversary of the U.S. Supreme Court's decision declaring school segregation unconstitutional and to press for a civil rights bill.

In a magnificent photograph, young King—the lionized symbol of black America's victory in Montgomery—stands in the Lincoln Memorial between two towering representatives of the fight against racial discrimination. At left is Roy Wilkins of the NAACP, the other is A. Philip Randolph, organizer of the Brotherhood of Sleeping Car Porters

union. They are at the Prayer Pilgrimage for Freedom in Washington, D.C., on May 17, 1957, and the moment is clearly a triumphant and yet tenuous coalescing of efforts by America's two major civil rights organizations.

For in that photo, King represents a spanking-new group, the direct-action-oriented Southern Christian Leadership Conference (SCLC), created at a meeting on February 14 and dedicated to opposing all forms of segregation and to fighting for black voter registration in the South. It was church-based and defined by its philosophy of nonviolence and noncooperation with unjust laws. It was also perceived by some officials of the NAACP to be a potential threat to the older organization's financial base in the South (in churches especially), to its membership, and to its legal approach. At the time of its formation, a *Pittsburgh Courier* editorial queried, "Are the organizers of the Southern Christian Leadership Conference implying by their action that the NAACP is no longer capable of doing what it has been doing for decades.…What sound reason is there for having two organizations with the same goal when one has been doing such an effective job?"

From the very first days of the SCLC, its leadership took great pains to overcome the NAACP's opposition. (Rev. Joseph Lowery recalled a meeting in New York with him, King, Abernathy, Wilkins, John Morsell, and Gloster Current, during which Current remarked, "To tell you the truth, gentlemen, at the end of the bus boycott, you all should have disbanded everything, and been back in the NAACP.") Yet, although the two organizations differed in methods (some argued that the Montgomery boycott's success was ultimately the result not of mass movement confrontation but of the kind of legal

King's rousing plea, "Give us the ballot, give us the ballot," moved the crowd and caught the attention of the press in his first national address.

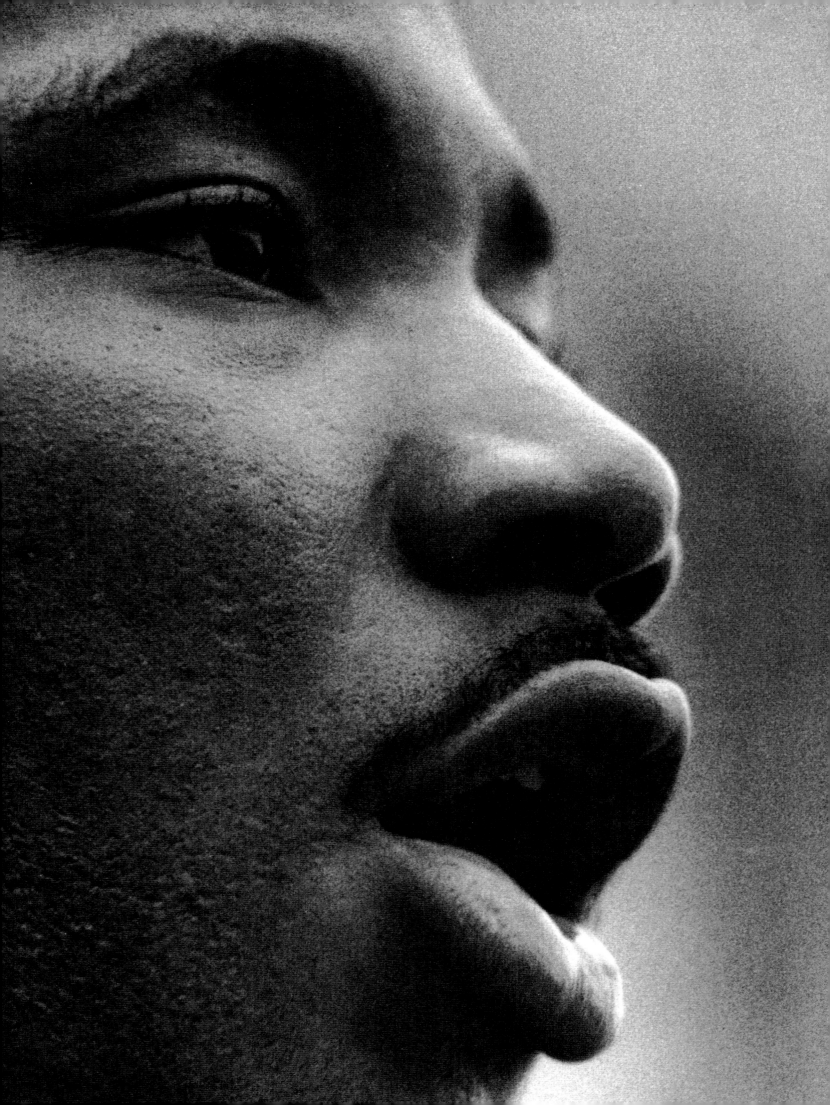

Pilgrims dressed in their Sunday best rest briefly in front of the memorial to the Great Emancipator.

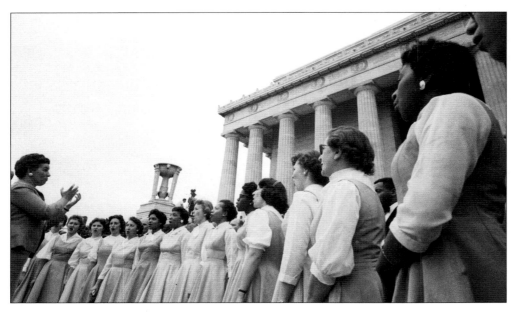

and lawful tactics that the NAACP had always championed), they shared identical goals and the SCLC's founders were all NAACP members.

Thus it was incumbent upon the younger group to convince the older one that their approaches were complementary, not competitive. Where one worked through the courts, they argued, the other engaged in community action that enforced those legal victories. King and other MIA members took out lifetime NAACP memberships, and King urged members of the Dexter Avenue Baptist Church to do the same. Well into the 1960s King spoke at NAACP fundraisers. Whenever possible the two groups tried to raise funds together, then split the proceeds, and some SCLC literature stated (for the NAACP's sake) that it was not trying to set up local units or draw individual memberships. Indeed, in his speech at the Prayer Pilgrimage, King emphasized to the crowd of thirty-seven thousand gathered before the Lincoln Memorial that "We have won marvelous victories through the work of the NAACP....[It] has done more to achieve civil rights for Negroes than any other organization we can point to."

Yet, despite these conciliatory moves aimed at cooperation, in another photo in which a smiling King walks to the podium to speak, with people cheering him and raising their hands in salute, we notice a rather sad-faced Roy Wilkins still sitting and staring at the camera—a portent perhaps of brewing problems between these two outstanding civil rights leaders that would intensify over the next decade.

Nevertheless, the Prayer Pilgrimage was a shining hour for King. It was his

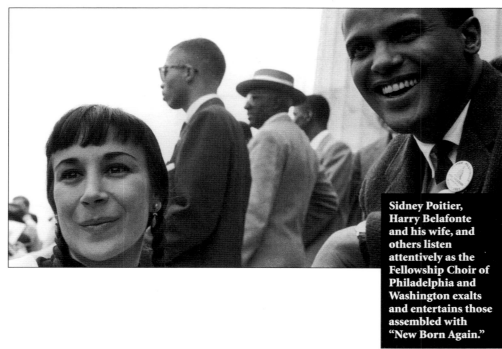

Sidney Poitier, Harry Belafonte and his wife, and others listen attentively as the Fellowship Choir of Philadelphia and Washington exalts and entertains those assembled with "New Born Again."

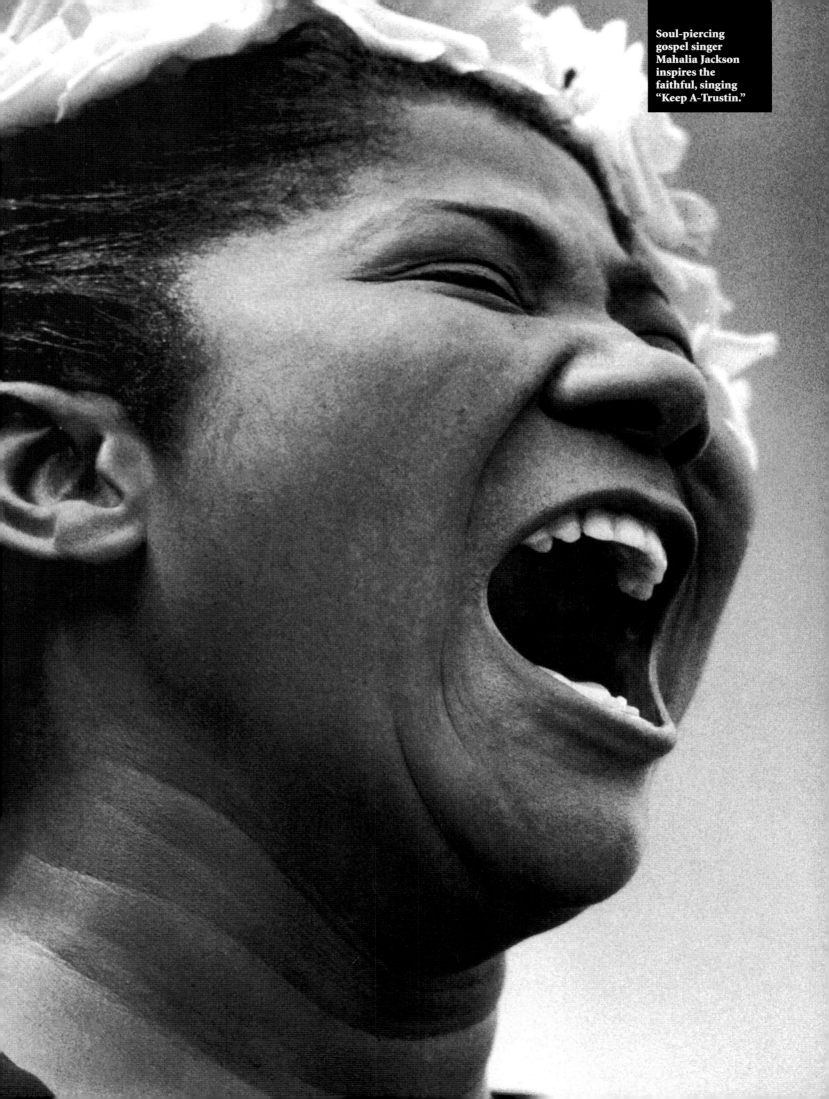

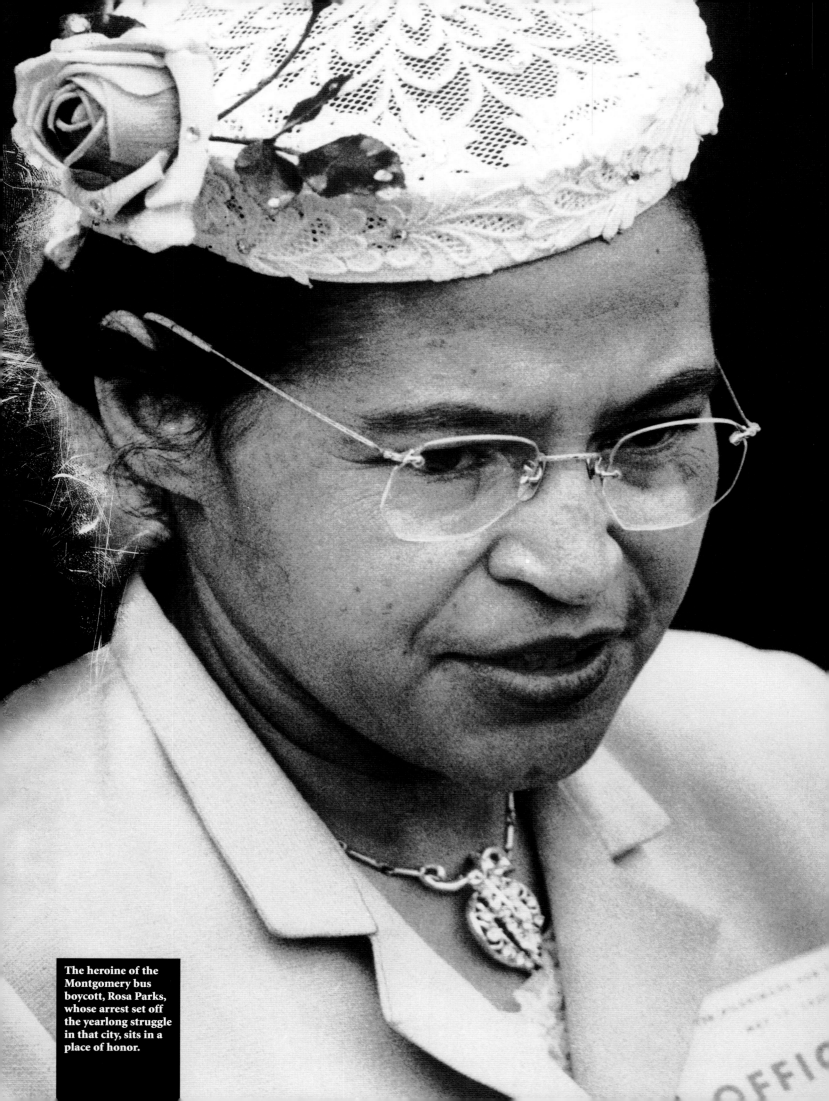

The heroine of the Montgomery bus boycott, Rosa Parks, whose arrest set off the yearlong struggle in that city, sits in a place of honor.

first speech before a national audience, an address aimed at demonstrating black solidarity, raising a nation's conscience on racial justice, and appealing to the Eisenhower administration to pass the Civil Rights Bill stalled in committees by southern politicians. (And surely it was influential in nudging Congress to establish that September the Civil Rights Commission and a new Civil Rights Division in the Department of Justice.) King was introduced by 68-year-old A. Philip Randolph, one of his idols and a leader in the labor movement, editor of the outspoken *Messenger,* and, as a fighter for equality for thirty years, one of the elder statesmen of the black liberation struggle.

"Give us the ballot," King said in remarks that revealed the struggles of the civil rights movement to be a continuation of the Civil War and black suffrage the fulfillment of Lincoln's vision. "We come humbly to say to the men in the forefront of our government that the civil rights issue is…an eternal moral issue which may well determine the destiny of our nation in the ideological struggle with communism….We must act now, before it is too late."

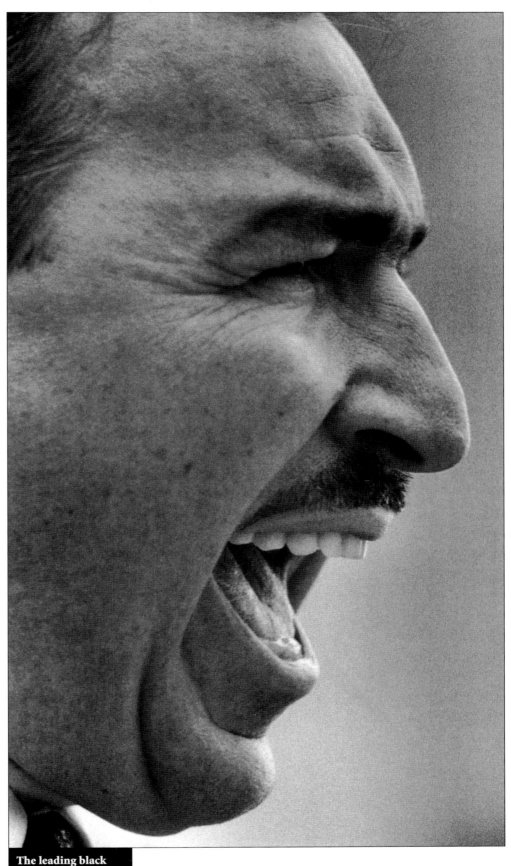

The leading black politician in the country, Harlem's fiery Congressman Rev. Adam Clayton Powell, Jr., rouses the crowd with his attack on the establishment's indifference to civil rights.

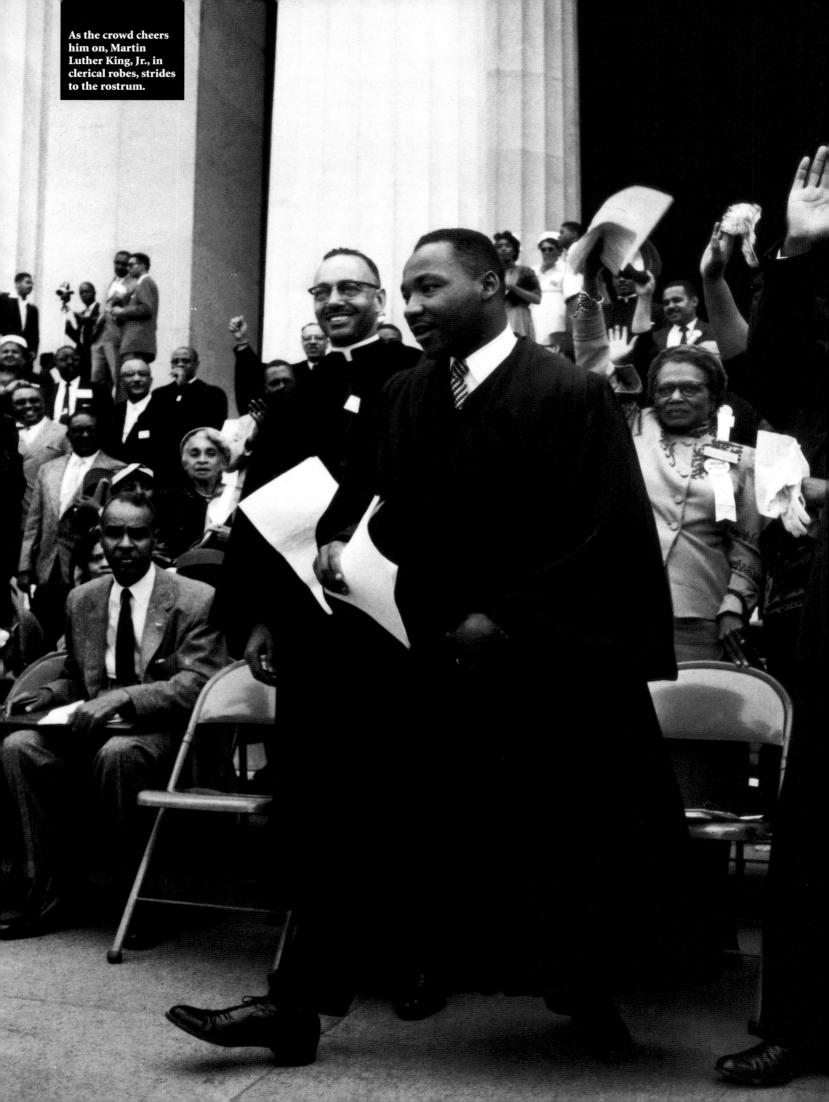

As the crowd cheers him on, Martin Luther King, Jr., in clerical robes, strides to the rostrum.

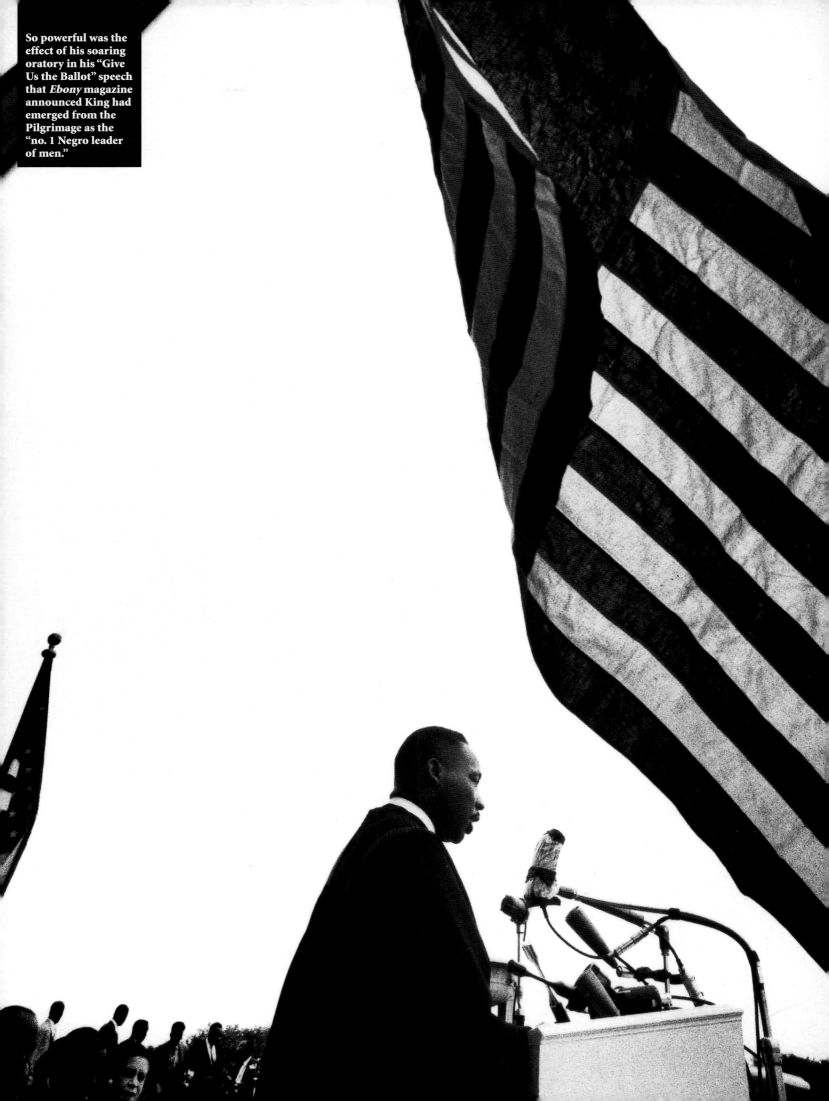

So powerful was the effect of his soaring oratory in his "Give Us the Ballot" speech that *Ebony* magazine announced King had emerged from the Pilgrimage as the "no. 1 Negro leader of men."

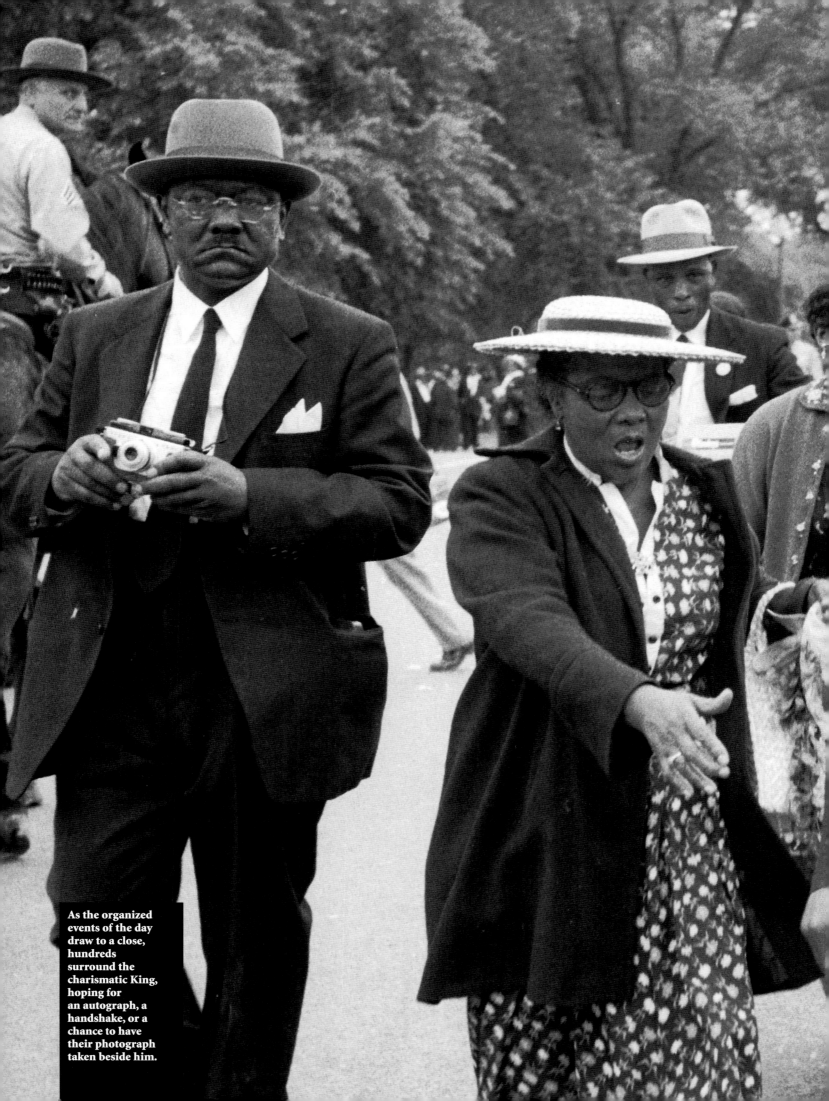

As the organized events of the day draw to a close, hundreds surround the charismatic King, hoping for an autograph, a handshake, or a chance to have their photograph taken beside him.

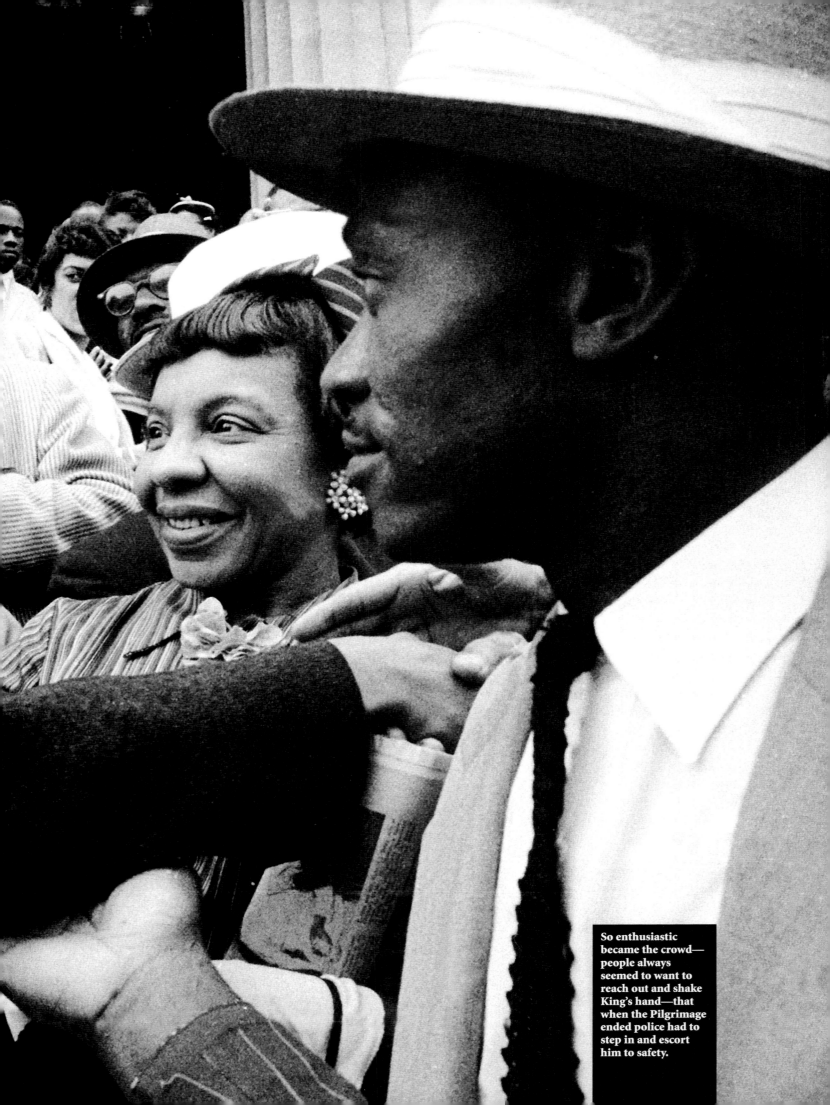

So enthusiastic became the crowd—people always seemed to want to reach out and shake King's hand—that when the Pilgrimage ended police had to step in and escort him to safety.

HARLEM STABBING

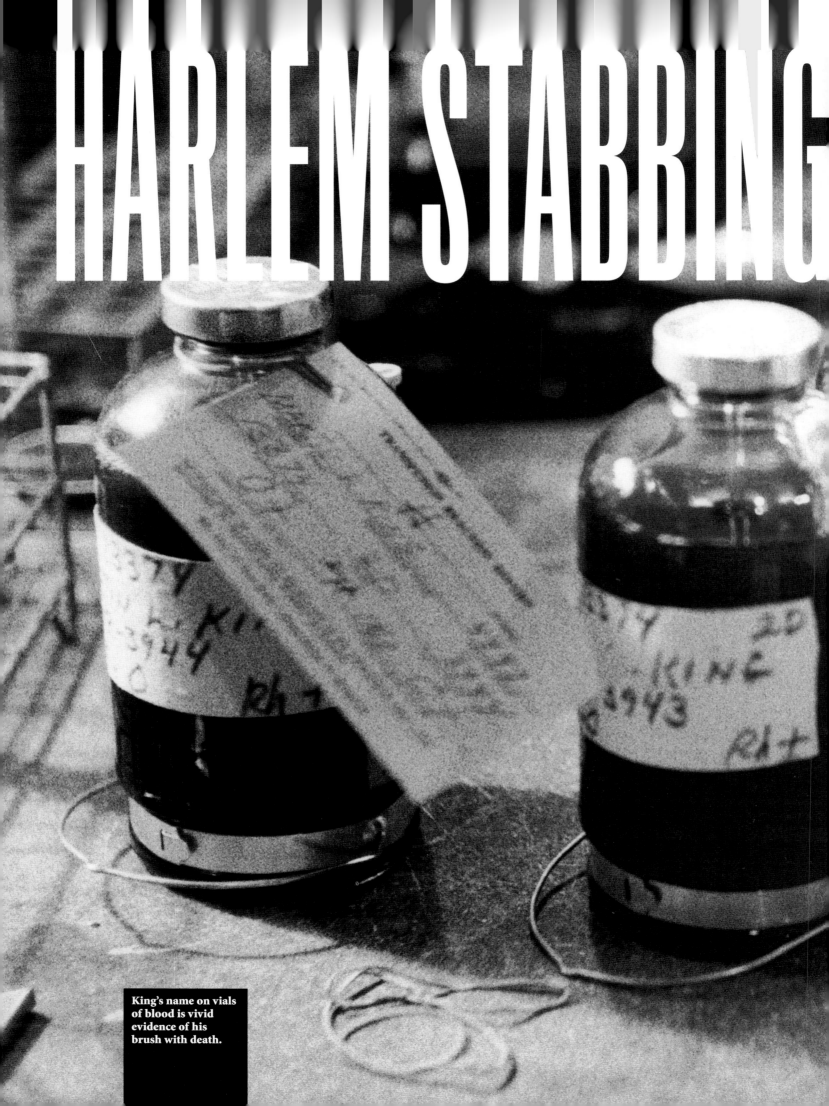

King's name on vials of blood is vivid evidence of his brush with death.

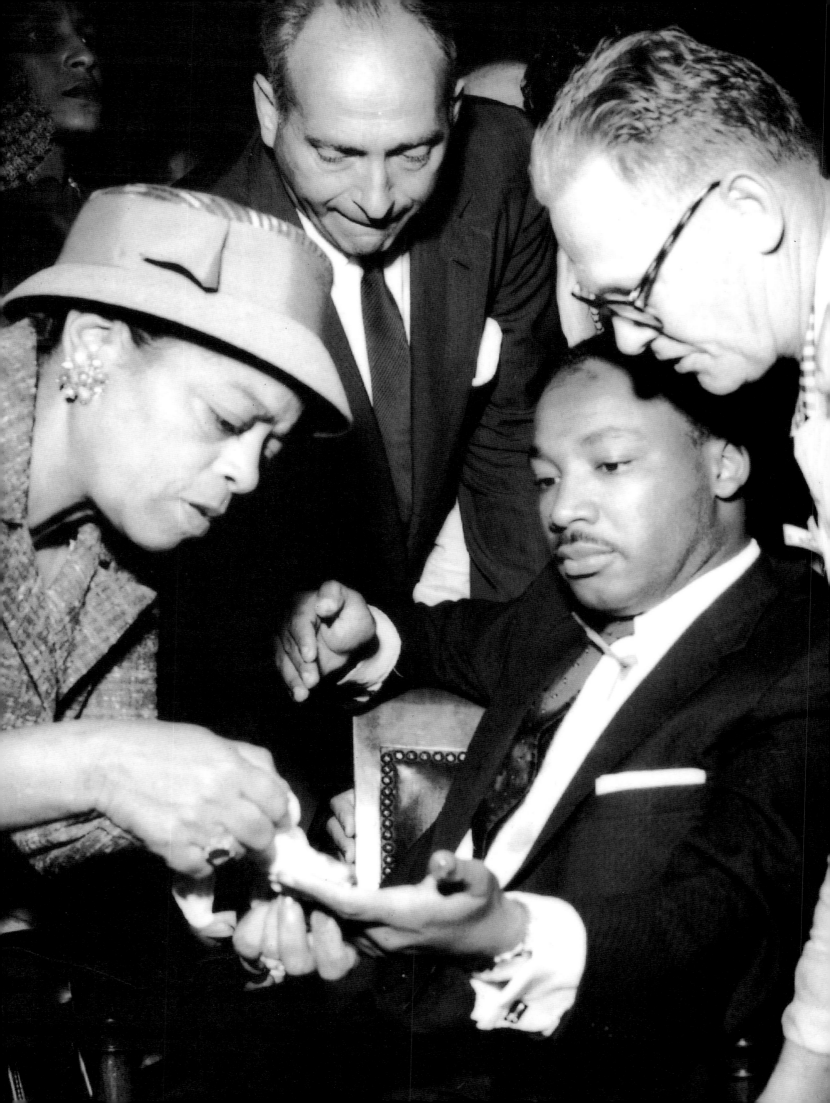

HARLEM STABBING

I'm so happy that you didn't sneeze.
~LETTER FROM A NINTH-GRADE
WHITE STUDENT, 1958

King's post-Montgomery period was, of course, not without danger. On September 20, 1958, he was autographing copies of his first book, *Stride Toward Freedom,* in Blumstein's Department Store on 125th Street in Harlem when a black woman, Izola Ware Curry, stabbed him almost fatally near his heart with a Japanese letter opener. He was taken to Harlem Hospital, where Dr. Aubre D. Maynard removed two of his ribs to get the knife out. "If you had sneezed during all the hours of waiting," Maynard said, "your aorta would have been punctured and you would have drowned in your own blood." He cut a small incision over King's heart. Permanent scar tissue formed in the shape of a cross. "He is a minister," the doctor explained. "It seemed appropriate."

King refused to press charges against the woman who attacked him. He told the authorities, "Don't do anything to her; don't prosecute her; get her healed." Curry was committed to an institution for the criminally insane.

As he convalesced, King received thousands of sympathy letters and cards from around the world. "What makes you think you are the 'exclusive property' of the Negro race only?" a white woman wrote. "You belong to us too, because we love you. Please don't lose faith in us 'whites.' There are many of us who are good and pray for your triumph."

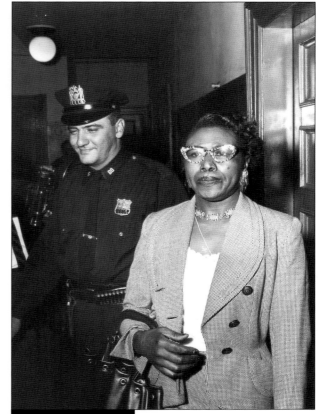

King's assailant, Izola Ware Curry, made no attempt to escape and was immediately taken into custody. Within the hour, police transported her to Harlem Hospital for King to identify.

While King was promoting his new book, a woman walked up to him and asked, "Are you Dr. King?" "Yes, I am," he said. She then drove a seven-inch letter opener into his chest. A bystander daubs blood from King's hand, which was also injured in the attack, as he waits for an ambulance to arrive.

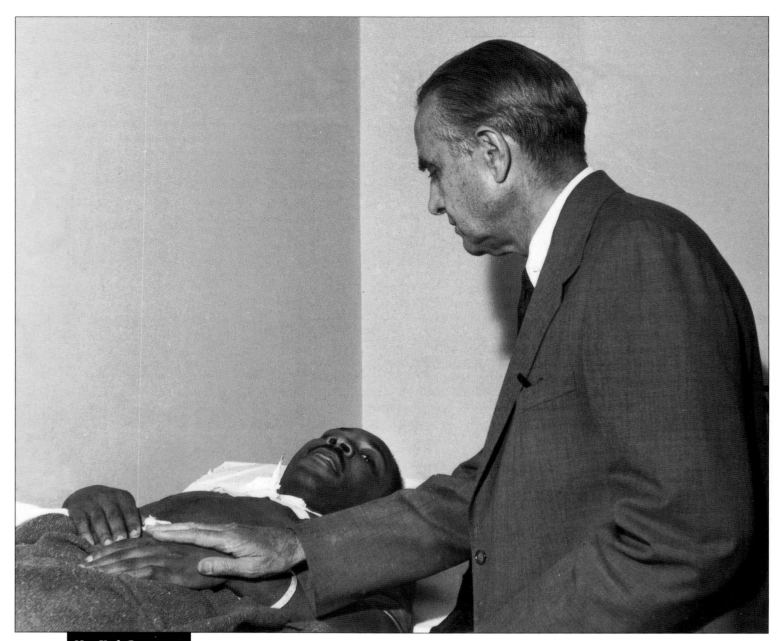

New York Governor Averell Harriman comforts King as he awaits delicate surgery to remove the letter opener, the tip of which lies lodged between his heart and his lung. Later Harriman waits anxiously with colleagues. He was joined by concerned notables such as A. Philip Randolph and Roy Wilkins.

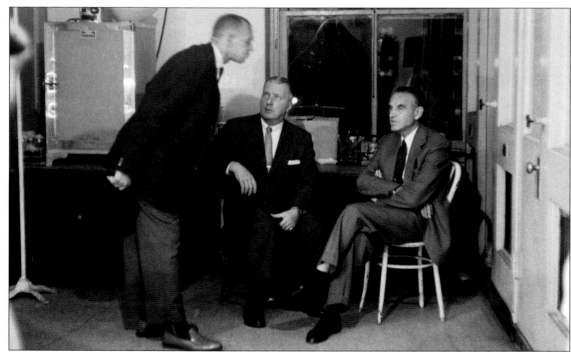

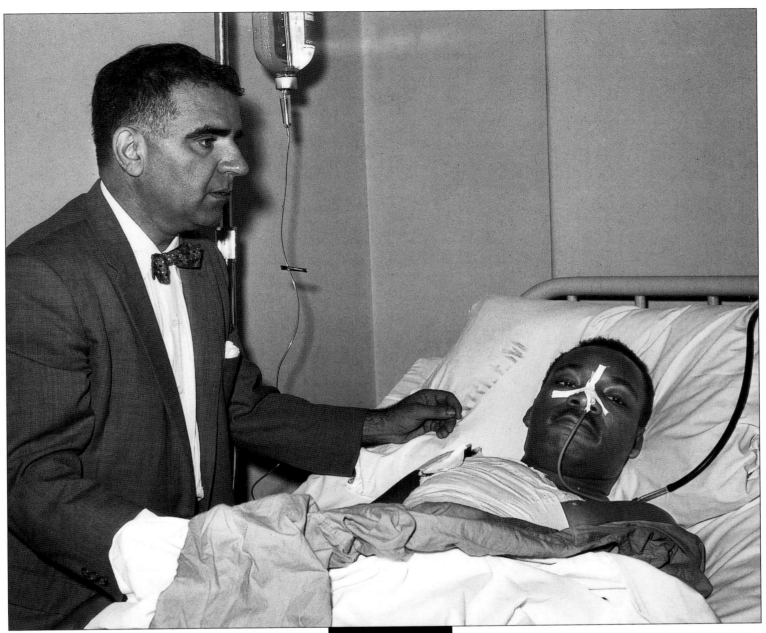

Following a three-hour operation to remove the letter opener, during which two of King's ribs were removed, Dr. Emil A. Naclerio examines the patient. While King undergoes surgery, Harriman snacks; behind him, a technician performs blood tests. Two days after the successful operation, King was back in danger. He developed pneumonia. By the next morning he was on the mend.

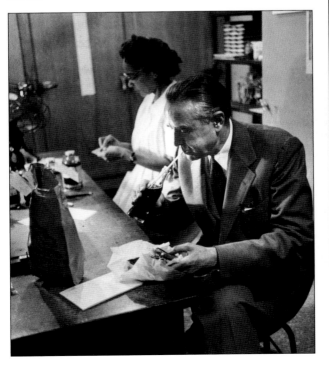

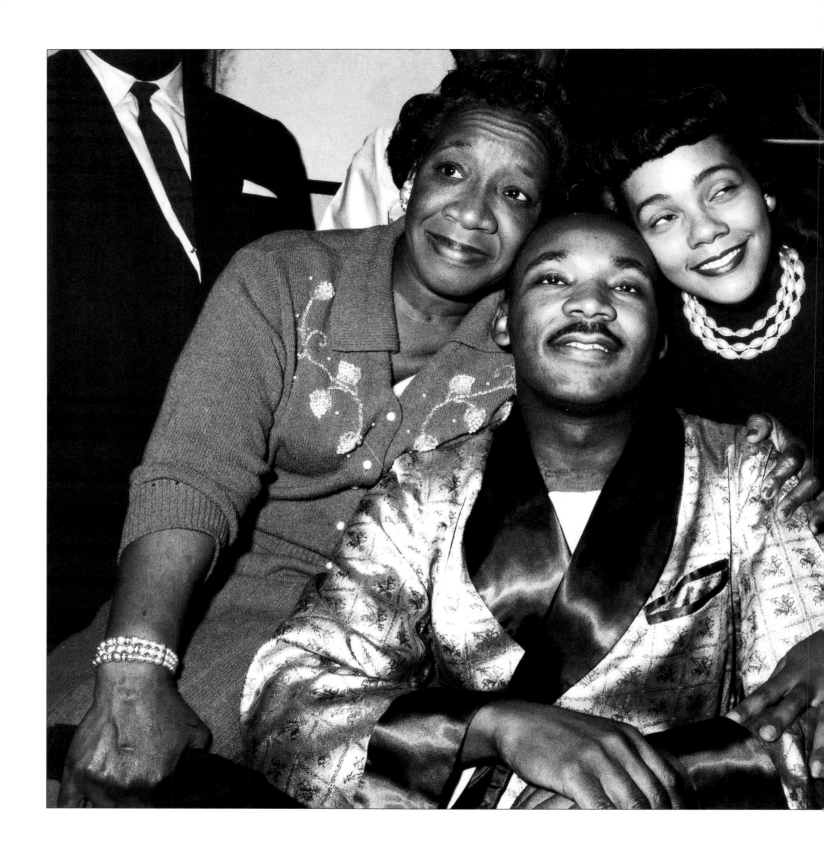

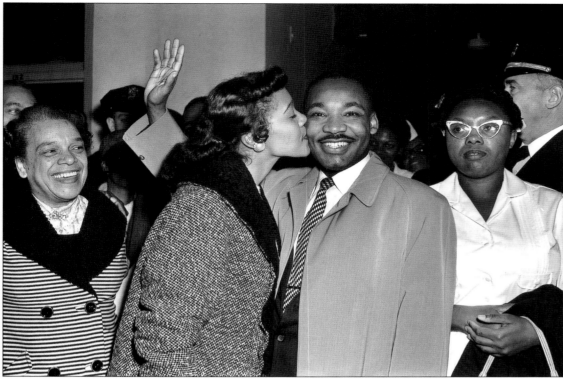

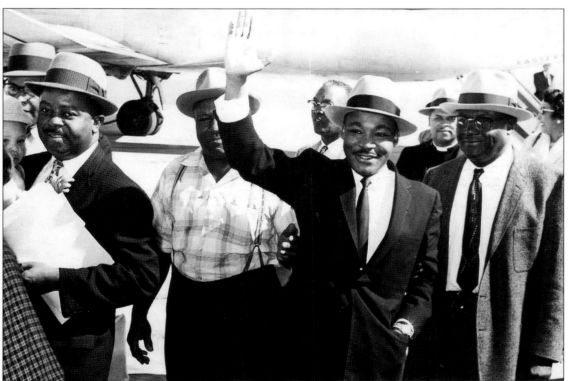

Ten days after the attack, a convalescing King cheerfully poses with his mother and his wife at a Harlem Hospital news conference. King told reporters he felt no ill will toward Curry. Later, diagnosed as a paranoid schizophrenic, Curry was committed to a hospital for the criminally insane.

Coretta Scott King kisses her husband as he is released from Harlem Hospital. On October 24, 1958, more than a month after he was stabbed, King waves to a large group of friends and neighbors assembled on the tarmac at Montgomery Airport. His full recovery took two more months.

LIFE IN ATLANTA

Husband, father,
crusader, author,
and pastor

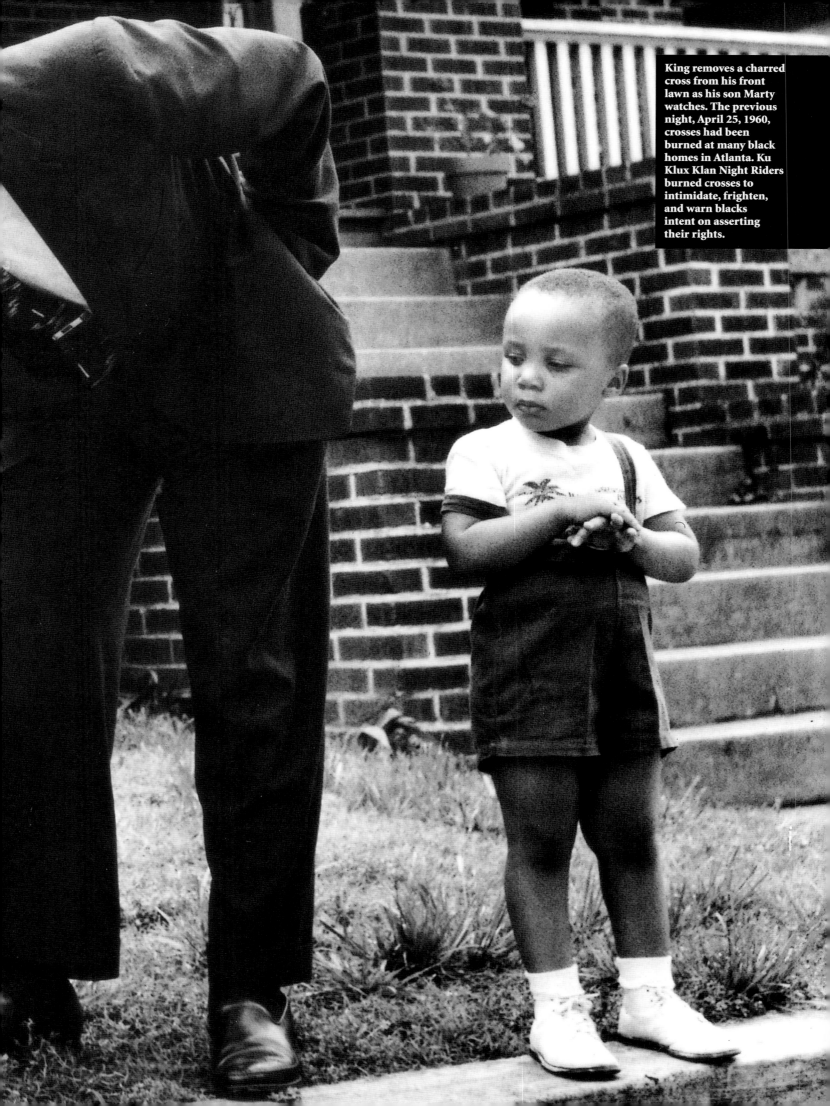

King removes a charred cross from his front lawn as his son Marty watches. The previous night, April 25, 1960, crosses had been burned at many black homes in Atlanta. Ku Klux Klan Night Riders burned crosses to intimidate, frighten, and warn blacks intent on asserting their rights.

LIFE IN ATLANTA

We must do a good job, irrespective of race, and do it so well that nobody can do it better.
~MARTIN LUTHER KING, JR.

It was with great reluctance that King resigned as pastor at Dexter Avenue Baptist Church and returned to Atlanta. He loved those in Montgomery who had fought side by side with him to break the yoke of segregation. But in the wake of that internationally celebrated victory, King was tired and felt the toll of sacrifices for the movement on his personal life. "As a result of my leadership in the Montgomery movement," he told the parishioners at Dexter, "my duties and activities tripled. A multiplicity of new responsibilities poured in upon me in

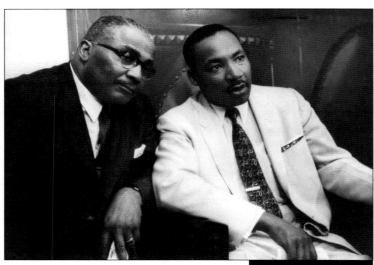

King and his father, co-pastors of Atlanta's Ebenezer Baptist Church, sit side by side. Moving back to Atlanta, where he could share the pulpit and pastoral duties with his father, gave King more time to devote to his family and the battle for equality.

almost staggering torrents. So I ended up futilely attempting to be four or five men in one."

His family returned to Atlanta on February 1, 1960. The scant few years after the Montgomery boycott had seen the birth of his son Martin Luther King III and his trip in 1957 to Africa for ceremonies celebrating Ghana's independence (King recognized early that the fights against colonialism and American segregation were the same, but also called the "Afro-American…a true hybrid, a combination of two cultures.") and to India in 1959. *Jet* magazine estimated that in 1958 alone King delivered 208 speeches and traveled 780,000 miles.

Even at rest, between movement campaigns, King remained extraordinarily busy. The world showered him with job offers, speaking requests, and awards, among them the NAACP's Spingarn Medal, presented at his alma mater Morehouse. At this event, his former teacher Benjamin Mays said of King, "Because you did not seek fame, it has come to you. It must have been a person like you that Emerson had in mind when he said, 'See how the masses of men worry themselves into nameless graves when here and there a great, unselfish soul forgets himself into immortality.' You are gentle and loving, Christian and brave, sane and wise."

Those words, perhaps more than any others, reveal the pre- and post-Montgomery character of King. As Jesse Jackson said in the 1990s, "He was a family man," although his one great regret in life was that he seldom had much time to devote to his beloved wife and children. He was raised to be a Race Man, but also to be something young militants in the 1960s derided as corny—

King, a Ph.D. in theology, at work in his study at the Ebenezer Baptist Church. He devoted a major part of his life to composing weekly sermons and writing articles, columns, speeches, and six books.

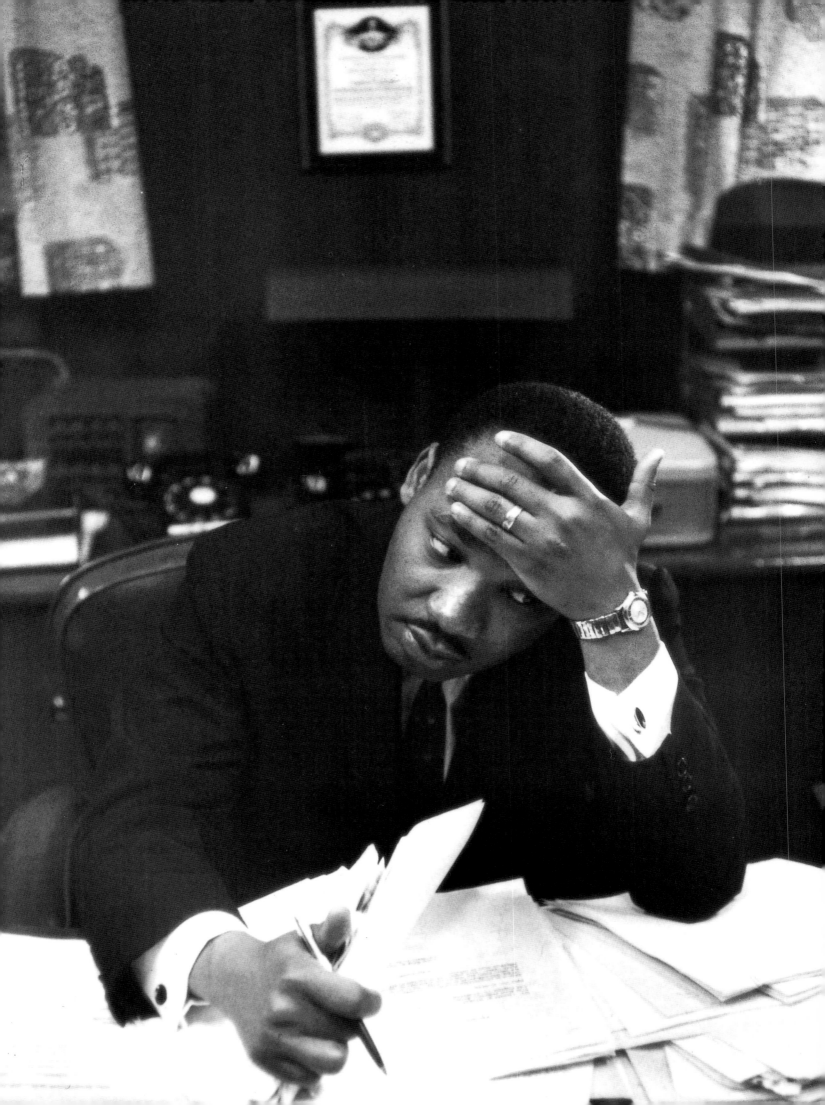

"a credit to his Race," which in King's case translated beautifully into an ongoing personal struggle for perfection and personal responsibility. At Crozer Seminary, he knew his each and every deed would be seen by whites as either a "credit" or a "demerit" for his people. Recollecting those days, King said, "If I were a minute late to class, I was almost morbidly conscious of it and sure that everyone noticed it. Rather than be thought of as always laughing, I'm afraid I was grimly serious for a time. I had a tendency to overdress, to keep my room spotless, my shoes perfectly shined, and my clothes immaculately pressed."

He preferred casual dress to those conservative dark suits he wore in public—for the public, one might say. He took to heart his own advice that "We shall have to create leaders who embody virtues we can respect." According to his wife, he genuinely was uninterested in money and material

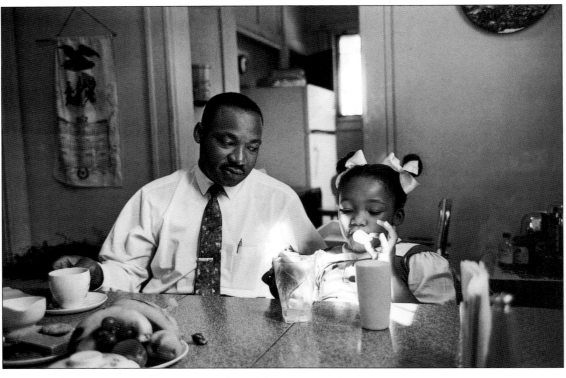

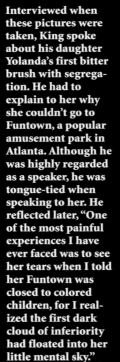

Interviewed when these pictures were taken, King spoke about his daughter Yolanda's first bitter brush with segregation. He had to explain to her why she couldn't go to Funtown, a popular amusement park in Atlanta. Although he was highly regarded as a speaker, he was tongue-tied when speaking to her. He reflected later, "One of the most painful experiences I have ever faced was to see her tears when I told her Funtown was closed to colored children, for I realized the first dark cloud of inferiority had floated into her little mental sky."

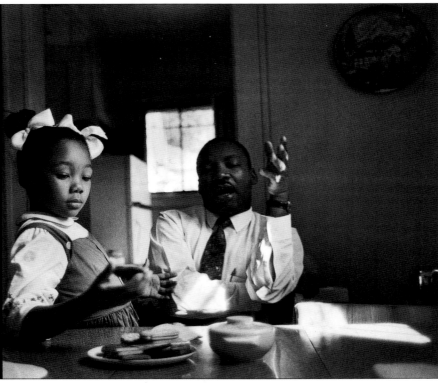

success and wished he could take a vow of poverty. "Martin always tried to eliminate from our lives all things we could do without," she said. He always felt that in order to serve his people fully he needed time for study. After his trip to India, King returned home committed to devoting one day a week to silence and meditation—that was one of his reasons for moving back to Atlanta, and he conditioned himself to get by on just four hours of sleep a night. But always his off-the-clock schedule took priority over King's hope for deepening his spiritual and intellectual practices.

At home, away from the camera, he worked on sermons that took two-thirds of a day to compose. One of his favorites was "The Three Dimensions of a Complete Life," which he delivered in London just before receiving the Nobel Peace Prize. He also composed speeches that looked critically inward at the black community and its promise as well as

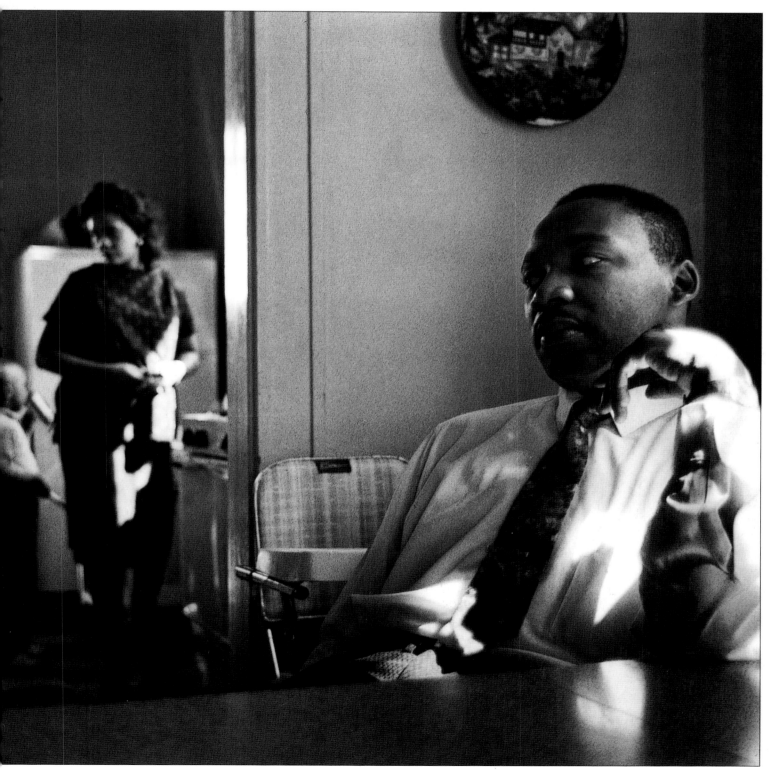

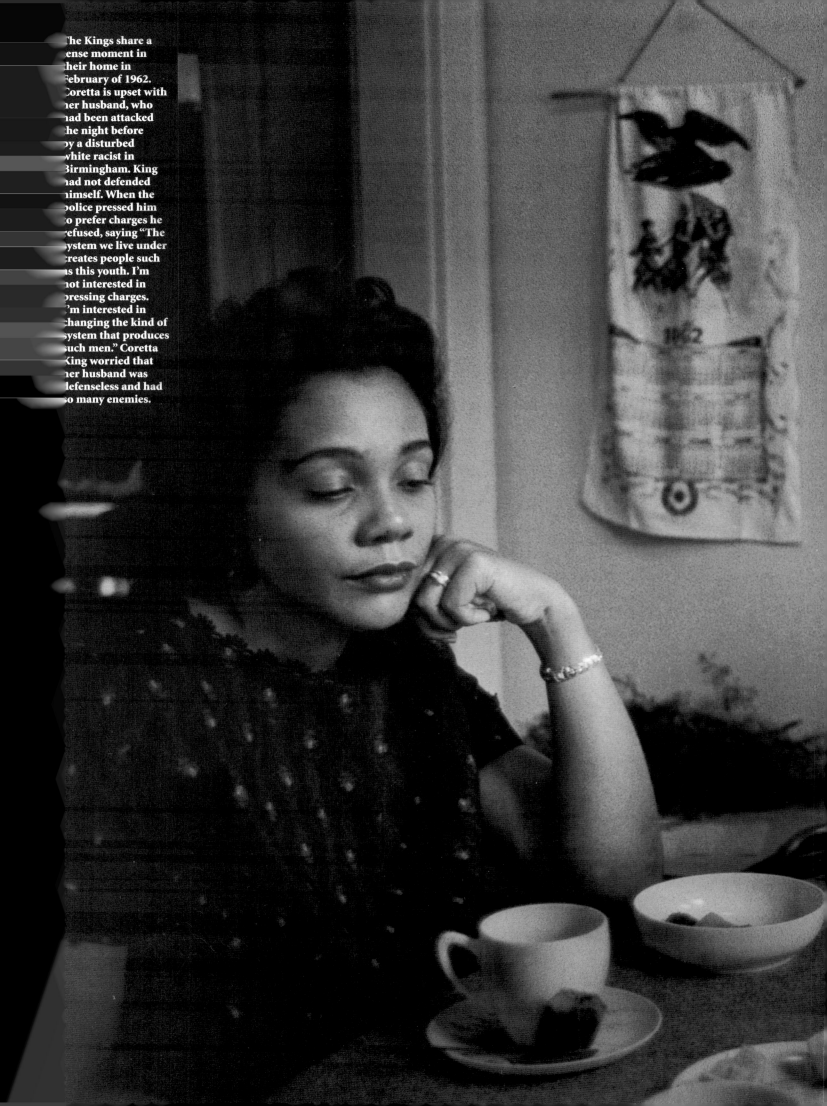

The Kings share a tense moment in their home in February of 1962. Coretta is upset with her husband, who had been attacked the night before by a disturbed white racist in Birmingham. King had not defended himself. When the police pressed him to prefer charges he refused, saying "The system we live under creates people such as this youth. I'm not interested in pressing charges. I'm interested in changing the kind of system that produces such men." Coretta King worried that her husband was defenseless and had so many enemies.

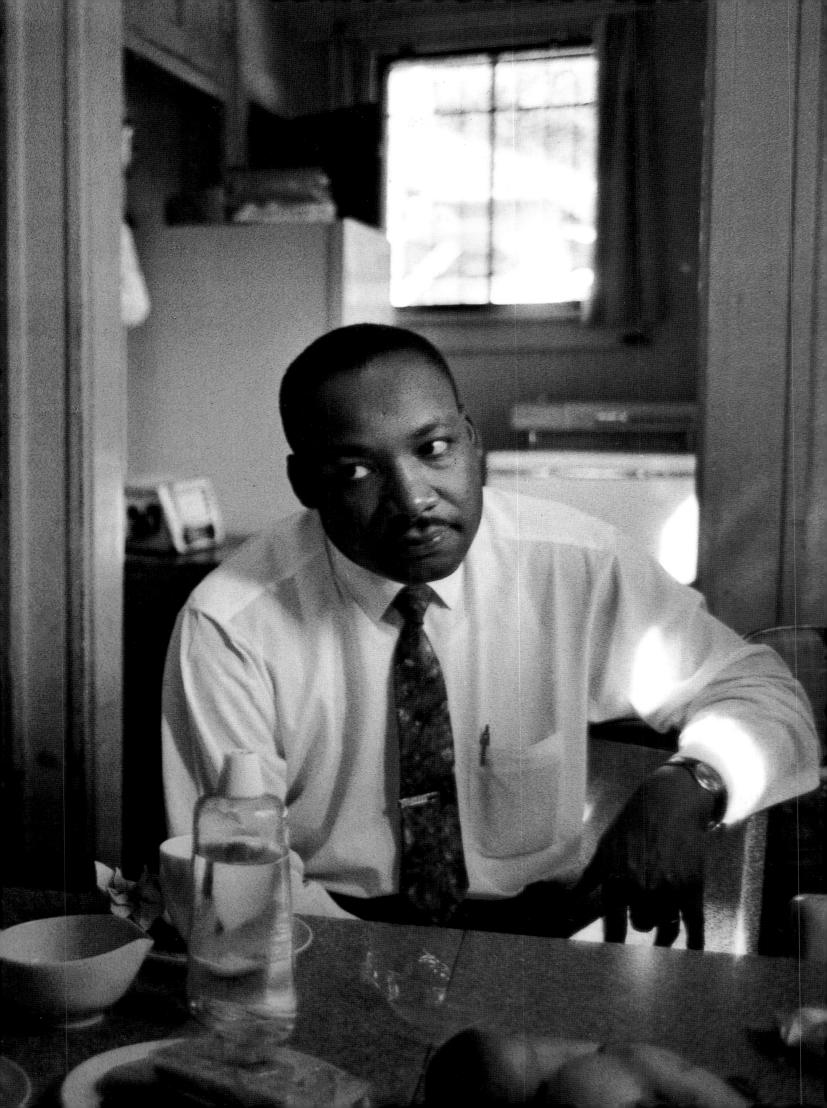

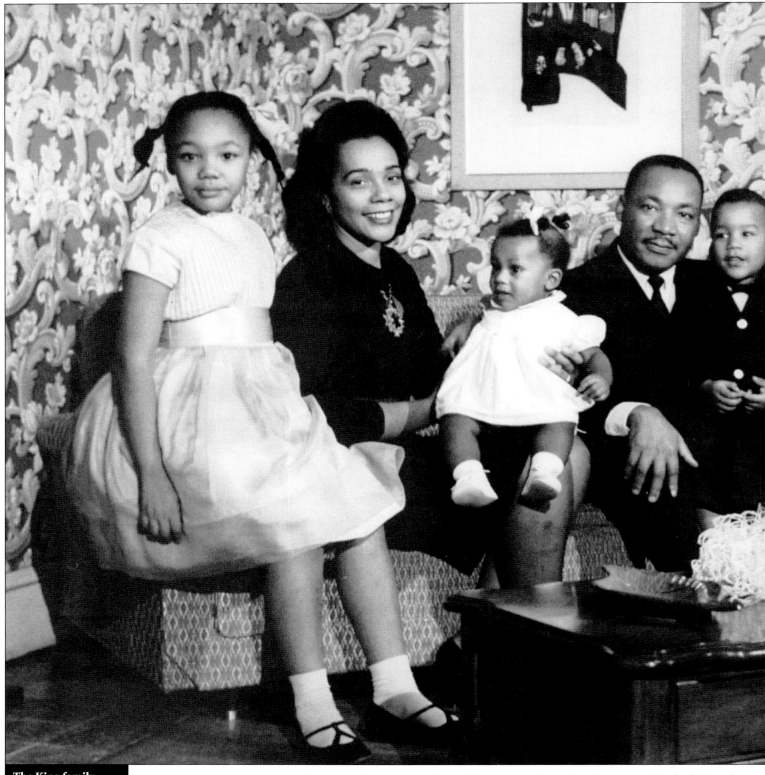

outward toward the shortcomings of the white world. "We must work on two fronts," he said. "On the one hand we must continually resist the system of segregation—the system which is the basic cause of our lagging standards; on the other hand, we must work constructively to improve the lagging standards which are the effects of segregation. There must be a rhythm of alteration between attacking the cause and healing the effects."

Some blacks were critical of King for those observations, although he was only being true to his first calling, that of a Baptist minister (often he dreamed of one day teaching theology at a college), and to his own words in his inspiring sermon "Transformed Nonconformist," in which he wrote, "Any Christian who blindly accepts the opinions of the majority and in fear and timidity follows a path of expediency and social approval is a mental and spiritual slave."

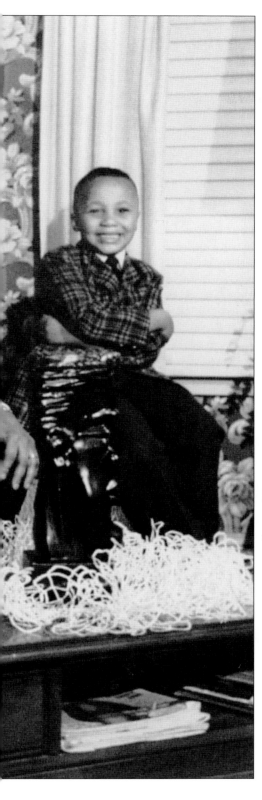

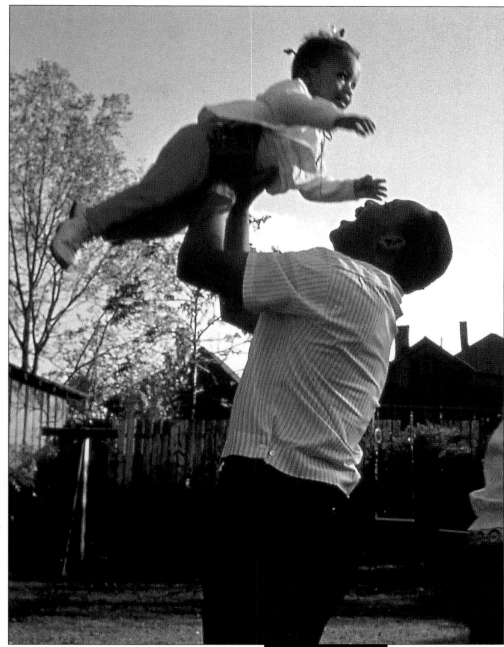

An elated King tosses his daughter Bunny into the air. He had recently learned that he had won the Nobel Peace Prize.

Newspapers under his arm, King returns home with his son Marty. Although in college King had been a sharp dresser, by this time in his life, for spiritual reasons, he dressed carefully and conservatively in less expensive suits.

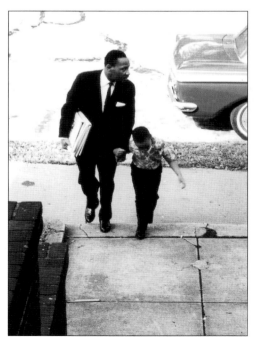

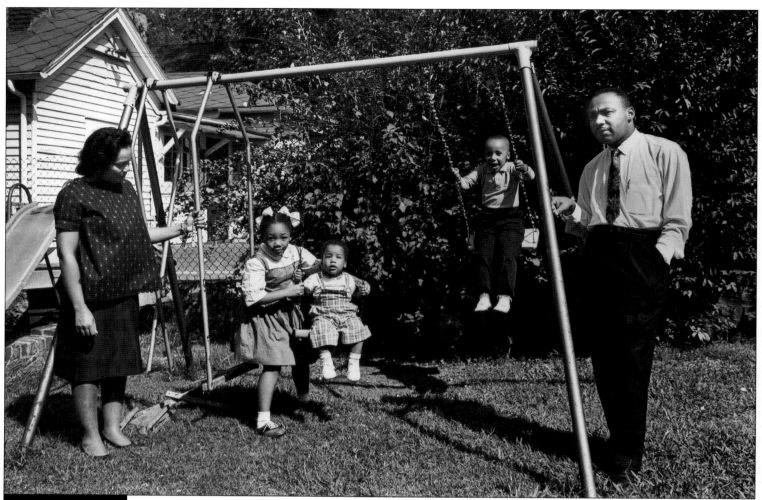

King thought of himself as a family man and treasured the times he had with his wife and children. His demanding schedule kept him away from home almost half the week. King's absence made Coretta almost entirely responsible for raising the family. At this time the Kings are expecting their fourth child, Bernice, whom they called Bunny.

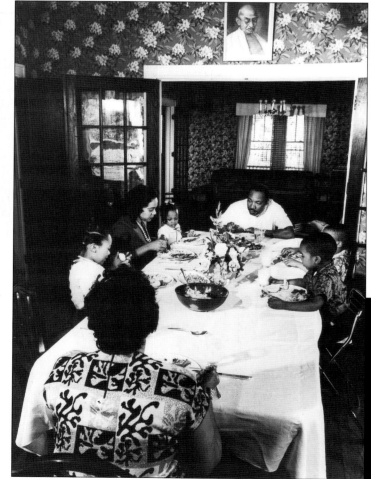

A portrait of Mohandas Gandhi, King's idol, hangs in a place of honor in the Kings' home. Gandhi was called the Mahatma, or Great Soul. Beneath it, the family gathers together for dinner. King had a hearty appetite and loved to eat.

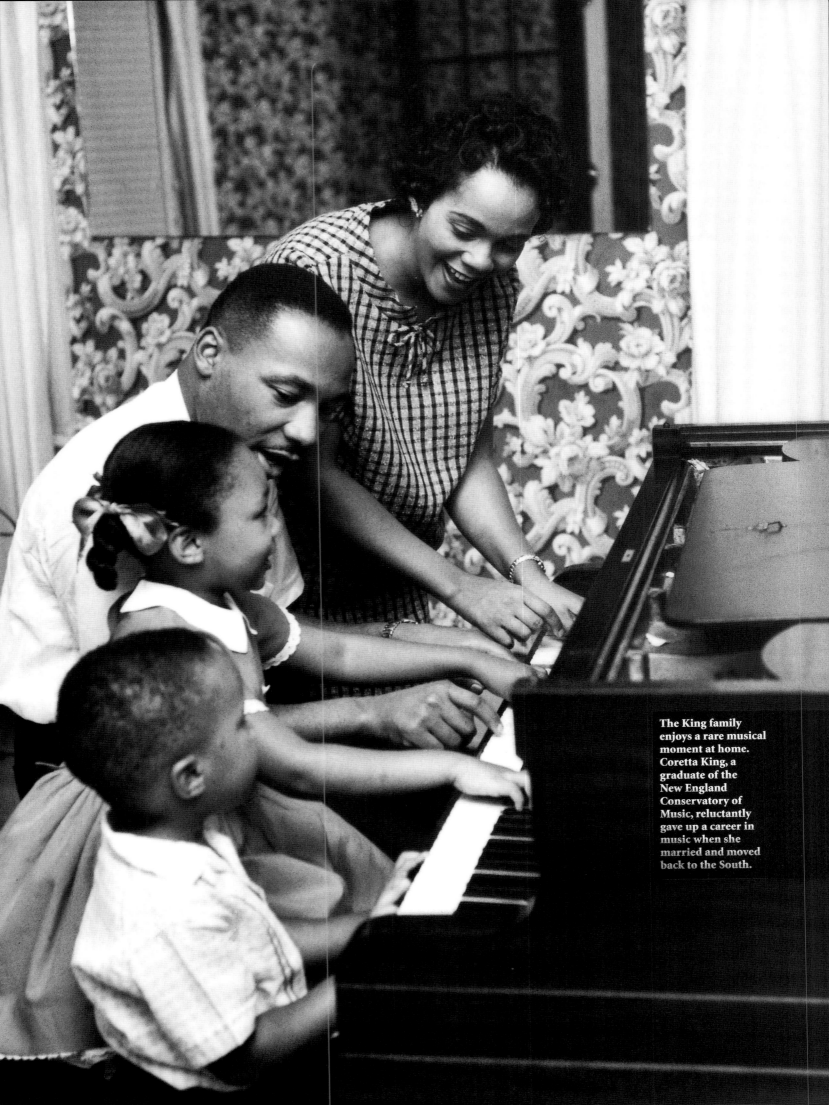

The King family
enjoys a rare musical
moment at home.
Coretta King, a
graduate of the
New England
Conservatory of
Music, reluctantly
gave up a career in
music when she
married and moved
back to the South.

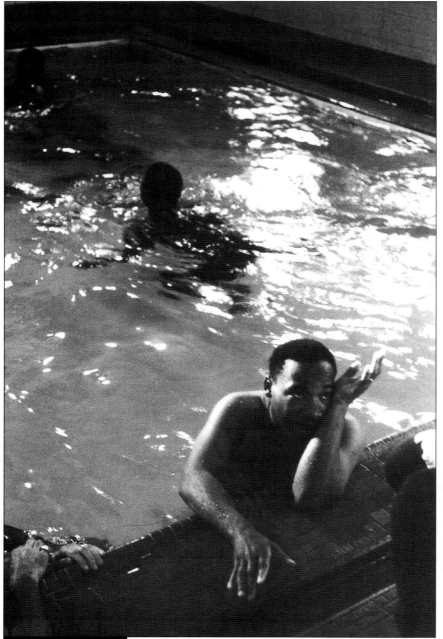

King takes a swim. His work with the civil rights movement left little time for such relaxation. Andrew Young once said of his friend, "He had the constitution of a bull. He could go on and on and on when things were going well."

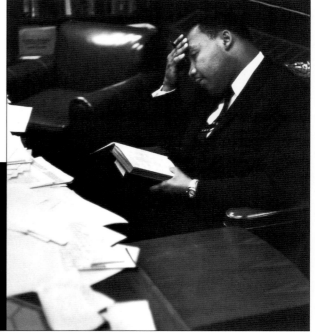

King works in his study at Ebenezer Baptist Church in 1960. Although he was highly visible in the struggle, leading marches and speaking constantly, King actually spent a good part of his time reading, thinking, and writing.

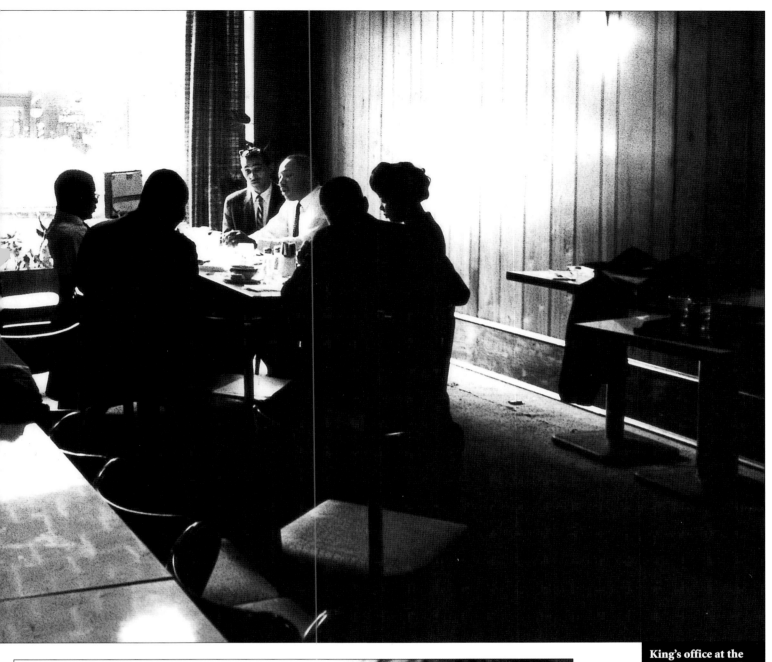

King's office at the SCLC was so small that he often met with his staff in a local restaurant.

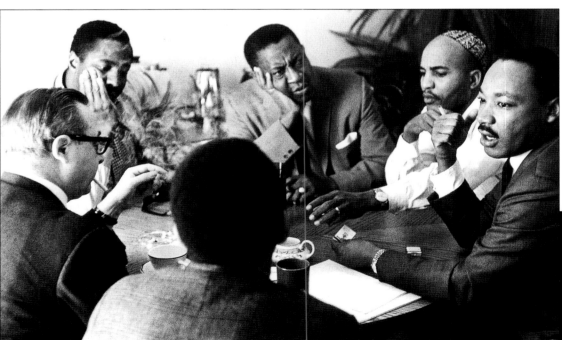

King, his aide James Bevel, and others join together for a strategy meeting in summer 1966. At this time Bevel was instrumental in involving King in the peace movement.

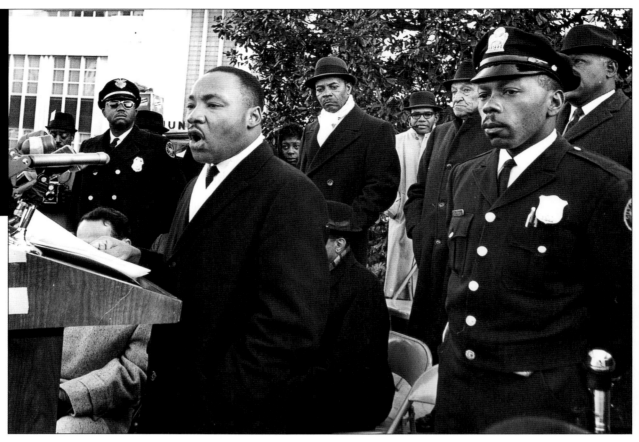

On December 13, 1963, police surround King, protecting him at an anti-segregation rally. They were equally likely to arrest him at such demonstrations. Here he addresses more than two thousand people gathered in Atlanta's Hurt Park in freezing weather.

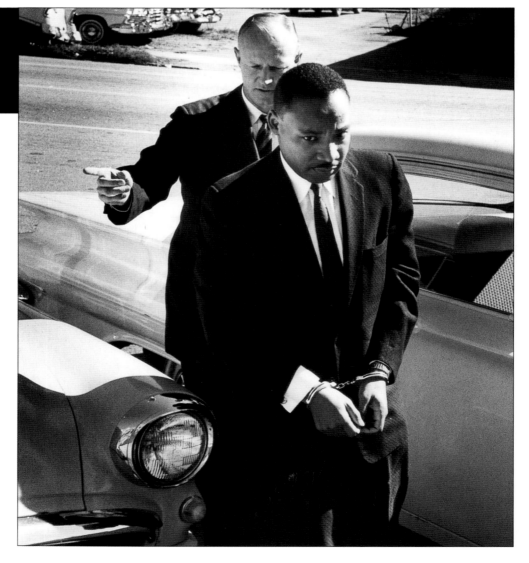

An officer escorts King to court after he takes part in a student sit-in demonstration at Rich's, an Atlanta department store.

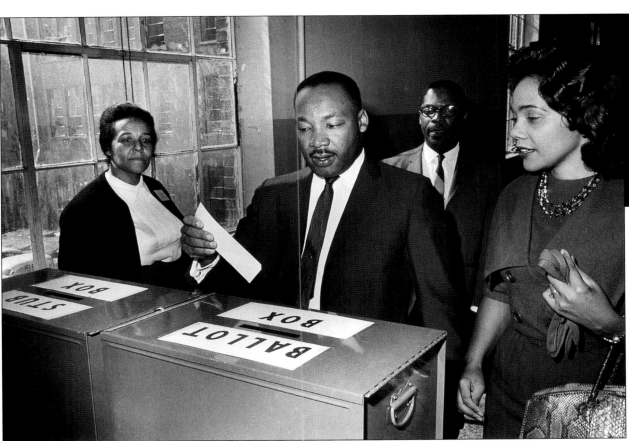

King, who devoted much of his life to black suffrage, casts his vote while Coretta waits her turn. In King's view, voting was the key to black liberation. As the country's leading spokesman for the black community, King was always courted by politicians.

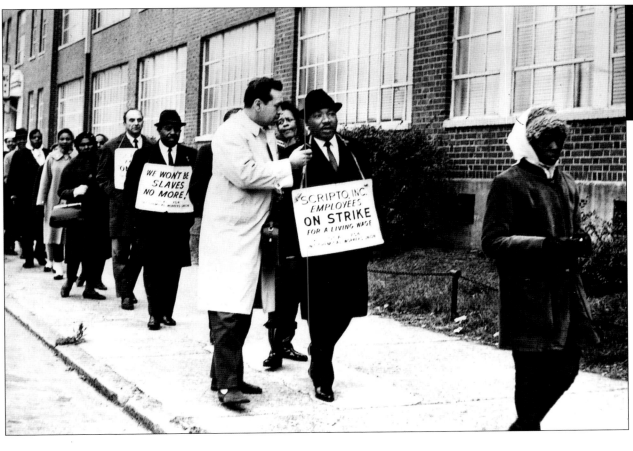

King talks to a reporter as he marches in a picket line at the Scripto plant. The picketers are demanding equal pay for black workers.

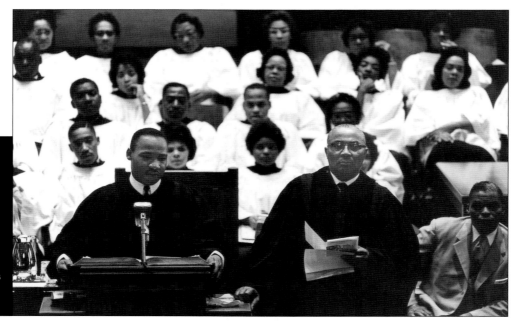

King and his father address the congregation at Ebenezer Baptist Church. Although they had distinctly different personalities and disagreed at times, Martin loved and respected his father, and Daddy King was devoted to and proud of his son.

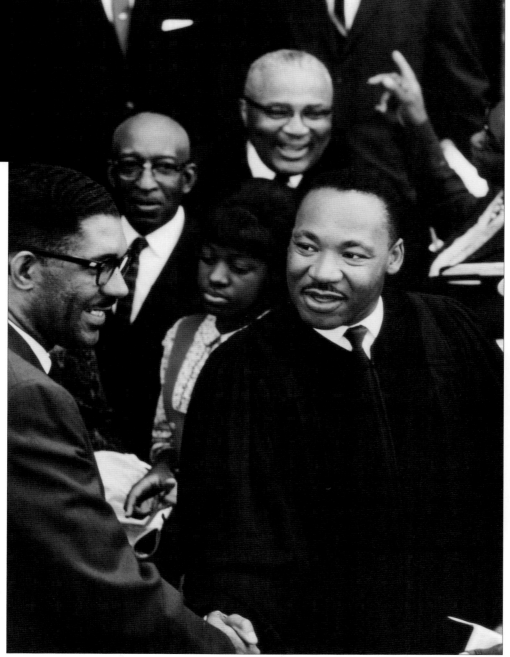

Rev. King chats with a parishioner after Sunday services. Friends and staff marveled that King was always thoughtful and attentive to everyone he dealt with, treating them in the most respectful and amiable way.

An electrifying preacher, King commiserated with his congregation and dramatized his own struggles, yet he always educated, exhorted, and exalted. He often returned to Atlanta from movement campaigns to join his parishioners on Sunday.

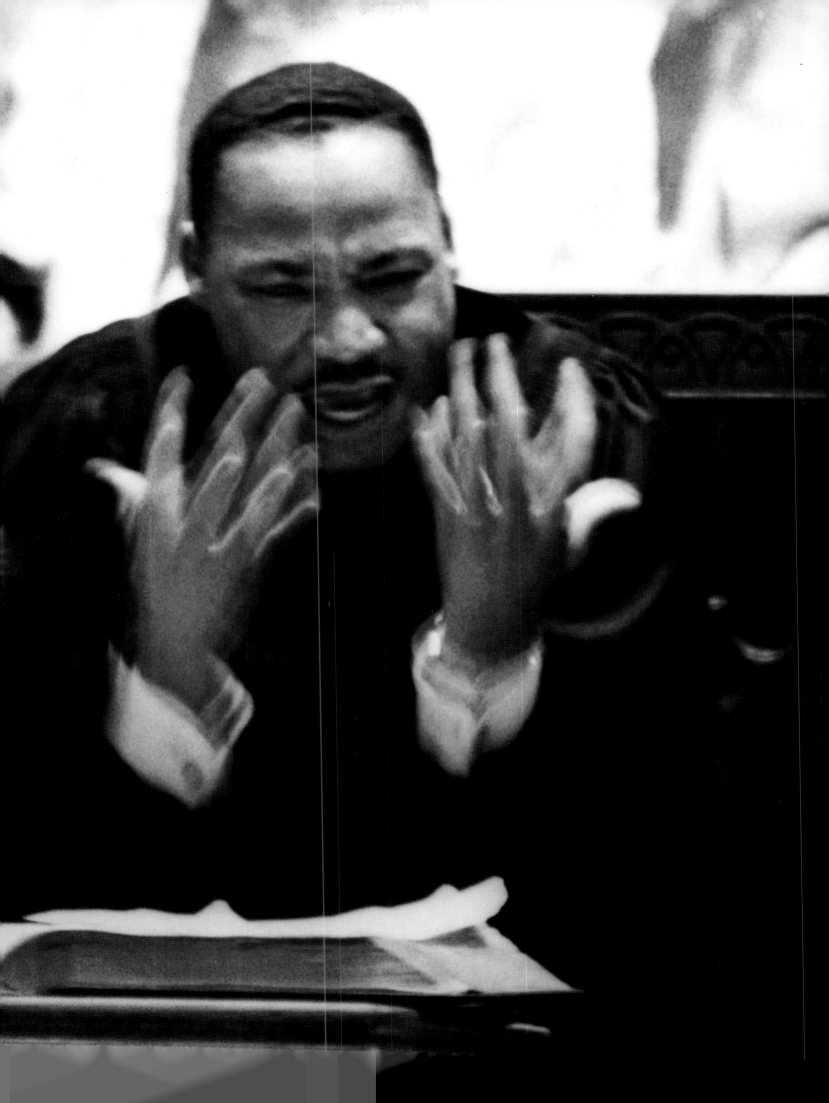

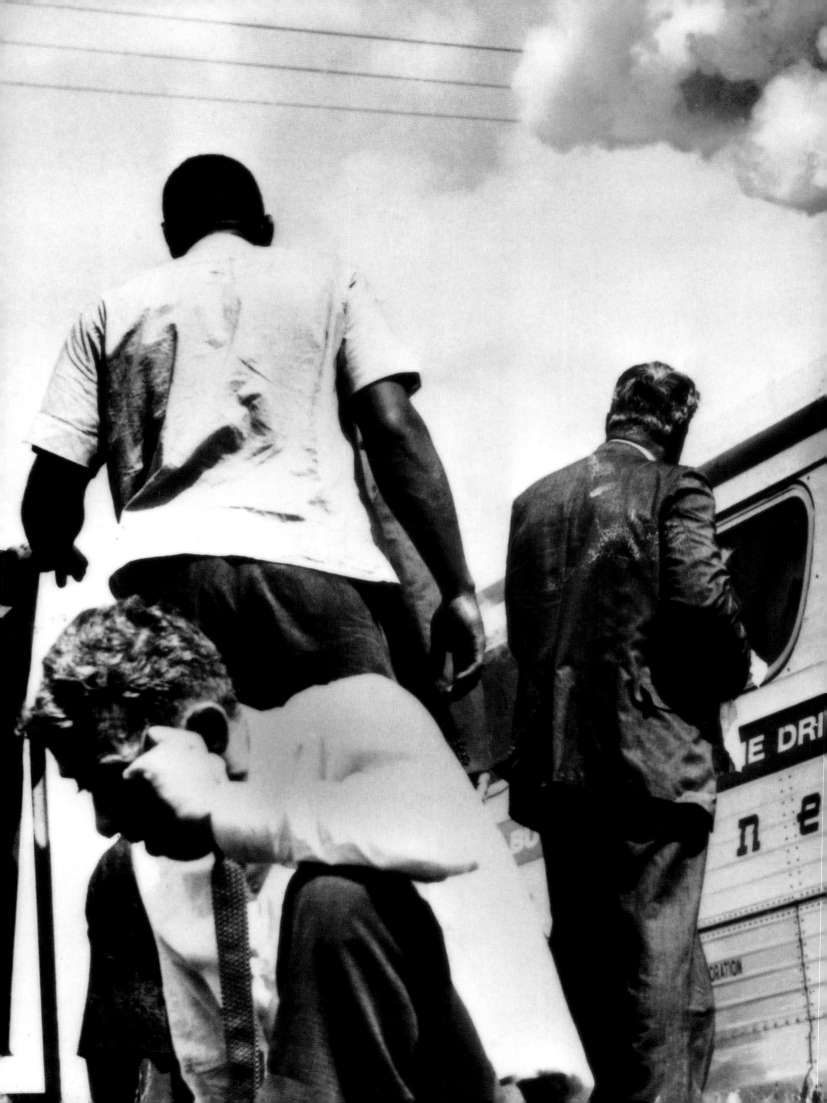

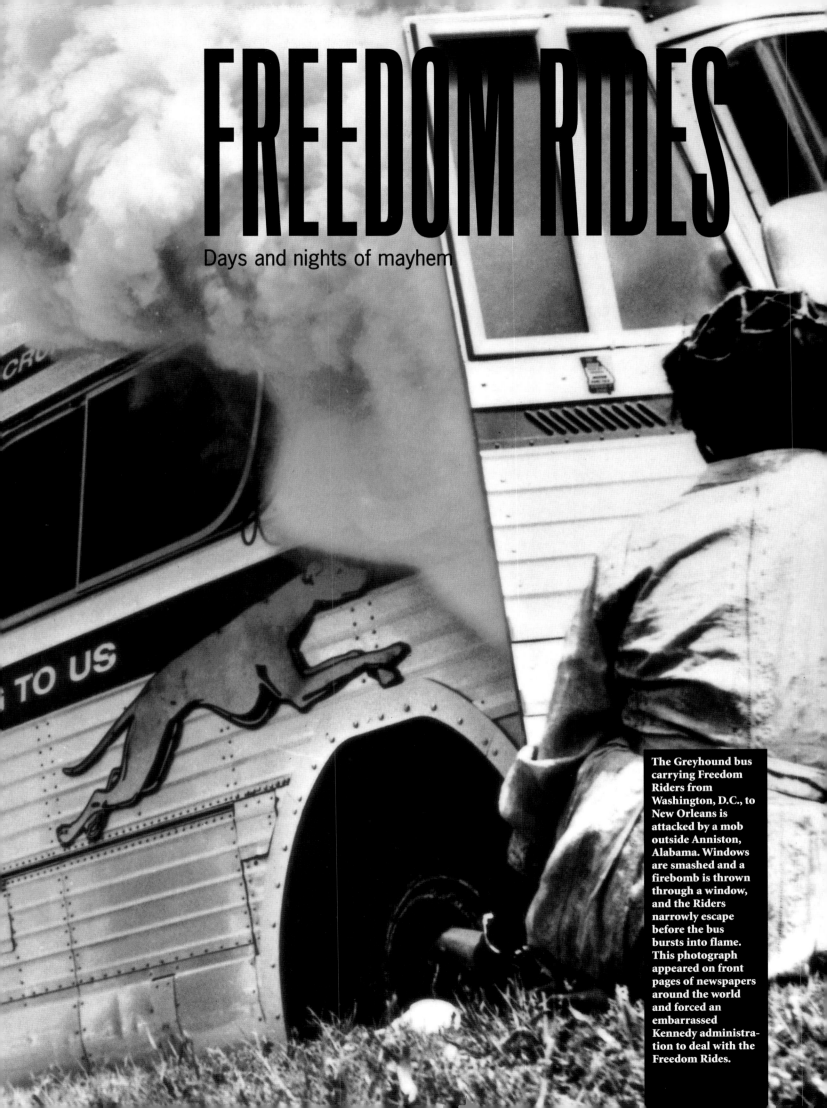

FREEDOM RIDES
Days and nights of mayhem

The Greyhound bus carrying Freedom Riders from Washington, D.C., to New Orleans is attacked by a mob outside Anniston, Alabama. Windows are smashed and a firebomb is thrown through a window, and the Riders narrowly escape before the bus bursts into flame. This photograph appeared on front pages of newspapers around the world and forced an embarrassed Kennedy administration to deal with the Freedom Rides.

FREEDOM RIDES

Freedom Riders must develop the quiet courage of dying for a cause.

~MARTIN LUTHER KING, JR., AT A
NONVIOLENT TRAINING SESSION

The next great chapter in the fight for freedom belonged to the students.

On February 1, 1960, Joseph McNeill, a student at North Carolina Agricultural and Technical College, his roommate Ezell Blair, Jr., and two other students sat down at a segregated Woolworth's lunch counter for service. Predictably, they were told Negroes could not eat there, so they returned day after day with the same demand, which inspired students across North Carolina to do the same in other public establishments, like dominoes falling, until fifty cities in the South witnessed increasingly militant young people (inspired by King, but acting

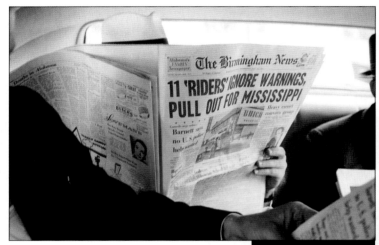

spontaneously on their own) defying racial inequality and packing the nation's jails. By April this sit-in movement found its own organizational apparatus, the Student Nonviolent Coordinating Committee (SNCC).

They identified, these students, with their counterparts in Africa, the Far East, and South America, who took to the streets to defy colonialism. And the violence they endured, the humiliations, and the denials of their humanity by vicious white supremacists enraged all Americans of goodwill, none more so than King himself, who in October delivered a speech to inspire SNCC activists, and then with thirty-six others was thrown in jail after they demanded to be served at a lunch counter in Rich's, a department store in Atlanta.

King refused to post bail. Five or six days later, trespassing charges were dropped by the merchants, and all were released—except King. He was served papers stating that he'd violated his probation for a traffic offense earlier in May. (When moving from Montgomery back to Atlanta, he'd neglected to change his state driver's license.) Then he was taken, chained like a hardened criminal, to Reidsville state prison. Only through the intervention of a furious Robert Kennedy, then Attorney General, who

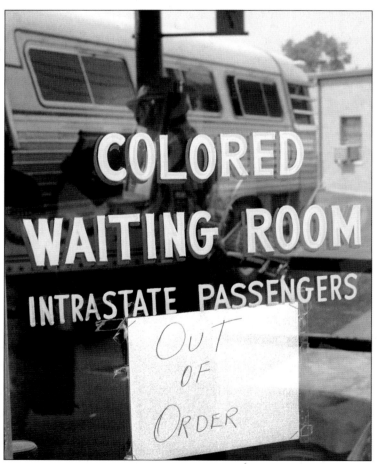

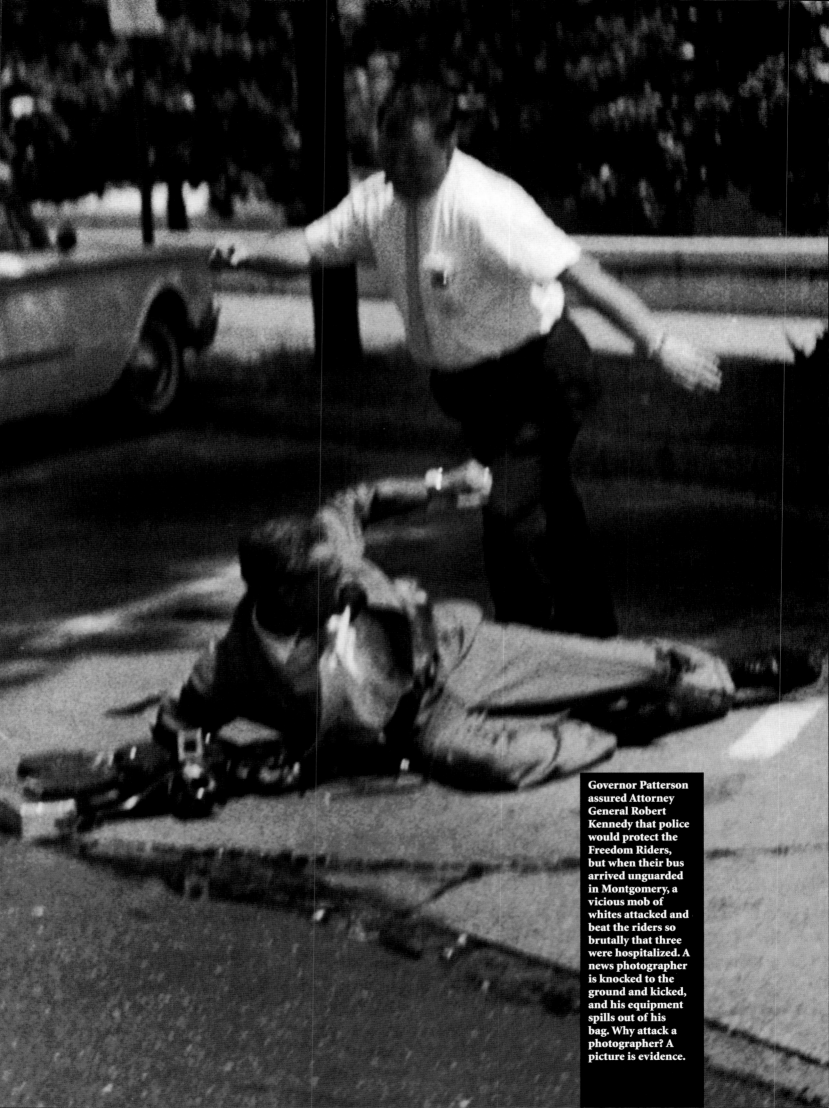

Governor Patterson assured Attorney General Robert Kennedy that police would protect the Freedom Riders, but when their bus arrived unguarded in Montgomery, a vicious mob of whites attacked and beat the riders so brutally that three were hospitalized. A news photographer is knocked to the ground and kicked, and his equipment spills out of his bag. Why attack a photographer? A picture is evidence.

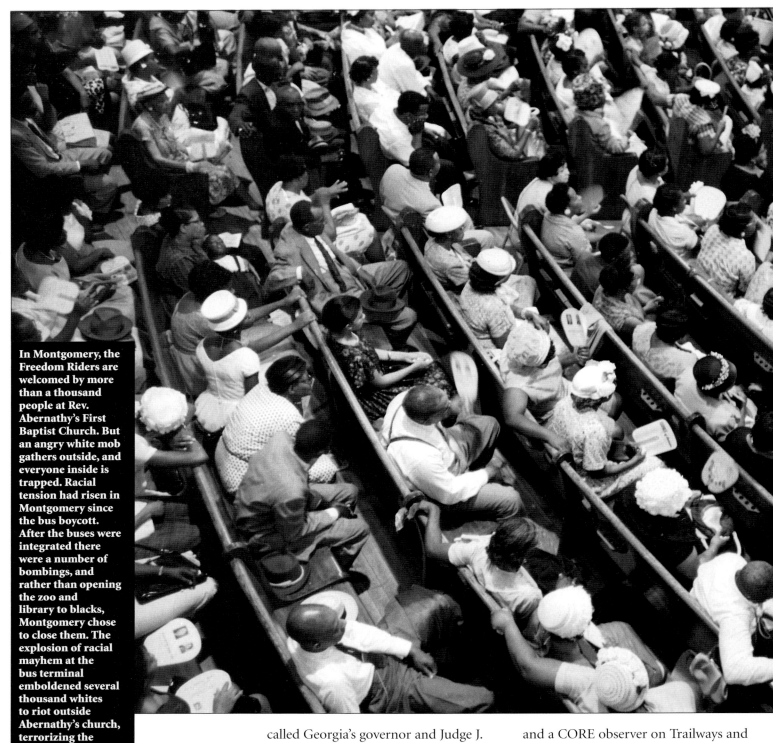

In Montgomery, the Freedom Riders are welcomed by more than a thousand people at Rev. Abernathy's First Baptist Church. But an angry white mob gathers outside, and everyone inside is trapped. Racial tension had risen in Montgomery since the bus boycott. After the buses were integrated there were a number of bombings, and rather than opening the zoo and library to blacks, Montgomery chose to close them. The explosion of racial mayhem at the bus terminal emboldened several thousand whites to riot outside Abernathy's church, terrorizing the congregation, while several hundred federal marshals surrounded the church and fought off the rioters.

called Georgia's governor and Judge J. Oscar Mitchell (while his brother John, only weeks away from the November elections, consoled a pregnant Coretta by phone), was King's incarceration in a segregated cell block, reserved for the worst offenders, limited to an overnight stay.

But the offensive phase of the civil rights movement had only just begun. On May 4, 1961, the Congress of Racial Equality (CORE), an interracial, nonviolent, passivist organization founded in 1942 in Chicago, initiated a project called the Freedom Rides. In Washington, D.C., they placed two groups of twelve activists

and a CORE observer on Trailways and Greyhound buses, directing them to test throughout the Deep South the Supreme Court's ruling to desegregate buses and terminals. In Rock Hill, South Carolina, they were assaulted; in Winnsboro, South Carolina, they were arrested. Near Anniston, Alabama, one of the buses was attacked by a white mob that broke windows, slashed tires, hurled a bomb that set the vehicle on fire, then beat the Freedom Riders as they emerged, trying to escape the flames. Although rescued by Rev. Fred Shuttlesworth and his group, the Alabama Christian Movement for

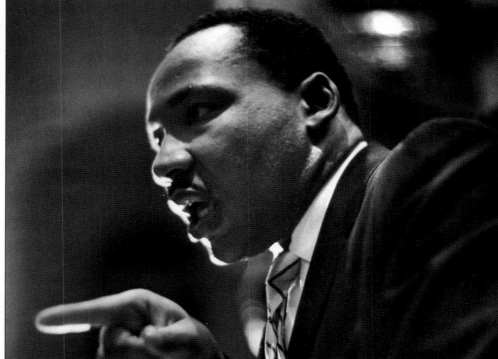

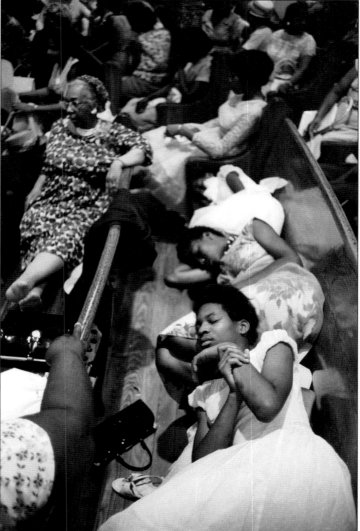

King, who flew to Montgomery to support and help the Riders, speaks to the fearful people inside the church: "We are going to be calm and we are going to stand up for what we know is right. Alabama will have to face the fact that we are determined to be free....Fear not, we've come too far to turn back."

Human Rights, they were too injured to continue the ride. The second bus, traveling to Birmingham, was also greeted by whites, who assaulted them with lead pipes, baseball bats, and bicycle chains with the consent of the police, who watched passively for fifteen minutes. Yet not once did the Freedom Riders retaliate with violence. At this point in their hellish odyssey, the bus companies refused to take them any farther. SNCC activists in Nashville picked up the torch, continuing the ride into Montgomery, where on May 20 they too were mobbed for twenty minutes by hundreds of whites, some of

As the melee outside continues, some inside the church apprehensively keep their vigil, while others sleep in pews.

— 83

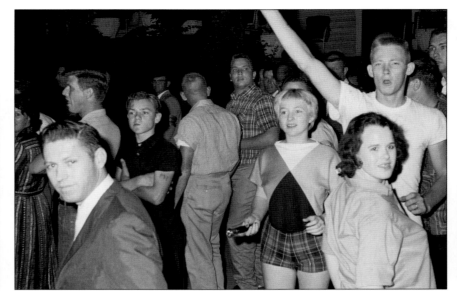

A riot explodes outside the church. The car of Montgomery lawyer Clifford Durr, a white friend of the movement, is set on fire. Federal marshals sent after the attack at the bus terminal attempt to keep order and guard the church, using tear gas to disperse the mob.

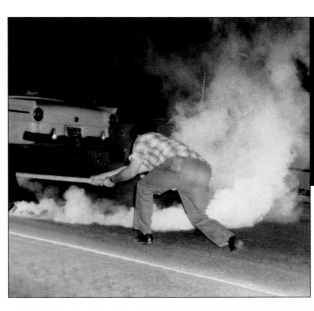

During the riot, King called Attorney General Kennedy and had increasingly angry telephone calls with him. Kennedy assured King the congregation would be safe. At one point Kennedy asked King to pray for him. King was not amused.

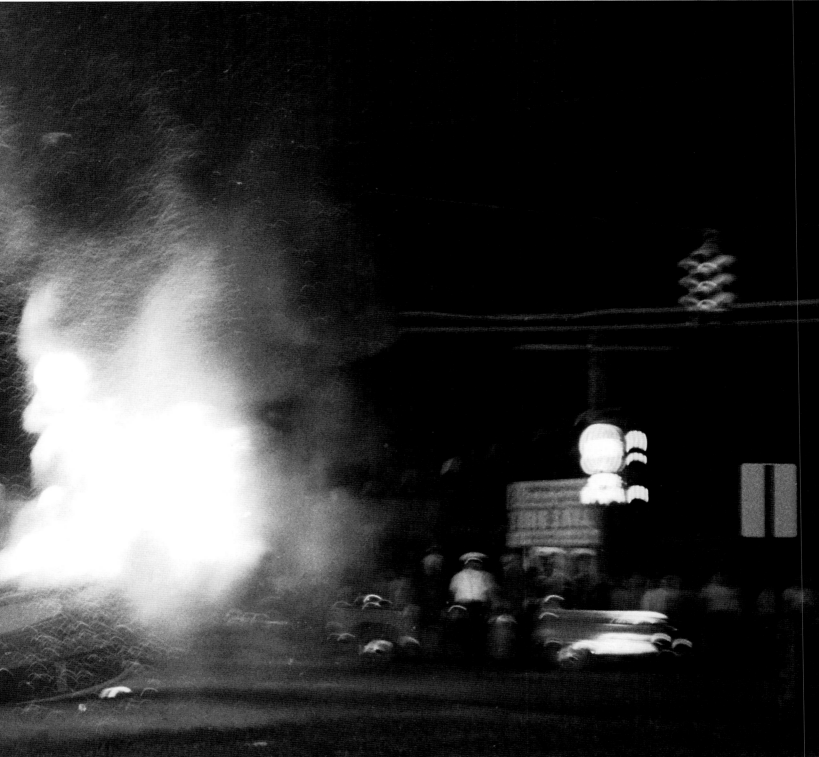

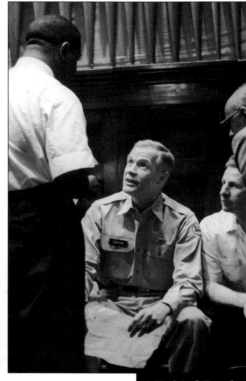

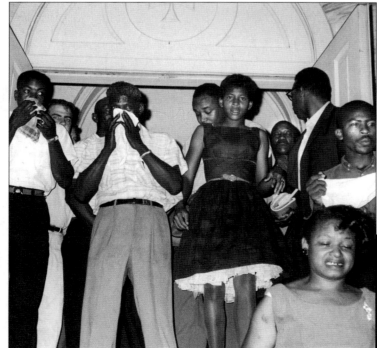

Abernathy and King sit together worried, frustrated, and fearful as the tumultuous night continues. Outside, Alabama National Guardsmen help the federal marshals subdue the rioters and clear the streets.

A National Guard officer goes over the plan for evacuating the people in the church.

As tear gas seeps into the church, the congregation members cover their faces with handkerchiefs and struggle for fresh air.

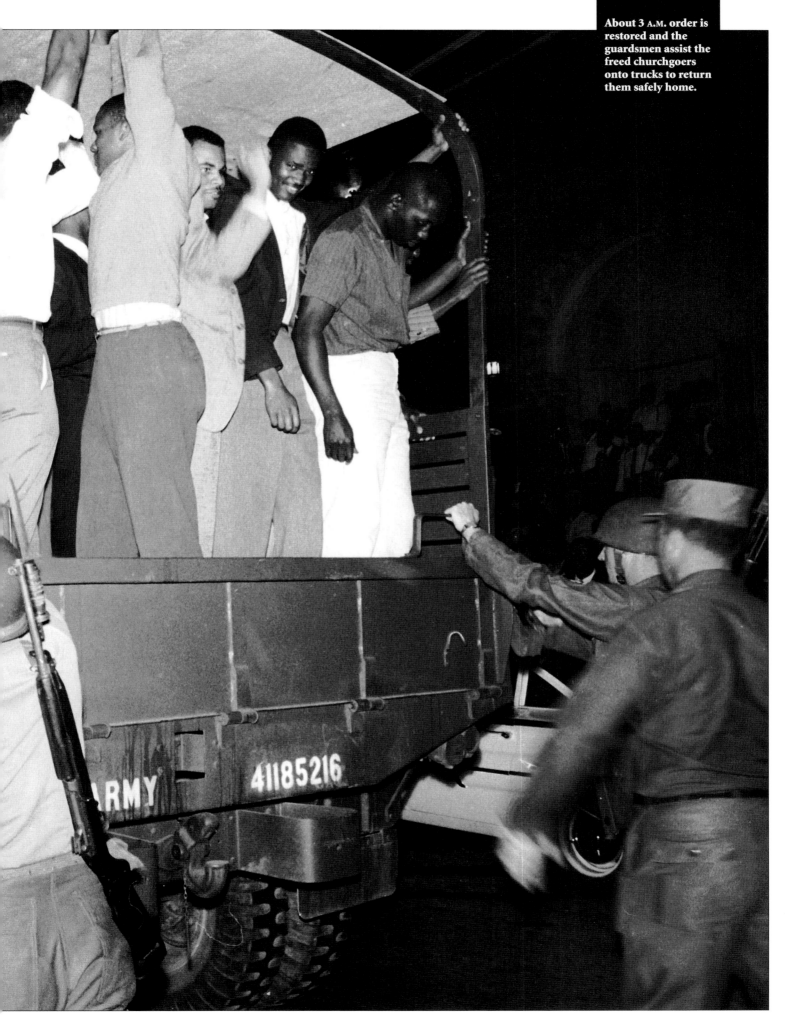

ARMY 41185216

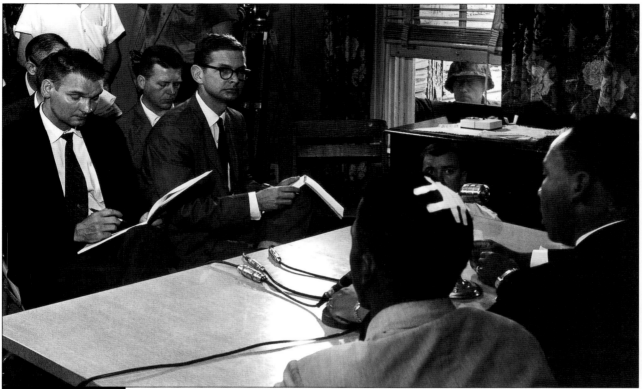

them Ku Klux Klan members. James Zwerg, a white student from Fisk University, was the first to step off the bus and was mauled.

The MIA sheltered the Riders in Rev. Abernathy's First Baptist Church. King traveled to Montgomery and spoke to twelve hundred people in the church. As the congregation sang "We Shall Overcome," several thousand whites surrounded the church. A car was set on fire. Then rocks crashed through First Baptist's stained-glass windows, raining splintered glass onto those gathered inside. From the church basement King called Robert Kennedy, who assured him that close to seven hundred U.S. marshals had already been dispatched. So they huddled together in a church under siege. They heard fighting outside. Then at last the federal government forced Governor John Patterson to call in the National Guard, which enabled those trapped in the church to go home and the Freedom Riders to continue their dangerous and historic journey on to Jackson, Mississippi, their battered bus protected by three airplanes, two helicopters, and seven patrol cars.

King was criticized by Riders who begged him to join them on the trip from Montgomery to Jackson. Given that he was on probation, he declined, which did not please some who reboarded the bus. Still, the Freedom Rides continued, taking the civil rights movement toward an unprecedented level of mass demonstrations. Three hundred more would be arrested in Jackson before the rides ended. But their heroism, and the crisis into which the country had been plunged by Jim Crow, led that September to the Interstate Commerce Commission's outlawing segregation in interstate buses and terminals. While King generally took a secondary, supportive role during the Freedom Rides and sit-ins, he served as chairman for the Freedom Rider Coordinating Committee, which provided workshops in nonviolent civil disobedience, and he praised their achievements time and again. Yet he was concerned that many young activists saw nonviolence only as a tactic, not as a way of life. He reminded them that "resistance and nonviolence are not in themselves good. There is another element that must be present in our struggle that then makes our resistance and nonviolence truly meaningful. That element is reconciliation. Our ultimate end must be the creation of the beloved community."

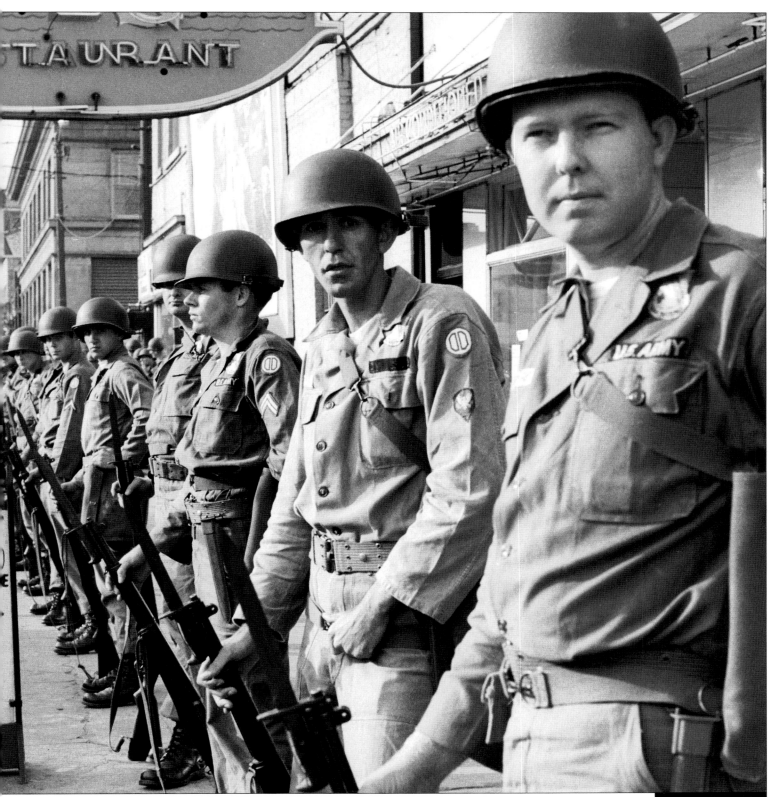

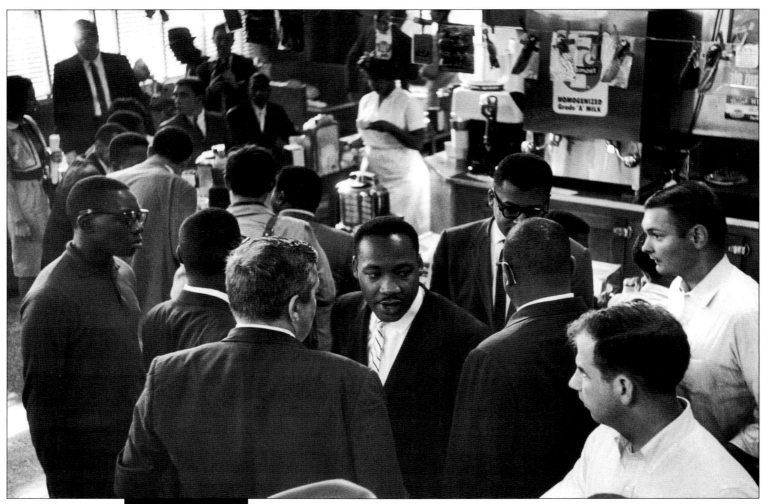

As the Freedom Riders prepare to set out for Jackson, King comes to the bus station to see them off, where they share a meal.

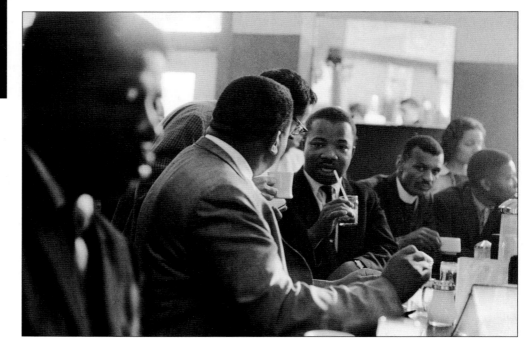

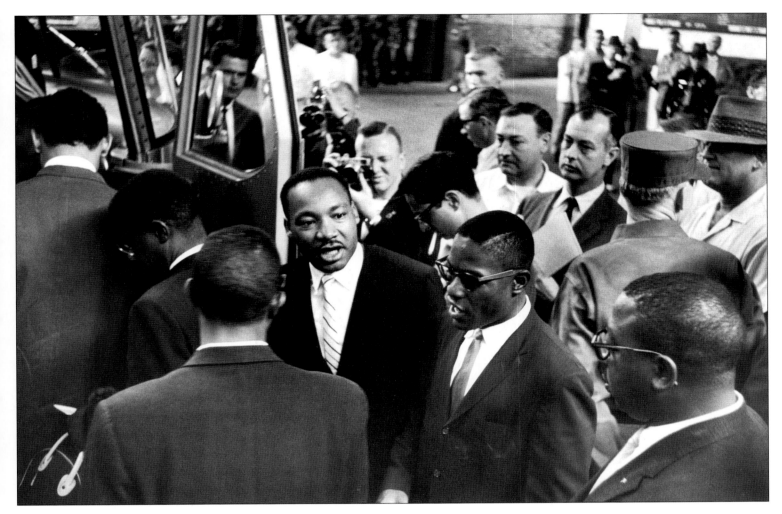

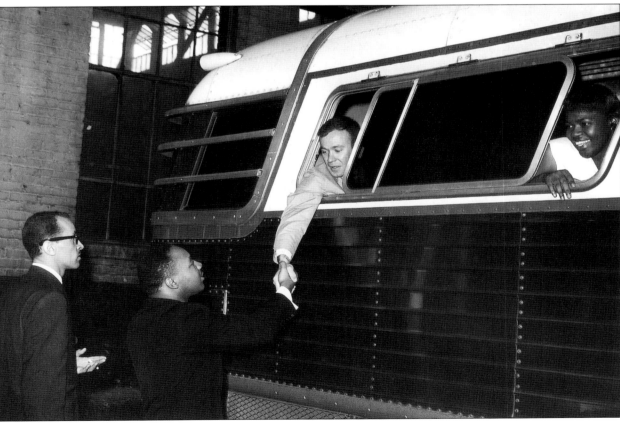

The Riders are disappointed with King's decision not to join them. He explains that he is on probation and that an arrest would violate it. King shakes hands and bids them a safe journey.

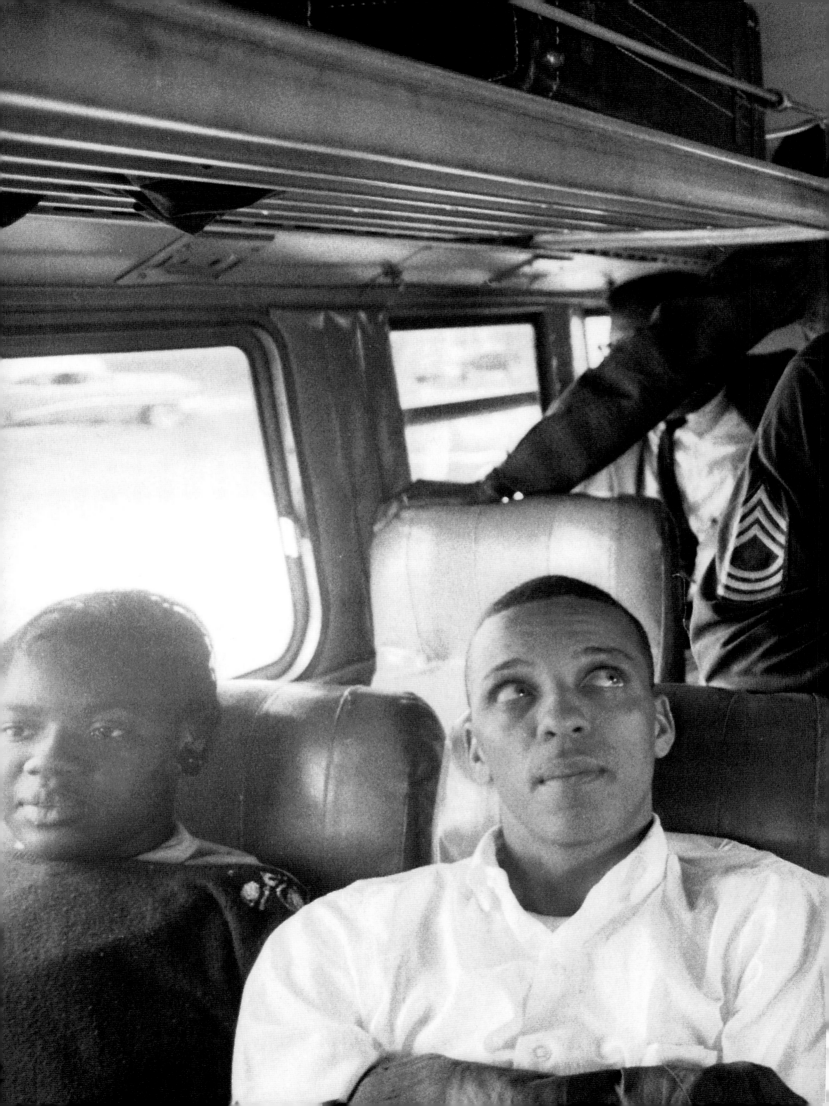

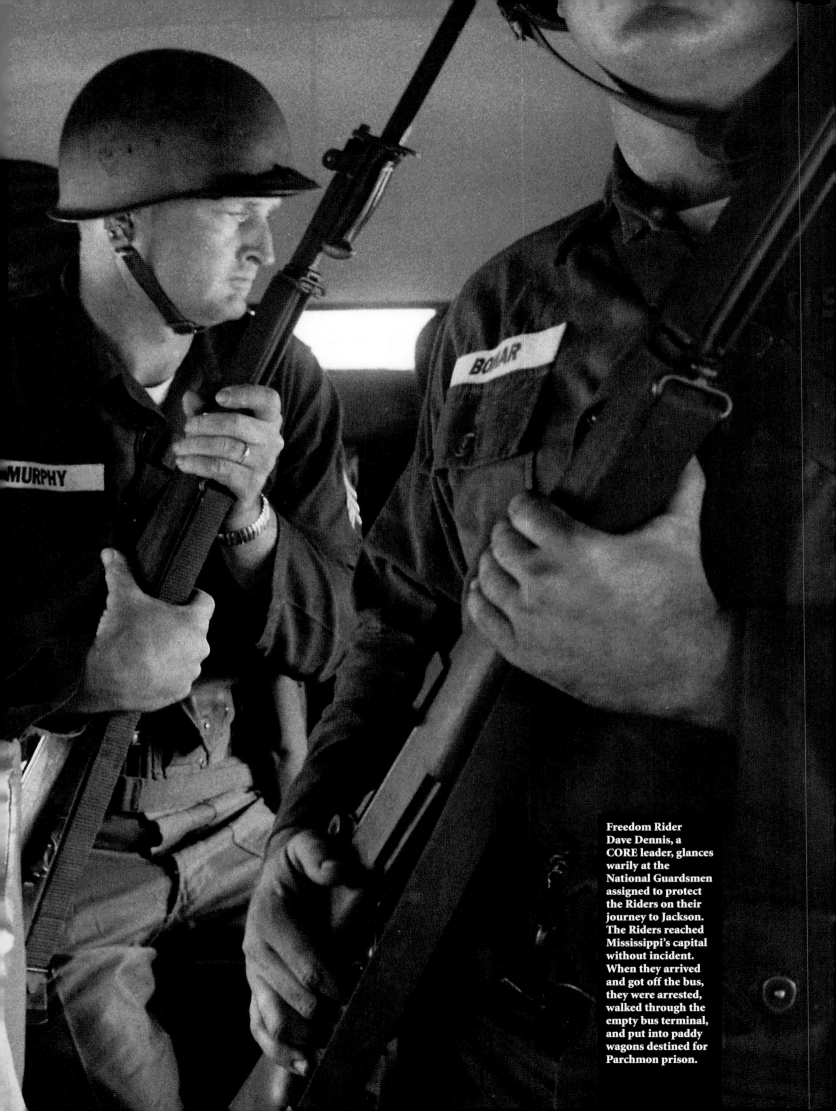

Freedom Rider Dave Dennis, a CORE leader, glances warily at the National Guardsmen assigned to protect the Riders on their journey to Jackson. The Riders reached Mississippi's capital without incident. When they arrived and got off the bus, they were arrested, walked through the empty bus terminal, and put into paddy wagons destined for Parchmon prison.

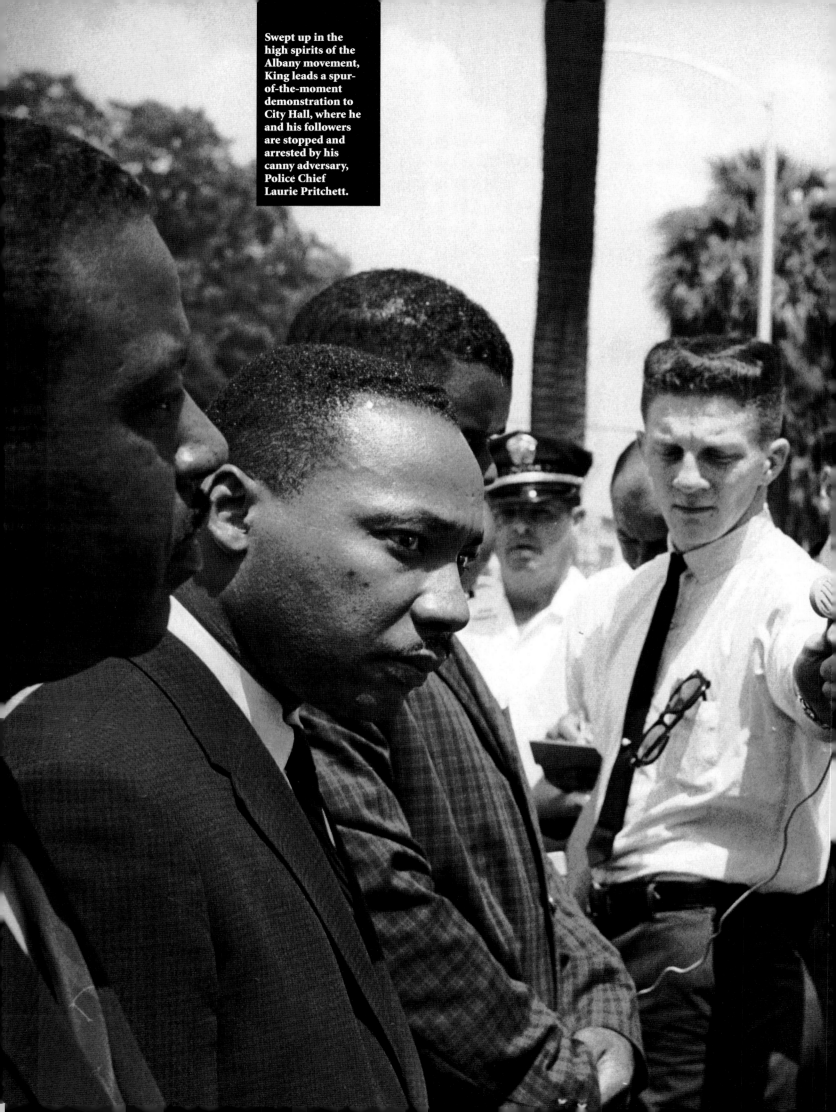

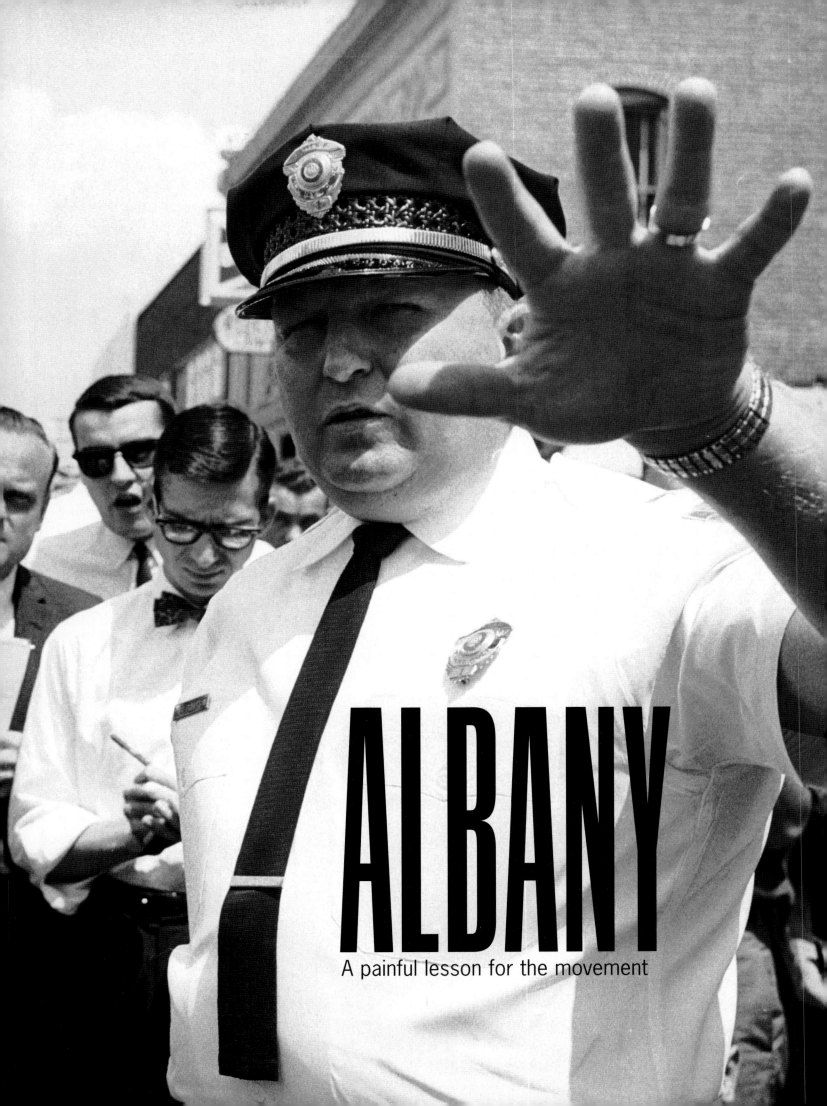

ALBANY

A painful lesson for the movement

ALBANY

A student of King's tactics in Montgomery, Police Chief Pritchett was determined to oppose nonviolence with nonviolence.

We should not devour each other to the delight of onlookers who would have us corrupt and sully the noble quality of our crusade.

~MARTIN LUTHER KING, JR., ALBANY, 1961

Albany, Georgia, was a dangerous cauldron of contradictions.

King only went to give a speech. Why get involved, he must have wondered, when SNCC already was battling in Albany for voting rights and the desegregation of public facilities. And besides, they feared his presence would overshadow the local leadership. But he went, invited by physician William G. Anderson, who defied SNCC's refusal to bring on board the celebrated, idealistic theist from Atlanta. And when 31-year-old King saw the passion and commitment of the black people packing Shiloh Baptist Church on December 15, 1961, he was moved and felt that perhaps Albany would provide his first major campaign since the bus boycott in Montgomery.

Sadly, it delivered King's first stinging defeat: a cornucopia of realpolitik. Despite the broad range of confrontational tactics employed by the SCLC on its maiden campaign, no more than 5 percent of Albany's black population (which was nearly half of the city) turned out for a bus boycott, nonviolence workshops, mass meetings, and sit-ins at the Jim Crow library and recreational facilities. Worse, King discovered blacks willing to work with the segregationists to maintain the status quo if they could personally profit from doing so.

Furthermore, after he, Abernathy, and other demonstrators were arrested at the bus station by Police Chief Laurie Pritchett for disturbing the peace and parading without a permit, King vowed to be in jail through Christmas. But the information he received led him to believe the Albany officials had blinked, agreeing to a truce. His bail was posted. He emerged hoping to see jubilant protesters but discovered that the local leadership, suspicious of him, had terminated the demonstrations in exchange for the city's promise to consider its

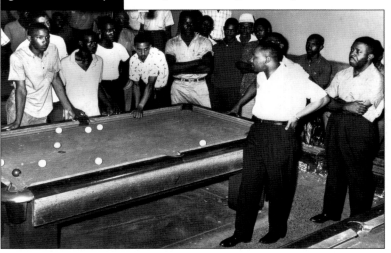

After a night of violence, King visits Albany's "Harlem," stopping at a pool hall. "I hate to hold up your game. I used to be a pool shark myself." He then tried to enlist the crowd to join the effort to end segregation nonviolently.

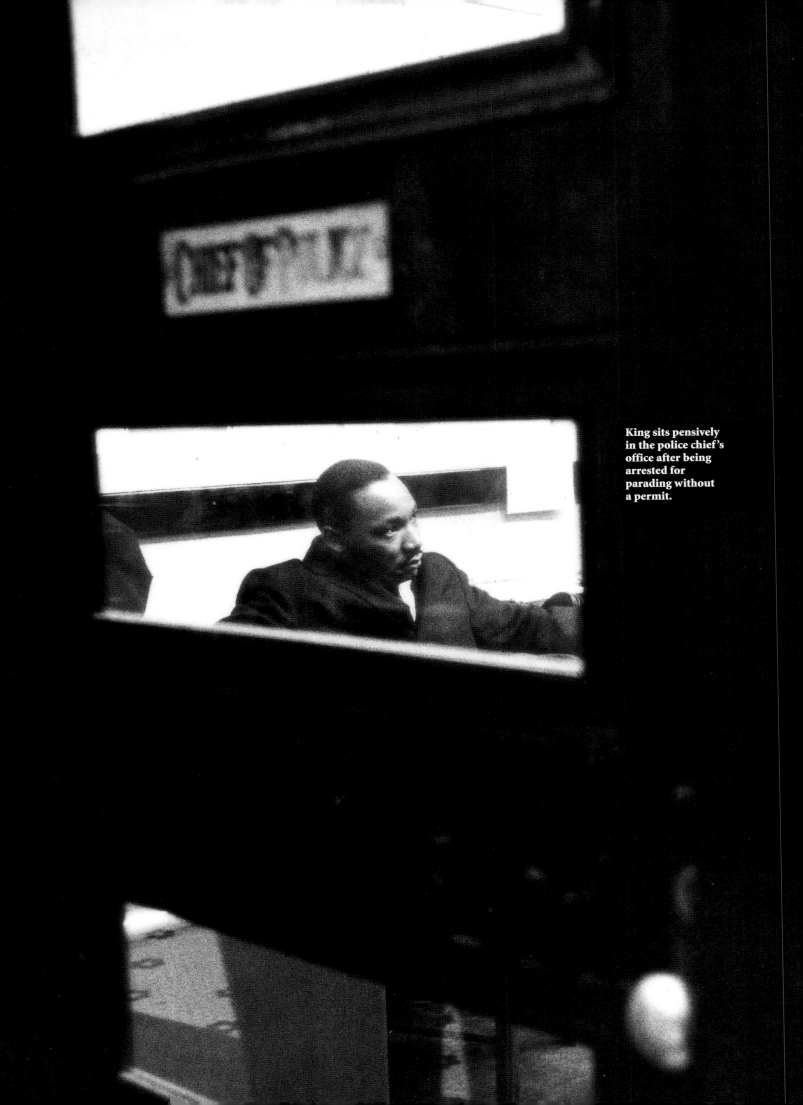

King sits pensively
in the police chief's
office after being
arrested for
parading without
a permit.

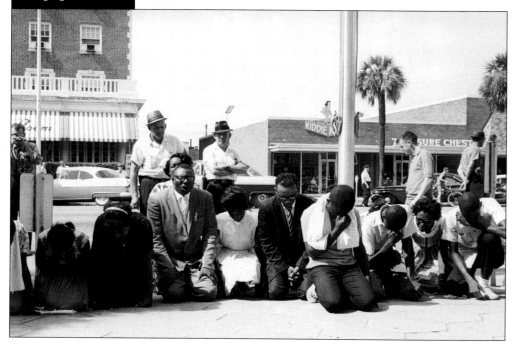

Nonviolent demonstrators kneel in prayer on an Albany sidewalk in an attempt to draw attention to the city's refusal to negotiate the end of segregation.

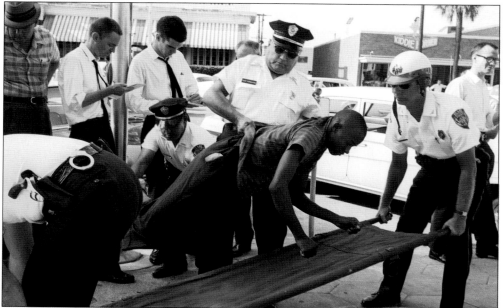

Police arrest demonstrators and carefully carry them away on stretchers. The politeness of the police is an attempt to kill the demonstrations with kindness.

demands. Yet Albany was as segregated as it had been before. Embarrassed, King apologized profusely for leaving jail prematurely.

King and the SCLC renewed their efforts, but they seriously underestimated Chief Pritchett, who had taken the time to study King's Gandhian strategies. He was an adversary they came to respect, for, like the city officials, Pritchett was a cunning player of the chess game known as nonviolent civil disobedience. Did the movement rely on publicity? Melodramatic footage of good Negroes being savaged by evil, Neanderthal whites? Well then, Pritchett decided, during the Albany demonstrations his policemen would be the very portrait of restraint and respect before the world's cameras; he even bowed his head when demonstrators prayed, then he politely arrested them. Ironically, it was like fighting fire with fire, countering the protesters' lawfulness with public civility and compassion by the police. Would King symbolize the frustration of Negroes if he were jailed? In Albany, white segregationists enlisted a Negro to pay their fines. SCLC leaders were perplexed. "I've been thrown out of a lot of places in my day," Abernathy said, "but never before have I been thrown out of a jail."

Pritchett assigned 24-hour police protection for King, another zugzwang that annoyed King no end. Officers arrested demonstrators left and right, but without a shred of recordable abuse—that took place only outside the city, for example at a prison where a pregnant woman was kicked so severely she later lost her child.

The SCLC found Albany to be a tissue of frustrations. They could not find enough protesters to fill the jails. Local leaders criticized their every move. On

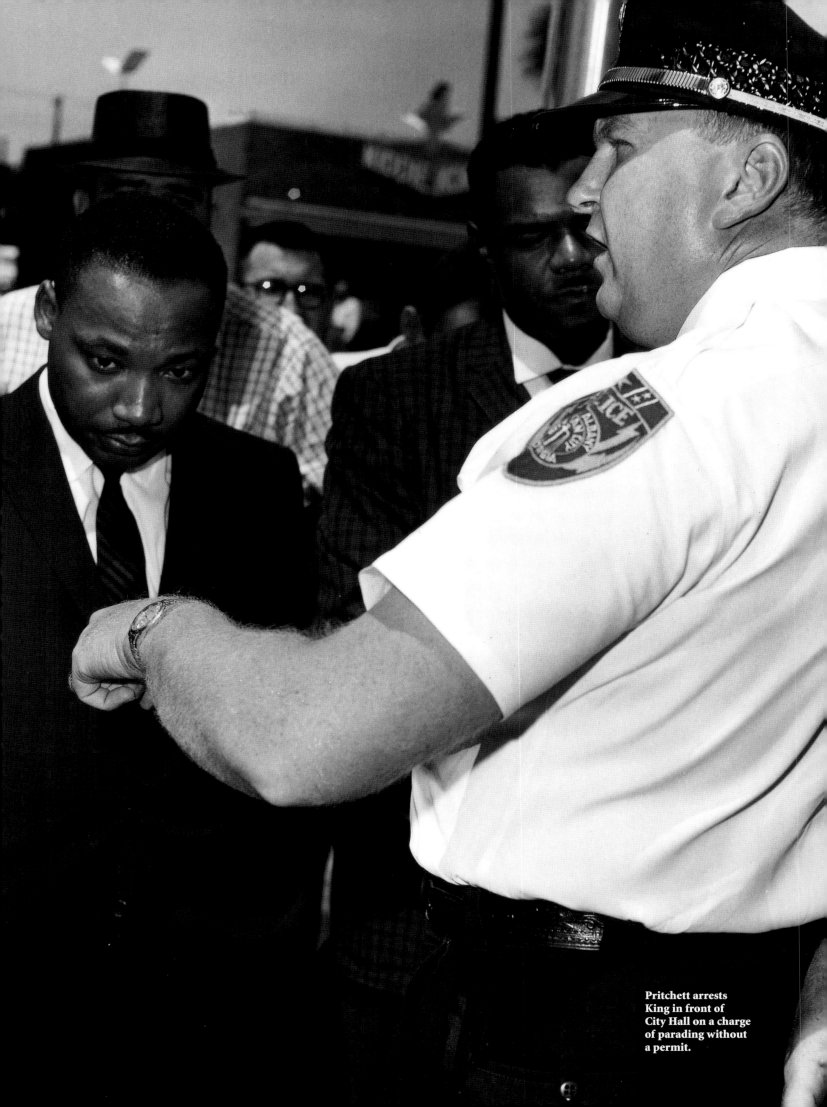

Pritchett arrests
King in front of
City Hall on a charge
of parading without
a permit.

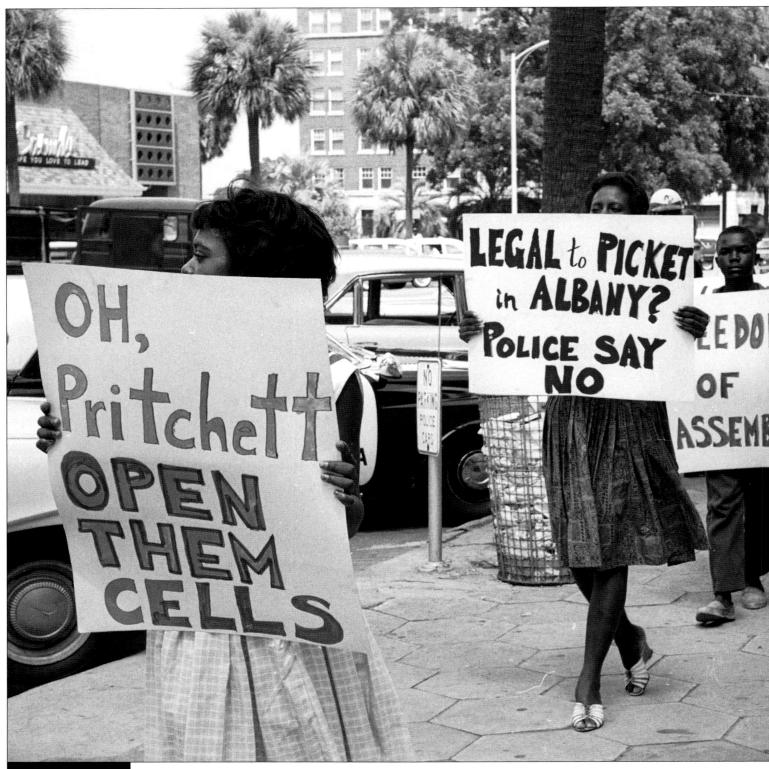

July 24, young blacks hurled rocks and bottles at the police, shattering King's insistence on nonviolence. That led to the city's calling in the National Guard, to King's pleading in pool halls with the black population to be nonviolent, and to declaring "A Day of Penance." The bus company agreed to desegregate, then shut down business altogether. The city parks were closed. So too the public library. And the federal government offered no

help whatsoever, not even to enforce the law. Indeed, Robert Kennedy recommended that King conclude his operations in Albany.

Militant students dismissed King's "Day of Penance" as weak, his methods as timid and riddled with poor judgment, and his performance as disappointing. The coup de grâce came in the form of a temporary injunction against civil disobedience in Albany. (In August the

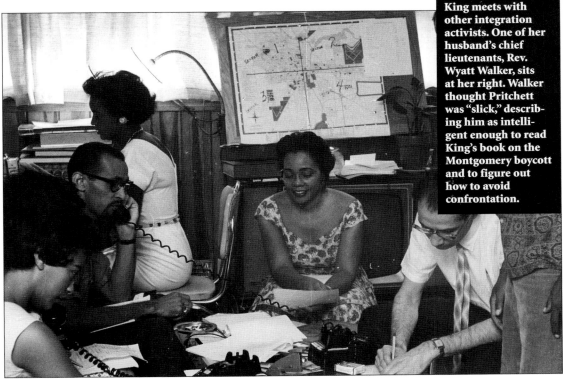

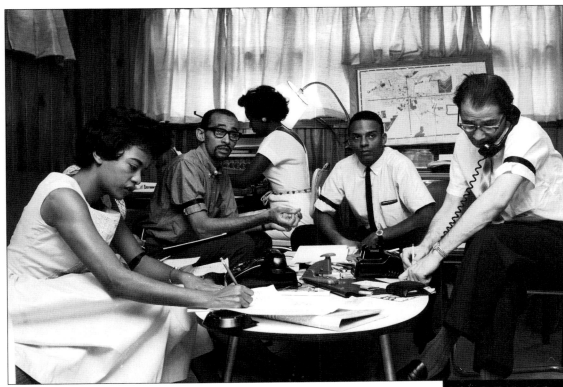

Justice Department would challenge this, but too late to undo the damage.) Because he did not wish to oppose the federal courts, which had helped the movement in the past, King obeyed the injunction. Local leaders and those in SNCC condemned him for that decision.

In the end, a disappointed King and the SCLC achieved none of their desegregation goals in Albany. They had entered that campaign with a vague purpose.

Without a plan. Without knowledge of the local situation and its intra-movement factionalism. They were fed misinformation and checkmated at virtually every stage of the game. The civil rights movement, the burgeoning struggle for black liberation was not, King saw, in his control. But from this lost battle he and the fledgling SCLC learned much that would prove useful in future campaigns.

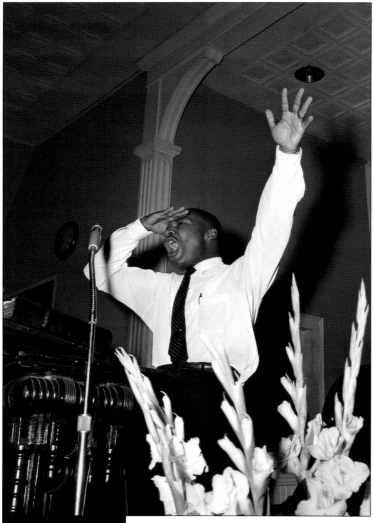

King's oratory mightily stirs Albany blacks, who fill a church to overflowing. He discusses the difficulties they will face as they try to upset a federal injunction forbidding demonstrations, which he has decided to obey. A higher court removed the injunction, but by that time violence had broken out, and King limited his activities to prayer vigils as he tried to avoid more violence.

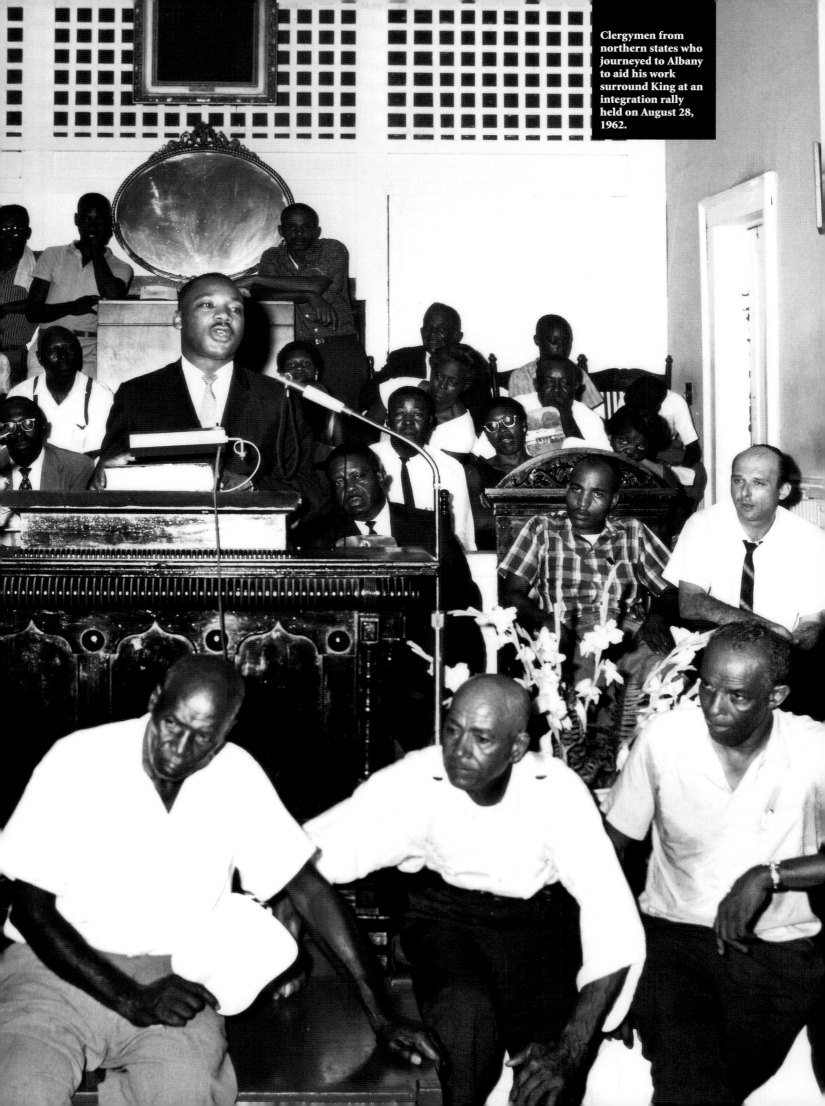

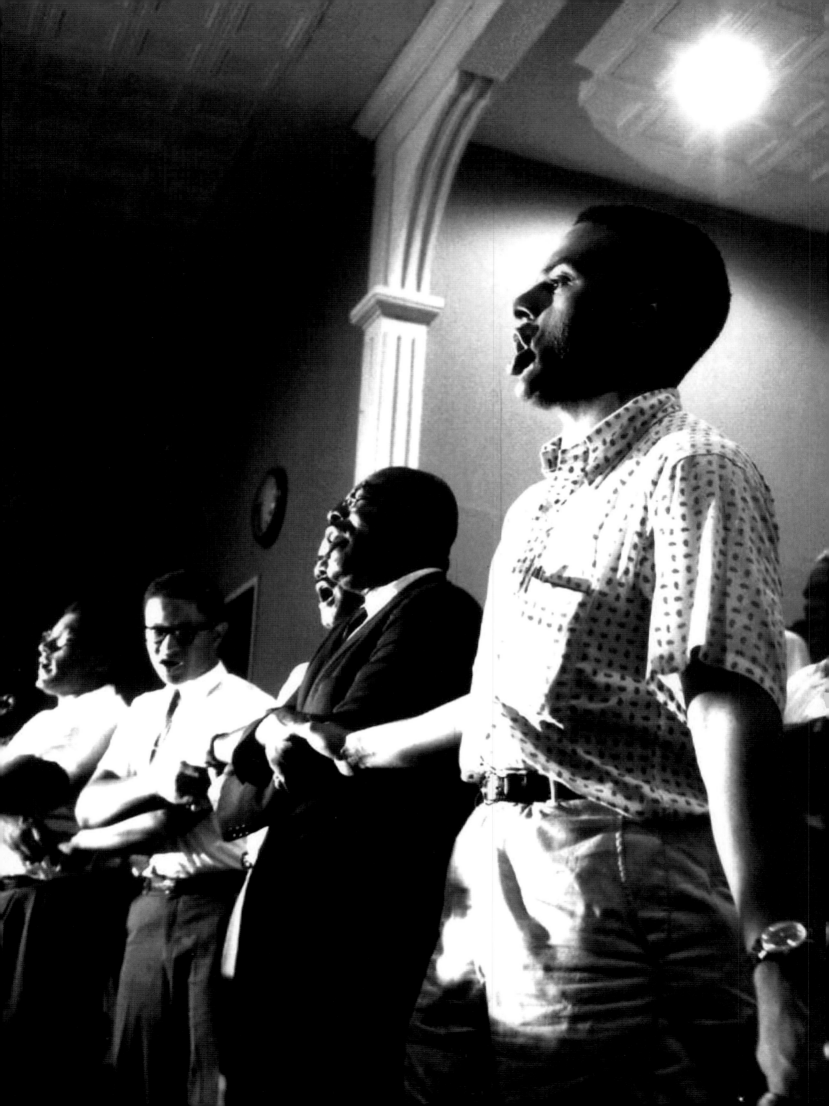

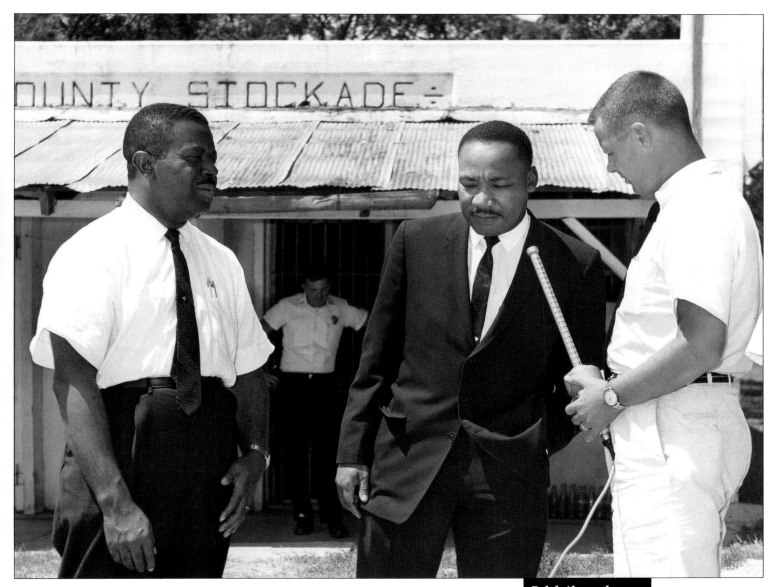

Andrew Young, King, and others sing the words "we shall overcome someday" from the movement's anthem.

Ralph Abernathy and a concerned and subdued King speak to a reporter after visiting white clergymen who were fasting while they were imprisoned in the Lee County Stockade, near Albany. They were later released, and King saw them off on their return journey north.

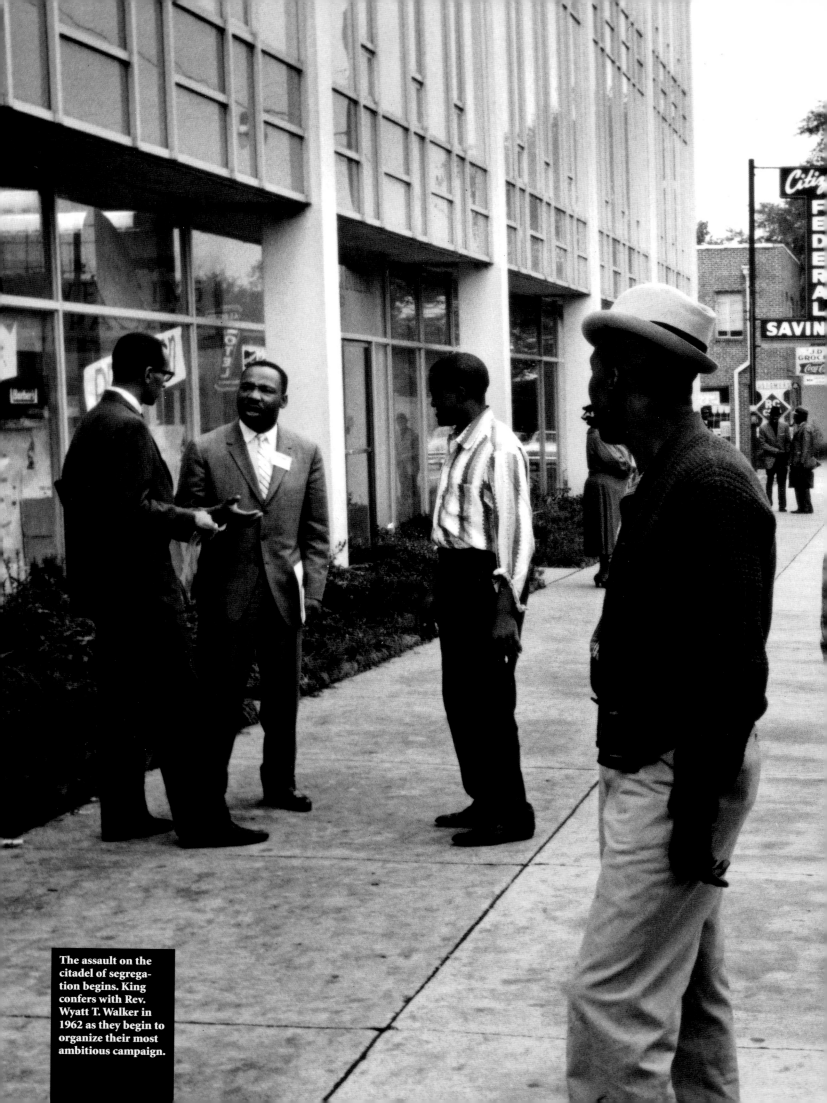

The assault on the citadel of segregation begins. King confers with Rev. Wyatt T. Walker in 1962 as they begin to organize their most ambitious campaign.

BIRMINGHAM

Segregation is brought to its knees

BIRMINGHAM

We will wear you down by our capacity to suffer.
~MARTIN LUTHER KING, JR.,
BIRMINGHAM, 1963

Bull Connor has done as much for civil rights as Abraham Lincoln.
~PRESIDENT JOHN F. KENNEDY, 1963

If Albany had been chaos, Birmingham was a magnificent symphony of brilliant strategies and sacrifices that forever changed America. King and the SCLC planned this campaign, "Project C" (Confrontation) as they called it, with veteran freedom fighter Rev. Fred Shuttlesworth for months in advance. They studied and anticipated the actions of their adversaries—racist Police Commissioner Eugene "Bull" Connor and Alabama Governor George Wallace—and others in what was considered to be this nation's most segregated and brutally repressive city. Knowing their phones were tapped, they devised code words. (Jail was "going to get baptized.") Twice they postponed Project C, first in order to monitor the elections for mayor in Birmingham, then to wait for the outcome of Connor's runoff election against Albert Boutwell,

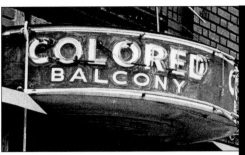

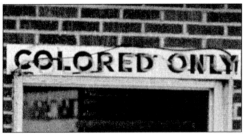

Birmingham had a well-deserved reputation as the most segregated and racially violent city in the Deep South. Its long string of unsolved racist bombings earned the city the epithet Bombingham.

who won. (Shuttlesworth called Boutwell "just a dignified Bull Connor.") The very next day, April 3, 1963, Project C was launched, although the delays had reduced the number of volunteers determined to go to jail from two hundred fifty to sixty-five.

From the start the Birmingham movement was focused. It targeted not the political power structure but segregated businesses—Woolworth's, H. L. Green's, and J. J. Newberry's—and produced a manifesto that demanded desegregation of all public facilities in stores, hiring of blacks by employers, the formation of a biracial committee to expedite integration, dismissal of all charges from previous protests, equal opportunity for blacks within the city government, and the reopening of closed municipal facilities on a desegregated basis. The SCLC and Shuttlesworth's Alabama Christian Movement for Human Rights began

Rev. Fred Shuttlesworth, leader of the Alabama Christian Movement for Human Rights, stands transfixed in front of his bombed house.

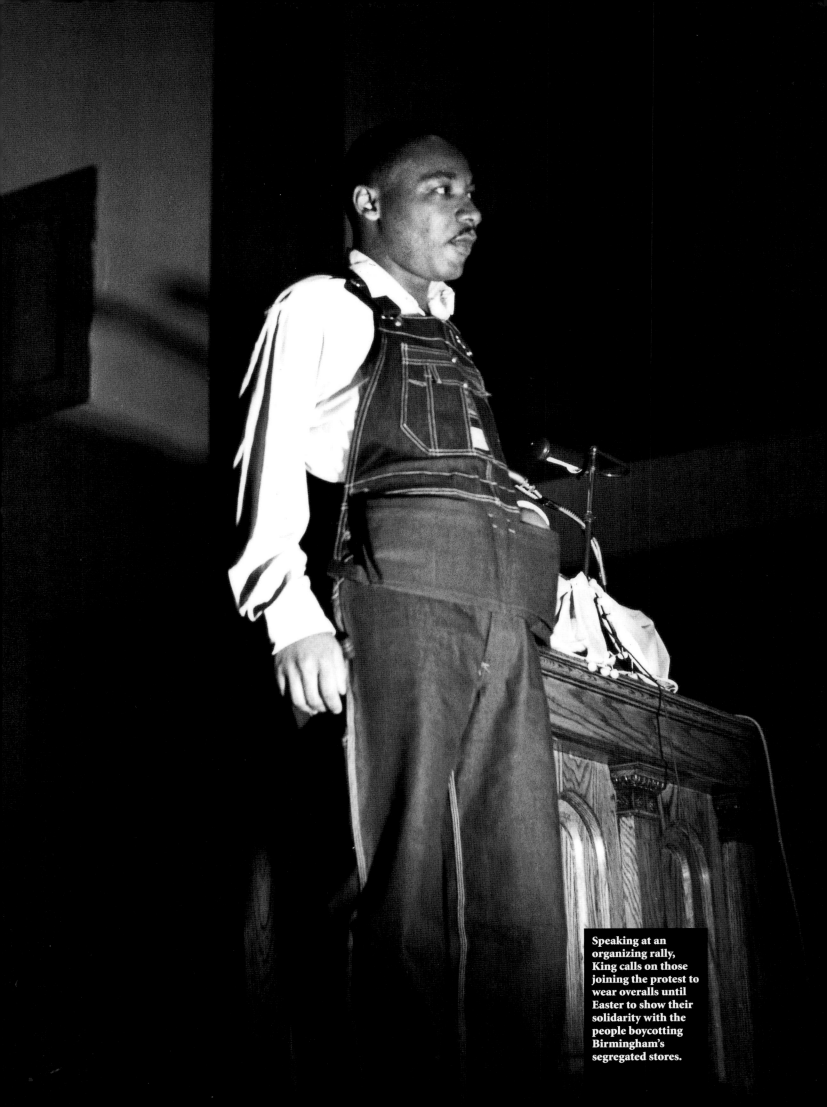

Speaking at an organizing rally, King calls on those joining the protest to wear overalls until Easter to show their solidarity with the people boycotting Birmingham's segregated stores.

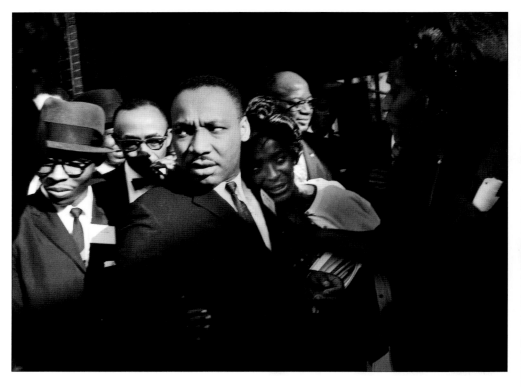

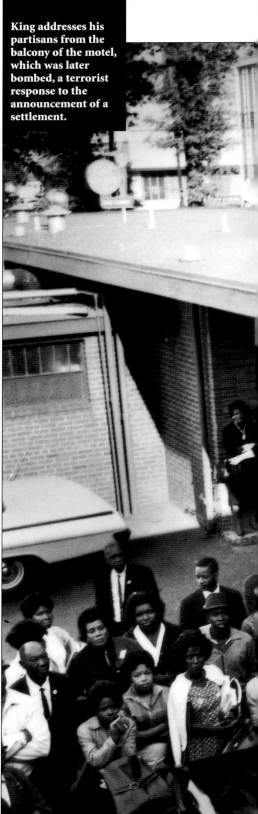

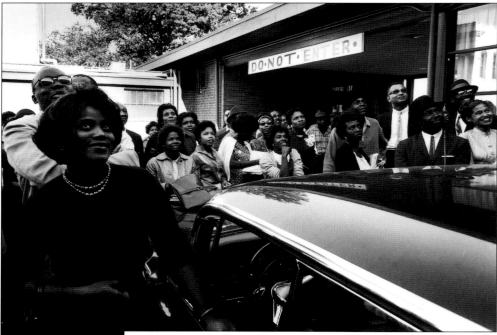

cautiously to conserve their resources and gradually build a crisis that would crescendo by Easter. They initially fielded only a few sit-ins, and Birmingham's divided government (split because the three city commissioners, Connor among them, declared they would remain in office until 1965) responded predictably by imitating strategies employed in Albany. Connor ordered his police officers to behave amicably. Then a

court injunction was obtained, ordering the demonstrators to stop.

This time, however—and for the first time—King decided to disobey a court order. Wearing denim work clothes similar to those of Alabama's poor, he marched toward downtown Birmingham with Ralph Abernathy on Good Friday, April 12, and after only eight blocks they were arrested. King was thrown into solitary confinement.

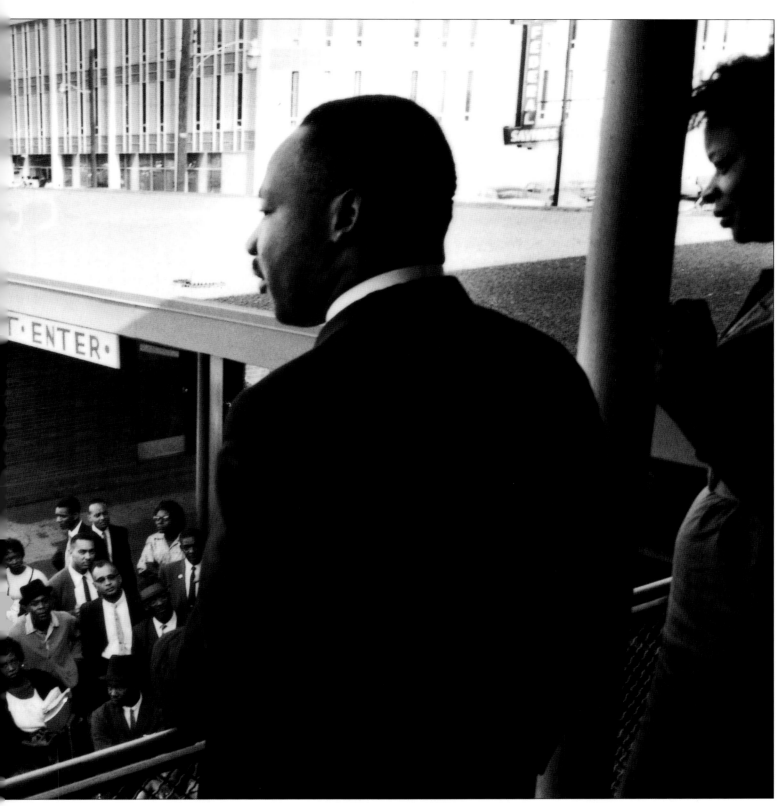

It was there, in a darkened cell, without a single note or textbook to refer to, and after he read a statement by eight Christian and Jewish clergy condemning his actions in the *Birmingham News,* that King composed, first in the margins of that paper, then on toilet paper, and finally on a legal pad provided by his lawyers, the philosophically and morally breathtaking "Letter from Birmingham Jail," destined to become one of the great

political documents in American history. "Any law that uplifts human personality is just," he wrote. "Any law that degrades human personality is unjust."

Upon his release, secured by $50,000 in bail funds raised by Harry Belafonte and the intervention of the Kennedys, King turned up the heat under the demonstrations, which had dwindled. They needed an army to fill the city's jails. Where to find it? The SCLC looked

toward the high-school students they had trained in nonviolence and discovered that hundreds of their younger siblings in the elementary schools insisted on fighting for freedom too. Thus was born the controversial "children's crusade" that put one thousand youngsters on Birmingham's streets. The next day the number reached twenty-five hundred and Bull Connor responded with fire hoses. An angry crowd of fifteen hundred

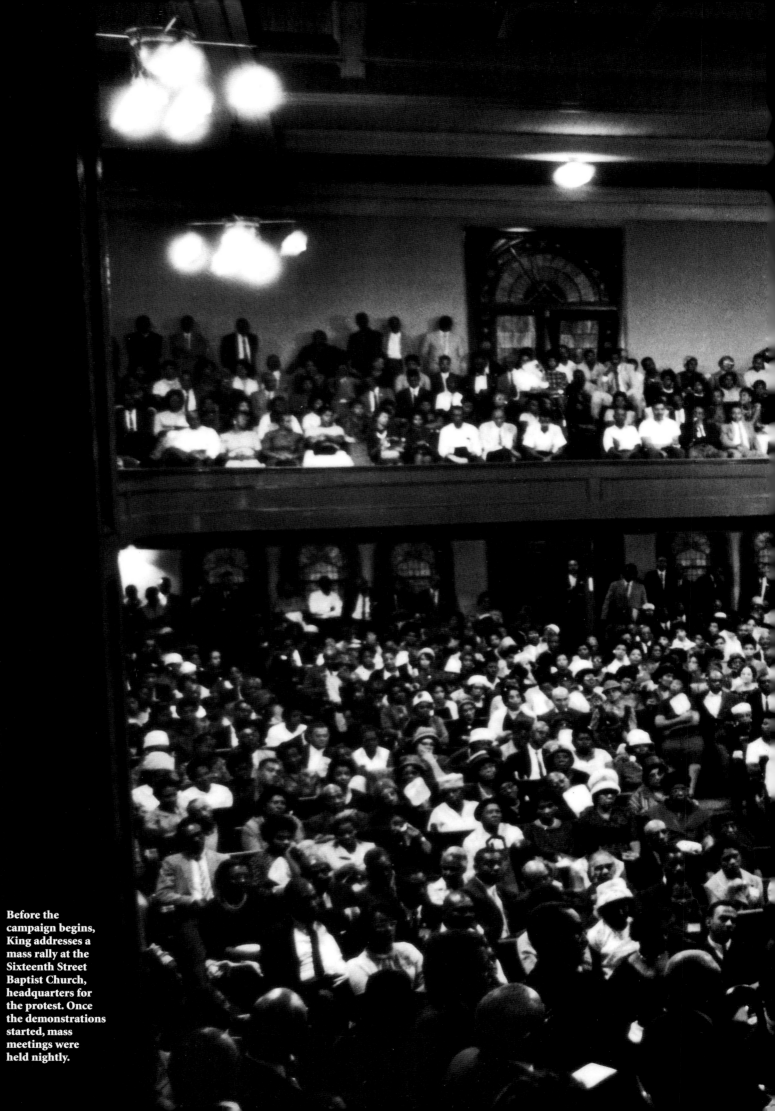

Before the campaign begins, King addresses a mass rally at the Sixteenth Street Baptist Church, headquarters for the protest. Once the demonstrations started, mass meetings were held nightly.

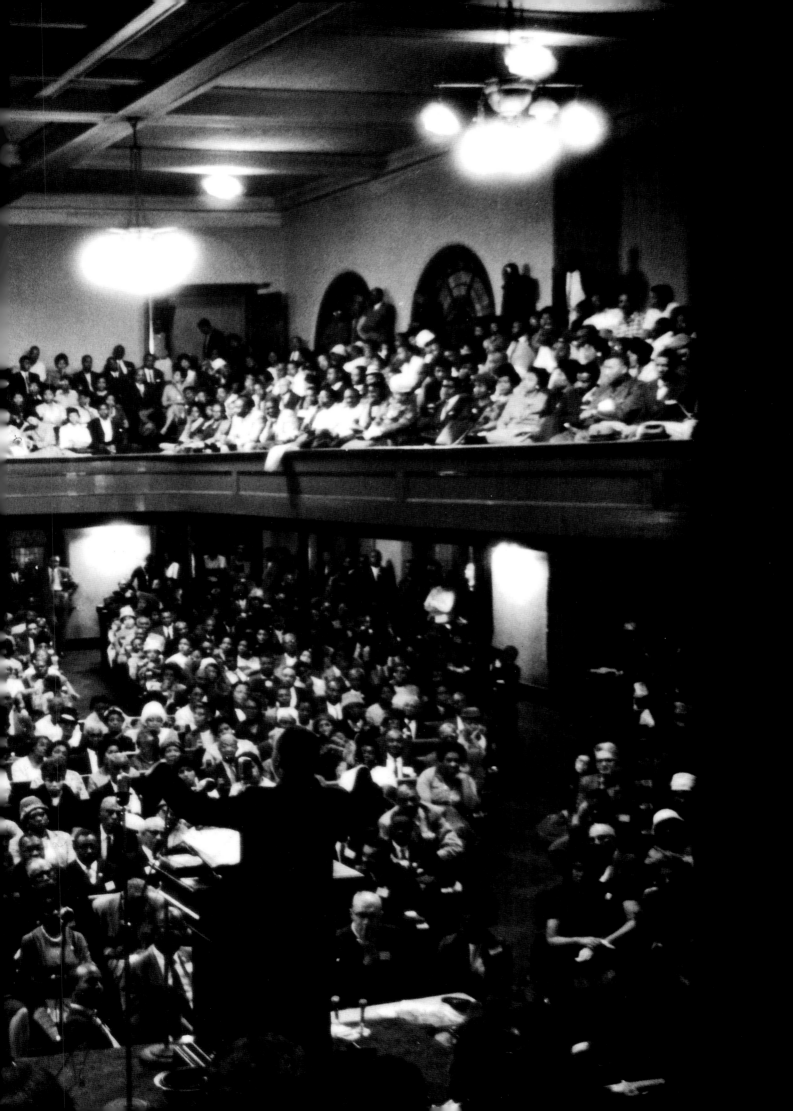

King's truly exalted oratory had to persuade his followers not only to believe in his vision but also to act on it. By faith and by deed, armed only with Christian love and nonviolent acts, they could overturn a vicious, cruel, and oppressive caste system. Birmingham would test the strength of his vision and both his and the people's courage.

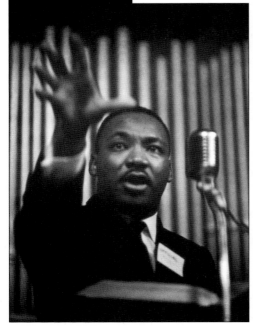

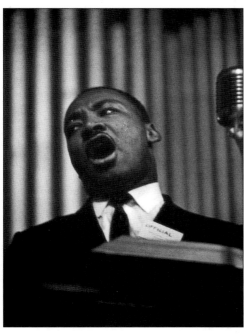

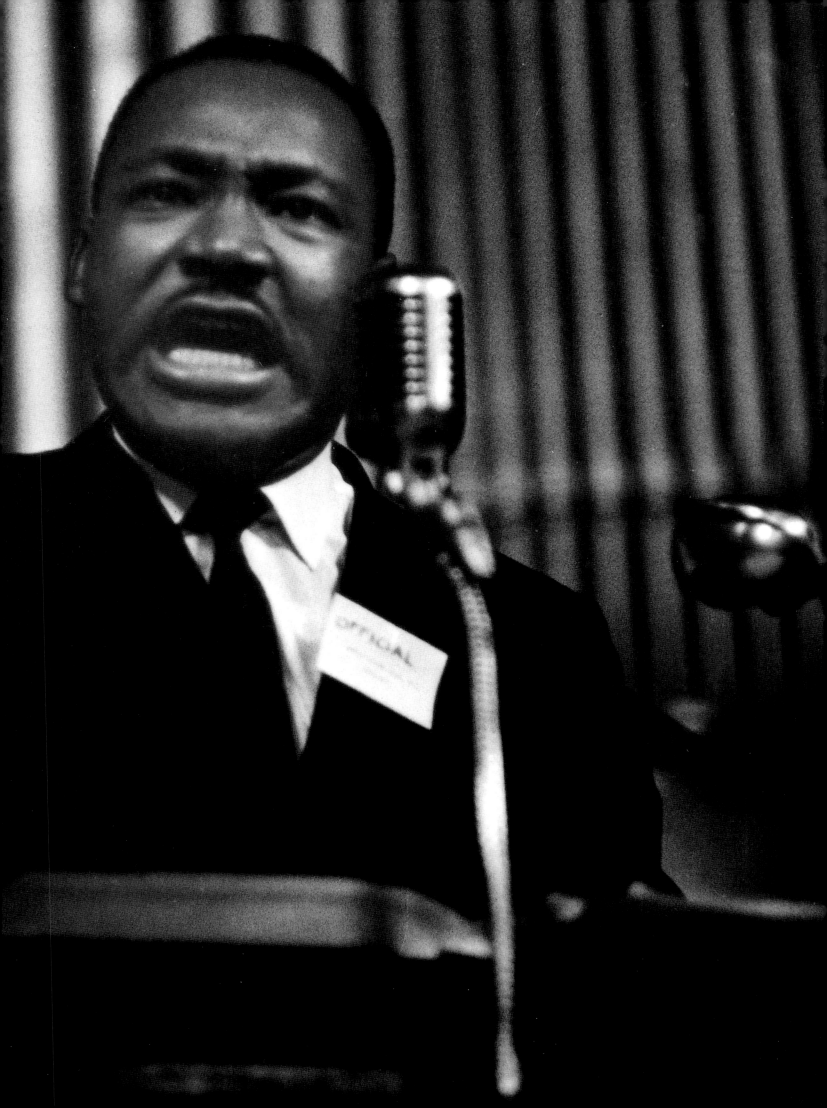

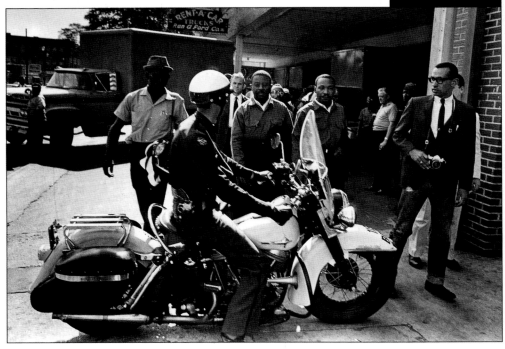

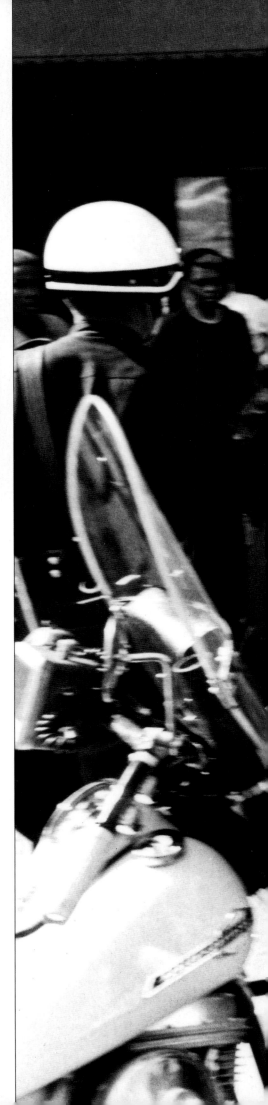

reacted violently to the treatment of the children. Connor then used police dogs—a show of brutality that in news footage broadcast worldwide sickened America and people everywhere.

It sickened the firemen, too. On May 5, hundreds of blacks held a prayer meeting near the city jail. When Connor shouted, "Dammit! Turn on the hoses," his men fell back as if they were mesmerized, some weeping, and let them proceed. King's masterful plan to "create such a crisis and foster such a tension in a community which has constantly refused to negotiate" had worked. The businessmen of Birmingham reached an agreement on King's manifesto on May 10. For the first time in the movement's history, jails had been filled. Out of the agony of the Birmingham campaign, a broad-based coalition involving the NAACP Legal Defense Fund, the United Automobile Workers, and diverse groups dedicated to liberty and reform was

forged. Added to which President Kennedy pressed the very next month for passage of a civil rights bill.

Tragically, the racist backlash continued in Birmingham after the settlement. The home of King's brother, A. D., and King's room at the Gaston Motel were bombed on May 11, probably by Klansmen. Blacks responded in kind, burning and looting and attacking the police. Finally, Kennedy dispatched three thousand federal troops to a location just outside Birmingham and promised to federalize the Alabama National Guard in order to quell the rioting on both sides and safeguard the settlement.

Like all of King's campaigns thus far, violence followed close on the heels of nonviolent civil disobedience. But Birmingham had proven to be a turning point for the movement (and the world), one that no segregationist—whether he resided in the governor's mansion or hid beneath a white robe—could reverse.

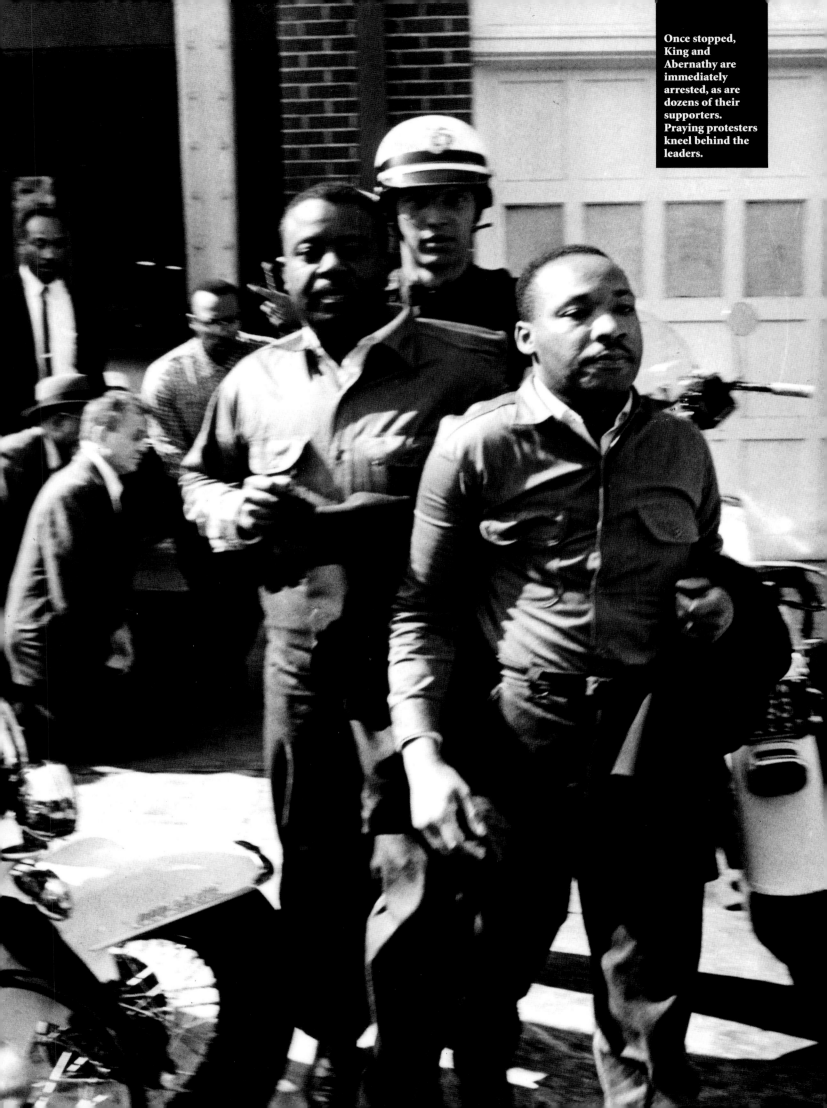

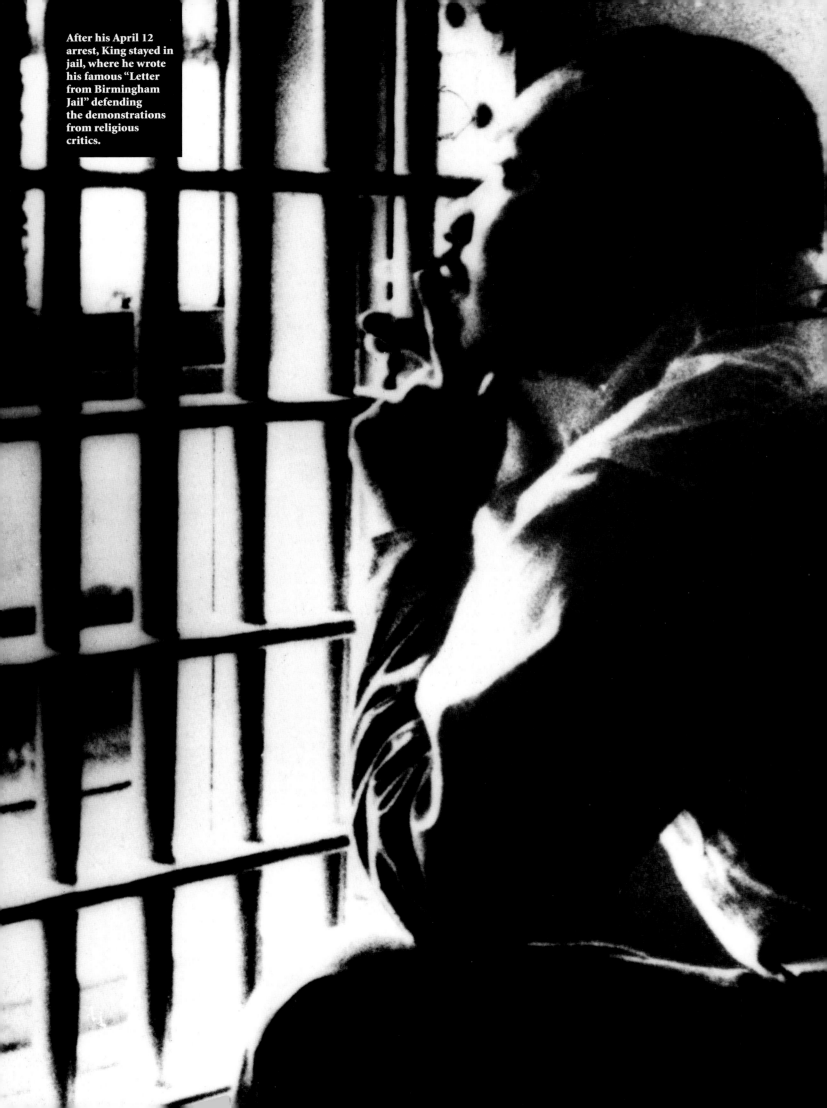

After his April 12 arrest, King stayed in jail, where he wrote his famous "Letter from Birmingham Jail" defending the demonstrations from religious critics.

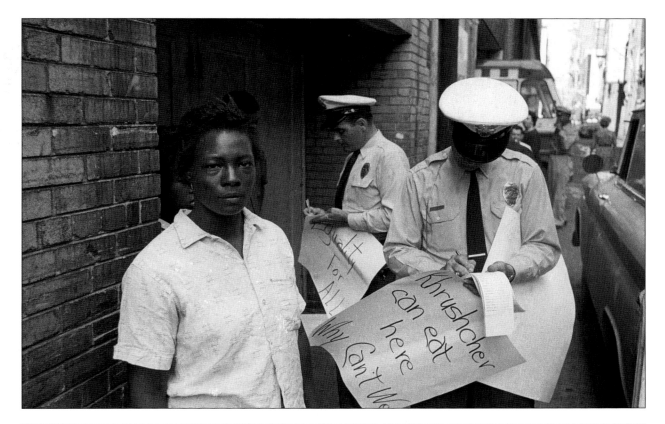

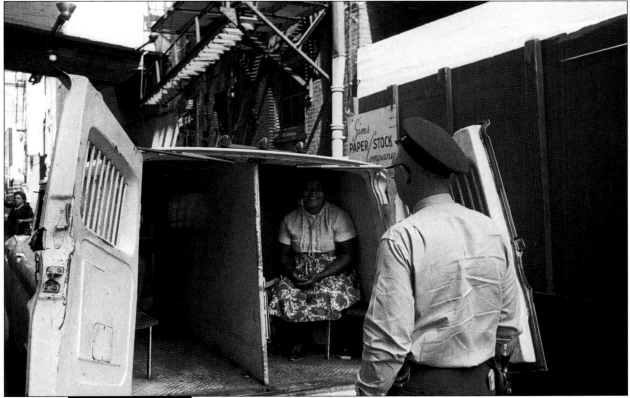

Police attempted to keep protesters in the black part of Birmingham. They manage to evade the police, infiltrate the downtown business district, and picket the segregated Loveman's Department Store, where they are arrested.

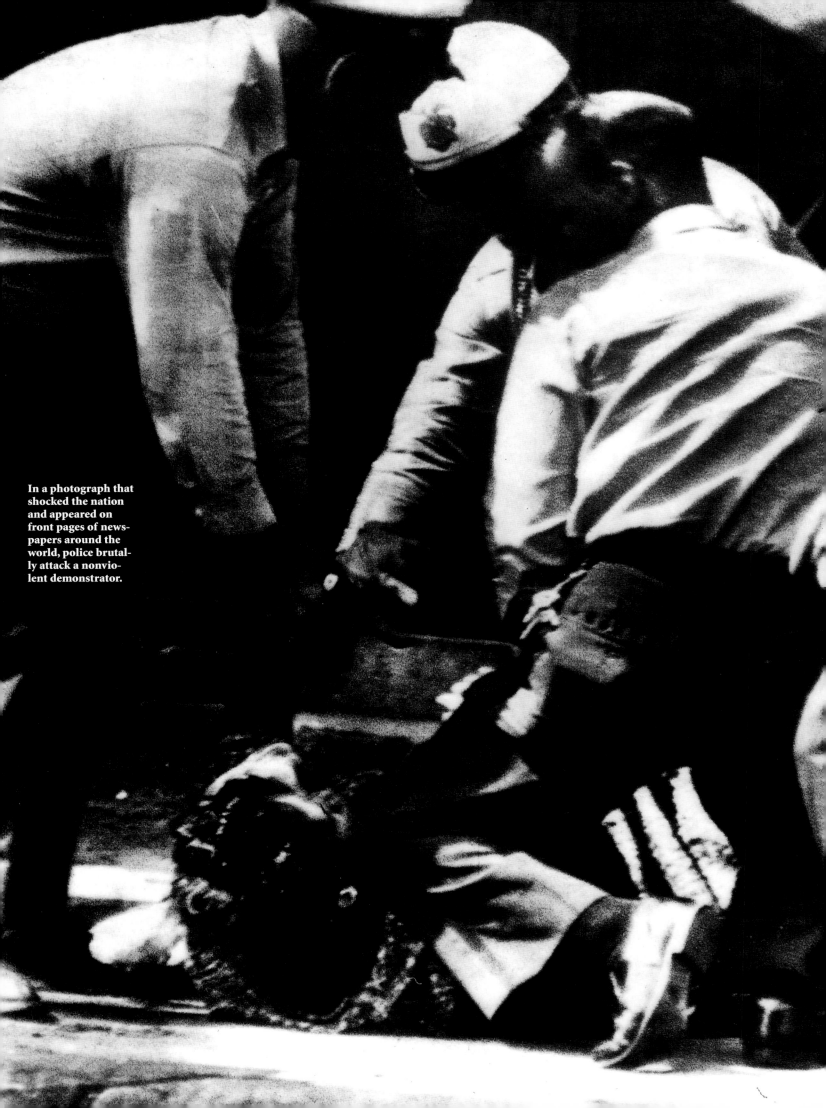

In a photograph that shocked the nation and appeared on front pages of newspapers around the world, police brutally attack a nonviolent demonstrator.

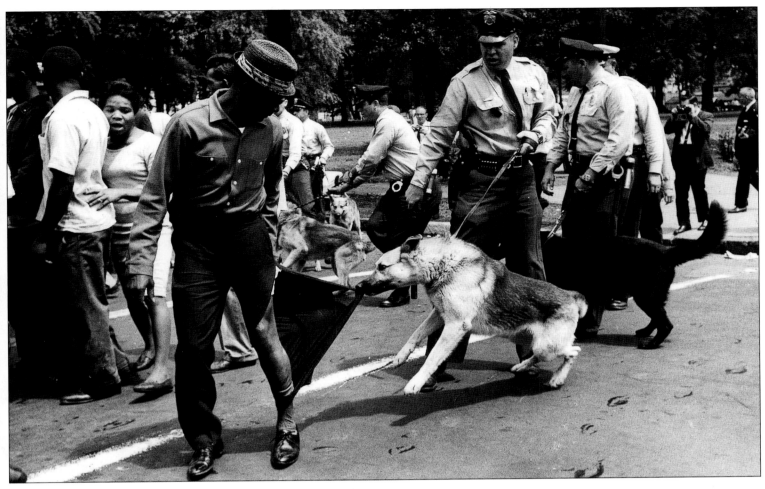

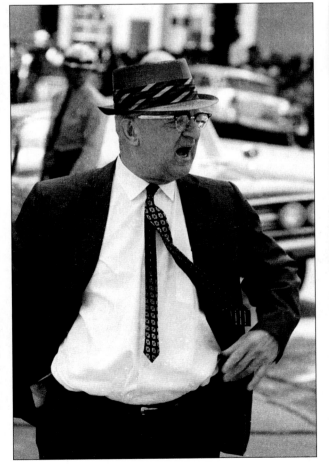

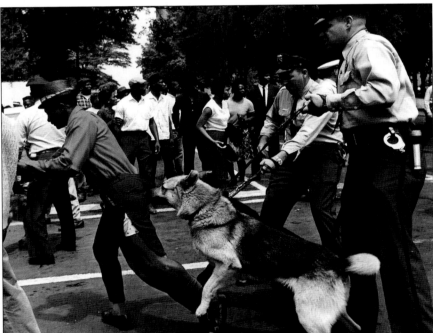

By using attack dogs on peaceful demonstrators, Eugene "Bull" Connor provoked an angry President Kennedy to demand that Birmingham's authorities stop abusing blacks and sit down and negotiate a settlement with their leaders.

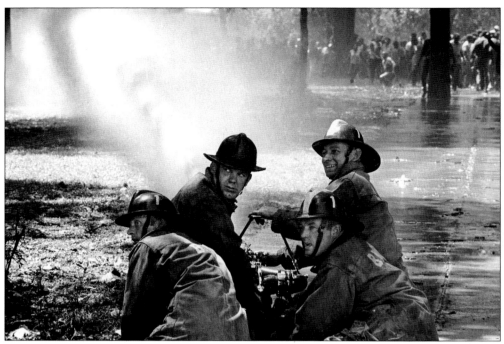

Firemen turn high-powered hoses capable of skinning bark from trees against peaceful demonstrators, who are knocked down and then skid across the grass in Kelly Ingram Park. By coming together and holding on to one another, they are able to stand up to the fire hoses. When they could no longer knock down the united protesters, the firemen turned off their hoses.

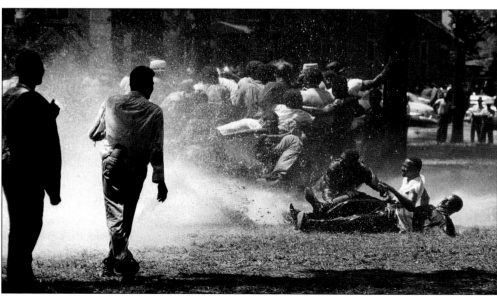

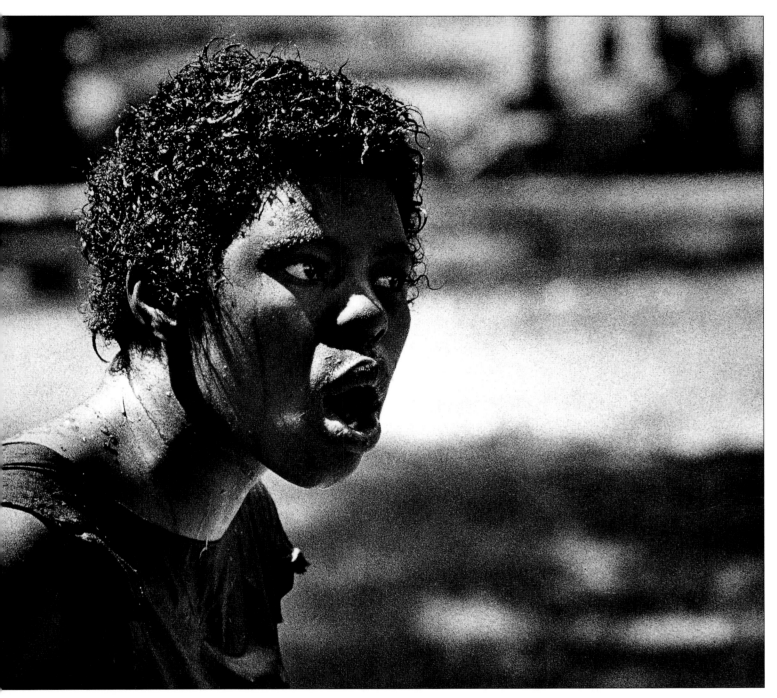

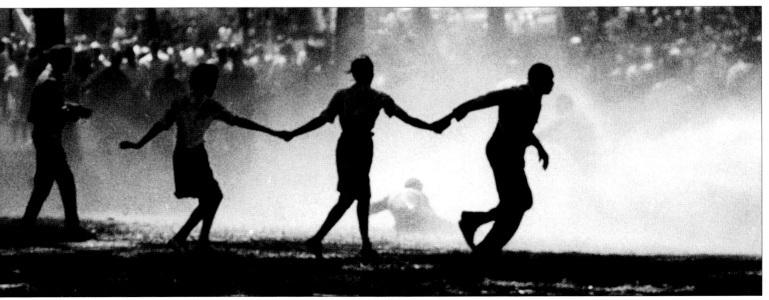

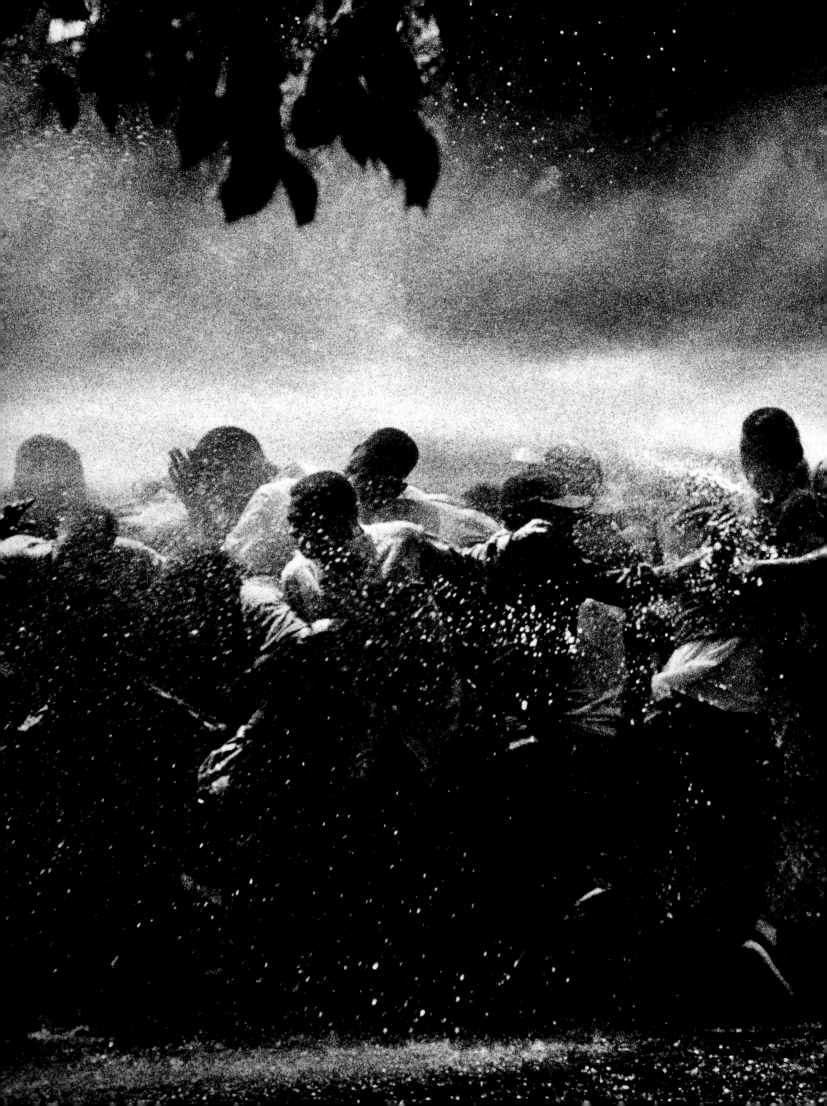

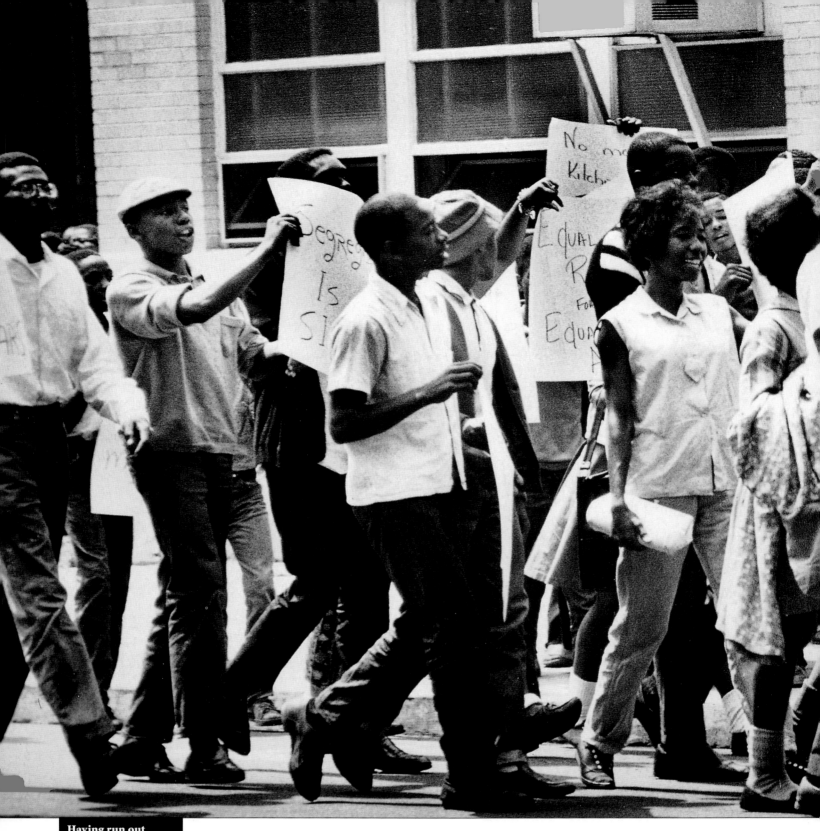

Having run out of protesters, the leaders worked with high-school students to fill the jails, a goal of the movement. Thousands of students were coached in nonviolence. They exuberantly march out of church, are immediately arrested, and then are bused to jail.

Out of jail, King meets nightly at mass meetings and exhorts his followers to victory by love and nonviolence.

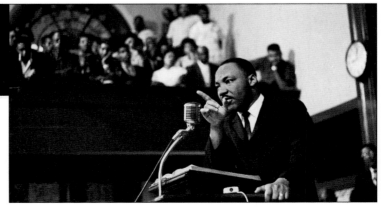

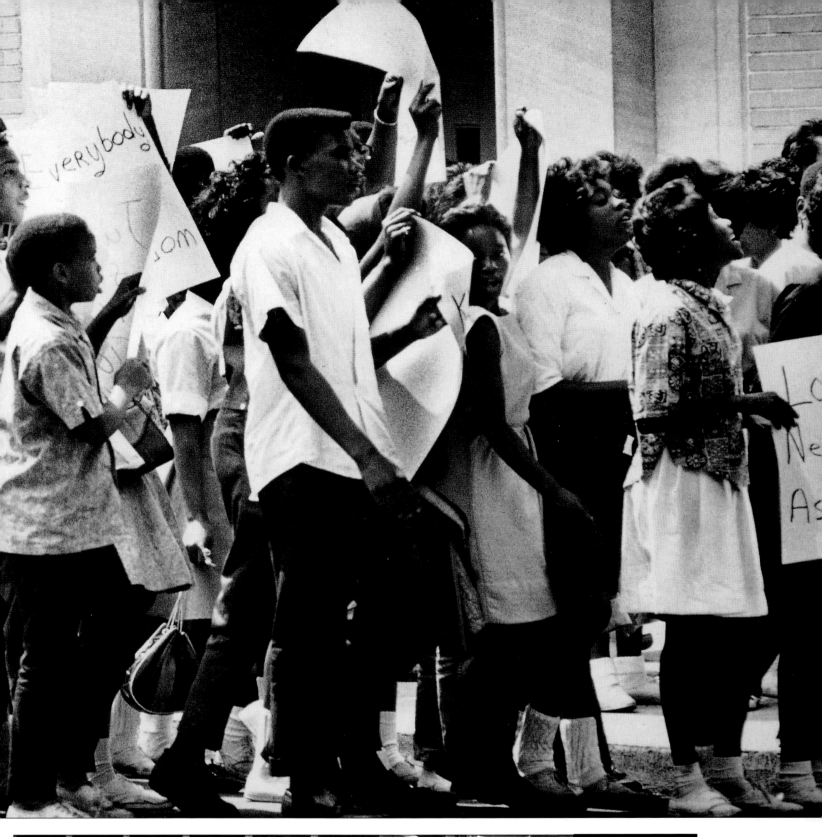

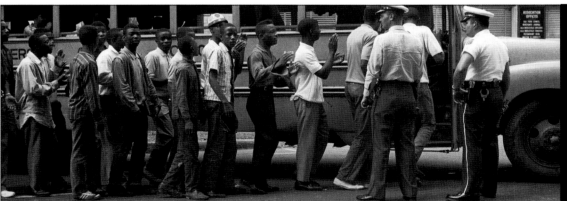

The police run out of official vehicles and have to use school buses. The more protesters the police arrested, the more the criminal justice system was thrown into chaos. The more students they arrested, the more the police lost control of the situation.

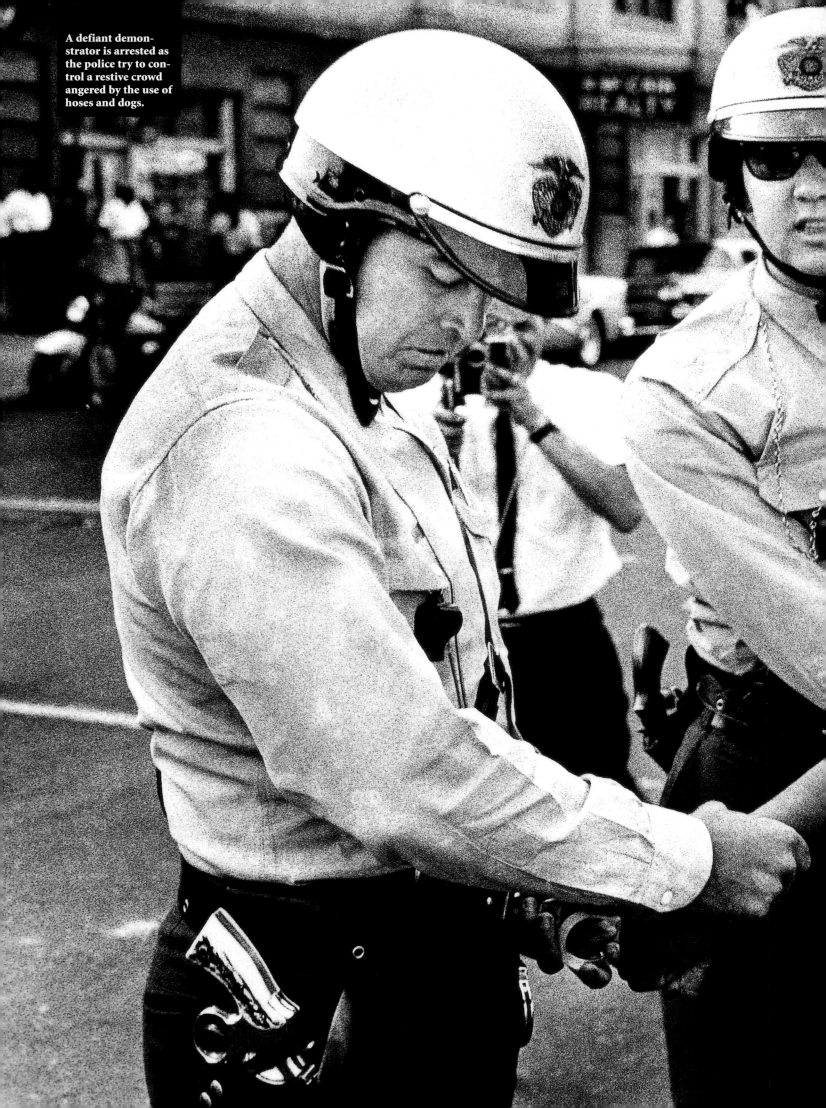

A defiant demonstrator is arrested as the police try to control a restive crowd angered by the use of hoses and dogs.

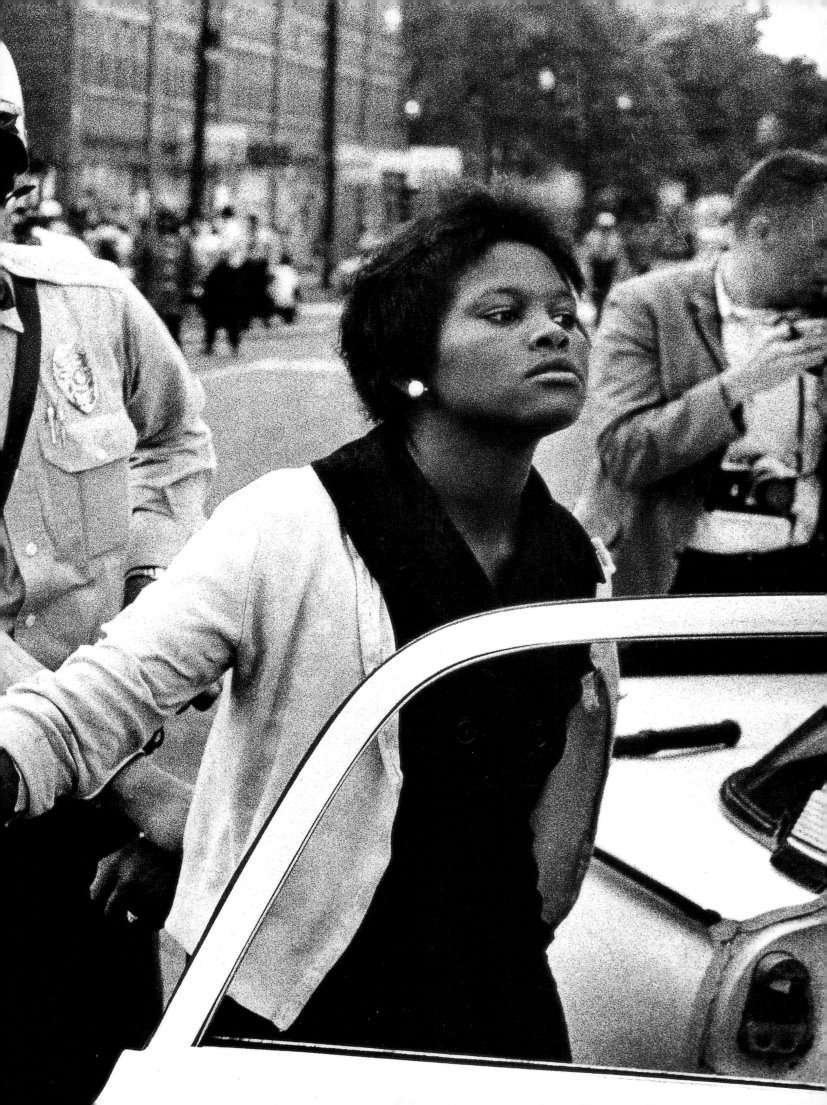

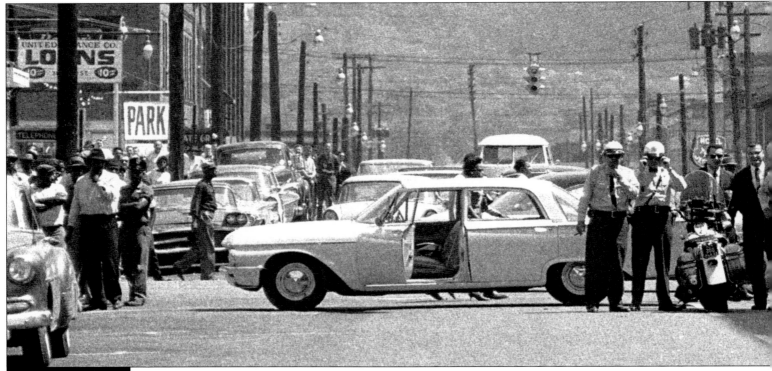

The police set up roadblocks in an attempt to confine the demonstrations to the black part of Birmingham.

White residents look on as the police attempt to control the protests.

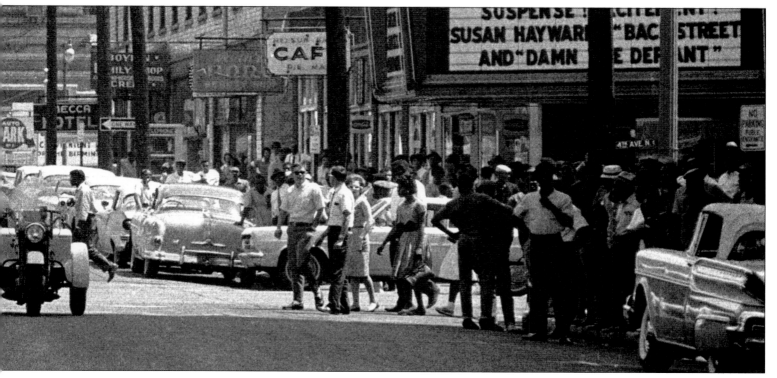

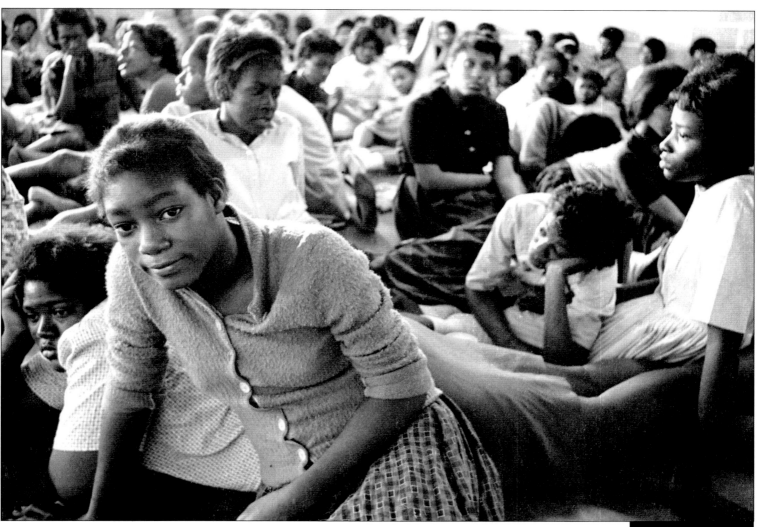

Thousands of students are held in a makeshift jail as the police turn a sports stadium into a holding pen.

— 131

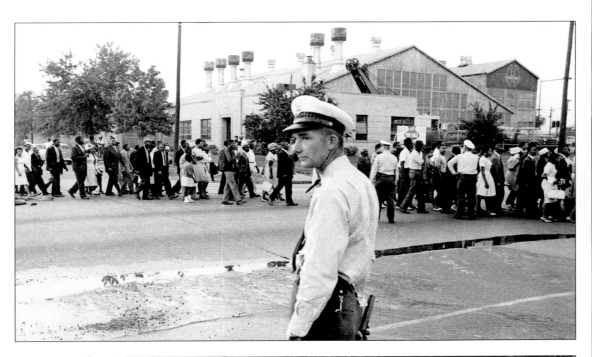

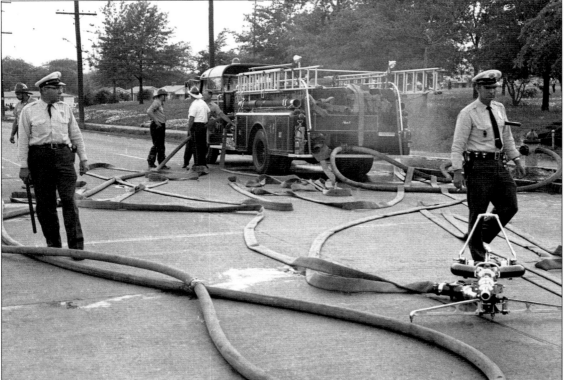

Blacks peacefully
marching to conduct
an outdoor Sunday
prayer vigil are
ordered to stop by
Bull Connor. When
they continue,
Connor orders
the firemen and
policemen to use the
high-powered hoses
on the kneeling
blacks. His orders
are ignored and
the prayer vigil
continues.

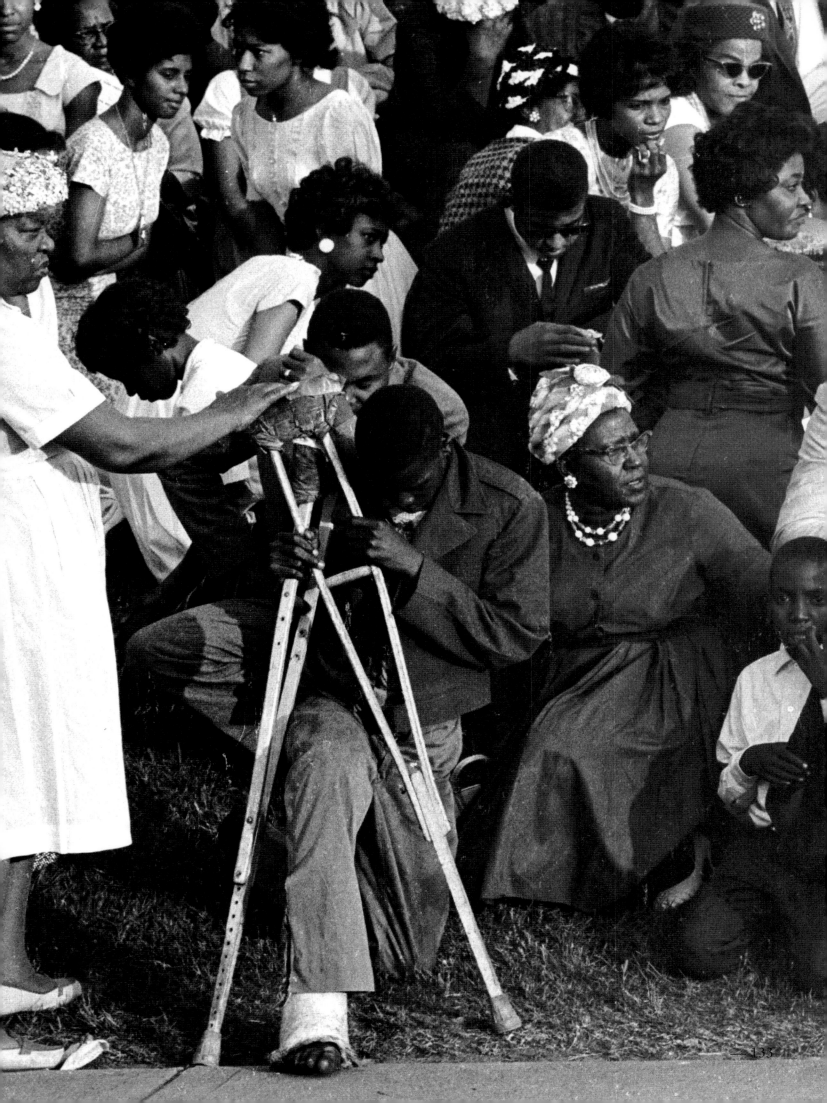

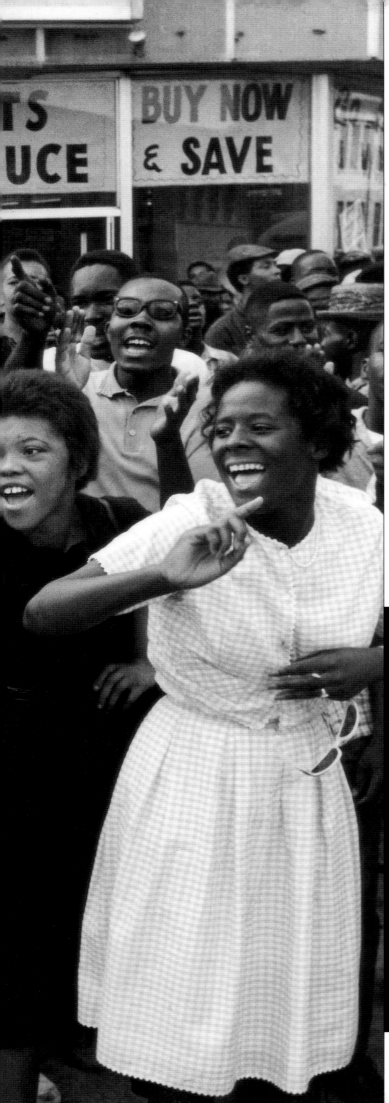

Birmingham's Bastille Day was May 7, 1963. The jails had been filled. That day as many as fifteen hundred young people dash from the Sixteenth Street Baptist Church and many hundred join them, converging in the downtown business district, which previously had been sealed off. Police are helpless. Downtown is a sea of black faces singing "We Shall Overcome." Blacks had been boycotting the stores, and whites stopped going downtown when the massive student arrests started. With their stores empty, merchants had little choice but to settle. In the business district, young people playfully jeer at a policeman.

After intense pressure from the federal government and a nation disgusted by racist police tactics, a settlement was mediated to end segregation and provide jobs in Birmingham's stores. Burke Marshall, the head of the Civil Rights Division of the Justice Department, led the negotiations. Before reading the terms of the settlement, Rev. Shuttlesworth says, "The city of Birmingham has reached an accord with its conscience." King commented later that week, "We are not going to allow this conflict in Birmingham to deteriorate into a struggle between white and black people. The tension in Birmingham is between justice and injustice."

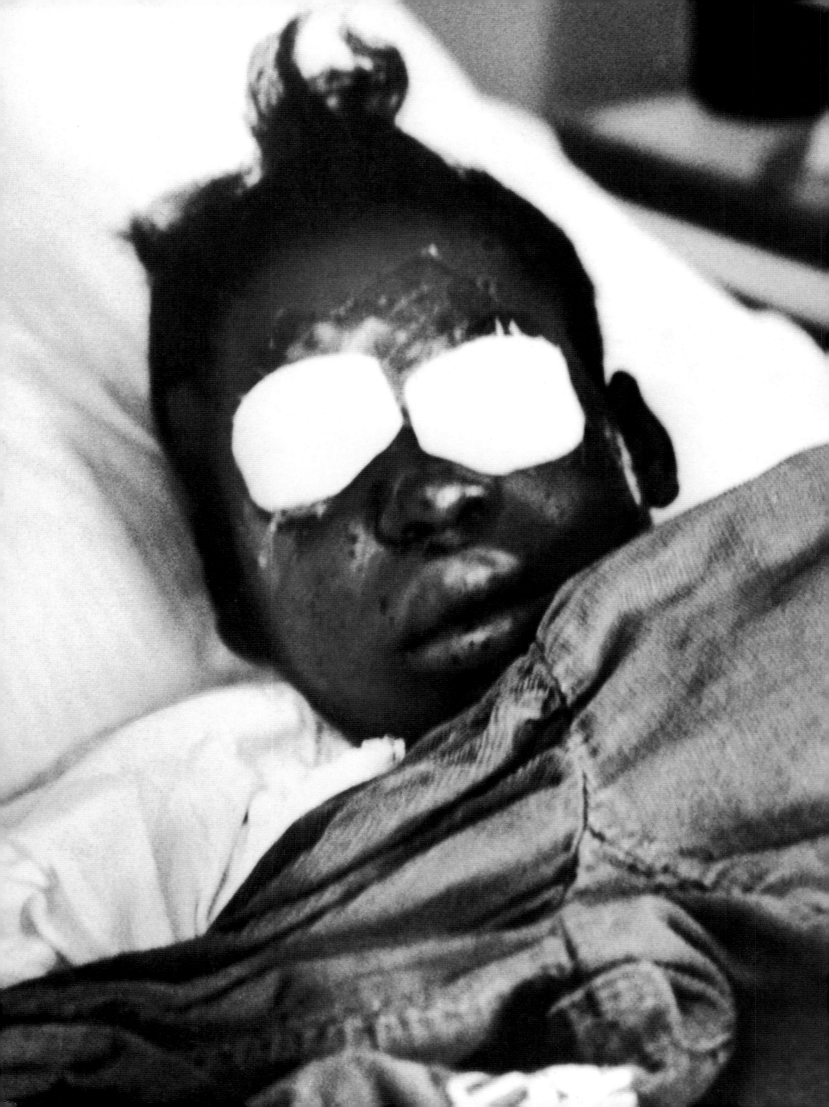

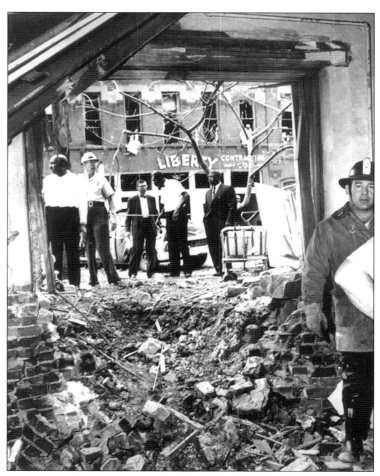

The damage to the church was massive. The bombing and the murders provoked a riot in which two blacks were killed and many blacks and whites were injured. King expresses his rage at a press conference.

Only a few months later, on September 15, 1953, four children were killed in the bombing of the Sixteenth Street Baptist Church Sunday School. Sarah Jean Collins, whose sister was murdered, was struck in the eyes by flying glass. She was one of twenty children injured.

Ministers and thousands of mourners gather at the Sixth Avenue Baptist Church memorial service for the little girls.

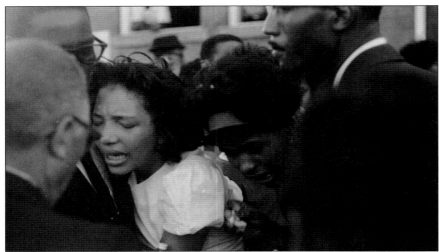

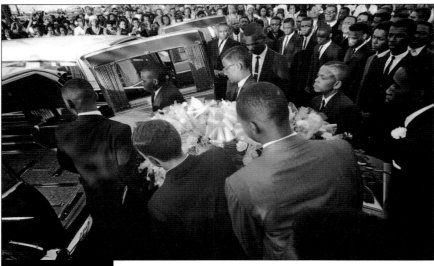

A casket the size of a cradle, bearing one of the tiny victims, is loaded into a hearse.

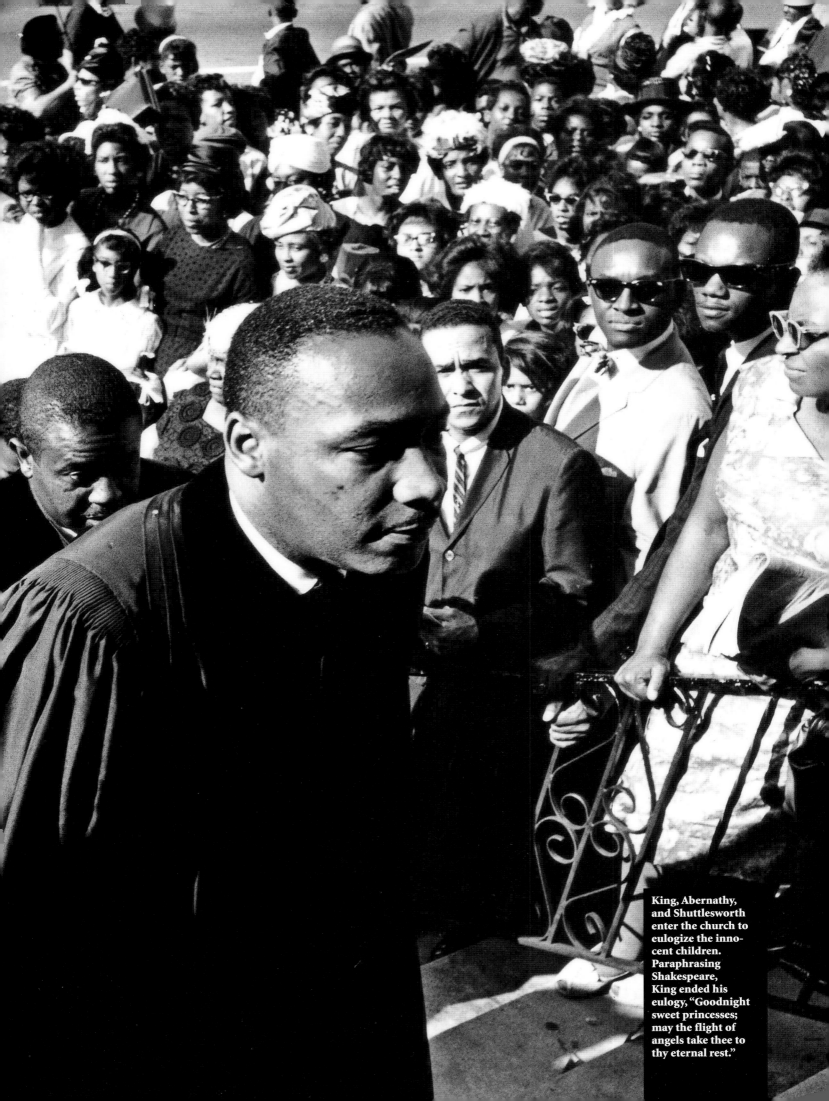

King, Abernathy, and Shuttlesworth enter the church to eulogize the innocent children. Paraphrasing Shakespeare, King ended his eulogy, "Goodnight sweet princesses; may the flight of angels take thee to thy eternal rest."

MARCH ON WASHINGTON

The dreamer elevates the nation

At the climax of his "I Have a Dream" speech, Martin Luther King, Jr., the final speaker at the march, raises his arm and calls out for deliverance with the electrifying words from an old spiritual, "Free at last! Free at last! Thank God almighty, we are free at last!"

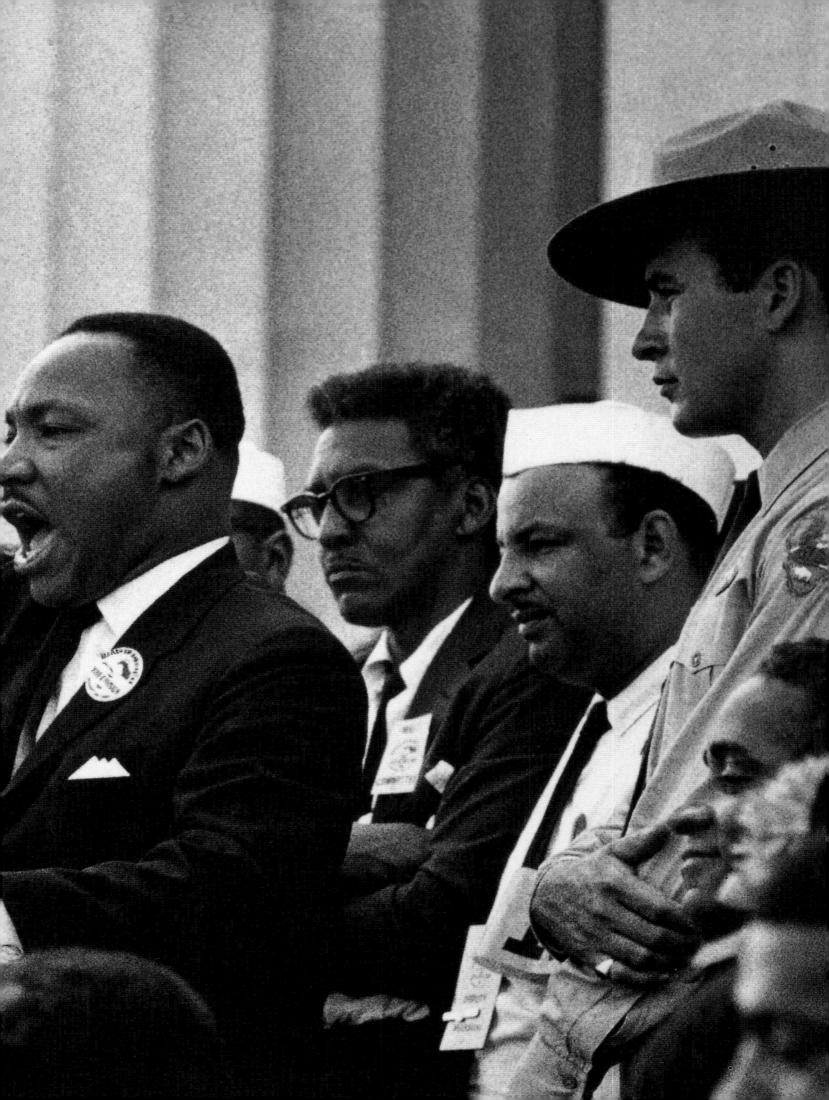

MARCH ON WASHINGTON

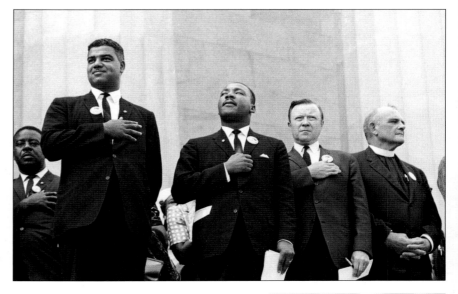

I have a dream my four little children will one day live in a nation where they will not be judged by the color of their skin but by the content of their character. I have a dream today!

~Martin Luther King, Jr.,
Washington, D.C., August 28, 1963

In the centennial year of the Emancipation Proclamation, just three months after the decisive Birmingham campaign, two months after the murder of NAACP leader Medgar Evers, and a scant three months before John F. Kennedy's assassination, a quarter of a million Americans—black and white and from across the full spectrum of progressive organizations—traveled to participate in the monumental March on Washington for jobs and freedom. While the nonviolent, orderly march would add even more credibility to King's philosophical position, he, with his characteristic generosity and humility, saw it not as a platform for himself but rather as the fulfillment of a long-held dream of A. Philip Randolph, the dean of

America's black leaders, who in 1941 and 1947 had hoped to realize a similar event. Now Randolph met with representatives from all the civil rights organizations, and with Walter Reuther, president of the United Auto Workers, to prepare a protest march of staggering yet inspiring proportions that would speed Kennedy's Civil Rights Bill through Congress. Bayard Rustin served as the march's national organizer. King's speech, scheduled as the final, keynote address, was to be limited to eight minutes, like all the others.

In Washington, D.C., at the Willard Hotel, King spent all night before the march working on his words, doubtful he would be able to express in eight minutes all that needed to be said. Perhaps, he thought, he could resurrect the refrain "I have a dream" he'd used so often before, most recently at Detroit's Cobo Hall in June. So far so good. But his presentation needed to thematically reach back one hundred years to revitalize Abraham Lincoln's call in the Gettysburg Address to reaffirm the equality of all men. After an hour of reflection, King settled on the simple, straightforward metaphor of America having issued blacks a bad check in respect to the "promissory note" signed by the Founders that said all men would be guaranteed the unalienable rights of "life, liberty, and the pursuit of happiness." He asked close friends— Ralph Abernathy, Andrew Young, and Walter Fauntroy—for their reactions, and by four in the morning on August 28, King was done, or so he thought.

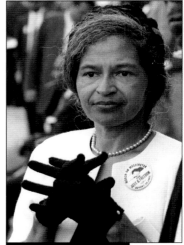

The ceremony commences on the steps of the Lincoln Memorial. King stands between Whitney Young, Jr., of the Urban League, and Walter Reuther, president of the United Auto Workers union, as they salute the flag. Rosa Parks is among the marchers.

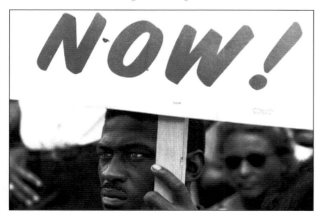

Although interracial marriage was not on the program, this marcher has his own agenda. At the time many states had laws prohibiting mixed marriages.

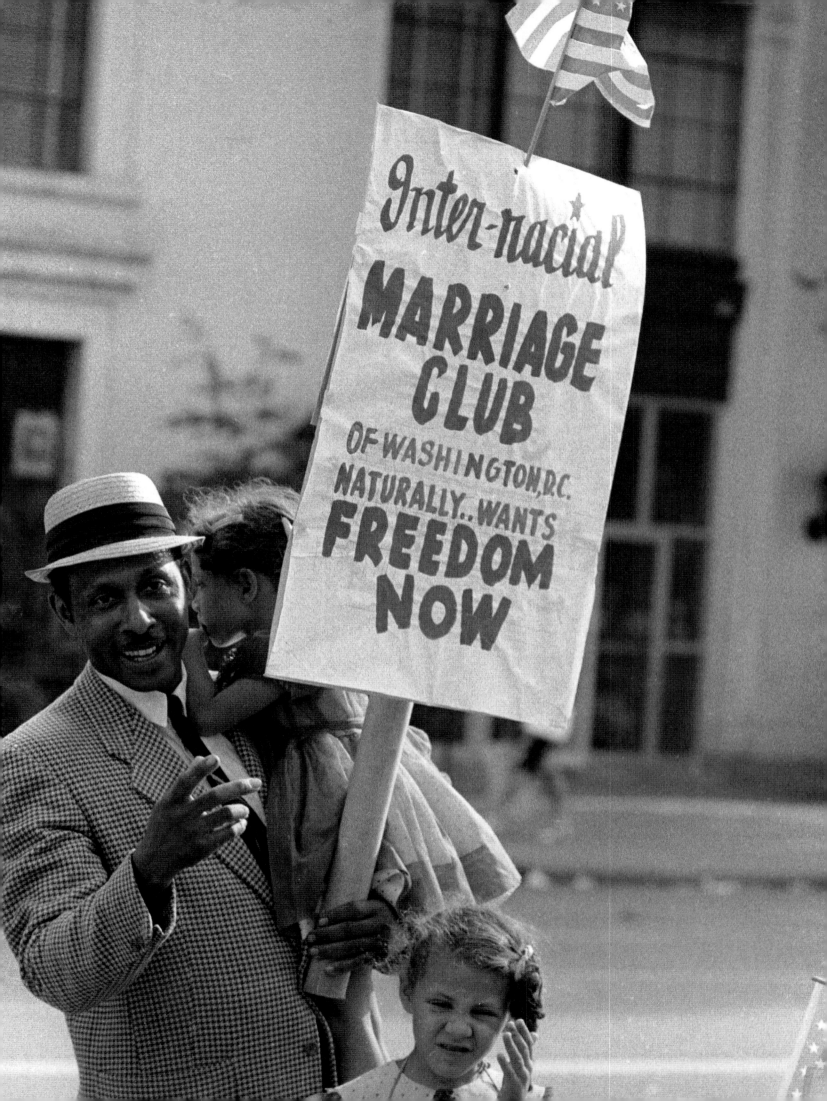

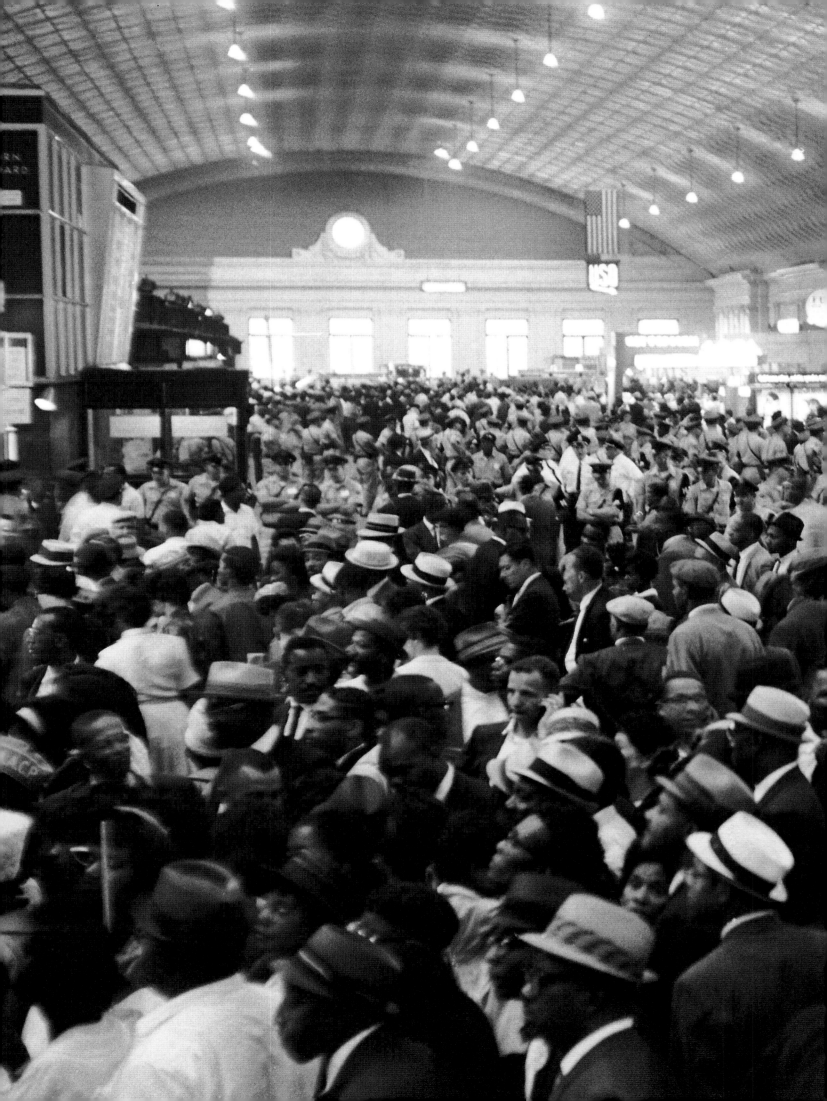

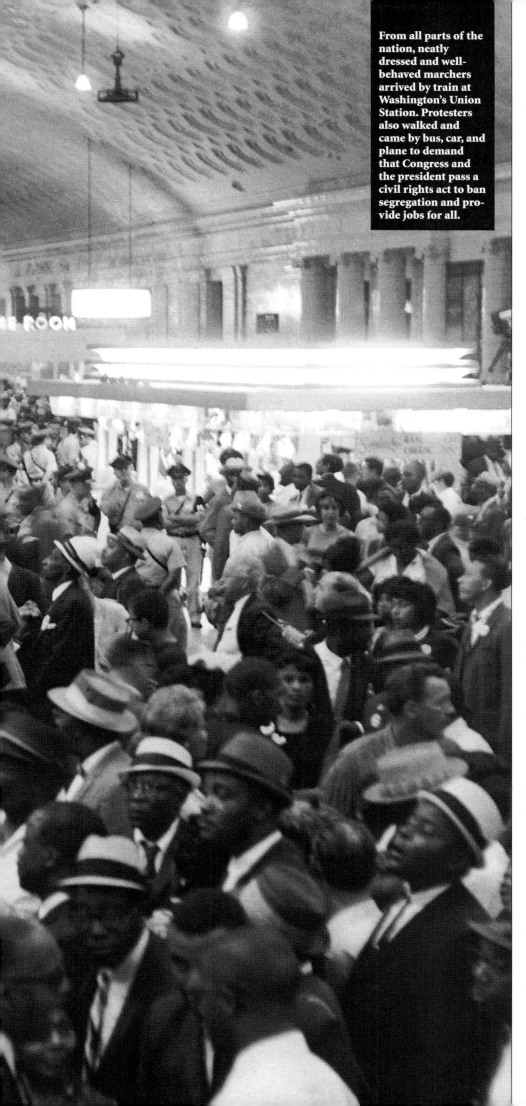

Initially, the march organizers feared a low turnout, and they hoped attendance would reach at least one hundred thousand. By noon their fears were dispelled when they saw crowds surging at the base of the Washington Monument. Whites had shown up in record numbers for the first time in movement history. And, unlike in Birmingham, white men of the cloth came, too, demonstrating their commitment to racial justice. Not only was this becoming the largest march ever assembled in the nation's capital, it was also a phenomenal media event, with people such as Mahalia Jackson, Joan Baez, Sidney Poitier, Charlton Heston, Harry Belafonte, Marlon Brando, Burt Lancaster, and Bob Dylan on hand to entertain the demonstrators and millions of Americans who watched the well-orchestrated proceedings on television.

And what did they see? For King, they witnessed a devastating denial of black stereotypes. A public relations coup. They saw impressive, learned black spokesmen ("If the press had expected something akin to a minstrel show," King observed later, "or a brawl, or a comic display of odd clothes and bad manners, they were disappointed") who embodied the finest American ideals and levels of cultural achievement. All were a credit to the (human) race. (Indeed, white Americans would not see on their televisions another collective representation of real black professionalism and distinction such as this until the Supreme Court confirmation hearings for Clarence Thomas decades later.)

Camilla Williams began the ceremony at one-thirty, with a spirited rendition of "The Star-spangled Banner." The speakers and entertainers came next, one after another, the crowd attentive until mid-afternoon, then beginning to thin around three o'clock when Roy Wilkins appeared at the podium. Some left. Those who remained were rejuvenated by Mahalia Jackson's moving delivery of "I Been 'Buked and I Been Scorned," and when she was done Randolph introduced King, the last speaker, as "the moral leader of the nation."

He began with the speech he had finished just hours before, then, as so

— 145

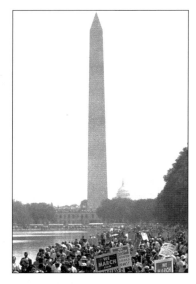

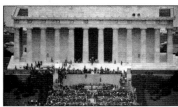

often happened with King, he began to feel the energy of his audience, their clapping and shouting, which fed his spirit so fully he turned away from his prepared text and launched extemporaneously into the words that would echo for decades in the ears of the American people:

"And when we allow freedom to ring…we will be able to speed up that day when all of God's children…will be able to join hands and sing in the words of the old Negro spiritual, 'Free at last! Free at last! Thank God almighty, we are free at last!'"

For Martin Luther King, Jr., newly anointed as the powerful voice of America's moral conscience, and for the nation as a whole, the March on Washington and his "I Have a Dream" speech lifted the civil rights movement as well as Western humanism to undreamed of and dizzying new heights.

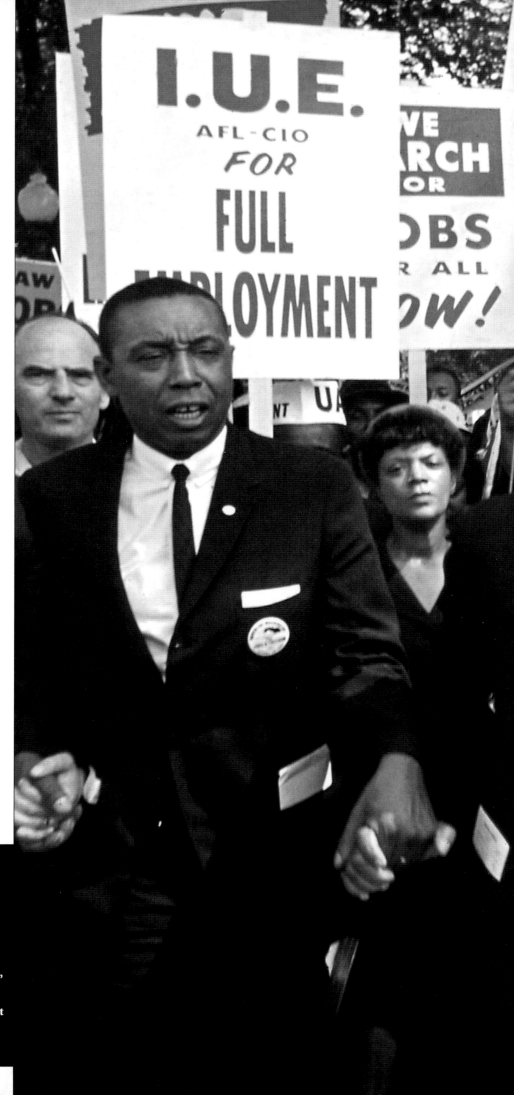

The marchers gathered at the Washington Monument and marched to the Lincoln Memorial. The march is led by King, fresh from his momentous victory in Birmingham, hand in hand with Floyd McKissick of CORE on his right and arm in arm with a clergyman on his left.

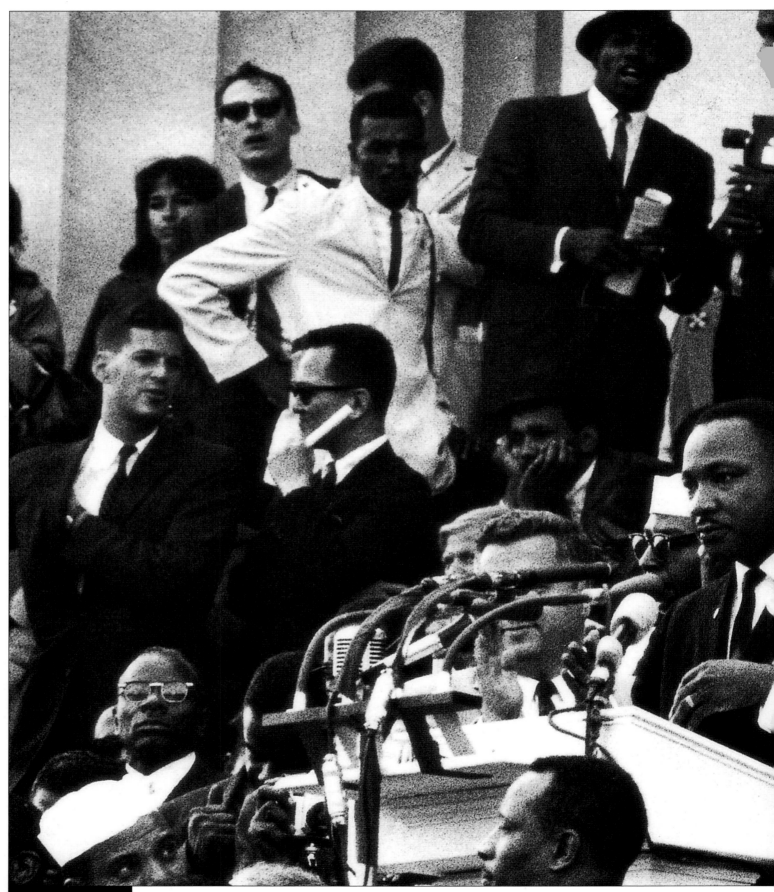

To a rising crescendo of cheers and applause, King delivers the most memorable speech of his life.

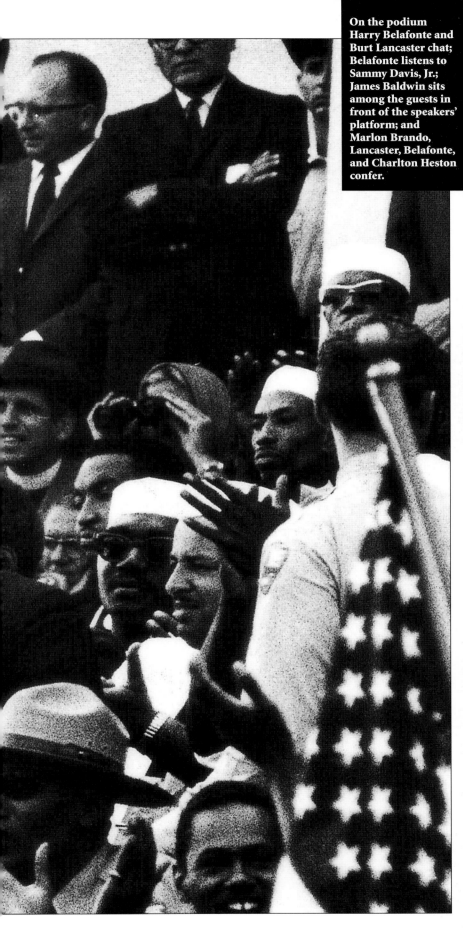

On the podium Harry Belafonte and Burt Lancaster chat; Belafonte listens to Sammy Davis, Jr.; James Baldwin sits among the guests in front of the speakers' platform; and Marlon Brando, Lancaster, Belafonte, and Charlton Heston confer.

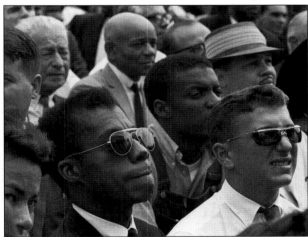

— 151

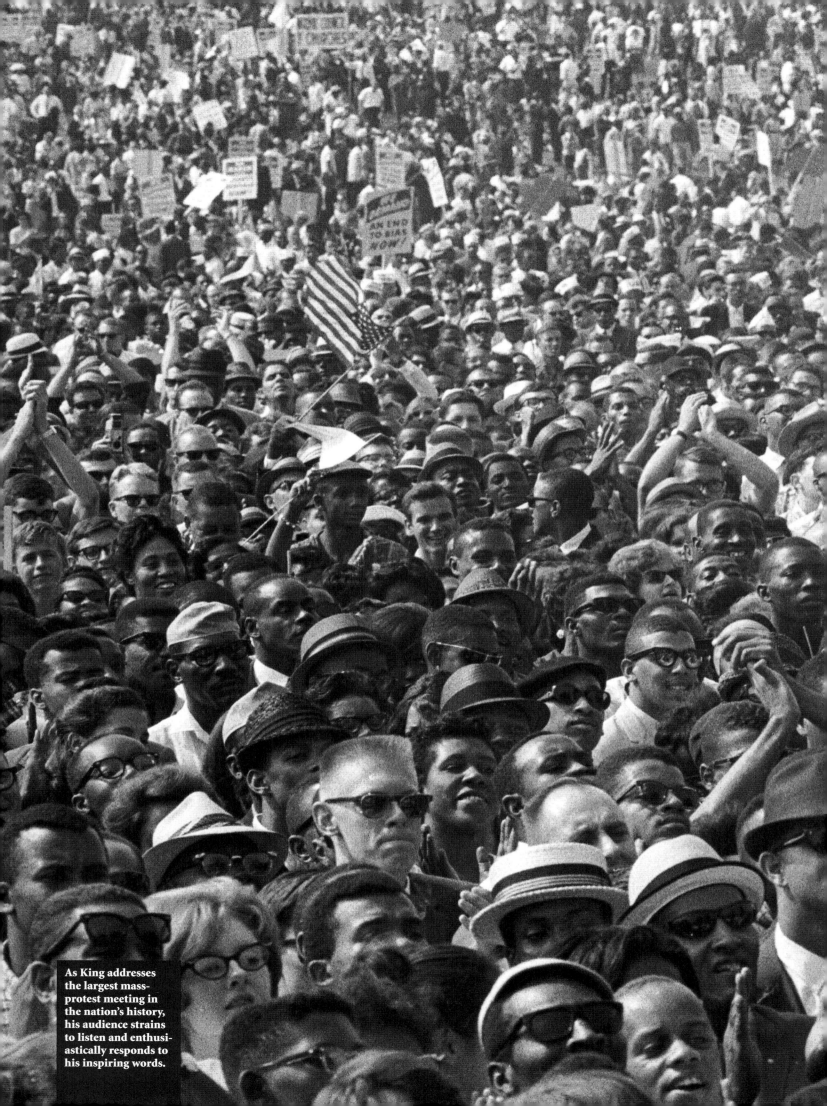

As King addresses the largest mass-protest meeting in the nation's history, his audience strains to listen and enthusiastically responds to his inspiring words.

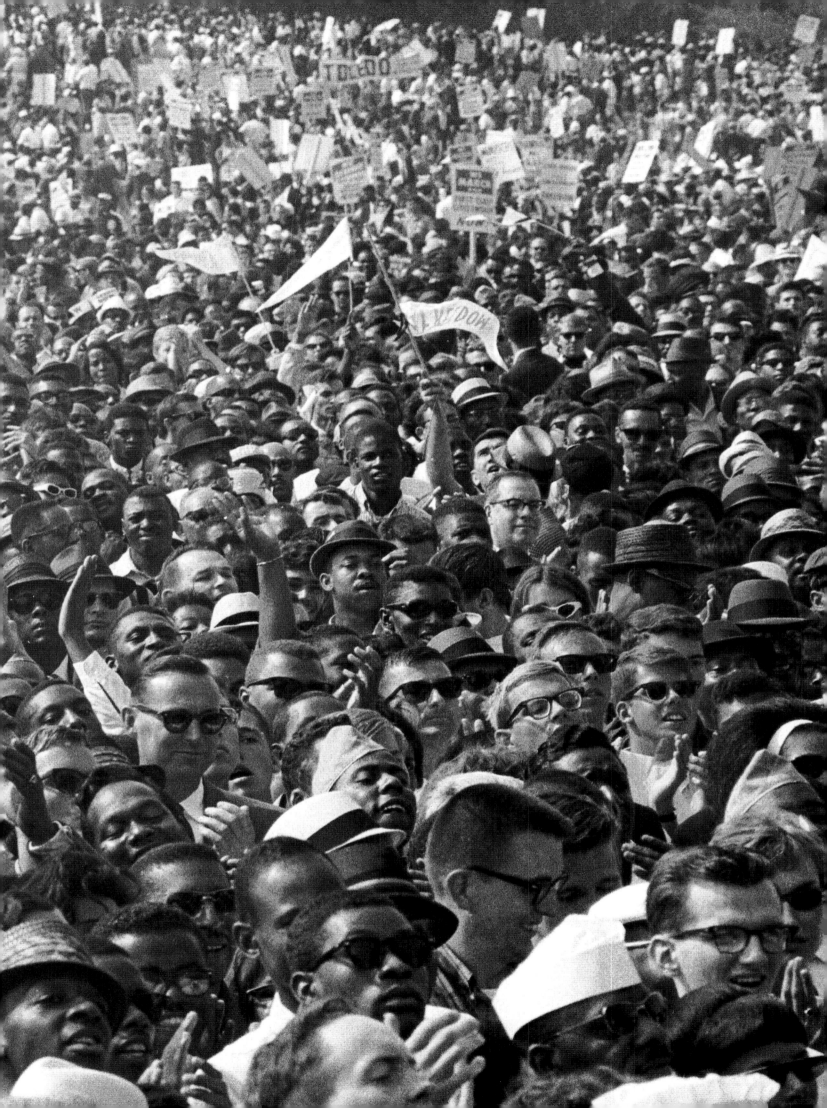

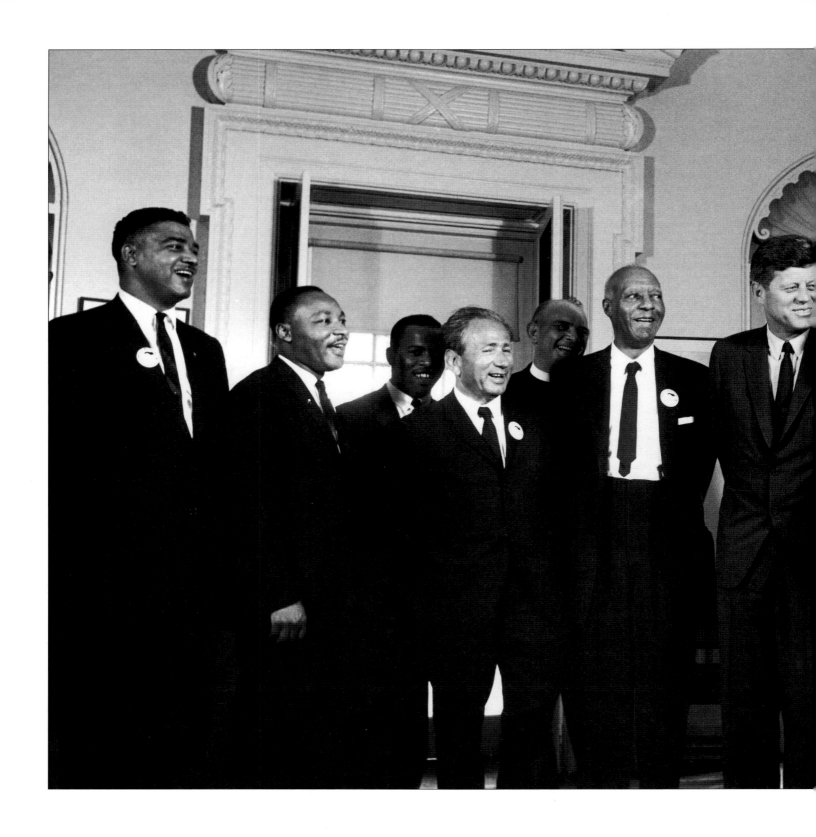

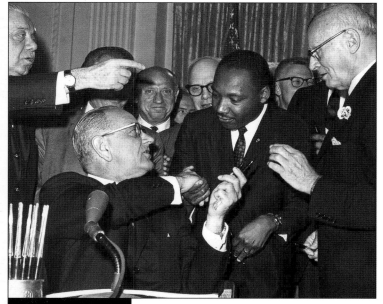

Civil rights and labor leaders are greeted by President Kennedy at the successful conclusion of the march. The president congratulated King on his speech and told his aides how much he was impressed by it. When he greeted King, Kennedy said, "I have a dream," which embarrassed King because he was singled out among the many who had spoken.

One of the march's aims was realized the following year, when President Lyndon Johnson signed into law the 1964 Civil Rights Act. He shakes the hand of the man who led the charge to outlaw segregation.

NOBEL PRIZE

A pacifist shares his glory

Stopping off in Stockholm to join the other Nobel laureates after receiving his Peace Prize in Oslo, King is treated to a traditional breakfast celebrating the Feast of St. Lucia, the Festival of Lights, which begins the Swedish Christmas season.

NOBEL PRIZE

Civilization and violence are antithetical concepts.

~MARTIN LUTHER KING, JR.,
NOBEL PRIZE ACCEPTANCE SPEECH, 1964

He was in Atlanta's St. Joseph's Hospital, exhausted and badly in need of rest, when his wife telephoned at 9 A.M. to relay the news: He had won the Nobel Peace Prize. At first King was disbelieving and felt like a man in a dream, yet it was so. At thirty-five he was suddenly, that October morning in 1964, the youngest Nobel laureate to receive the world's most coveted award and only the third black, following Ralph Bunche and South Africa's Chief Albert Luthuli. Where the Civil Rights Act only a few months earlier was vindication for the efforts of thousands of civil rights activists, this honor—which truly thrust King onto the world stage—was the ultimate acknowledgment of his vision of agapic love, social interdependence, and the beloved community. But King, of course, would

never claim it for himself alone. It was, he said, for the nameless "ground crew" of activists who would never appear in *Who's Who* but upon whose shoulders he stood. And the $54,600 prize money? That he decided to donate to the SCLC, CORE, SNCC, the NAACP, the National Council of Negro Women, and the American Foundation for Nonviolence.

King and his entourage left for the ceremony in Norway on December 4. They stopped in London, where King delivered his sermon "The Three Dimensions of a Complete Life" at St. Paul's Cathedral. He reminded his audience of four thousand that the first dimension was self-acceptance, development of one's personal resources, and doing life's work "so well that the living, the dead, or the unborn couldn't do it any better"; the second service to mankind was learning "that there is nothing greater than to do something for others"; and the third, said King, was the quest for the divine, for "We were made for God, and we will be restless until we find rest in him."

From London, King traveled on to Oslo, where he was met on December 8 by Nobel officials, an excited crowd of young people, and children who showered bouquets of flowers upon him, his family, and his friends. And the press was after him now in a new way, asking him questions about world affairs, for as a Nobel laureate his views were indisputably of global significance.

For the ceremony in Aula Hall at Oslo University, King dressed in striped trousers, a gray tailcoat, and an ascot (which he very much disliked). He was introduced by the chairman of the Norwegian Parliament as "the first person in the Western world to have shown us that a struggle can be waged without violence." (The unstated implication of Gandhi's nonviolent approach in the Eastern world is interesting to note insofar as King, later, would nominate for the Nobel Thich Nhat Hahn, the poet, outstanding Buddhist teacher, and chairman of the Vietnam Peace Delegation. Of King, Nhat Hahn says in his book *Living Buddha, Living Christ,* "The moment I met Martin Luther King, Jr., I knew I was

King's family prepares to travel with him to London en route to Oslo, where he will receive the Peace Prize. King's party numbered thirty.

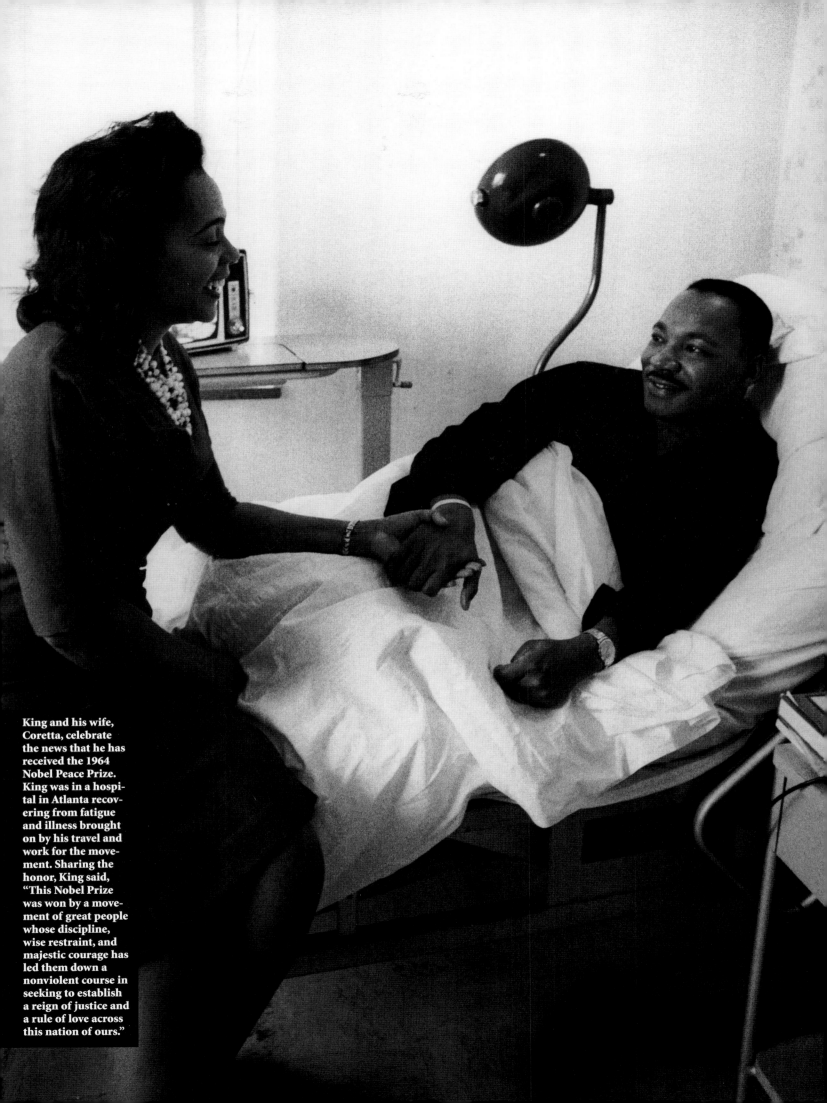

King and his wife, Coretta, celebrate the news that he has received the 1964 Nobel Peace Prize. King was in a hospital in Atlanta recovering from fatigue and illness brought on by his travel and work for the movement. Sharing the honor, King said, "This Nobel Prize was won by a movement of great people whose discipline, wise restraint, and majestic courage has led them down a nonviolent course in seeking to establish a reign of justice and a rule of love across this nation of ours."

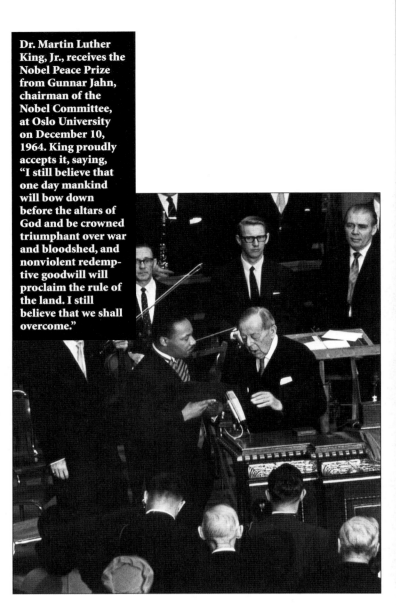

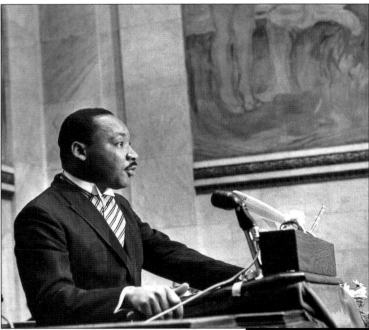

In his laureate's speech, King pleads for brotherly love and for the use of nonviolent means to resolve conflicts.

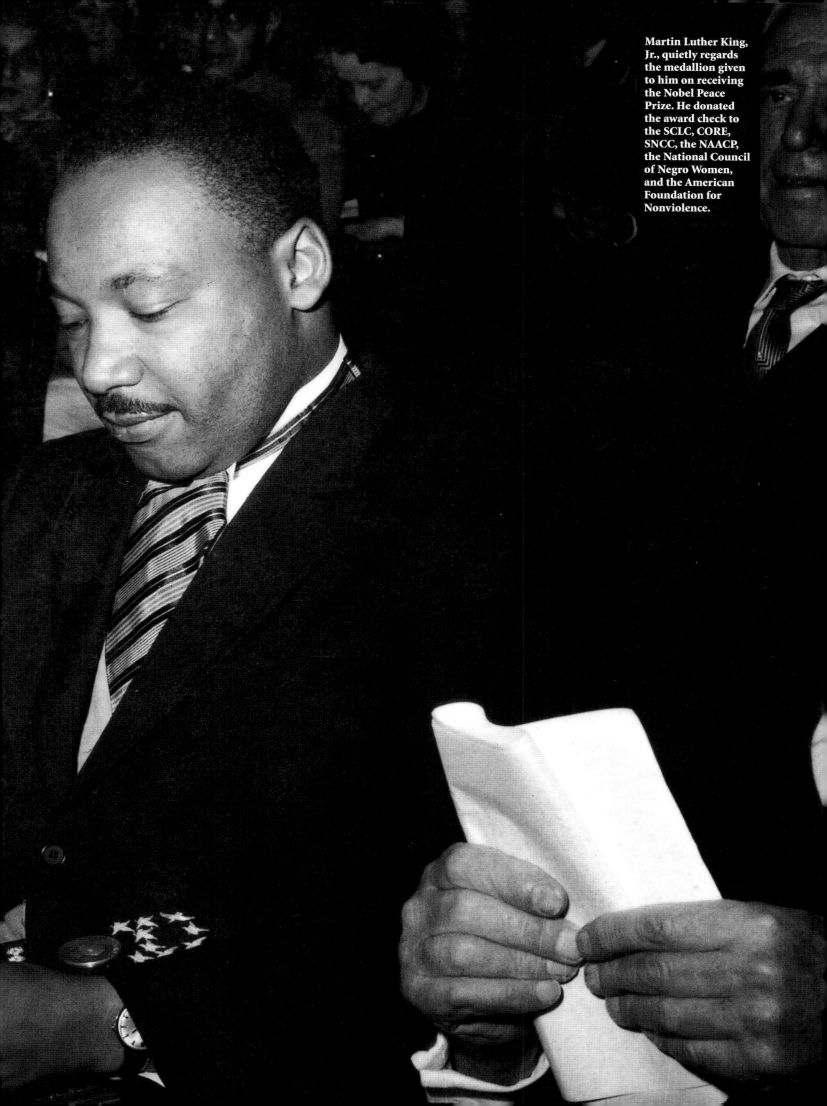

Martin Luther King, Jr., quietly regards the medallion given to him on receiving the Nobel Peace Prize. He donated the award check to the SCLC, CORE, SNCC, the NAACP, the National Council of Negro Women, and the American Foundation for Nonviolence.

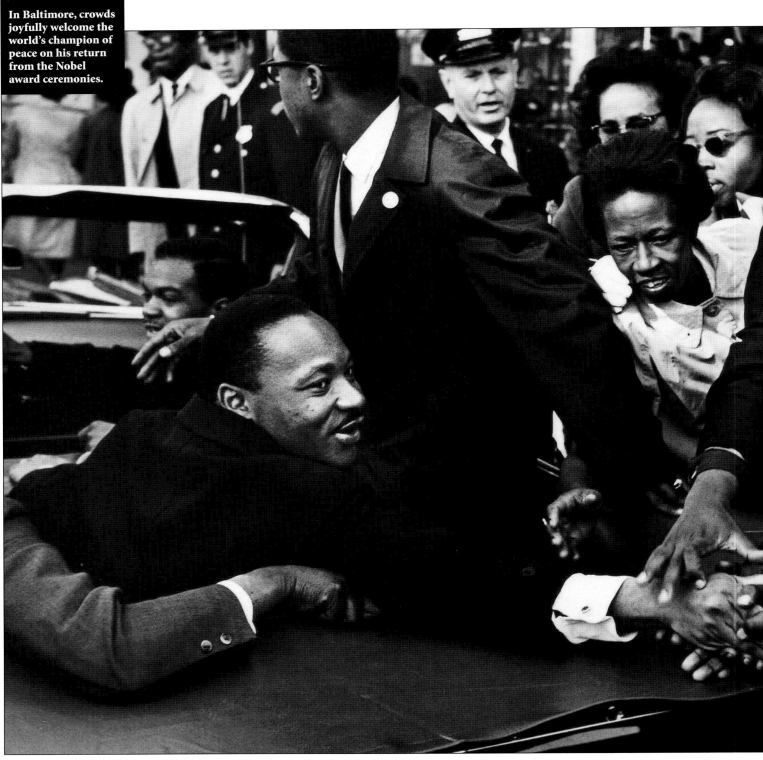

In Baltimore, crowds joyfully welcome the world's champion of peace on his return from the Nobel award ceremonies.

in the presence of a holy person. Not just his good work but his very being was a source of great inspiration for me." That friendship with Nhat Hahn, which began in 1966, contributed to King's opposition to the Vietnam War.)

The following day King formally accepted his prize "in the spirit of the curator of some precious heirloom which he holds in trust for its true owners—all those to whom beauty is truth and truth beauty—and in whose eyes the beauty of genuine brotherhood and peace is more precious than diamonds or silver or

gold." He continued, speaking what were perhaps the most profound words of his career:

"Nonviolence is the answer to the crucial political and moral question of our time....The foundation of such a method is love....I have the audacity to believe that peoples everywhere can have three meals a day for their bodies, education and culture for their minds, and dignity, equality and freedom for their spirits."

Yes, indeed, in Oslo King had at last arrived on the mountaintop. In

Stockholm he attended a reception for all the Nobel winners that year—and he noted as he traveled through Norway how well a democratic, socialist country provided universal heath care and free education for its people. Although tired during the trip back through Paris, and taking sleeping pills, when he arrived in New York fireboats on the Hudson River geysered fountains of water to welcome him home and the mayor presented him with the Medallion of Honor. On and on that December he moved through celebratory festivities—at the White

162 —

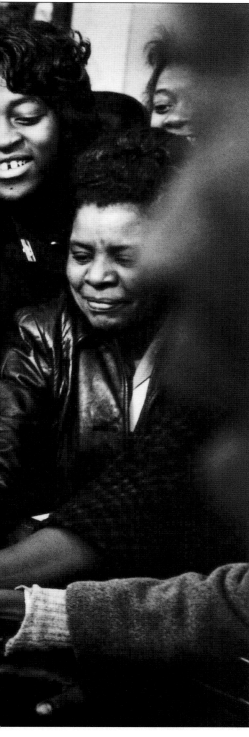

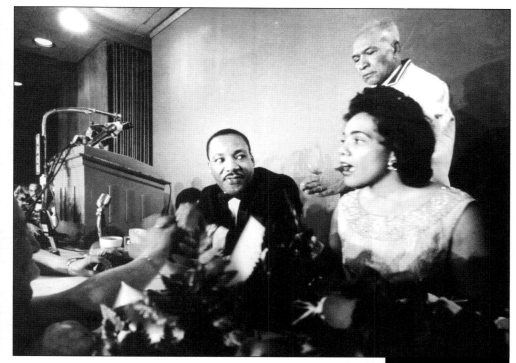

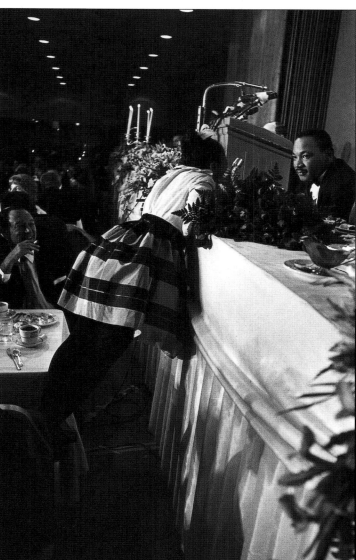

House, in the home of New York's Governor Nelson Rockefeller, to the streets of Baltimore, and to Atlanta. To the people of Harlem, filling a black church in his honor, he said, "I really wish I could just stay on the mountain, but I must go back to the valley. I must go back because my brothers and sisters down in Mississippi and Alabama can't register and vote."

That valley had a name: Selma.

And there, far from the heights, King would descend yet again into the hell of America's racial nightmare.

Atlanta held a celebratory dinner for King. Blacks and whites from all walks of life gathered together to honor the Nobel laureate. At one highly moving moment, southern whites joined in as the guests sang "We Shall Overcome."

The King children attended the celebration dinner. Yolanda has a word with her parents. Such casual social mingling between blacks and whites was not customary in the South and was vivid testimony to what King had accomplished. At evening's end, King, tears in his eyes, remarked, "I am tempted to stay here in a more serene life, but I must return to the valley...of anger and prejudice."

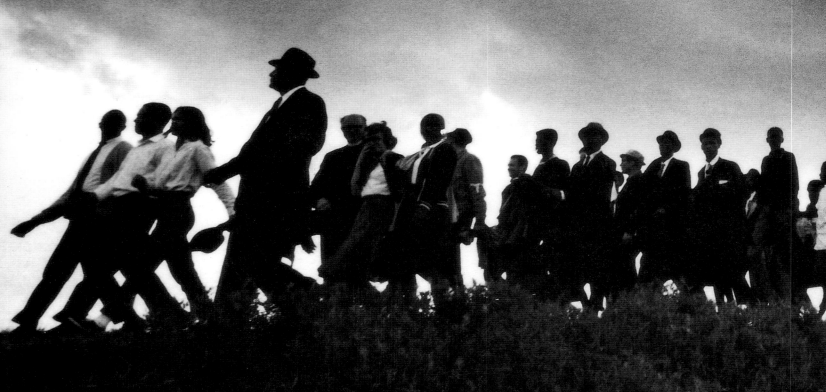

SELMA

The law of the land written in blood

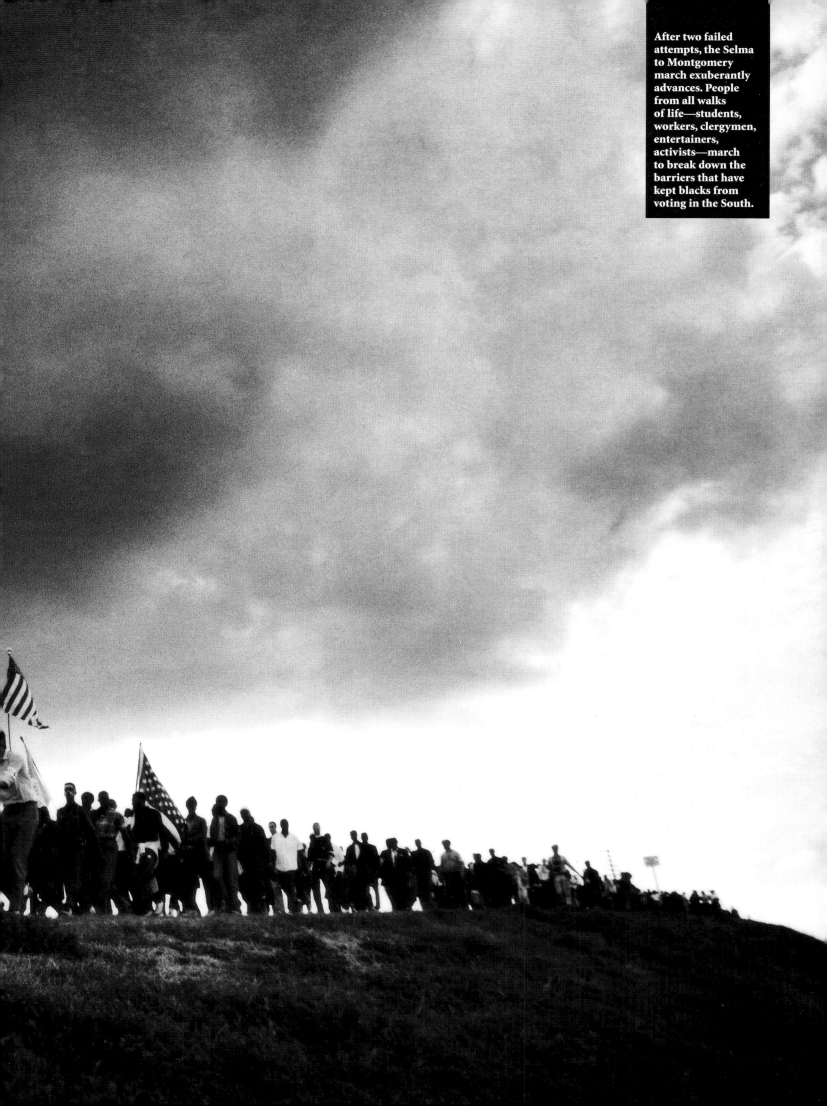

After two failed attempts, the Selma to Montgomery march exuberantly advances. People from all walks of life—students, workers, clergymen, entertainers, activists—march to break down the barriers that have kept blacks from voting in the South.

SELMA

*We must come to see that the end we
seek is a society at peace with itself,
a society that can live with its conscience.
That will be a day not of the white man,
not of the black man. That will be the
day of man as man.*
~MARTIN LUTHER KING, JR.,
SELMA, 1965

Less than sixty days after King received
the Nobel Peace Prize, he was in jail
again, immersed in Project Alabama,
which had two primary objectives: first,
to accelerate voter registration for the
70 percent of blacks who lacked the
franchise in five states of the Deep South;
and second, to convince Lyndon Baines
Johnson that voting rights legislation was
needed. The president was sympathetic,
but doubted Congress would approve a
new bill for blacks so soon after the pas-
sage of the Civil Rights Act the previous
year, and he told King he needed the
support of the southern bloc for other
Great Society programs.

King knew what he had to do, where,
and how. Like Birmingham, Selma pro-
vided a perfect stage for his organization-
al genius. It offered the possibilities of
spectacle. It provided hissable villains—
segregationist governor George Wallace
and atavistic white supremacists led by
Sheriff Jim Clark (a clone of "Bull"
Connor), who arrested blacks for meet-
ing together (a violation of their First
Amendment rights). Sadly, there would
be martyrs too, three in all. And, as with
any masterfully constructed drama, the
denouement would be more far reaching
and greater than the sum of its players,
surprising even King himself in its plot
twists, cameos, and subplots.

The campaign began in January 1965,
the groundwork prepared earlier by John
Lewis and other SNCC activists. James
Bevel was project director, Hosea
Williams field general. King and Lewis
began by leading four hundred blacks to
Sheriff Clark's courthouse to register.
Predictably, they were gently rebuffed, for

"We will bring a
voting bill into being
on the streets of
Selma," King had
vowed. The battle
begins. King and
Abernathy and their
followers kneel in
prayer on February
1, 1965. At that time,
only 1 percent of the
blacks in Selma were
registered although
they made up half
of the population.

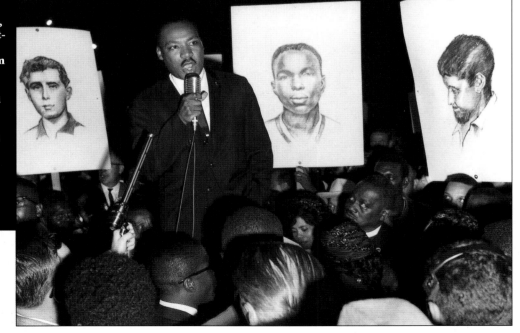

At the Democratic
Convention in 1964,
King argues for seat-
ing the all-black
Mississippi Freedom
Democratic Party.
He stands before
pictures of the slain
civil rights workers
Schwerner, Chaney,
and Goodman, who
were killed earlier
that year during
Freedom Summer,
an effort to get
blacks registered
to vote.

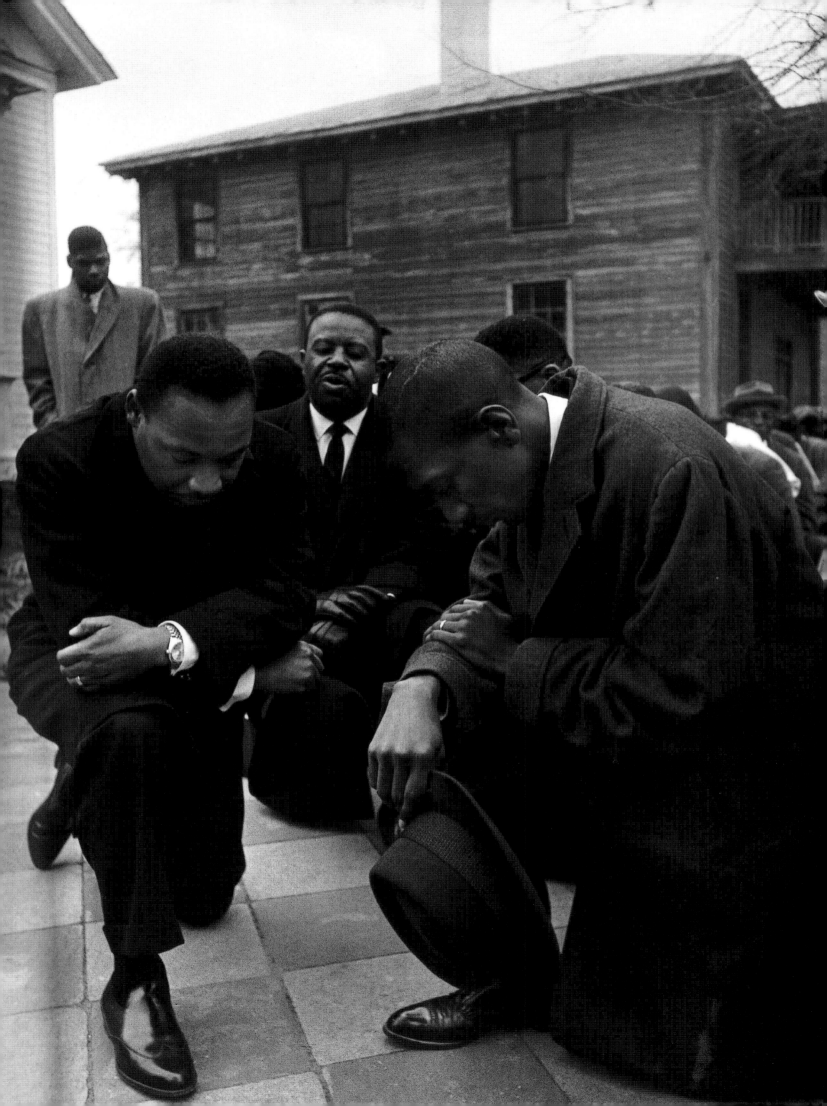

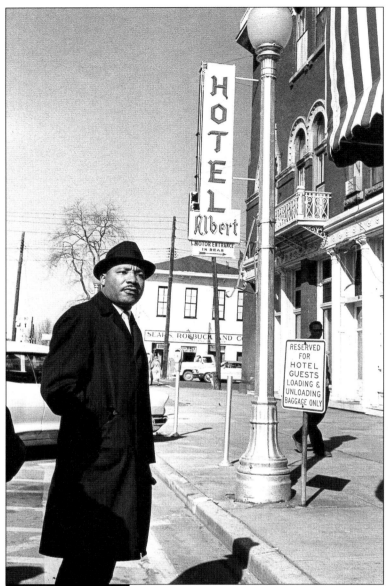

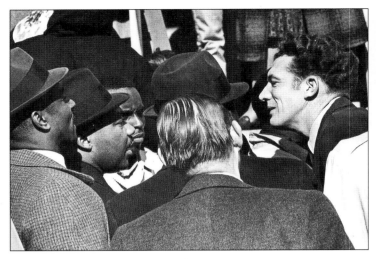

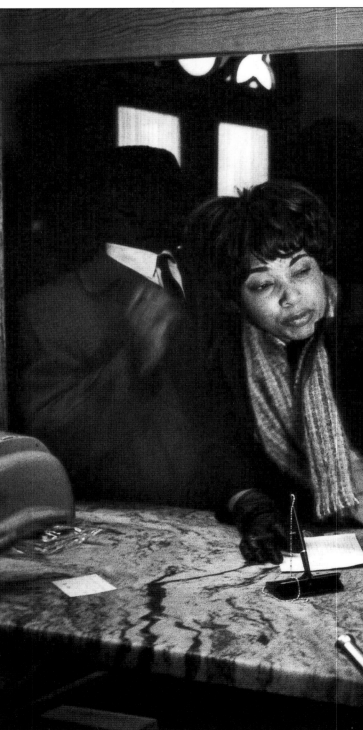

King stands in front of the Hotel Albert, where he successfully registers for a room, testing the hotel's compliance with the 1964 Civil Rights Act barring segregated public facilities.

Selma officials had studied Pritchett's tactics for defusing activists in Albany. King and his staff secured lodging at the Hotel Albert (the first blacks ever to do so), but in the lobby King was struck on his head by a white man, who was quickly arrested. That blow, which staggered him, was but the first note in a violent "season of suffering" to come.

Act One of Project Alabama followed SCLC's script. King sent wave after wave of blacks to the courthouse to register, then led a mass march from Brown Chapel after telling them, "If Negroes could vote, there would be no Jim Clark, there would be no oppressive poverty directed at Negroes, our children would not be crippled by segregated schools, and the whole community might live together in harmony." He was arrested for parading without a permit and, while in jail, was surprised that Malcolm X—

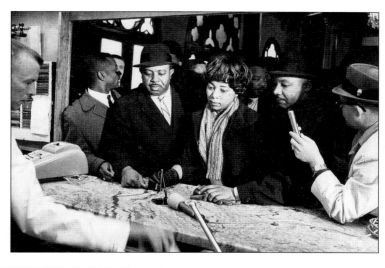

As King leads protesters to the courthouse, he is confronted by Jimmy Robinson, a member of the National States Rights Party, a racist group. Later that day, as King registers at the hotel, Robinson savagely attacks him from behind.

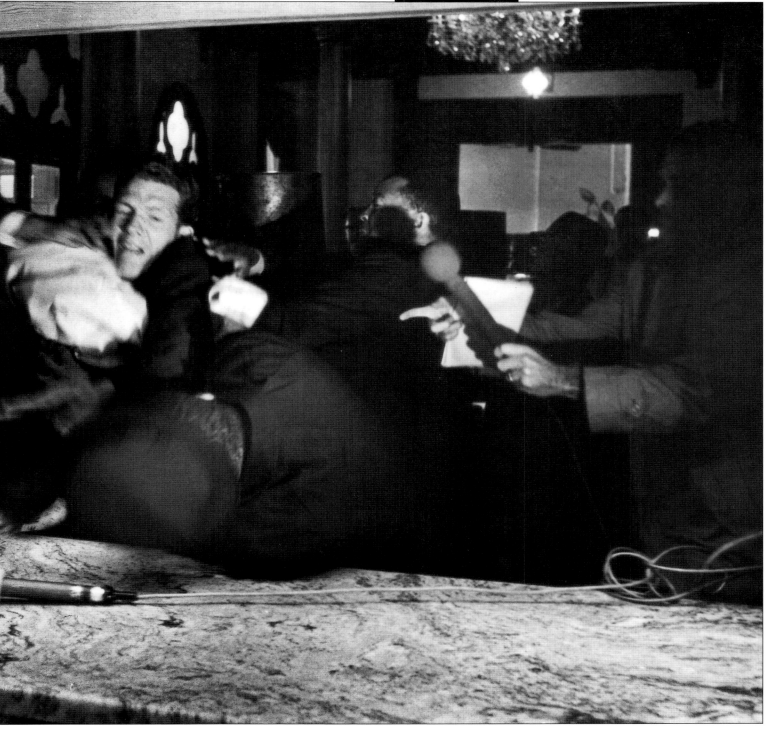

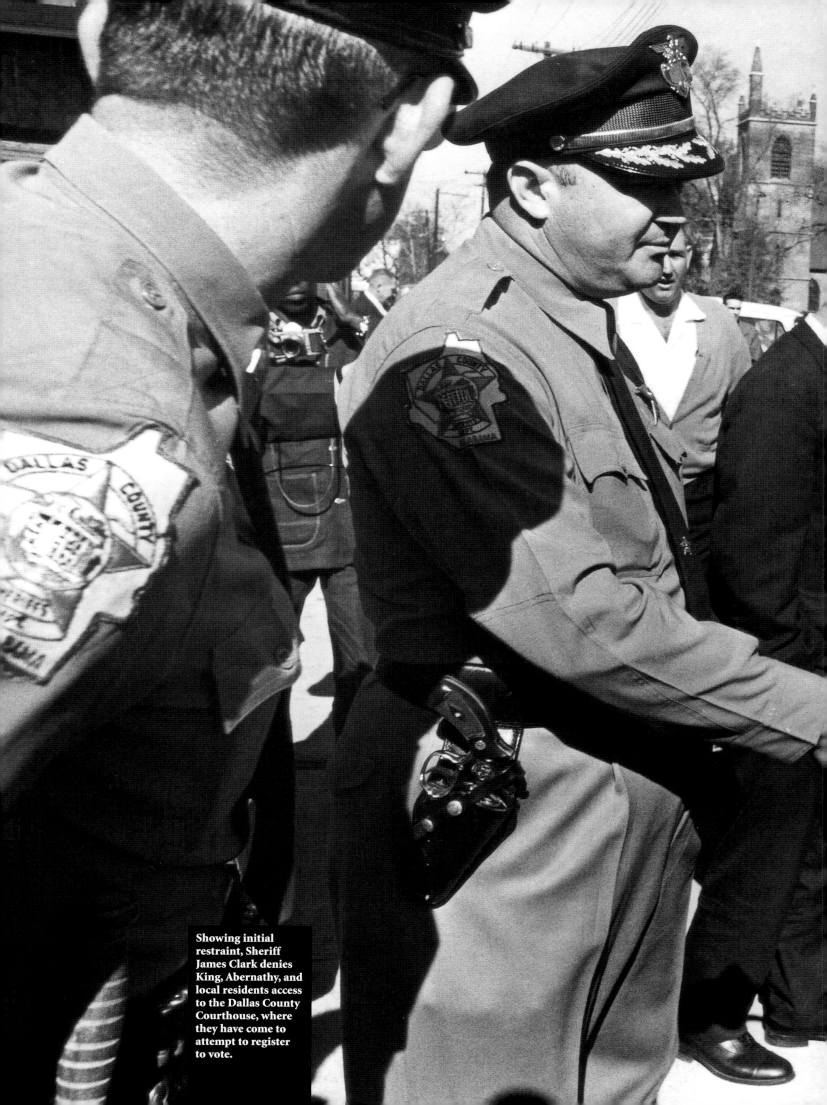

Showing initial restraint, Sheriff James Clark denies King, Abernathy, and local residents access to the Dallas County Courthouse, where they have come to attempt to register to vote.

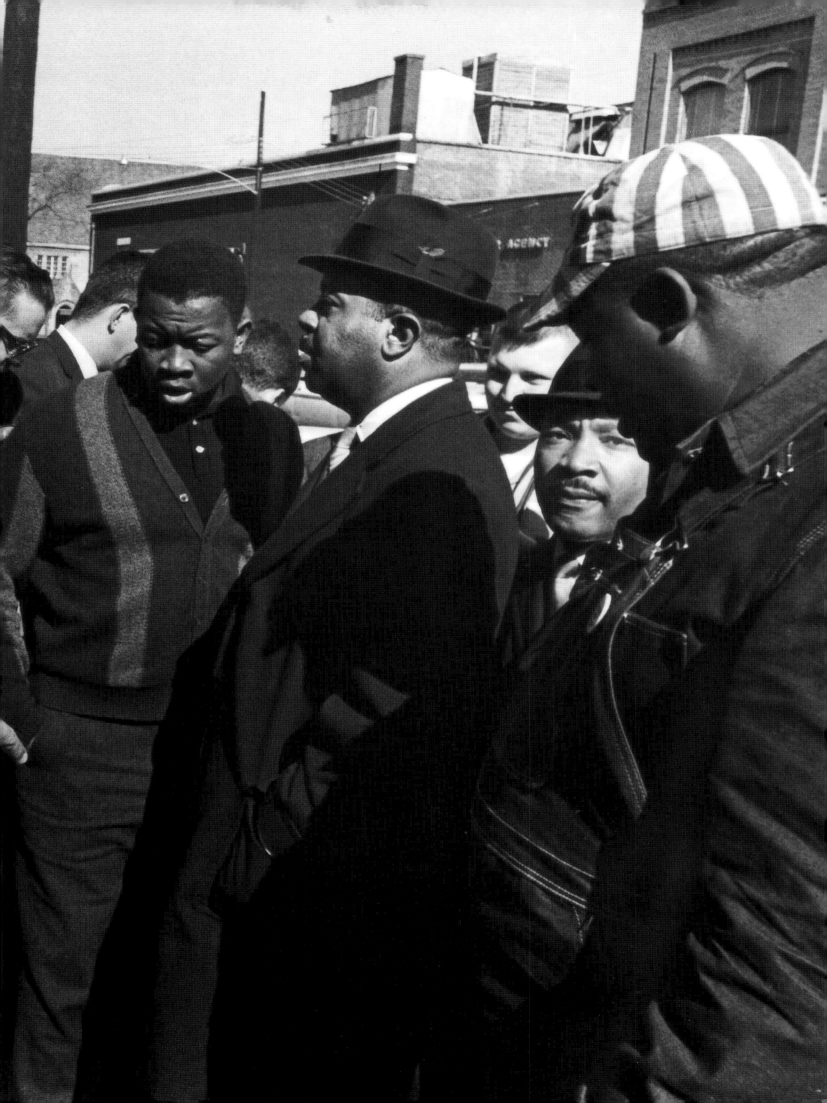

recently divorced from the Nation of Islam and declaring that brotherhood was America's only salvation—traveled to Selma and gave a speech at Brown Chapel. (Three weeks later he would be dead.) The Muslim leader told Coretta, "I want Dr. King to know that I didn't come to Selma to make his job difficult. I really did come thinking I could make it easier. If the white people realize what the alternative is, perhaps, they will be more willing to hear Dr. King," a declaration that supported King's warning in "Letter from Birmingham Jail" that if America rejected his approach, blacks would drift toward the camp (or cult) of a separatist black nationalism and, just possibly, race war.

Act Two built upon the first, thanks to Sheriff Clark's goons driving demonstrators from town and into ditches with cattle prods. Three thousand filled the jails. Released and recently back from a conference with Vice President Hubert Humphrey and Attorney General Katzenbach, King again went on the offensive, leading twenty-eight hundred to the courthouse, where an enraged Clark slammed a billy club into C. T. Vivian's stomach. Now the violence was dicey, dangerous. King expanded the war into neighboring counties and started night marches, and it was during one of these that the campaign tragically produced its first martyr, young Jimmy Lee Jackson, who was shot by the police while he was trying to protect his mother and grandfather.

The opposition the marchers faced forced them on, regardless of rumors of assassination teams in the area targeting King. The SCLC decided to launch a mass march from Selma to Montgomery, where a petition protesting police brutality would be delivered to the governor. Wallace immediately prohibited the march, which King was to have led on Sunday, March 7. He decided against doing so because he felt he was neglecting his congregation in Atlanta and wanted to preach there that day. That decision would weigh heavily on King's soul. For come Sunday—what is now known as Bloody Sunday—Williams and Lewis led more than five hundred across the Edmund Pettus Bridge and down

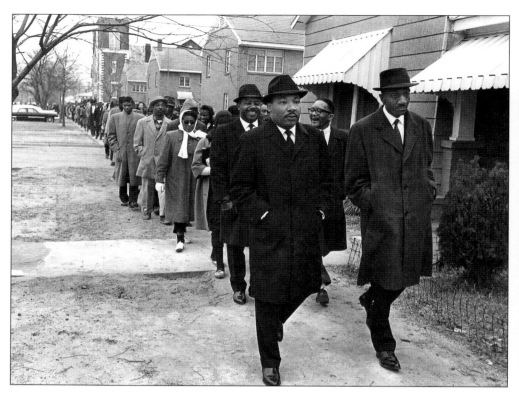

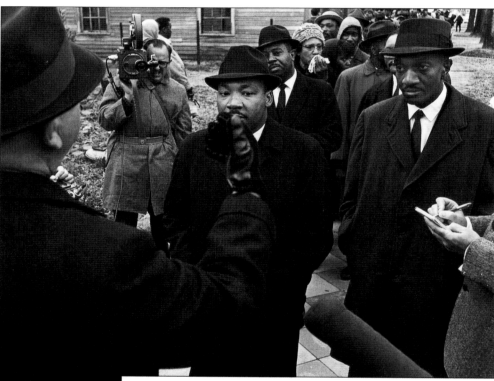

As the protest mounts and the campaign to register voters intensifies, King leads two hundred fifty demonstrators to the courthouse. All are arrested for parading without a permit by Selma's Public Safety Director, Wilson Baker.

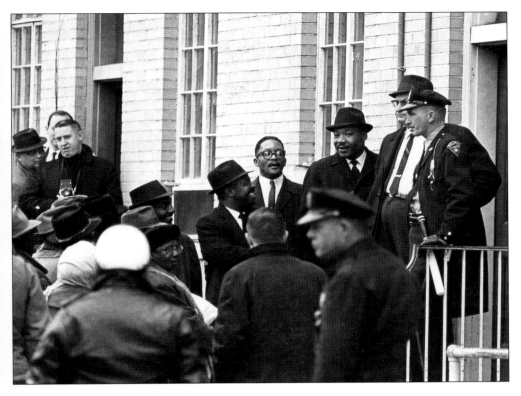

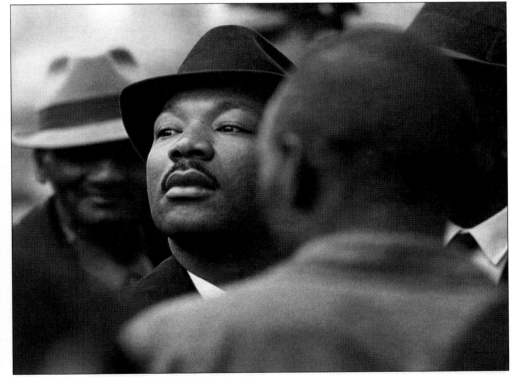

Highway 80, where they were stopped by state troopers and cavalry who, at Clark's order to "Get those goddamn niggers," laid them low with clubs and bullwhips, then continued their rampage through the black section of Selma.

The televised images of raging, racist police horrified the nation. King telegrammed clergy all over the country, asking them to join the battle. And they came, pouring into Selma—priests, nuns, rabbis—in the greatest demonstration of ecumenical support from the nation's religious leaders the movement had seen. On Tuesday, King led fifteen hundred— among them four hundred and fifty clergymen—across the Pettus Bridge, the site of Bloody Sunday. They faced the same line of police. King led his army in prayer, and then because he knew he could not march them into a wall of cops itching for a confrontation, he had them turn back, hoping he had made the point that the campaign could not be stopped. For this move he was criticized by SNCC leaders, who withdrew from Project Alabama. (Some stayed, like John Lewis.) And then came the second murder. While walking past a white cafe, James Reeb, a white Unitarian minister from Boston, was beaten to death. (Nor would he be the last to die, for on March 25, another white volunteer, Viola Liuzzo, was shot as she drove protesters back to Selma.)

The outrage of Reeb's murder moved President Johnson to action. (Sad to say, he mentioned Reeb in his famous speech, but not Jimmy Lee Jackson, and he sent flowers to Mrs. Reeb, none to Jackson's family—a racial slight that was not lost on the increasingly militant SNCC.) Johnson told Congress he would put a voting rights act on the fast track, the front burner, stating, "What happened in Selma is part of a far larger movement which reaches into every section and state of America. It is the effort of American Negroes to secure for themselves the full blessings of American life….Their cause must be our cause, too. Because it is not just Negroes. . .who must overcome the crippling legacy of bigotry and injustice. And we shall overcome."

Thus did the curtain rise on a majestic Act Three unparalleled in American

— 173

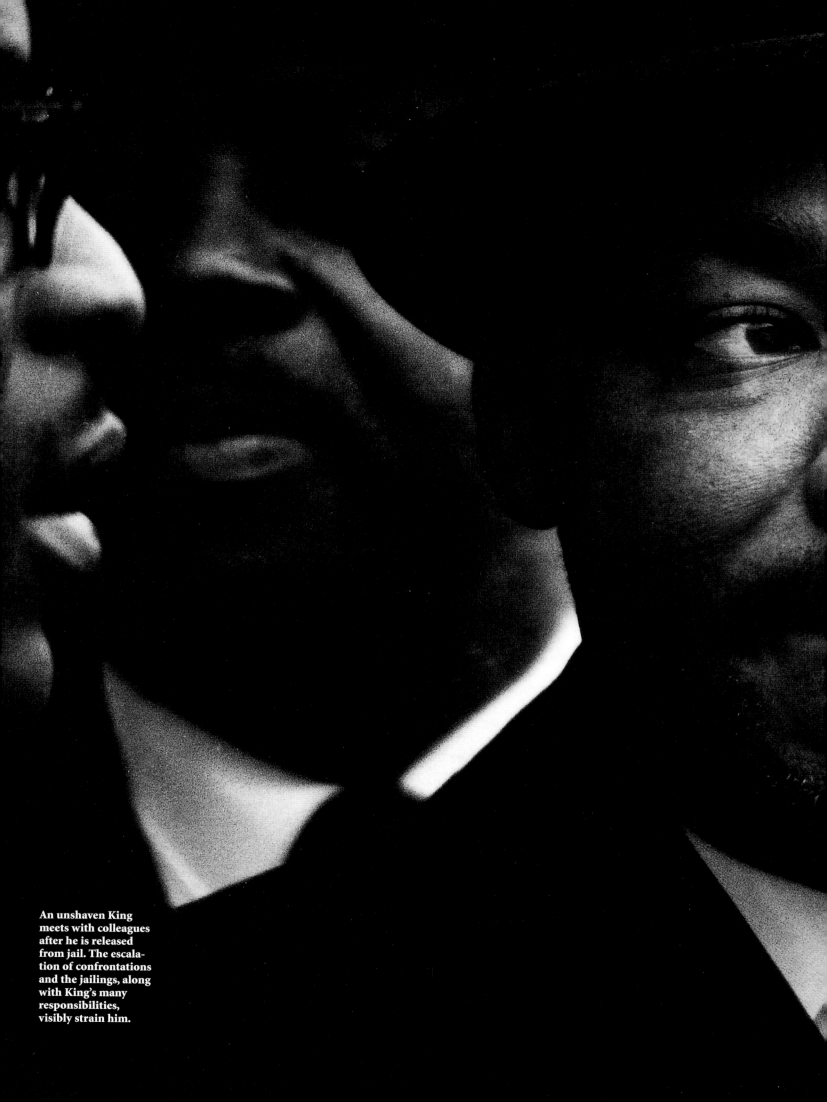

An unshaven King meets with colleagues after he is released from jail. The escalation of confrontations and the jailings, along with King's many responsibilities, visibly strain him.

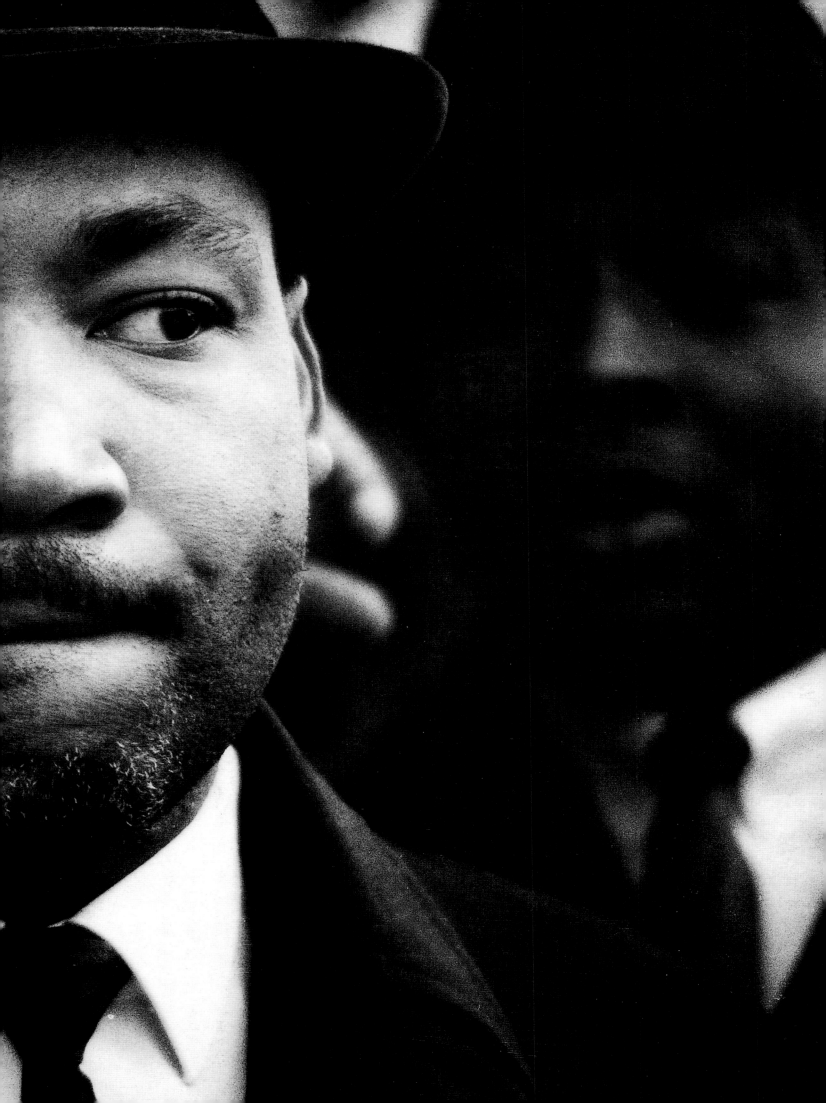

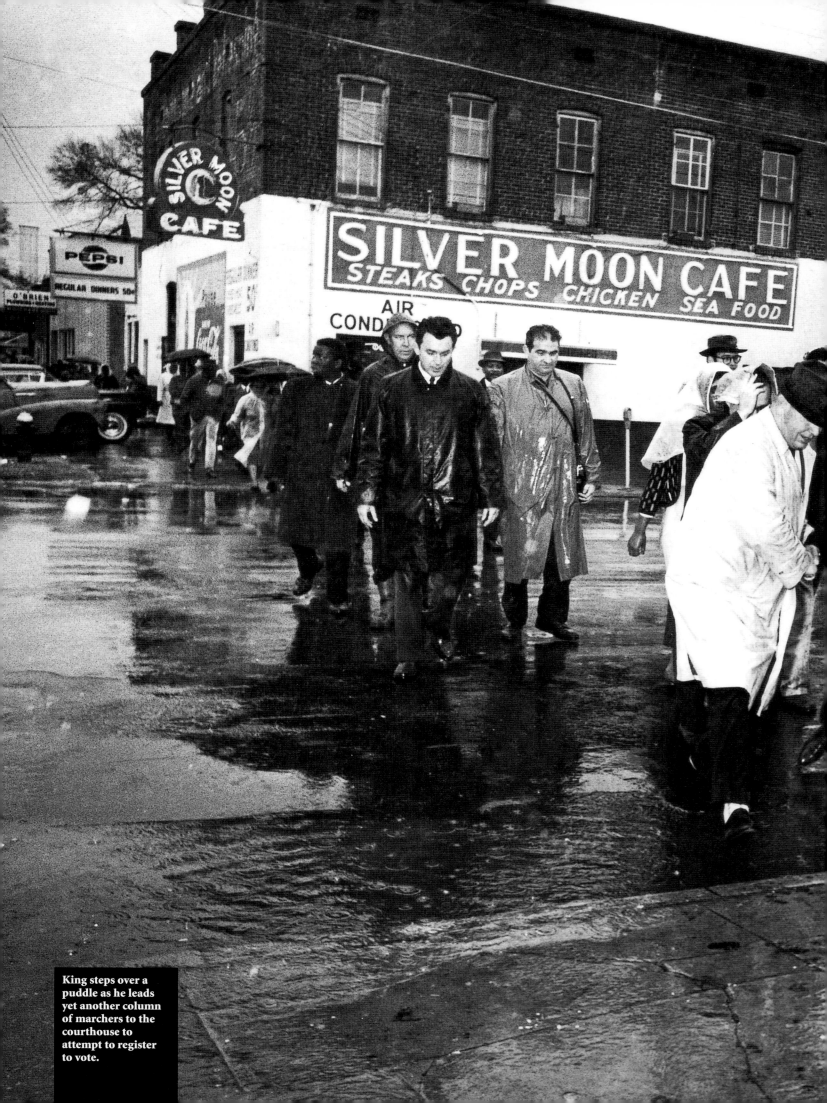

King steps over a puddle as he leads yet another column of marchers to the courthouse to attempt to register to vote.

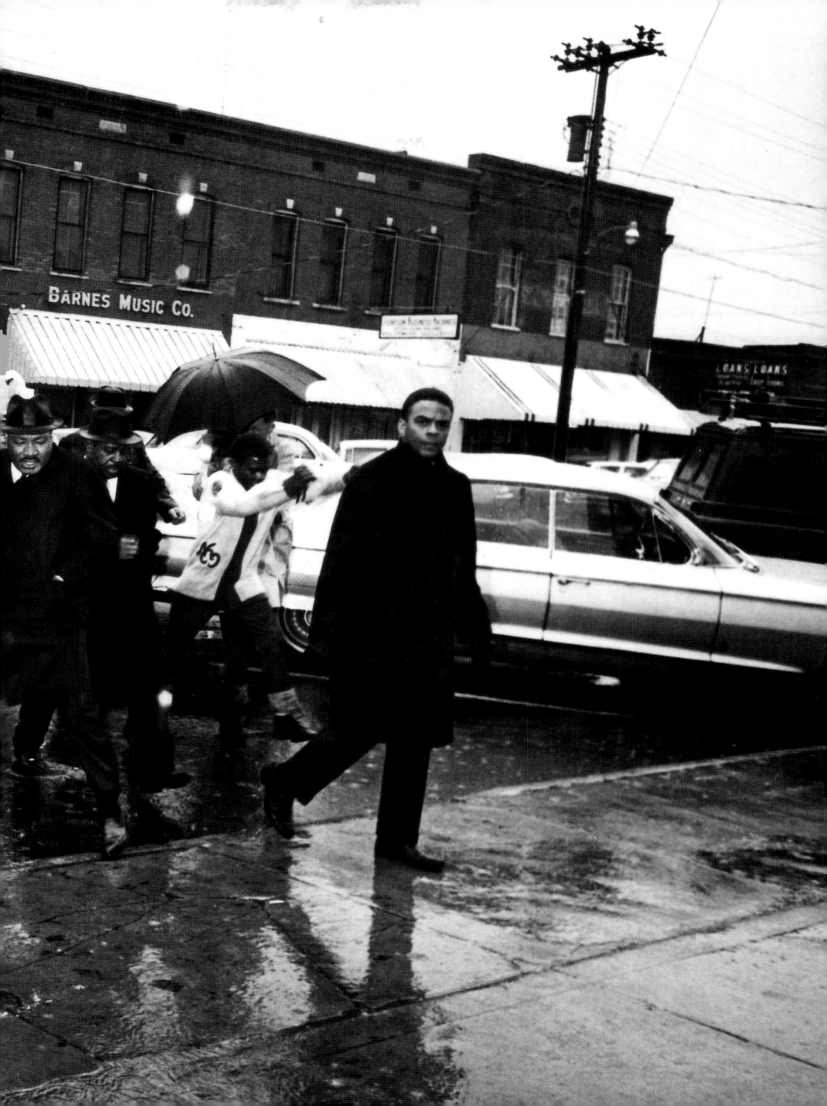

On March 7, 1965, more than five hundred marchers led by John Lewis and Hosea Williams cross the Edmund Pettus Bridge as they set off for Montgomery. When they reach the other side, Alabama State Police bar their way and order them to disperse within two minutes. Seconds after the order, even though the marchers begin to retreat, state police rush the marchers, gassing and brutally clubbing them to the ground. At least seventy protesters required treatment for broken bones and head wounds.

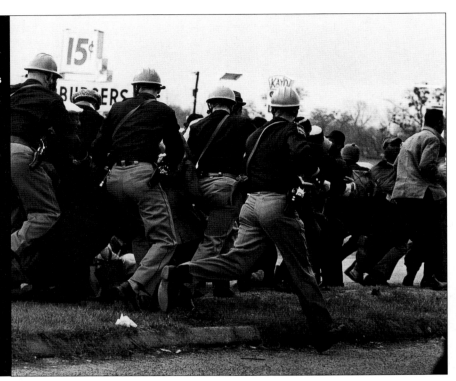

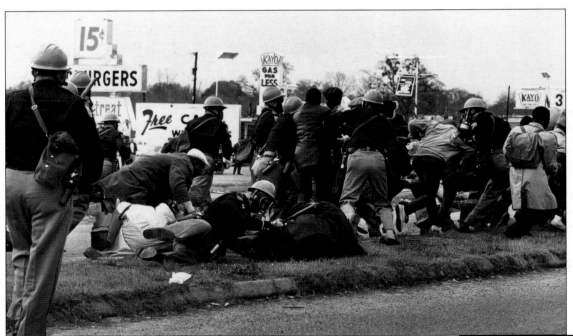

The state police beat the marchers, expecting to frighten and intimidate them and end the demonstrations. The vicious attack, now known as Bloody Sunday, was filmed and photographed, then seen by an appalled nation, making passage of a voting rights act a near certainty.

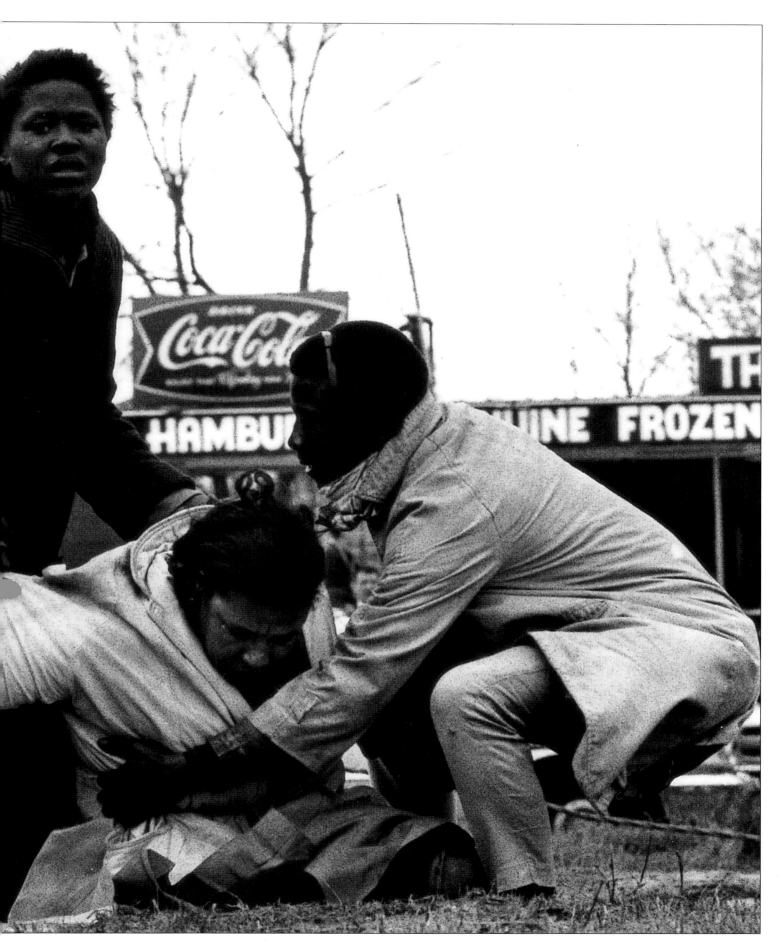

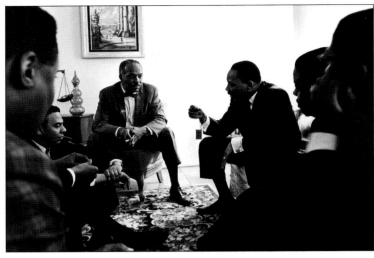

political history. More good news came when a Montgomery judge green-lighted the fifty-four-mile Selma to Montgomery march. Protected by a federalized Alabama National Guard and four thousand Army troops provided by the president, King and five thousand marchers who cut across all divisions of religion, race, and class began their historic trek on Sunday, March 21. They slept in tents, tramped down the Jefferson Davis Highway through the rain, and passed billboards splashed with photos of King supposedly at a "Communist training camp" (in fact, it was a racially mixed, civil rights and union organizer workshop at Highlander Folk School in Tennessee), and on Wednesday they reached Montgomery, where ten years earlier the civil rights movement had begun with a bus boycott. That night marchers and others arriving from all over the country were entertained by performers as diverse as Leonard Bernstein, Harry Belafonte, Sammy Davis, Jr., Billy Eckstine, and Peter, Paul, and Mary, to name only a few.

On Thursday, March 25, King, at the head of twenty-five thousand people, delivered the petition of Selma's black people for voting rights and the end of fascist police treatment. Wallace refused to accept it. He stayed in the capitol building and sulked, looking through his window at thousands of Americans who had taken a stand for brotherhood and smashed the last century-old obstacle to black equality. For many, this was—and remains—the movement's, and King's, finest hour.

Although King was barred by a federal court order from marching from Selma to Montgomery, he led a group of protesters, including many clergymen, across the Edmund Pettus Bridge up to the police lines. There they stop and kneel in prayer, turn around, and return to Selma.

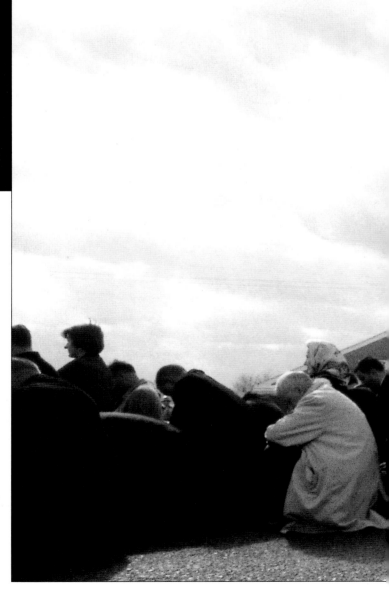

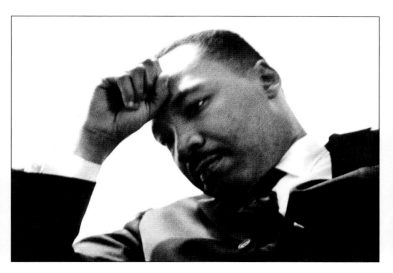

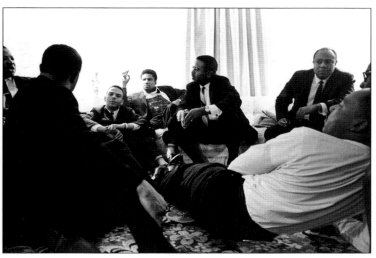

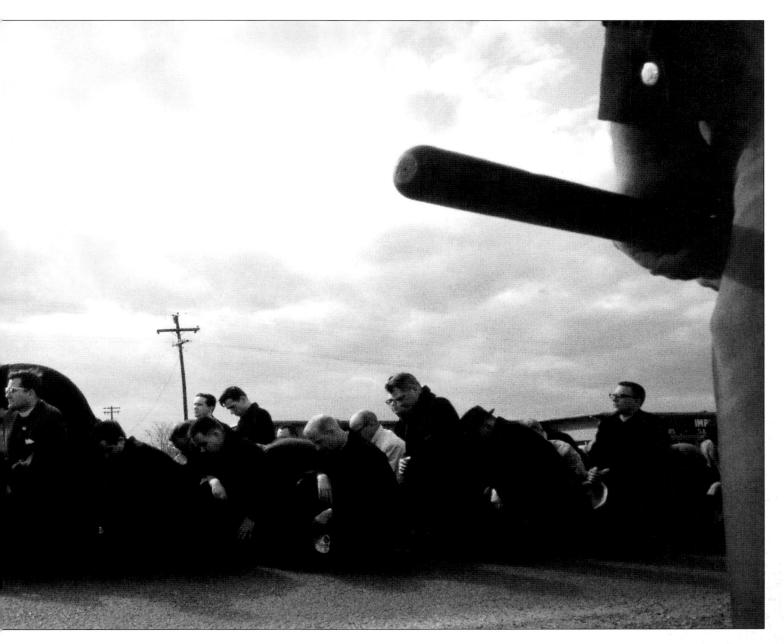

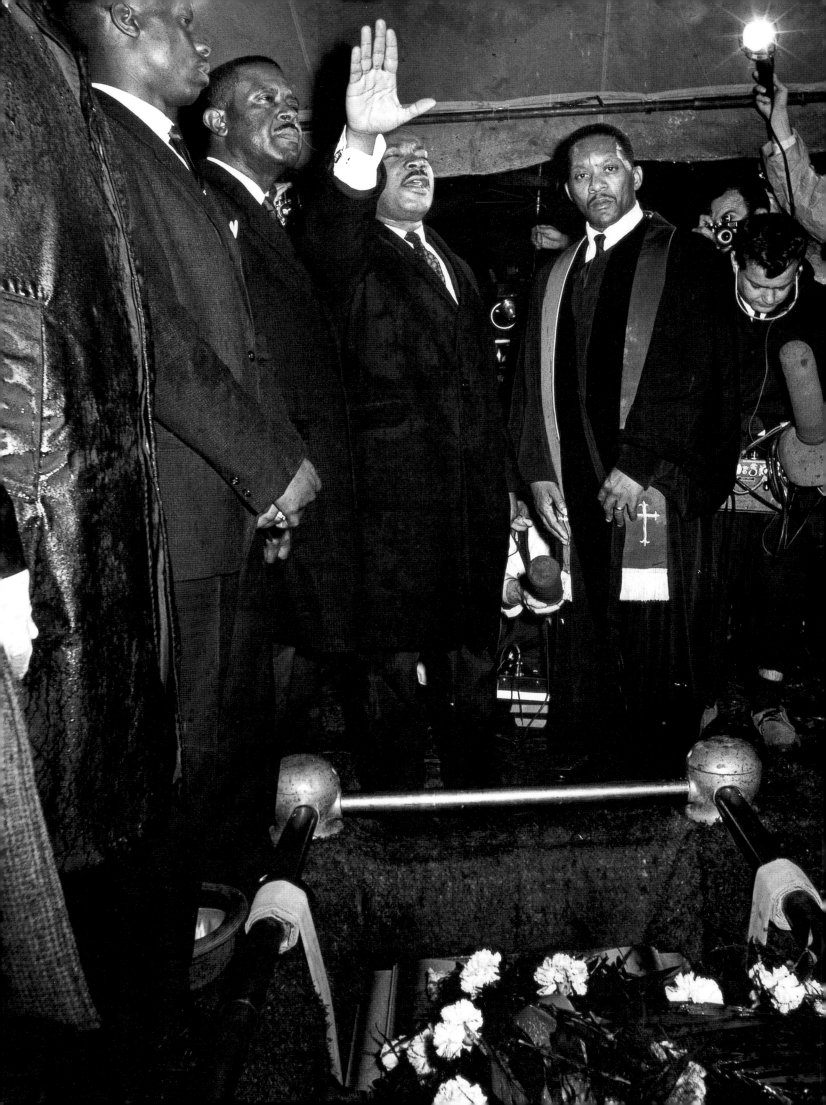

As the protests increased, demonstrators began to hold night marches in neighboring counties. On one such march a young black man, Jimmy Lee Jackson, was shot down by the police as he was protecting his family. At his burial Dr. King hopes love will conquer hate through justice.

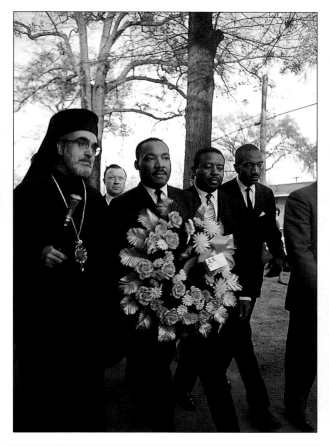

At King's request, hundreds of clergymen rushed to Selma. Returning home after dinner, Rev. James Reeb was savagely beaten and later died. King holds a night vigil for Reeb, then returns to Brown Chapel, where he eulogizes Reeb. He lays blame for Reeb's and Jackson's killings at the feet of the state officials. "He [Reeb] was murdered by an atmosphere of inhumanity in Alabama that tolerated the vicious murder of Jimmy Lee Jackson in Marion and the brutal beatings of Sunday in Selma."

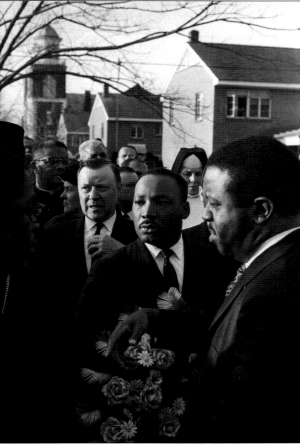

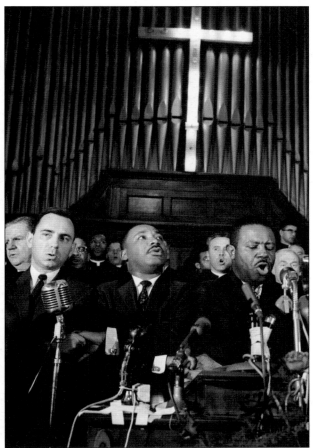

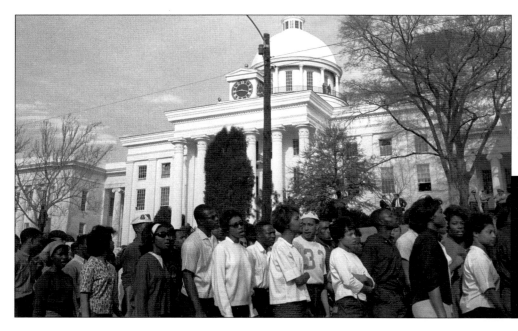

College students led by SNCC organizers peacefully march in front of the statehouse in Montgomery. On their way back, they are brutally beaten by state troopers and possemen on horses.

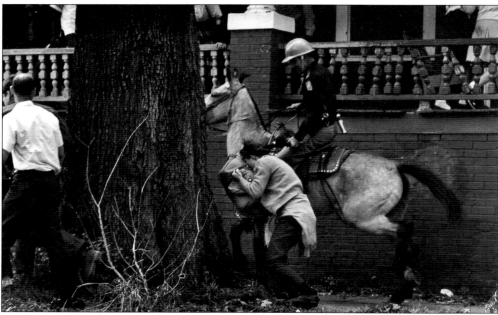

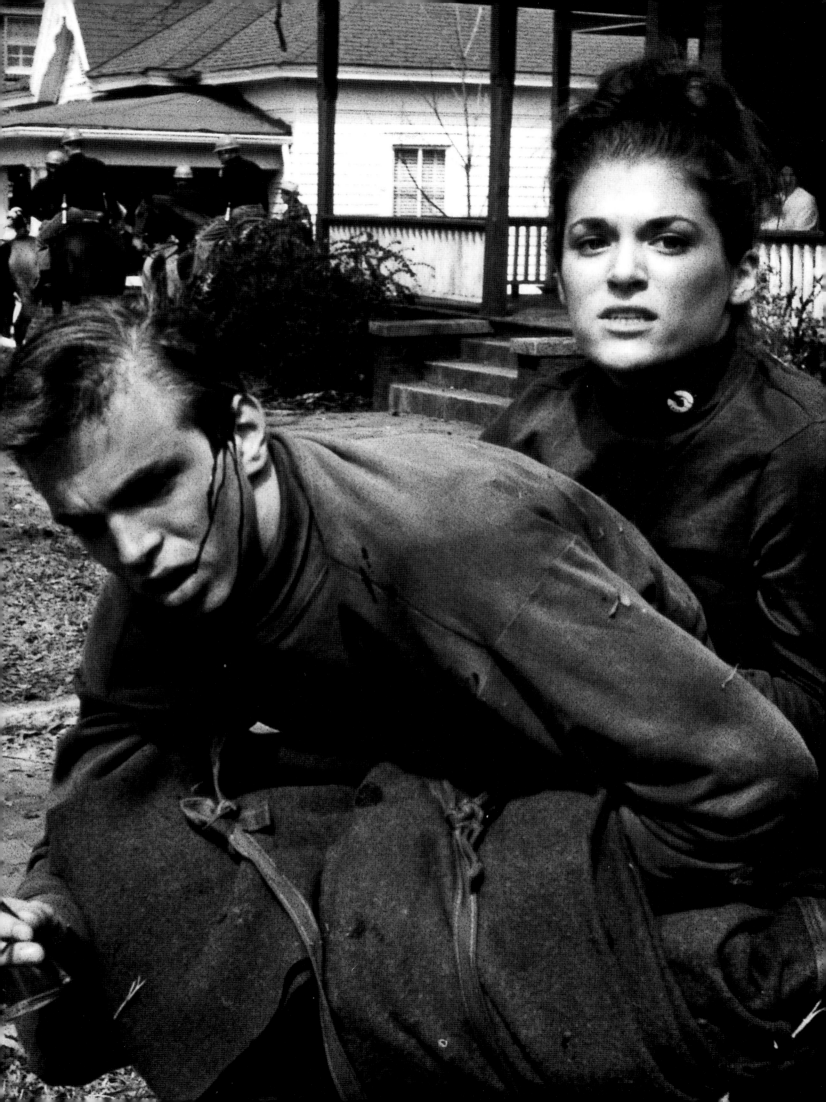

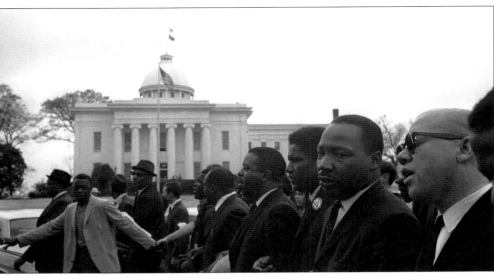

Dr. King and James Forman, leader of SNCC, lead a protest march around the statehouse in Montgomery to protest the beatings of the students. They wind up at the Montgomery county courthouse where Sheriff Butler apologizes for the beatings.

Back in Selma, while the demonstrators await the beginning of the great march to Montgomery, police confine the demonstrations to the area around Brown Chapel. Occasionally demonstrators infiltrate the blockade to the downtown business district, where they are summarily arrested.

Proudly Sheriff Clark wears a button declaring "Never," which was Governor George Wallace's watchword against integration

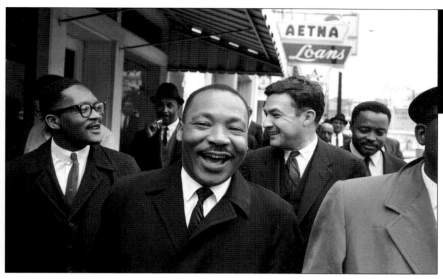

King smiles triumphantly after getting permission to begin the Selma to Montgomery March from a federal judge in Montgomery.

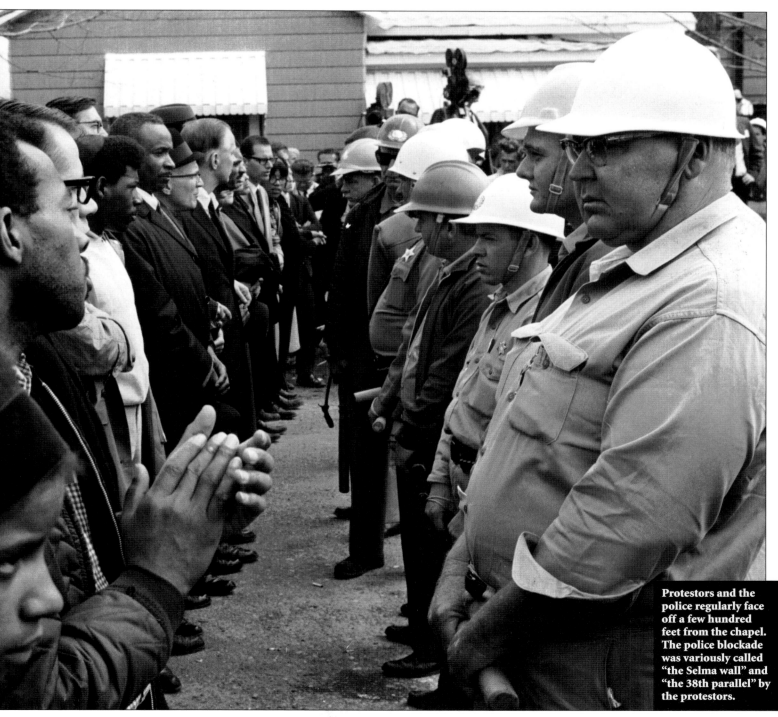

Protestors and the police regularly face off a few hundred feet from the chapel. The police blockade was variously called "the Selma wall" and "the 38th parallel" by the protestors.

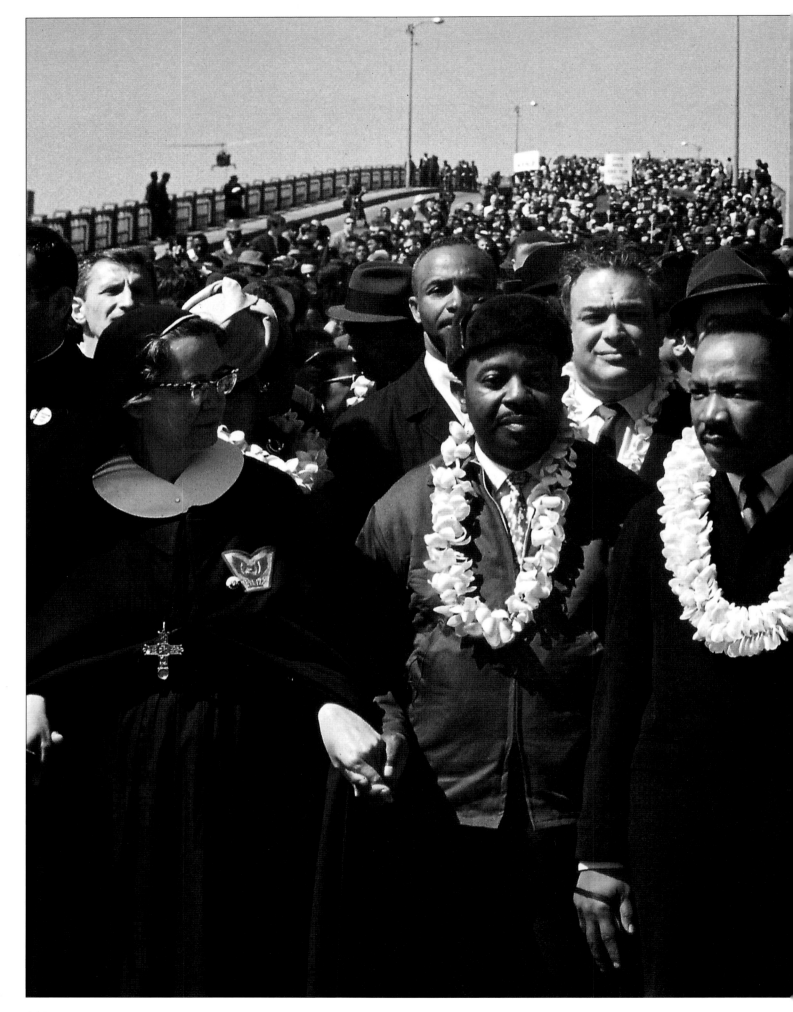

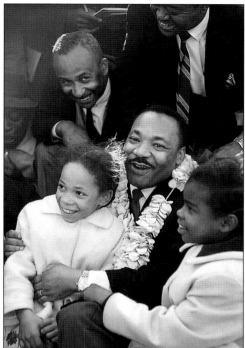

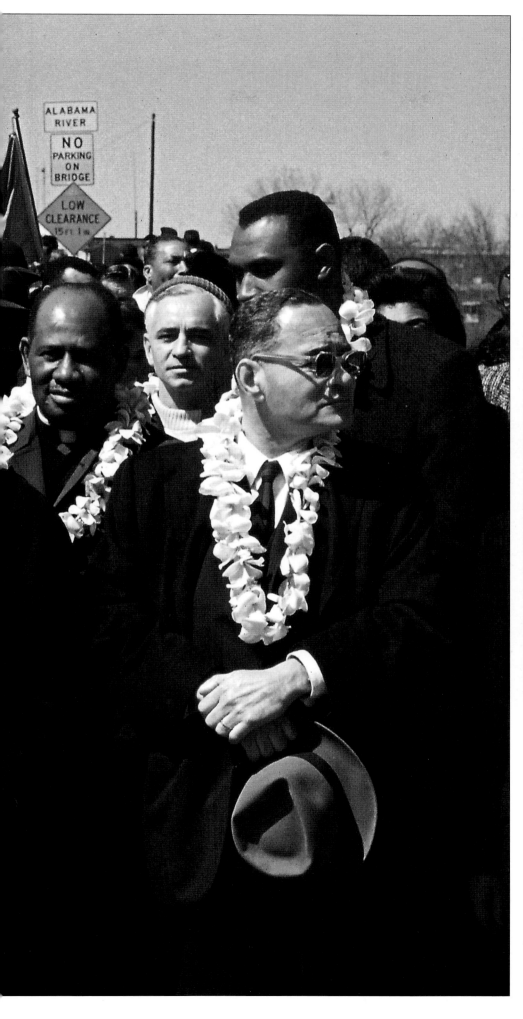

On March 21, the historic Selma to Montgomery March finally begins. King leads three thousand peacefully and without incident across the Edmund Pettus Bridge and begins the fifty-four-mile trek to the state capital. The march is protected by federalized Alabama Guardsmen and U.S. Army troops. As had been agreed, after eight miles, only three hundred were allowed to continue the march. Their ranks can swell again when they come within eight miles of Montgomery.

Marchers proudly displayed American flags, reflecting their belief that the First Amendment, federal courts, President Johnson, and the U.S. Army made the march through the heart of Dixie possible.

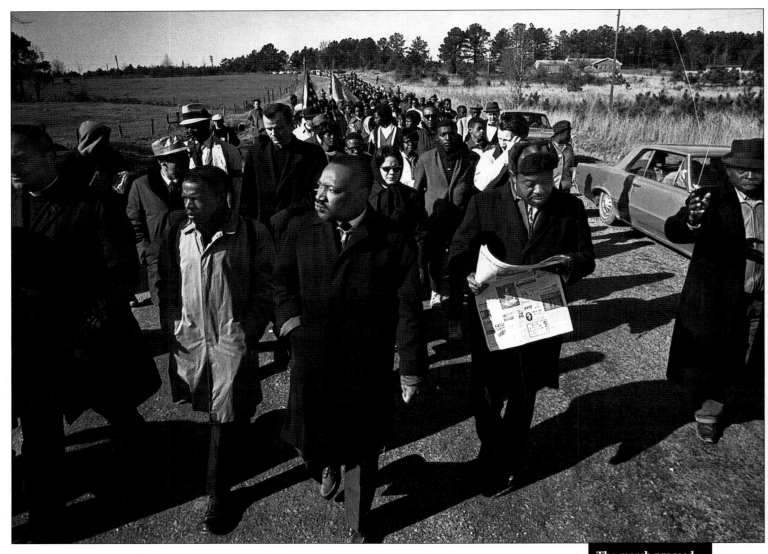

The march proceeded without incident along Jefferson Davis Highway, overseen by troops posted at regular intervals, guarded by circling helicopters, and with jeeps and military vehicles patrolling all along the way. Although they were wearied by the long distances they had to cover on foot, the mood of the marchers was exuberant. A great American right was being exercised—to peacefully protest injustice. At a resting point, Dr. King changes socks.

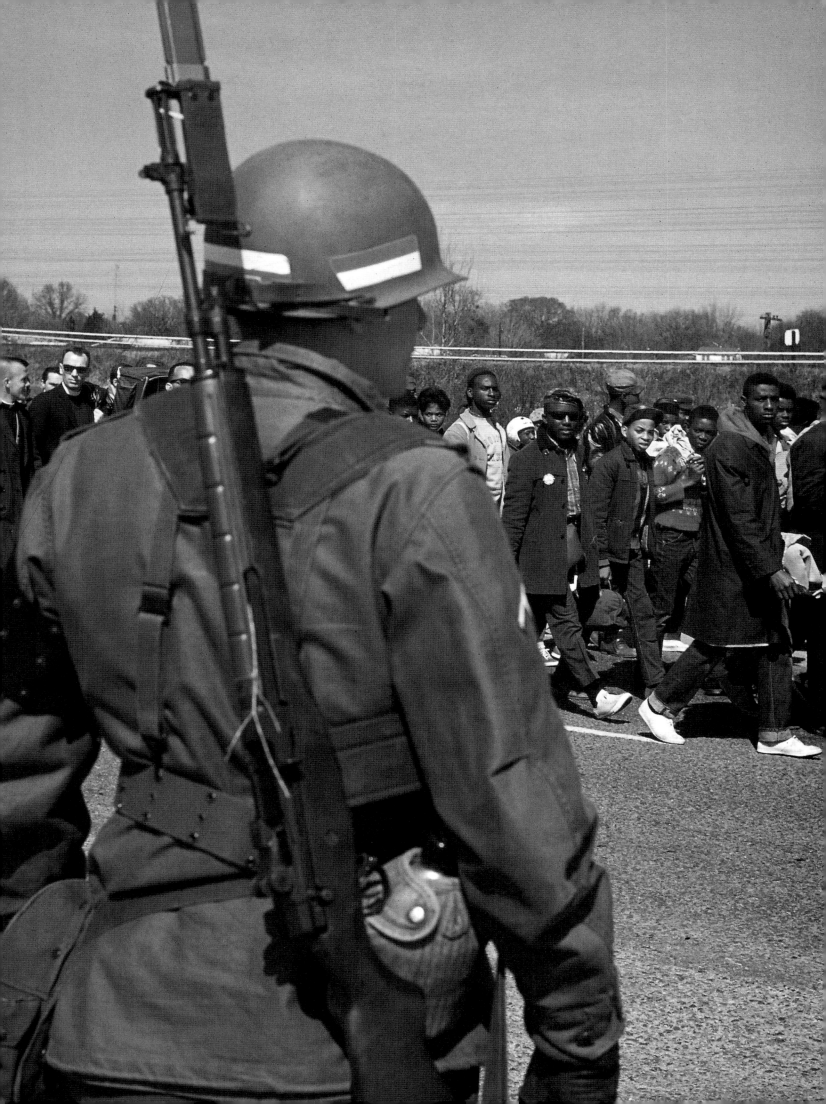

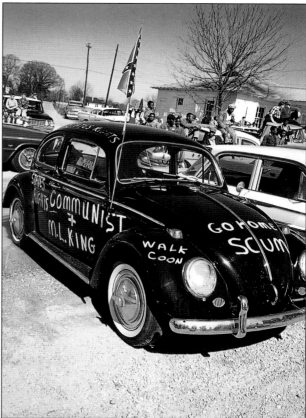

Local blacks along the road enthusiastically greeted the marchers. Many of the whites who came out to watch were hostile, some displaying the confederate flag and jeering.

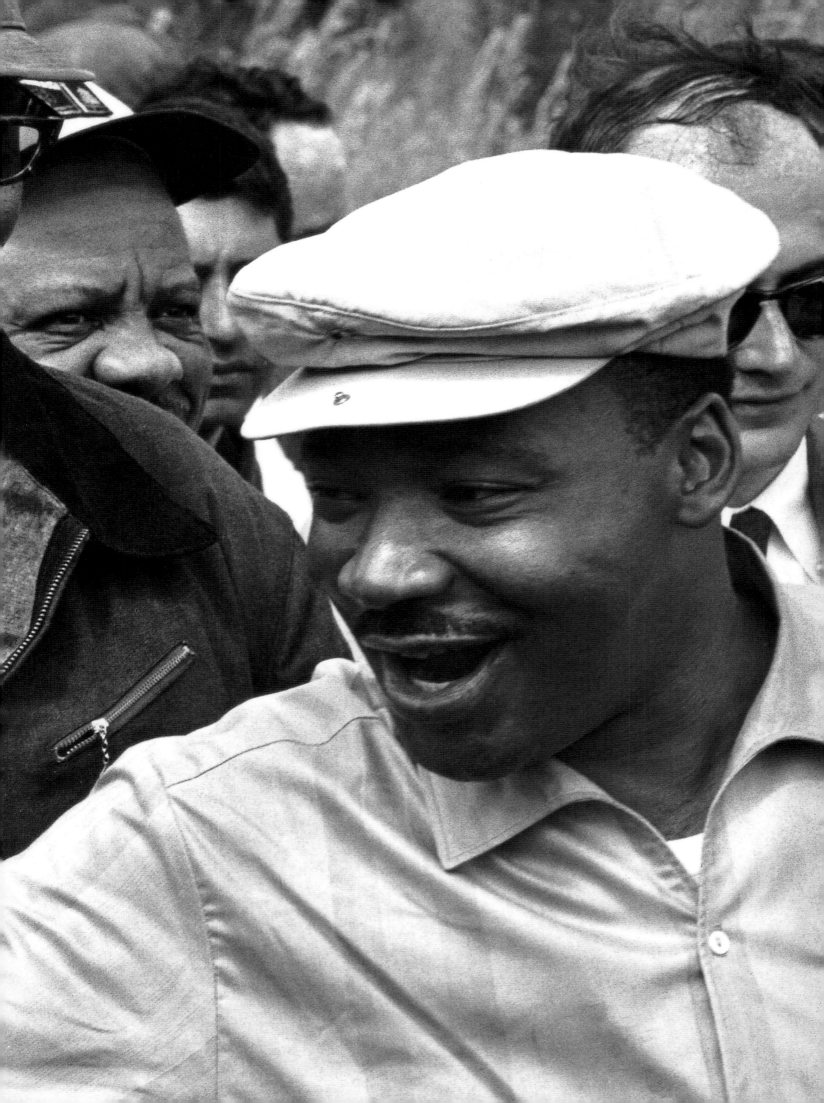

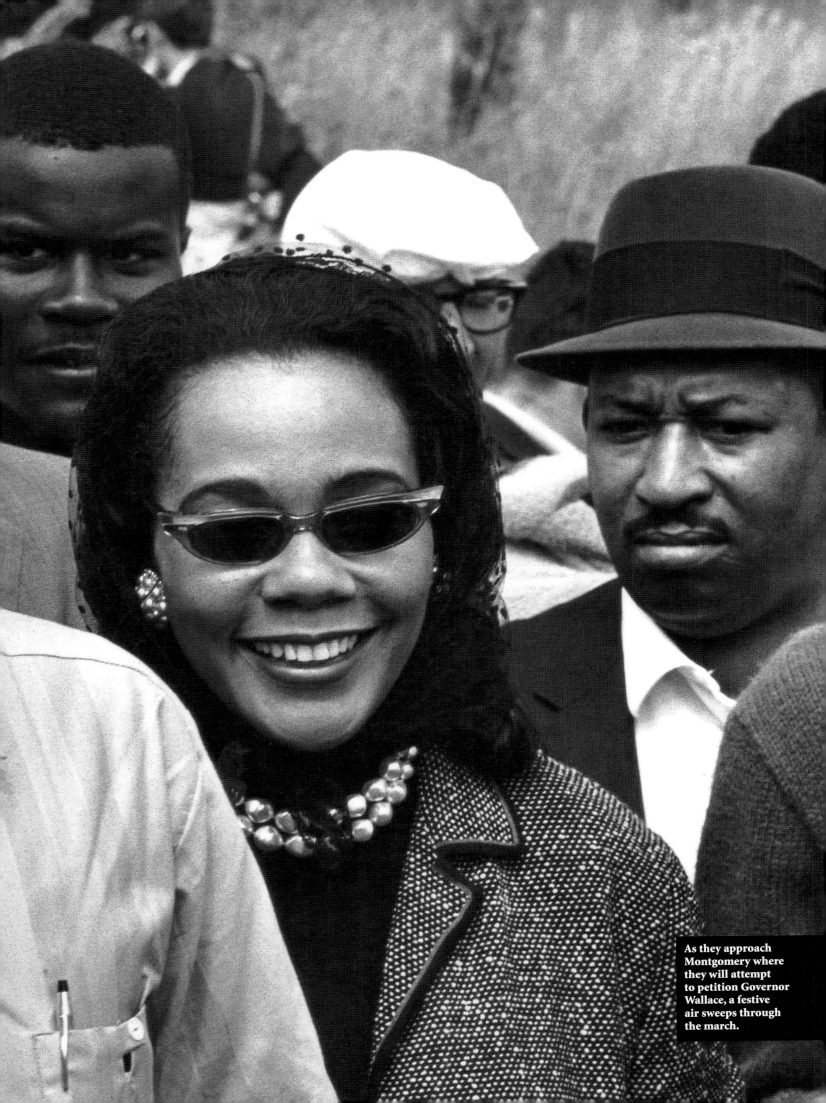

As they approach Montgomery where they will attempt to petition Governor Wallace, a festive air sweeps through the march.

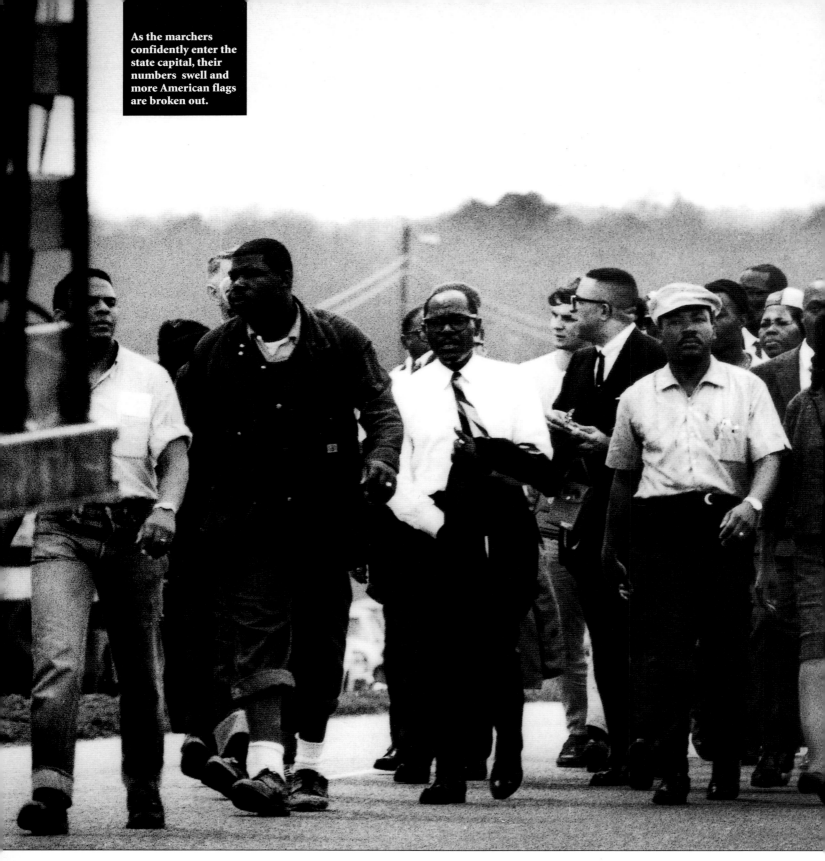

As the marchers confidently enter the state capital, their numbers swell and more American flags are broken out.

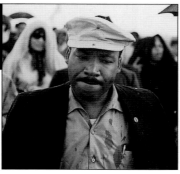

Braving the rain and singing, King leads the march as it approaches its finale.

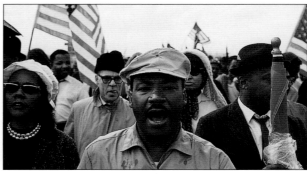

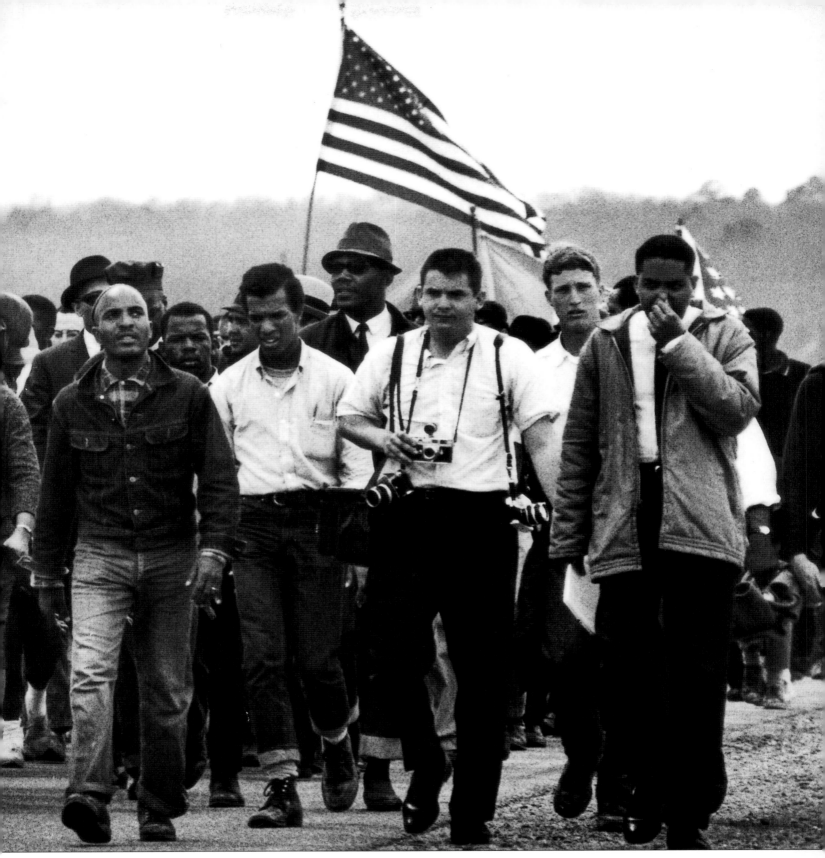

At the Montgomery Airport, King and his wife wait for Harry Belafonte and Tony Bennett to arrive.

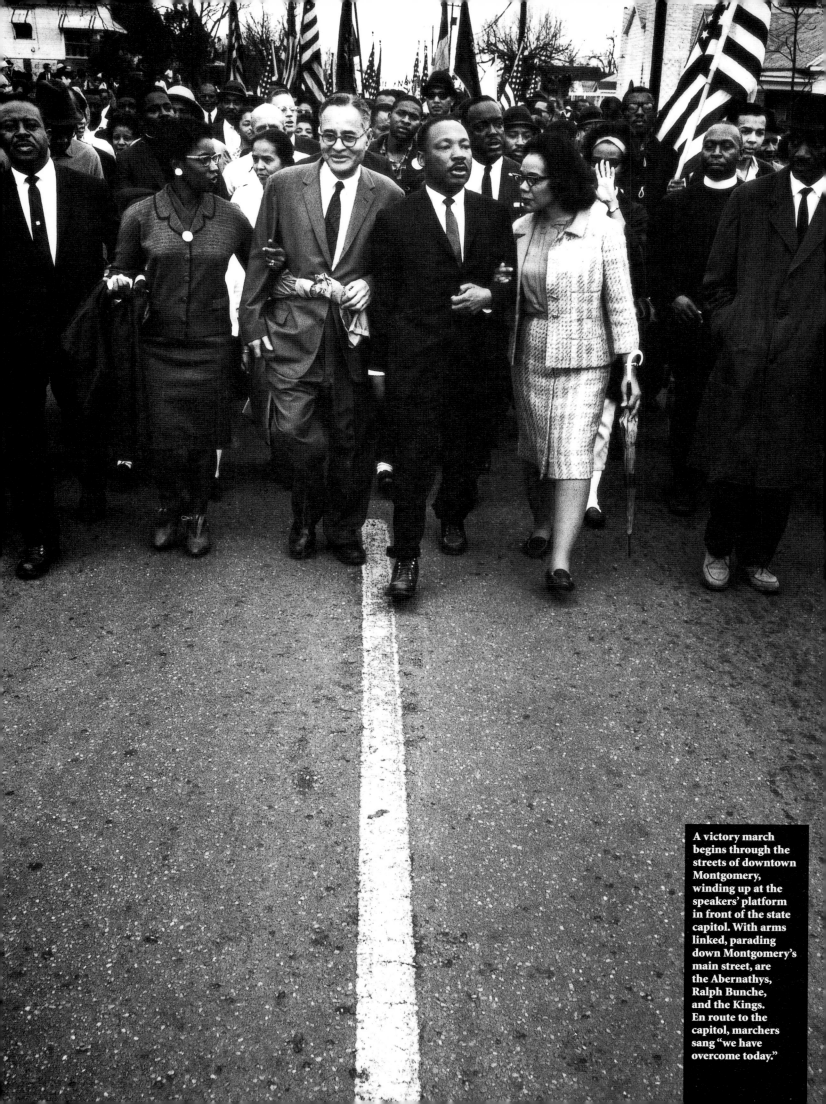

A victory march begins through the streets of downtown Montgomery, winding up at the speakers' platform in front of the state capitol. With arms linked, parading down Montgomery's main street, are the Abernathys, Ralph Bunche, and the Kings. En route to the capitol, marchers sang "we have overcome today."

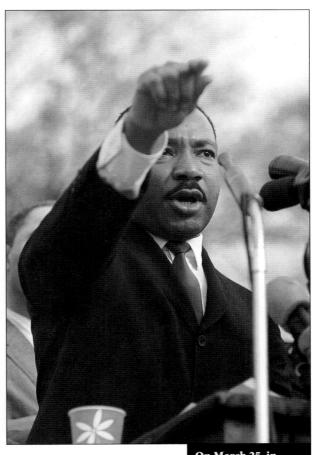

On the podium, Peter, Paul, and Mary sing along with Joan Baez, Oscar Brand, and Harry Belafonte.

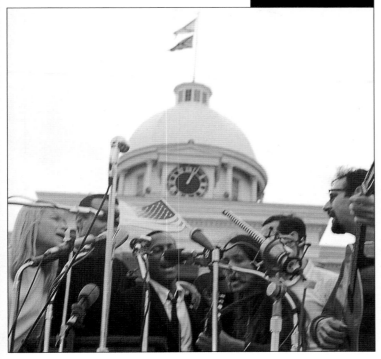

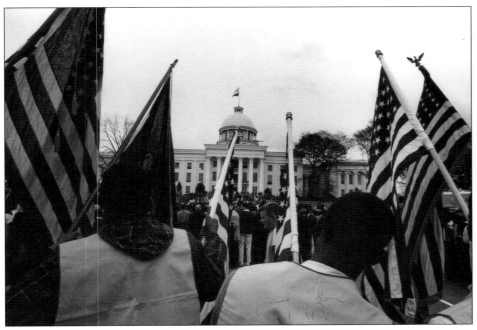

On March 25, in front of the Alabama statehouse, before a cheering crowd of twenty-five thousand supporters from all over the nation, King exclaims, "Let us march on ballot boxes until race baiters disappear from the political arena." To roars of approval, he climaxes his speech chanting, "How long will it take?…How long? Not long. Because the arm of the moral universe is long but it bends toward justice."

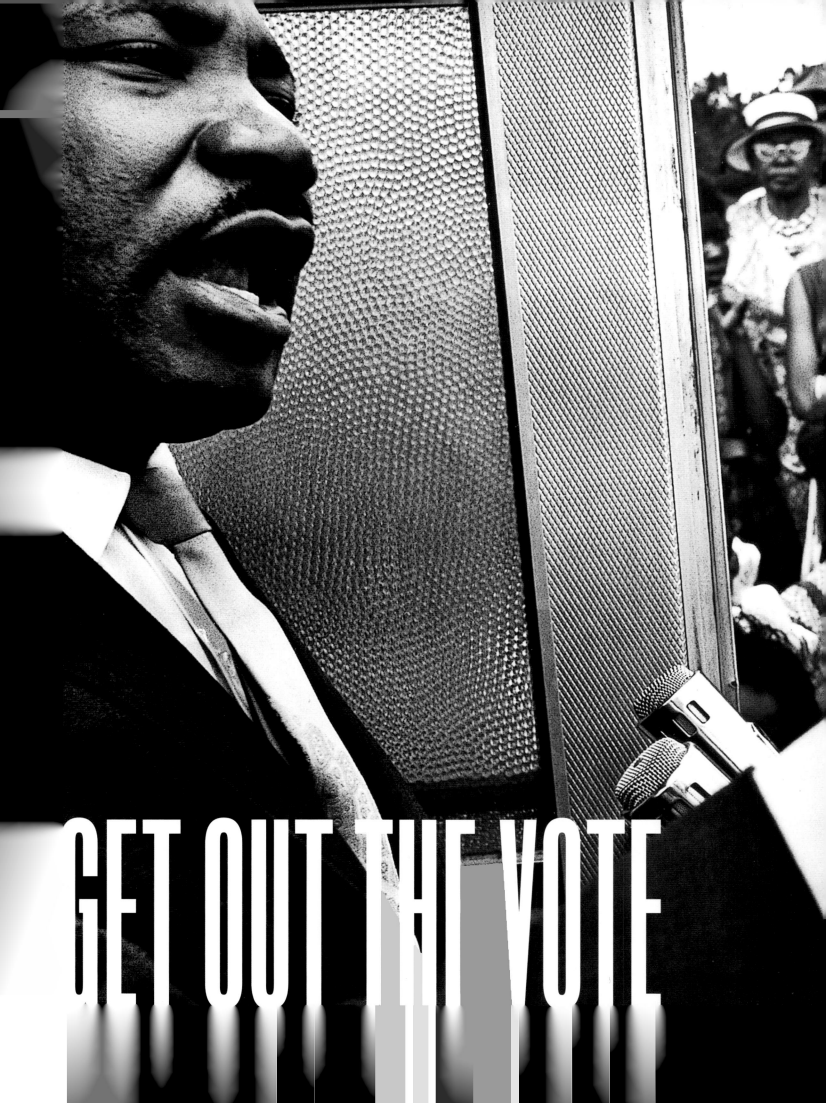

GET OUT THE VOTE

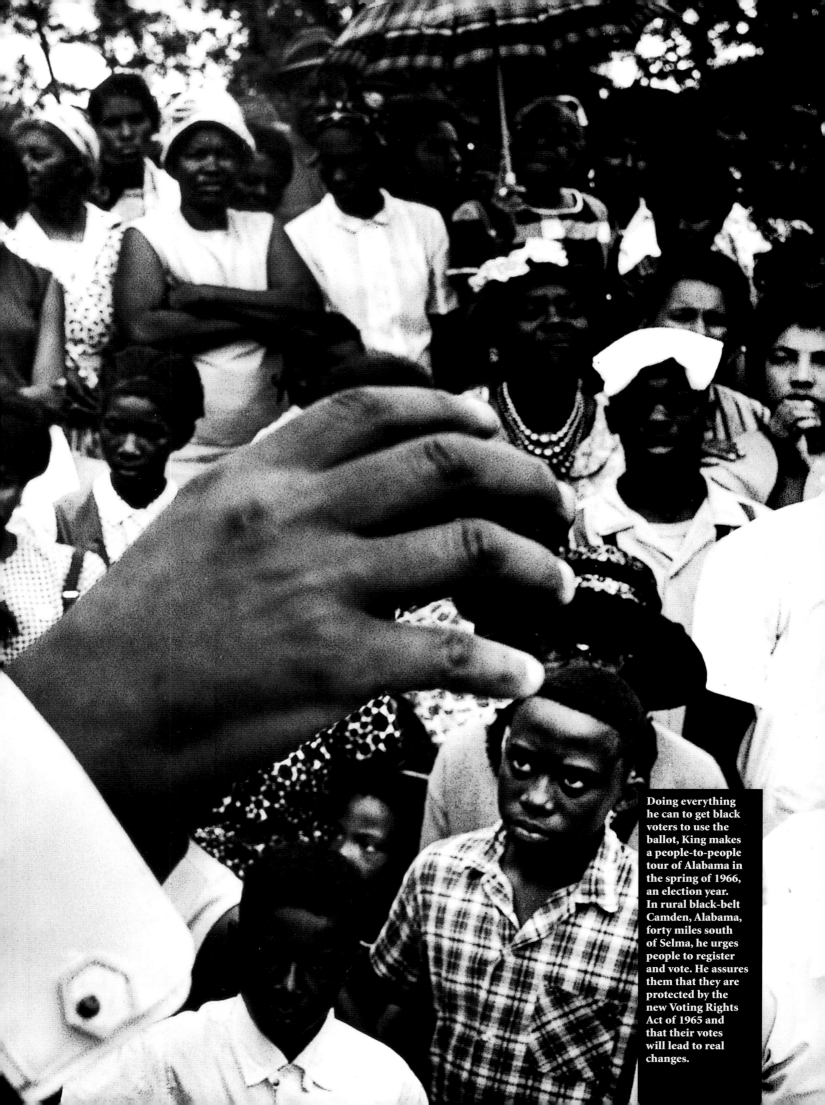

Doing everything he can to get black voters to use the ballot, King makes a people-to-people tour of Alabama in the spring of 1966, an election year. In rural black-belt Camden, Alabama, forty miles south of Selma, he urges people to register and vote. He assures them that they are protected by the new Voting Rights Act of 1965 and that their votes will lead to real changes.

GET OUT THE VOTE

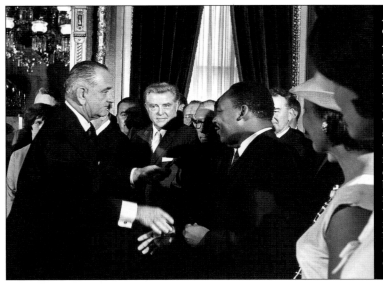

The right of citizens of the United States to vote shall not be denied or abridged by the United States or by any State on account of race, color, or previous condition of servitude.
~THE FIFTEENTH AMENDMENT (1870)

A man is not a first class citizen, a number one citizen, unless he is a voter.
~REV. JOSEPH CARTER,
ST. FRANCISVILLE, LOUISIANA, 1964

For a free people, the franchise means everything. In a democratic republic, it is the proper name of empowerment. It is the essence of political equality. Throughout the South, particularly in places where blacks outnumbered whites, those who were determined to deny this constitutional right to citizens of color found no form of terrorism too terrible if it vouchsafed voting as an exclusively white privilege.

Of the five million eligible black voters in the South in the late 1950s, only 1.3 million exercised this privilege at the ballot box. From its inception, the SCLC identified voter registration as one of its two primary theaters for direct action (the other was desegregation). In 1958 it launched a Crusade for Citizenship aimed at setting up voting clinics across the South and documenting the efforts by whites to disenfranchise blacks. The goal was to register ten million blacks before the elections in 1960. King insisted that when his people had the full power of the ballot box, it would advance the cause of both blacks and whites. He said, "We have learned in the course of our freedom struggle that the needs of twenty million Negroes are not truly separable from those of the nearly two hundred million whites…all of whom will benefit from a color-blind land of plenty that provides for the nourishment of each man's body, mind and spirit."

But the obstructionist efforts by the segregationists, long entrenched in some counties and formidable, were based on fear tactics (what King listed as "the gun, the club, and the cattle prod") dating back to the days of Reconstruction. Blacks who attempted to register were beaten. Or hanged. They had snakes

At the signing of the Voting Rights Act of 1965, held in the room where Johnson believed Lincoln had signed the Emancipation Proclamation, the President said, "The vote is the most powerful instrument ever devised by man for breaking down injustice and the terrible walls that imprison men because they are different from other men."

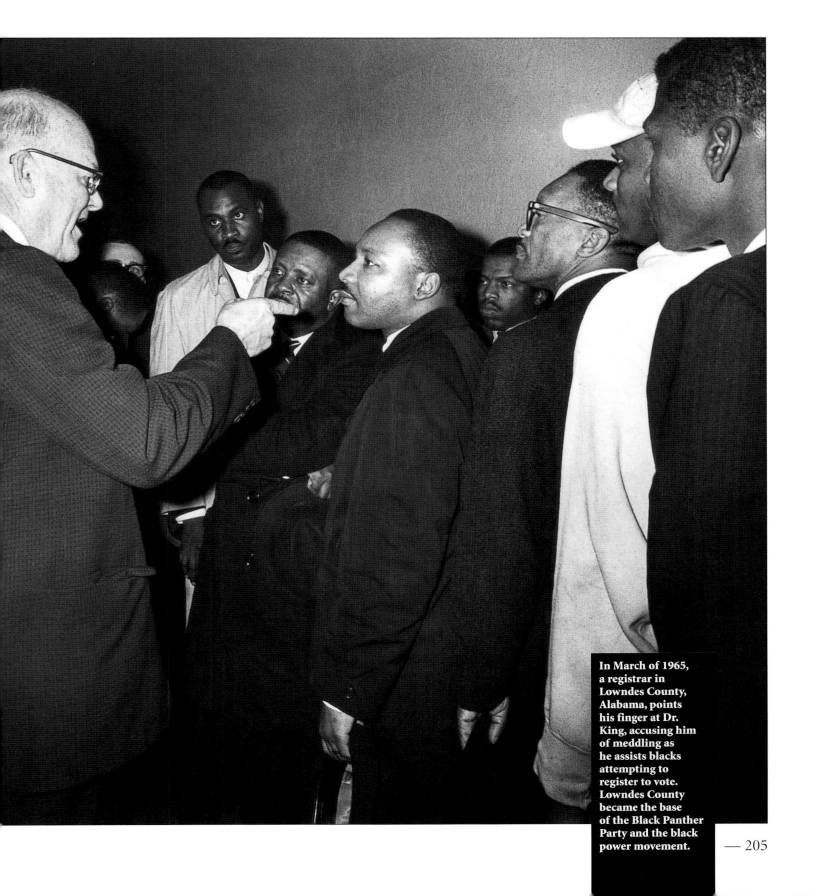

In March of 1965, a registrar in Lowndes County, Alabama, points his finger at Dr. King, accusing him of meddling as he assists blacks attempting to register to vote. Lowndes County became the base of the Black Panther Party and the black power movement.

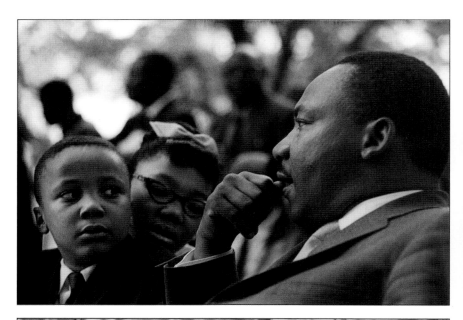

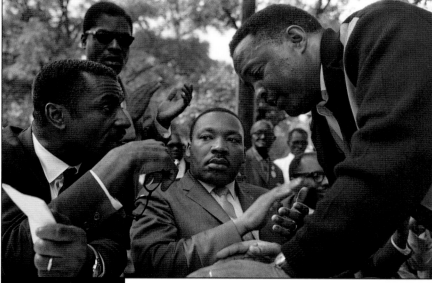

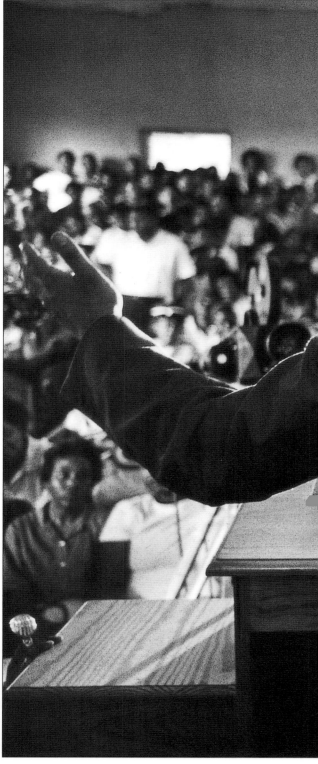

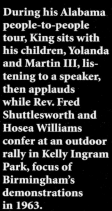

dropped on them as they stood in line to register. They faced preposterous "literacy tests" (when many illiterate whites were registered). State poll taxes (these were not outlawed in federal elections until passage of the Twenty-fourth Amendment in 1964). And economic reprisals. Their homes were burned, their families driven out of town.

Armed with the new Voting Rights Act, King toured rural counties in 1966 to make sure newly enfranchised black

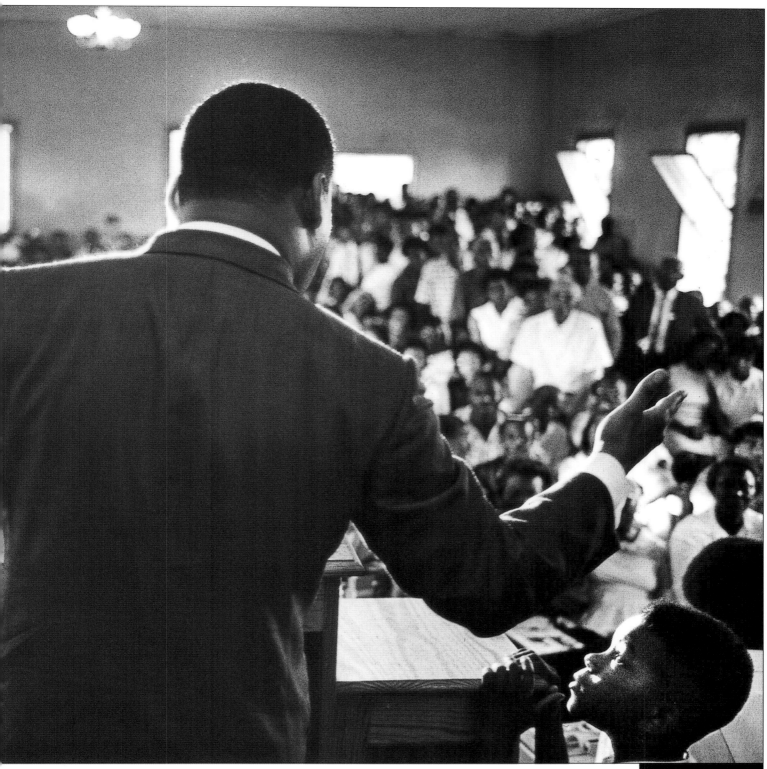

voters registered, then voted. He was enthusiastically and respectfully greeted by the large crowds who came to see him and participate in yet another, more traditional, form of direct action. So sweeping were the provisions of the law that for counties with proven patterns of racial discrimination federal registrars and FBI agents supervised and oversaw the electoral process. Illiterate blacks could even vote orally. That year voters elected the first black sheriff in the rural deep South in this century, Thomas Gilmore.

Standing at the Selma bridge thirty-five years after Bloody Sunday, celebrating those who had marched across it, President Clinton noted that not only had nine thousand black officials been elected in the South since then, but that if King had not freed us all, two white southerners, himself and Jimmy Carter, could never have become president.

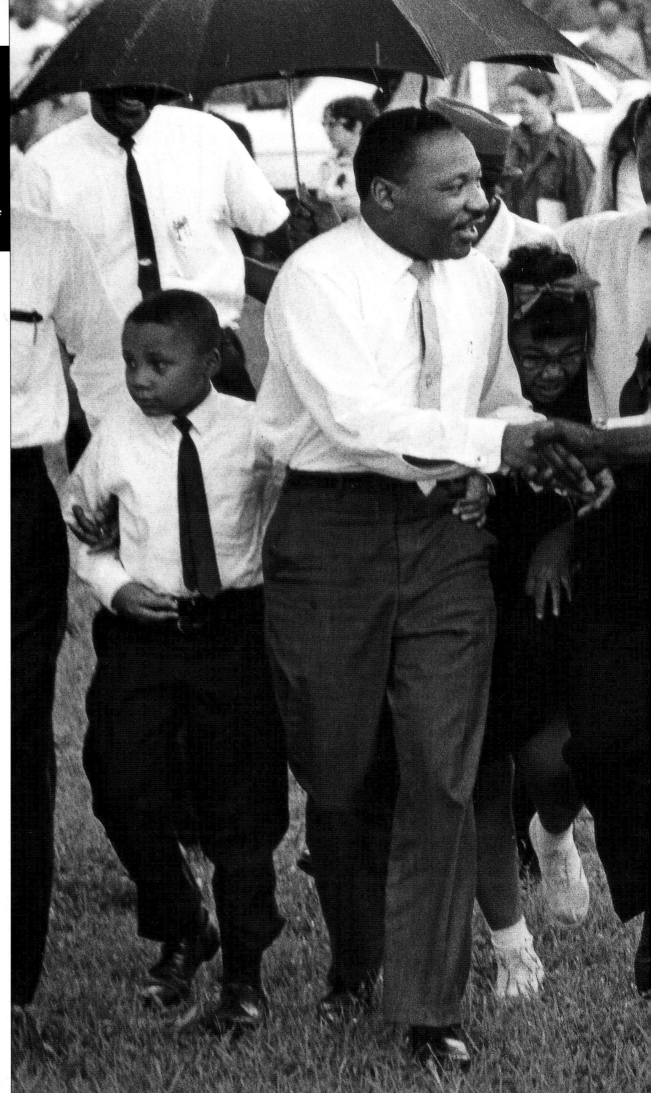

With his children Martin III and Yolanda in tow, and escorted by his aide, Hosea Williams, King leaves a country church on his tour and greets a young man with his message: Vote. Although King had no personal interest in elected office, here he looks very much like a campaigner.

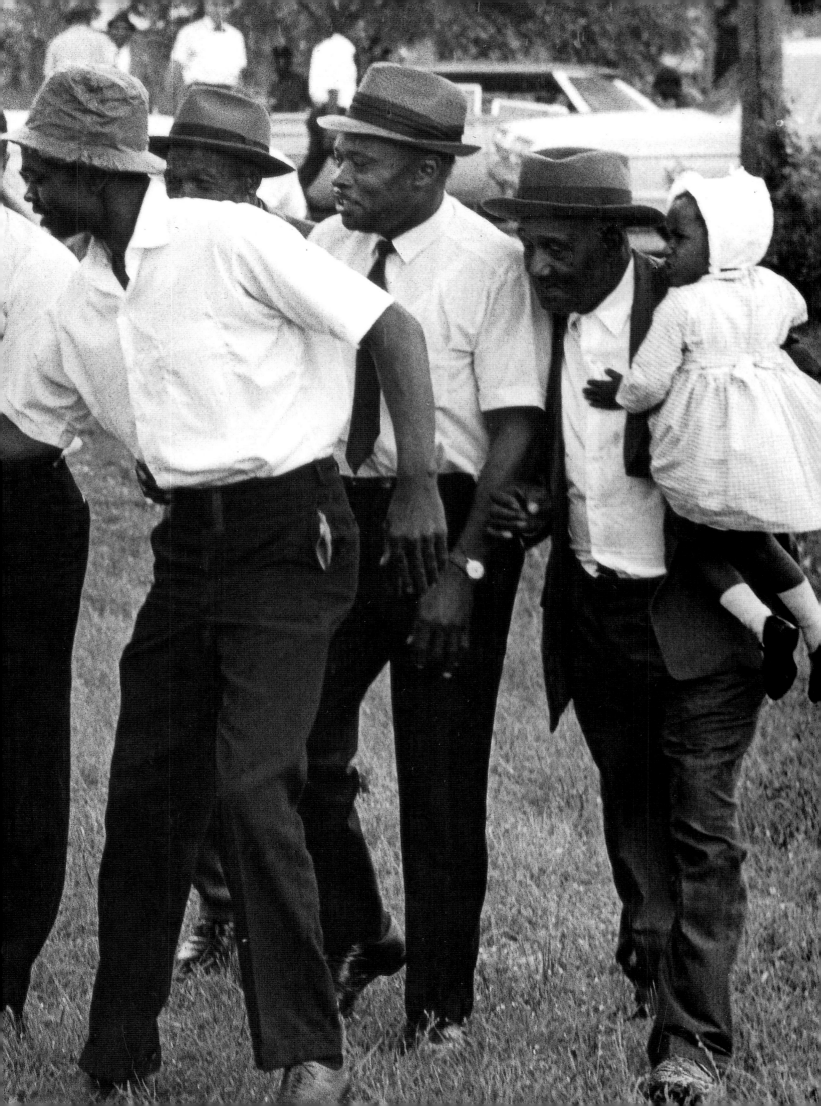

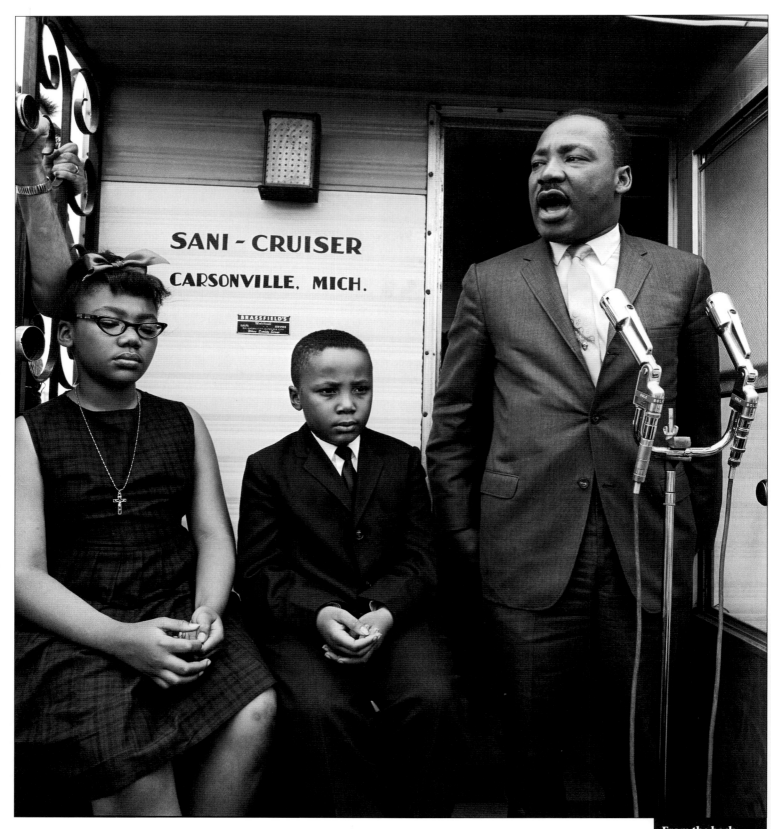

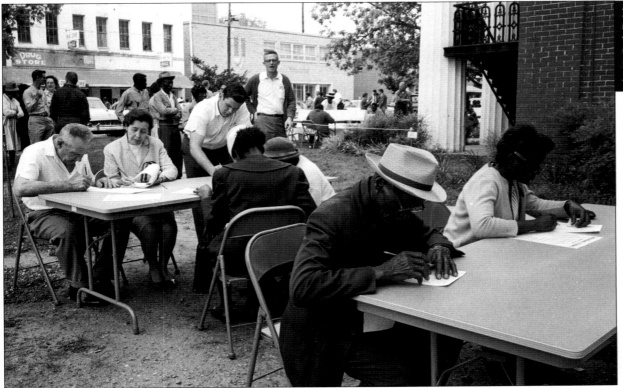

New black voters sit alongside white voters as they cast their first ballots in Camden, Alabama, in 1966.

In 1976, Prince Arnold of Camden, Alabama, becomes the first black sheriff elected in this century in this predominantly black county.

In Camden in 1966, an illiterate new black voter casts his ballot orally in the presence of a federal registrar under the new Voting Rights Act. The law reflected King's view that literacy tests should be abolished "in those areas where Negroes have been disadvantaged by generations of inferior, segregated education."

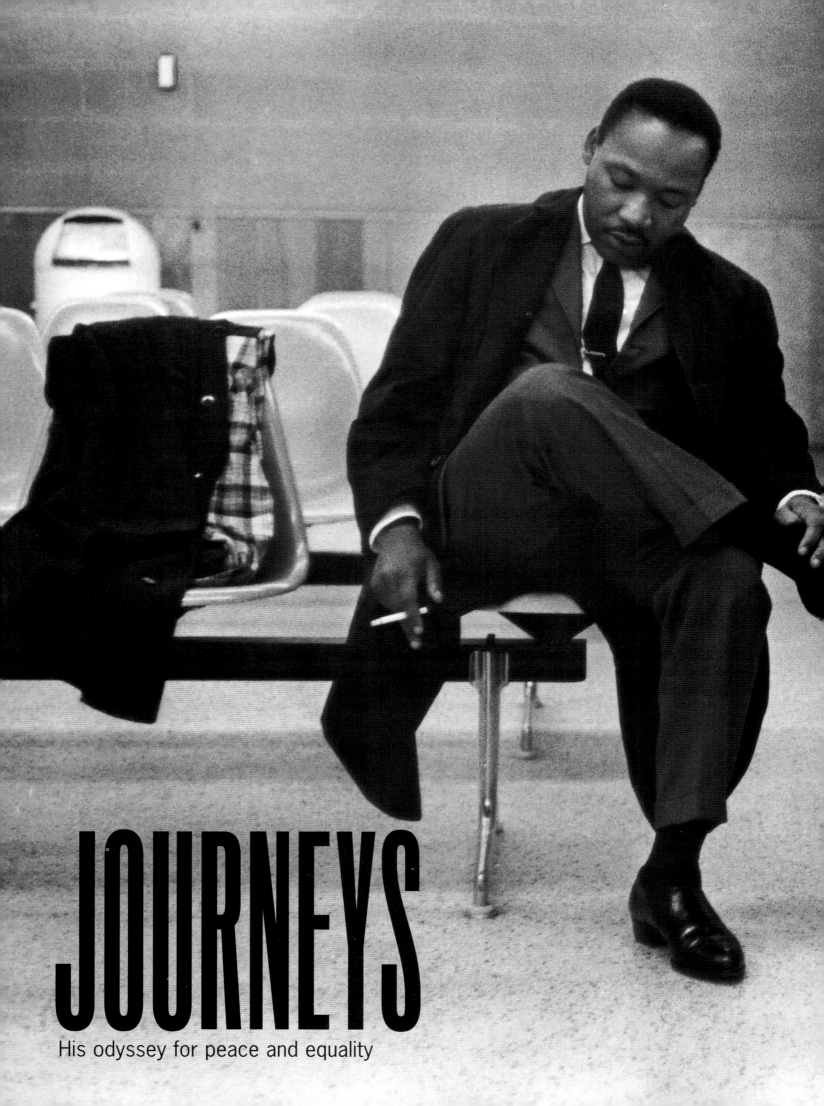

JOURNEYS

His odyssey for peace and equality

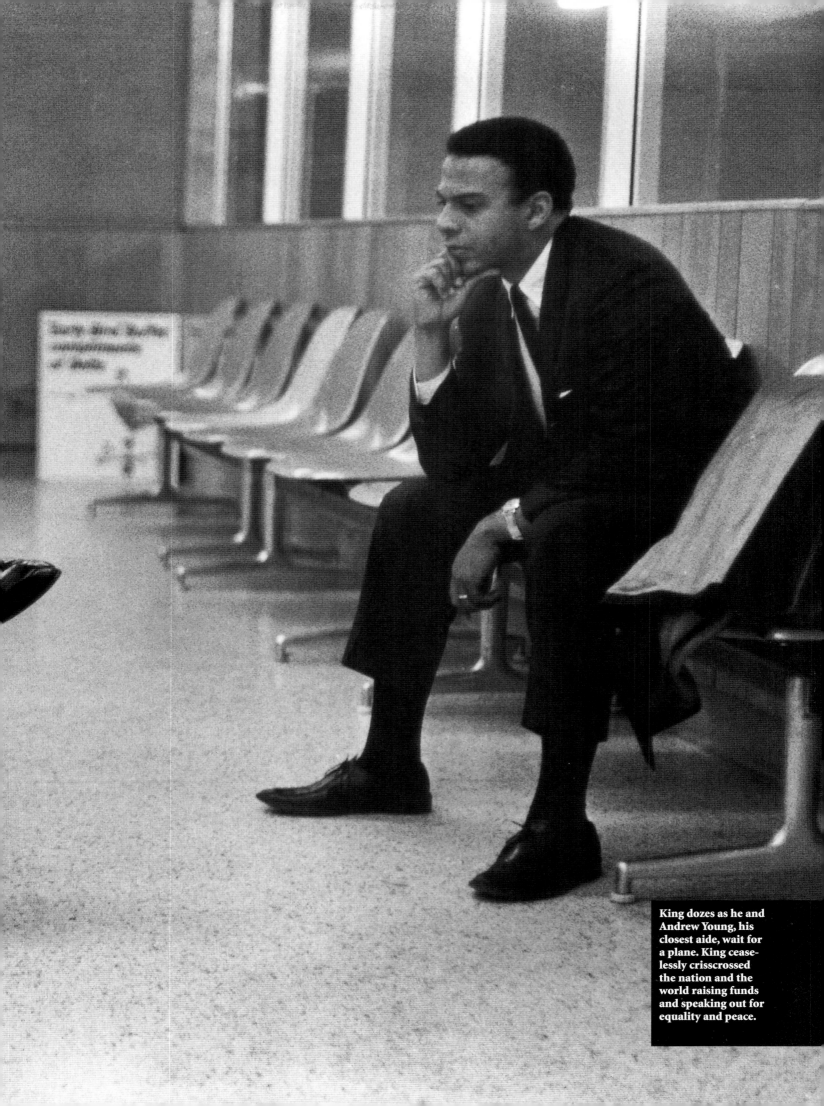

King dozes as he and
Andrew Young, his
closest aide, wait for
a plane. King cease-
lessly crisscrossed
the nation and the
world raising funds
and speaking out for
equality and peace.

JOURNEYS

This is a calling that takes me beyond national allegiances.
~MARTIN LUTHER KING, JR., 1967

Few men in the twentieth century seem as washed by all waters as Martin Luther King, Jr., whose travels during the thirteen years of his public life took him from Montgomery to Memphis, from cramped jail cells in the Jim Crow South to English cathedrals, from America's inner-city ghettos to ashrams in India. And the range of humanity touched by his life and vision—politicians, the rural poor, celebrities, and heads of state—

GHANA, 1957

Invited by Ghana's new president, Kwame Nkrumah, to attend the country's independence celebration, the Kings travel there in March 1957. In Accra they met Vice President Richard Nixon, and King pressed him to "come visit us down in Alabama" to see for himself how his fellow Americans were seeking the same kind of freedom that Ghana was about to enjoy.

appears, in retrospect, to include all of mankind's colors, classes, and castes.

We can only wonder: How did he do it? What inner resources enabled him—as a private citizen—to travel tens of thousands of miles each month, back and forth in a country as divided as it had been during the Civil War, maintaining a schedule more suited for a president than a preacher, and then to tirelessly traverse the entire war-wracked planet, West and East, delivering to thousands his unique message of redemption, brotherly love, and social revolution?

Perhaps these photos of his globetrotting provide a clue. Here, remarkably, was a genuinely universal man in black skin.

INDIA, 1959

Traveling in India as guests of the Gandhi Peace Foundation, King and his wife meet with Indian Prime Minister Jawaharlal Nehru.

BIRMINGHAM, 1960

Kenneth Kaunda, future president of Zambia, visits King and meets with members of the press in King's Birmingham office in 1960.

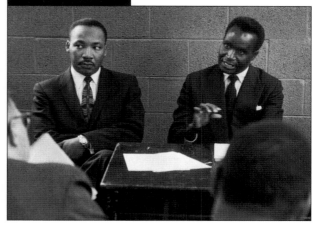

NEW YORK CITY, 1962

King amiably chuckles and chats with comedian Bob Hope, another driven world traveler, during an impromptu encounter at New York's Idlewild (now Kennedy) Airport.

Before entering the New Delhi shrine to Mohandas Gandhi, whose books, thinking, and methods he studied and adopted, King removes his shoes, a traditional sign of respect for the Mahatma. At the site he left a wreath of flowers and paused to pray.

— 215

DETROIT, 1963

At the high point of a triumphant freedom march through downtown Detroit, a turnout of one hundred thousand supporters fills Cobo Hall Arena as part of King's drive to rally support for the forthcoming March on Washington.

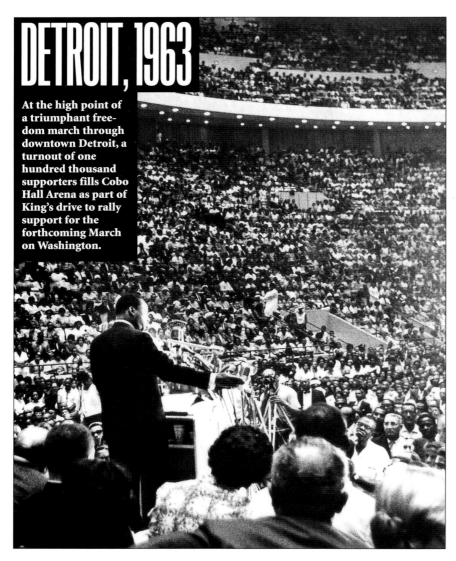

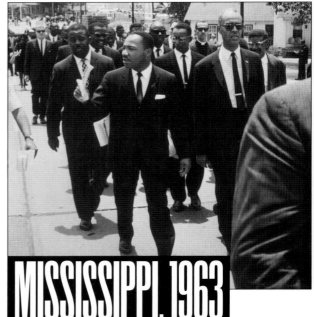

MISSISSIPPI, 1963

Joined by Roy Wilkins and Ralph Abernathy, King walks in the funeral procession for the assassinated Mississippi NAACP organizer Medgar Evers.

LONDON, 1964

Pausing in London on his journey to Oslo to receive the Nobel Peace Prize, King delivers his memorable sermon "The Three Dimensions of a Complete Life" at St. Paul's Cathedral. King was the first non-Anglican to preach in the church.

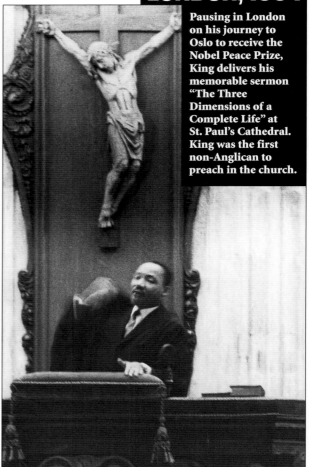

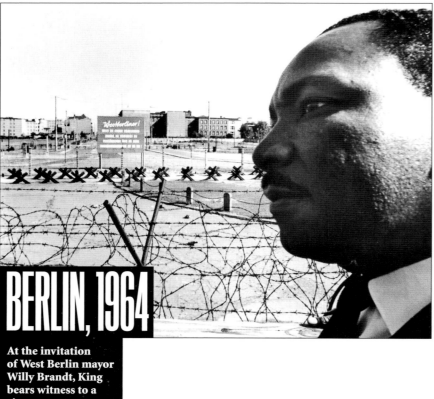

BERLIN, 1964

At the invitation of West Berlin mayor Willy Brandt, King bears witness to a city, a country, and a people who are divided.

216 —

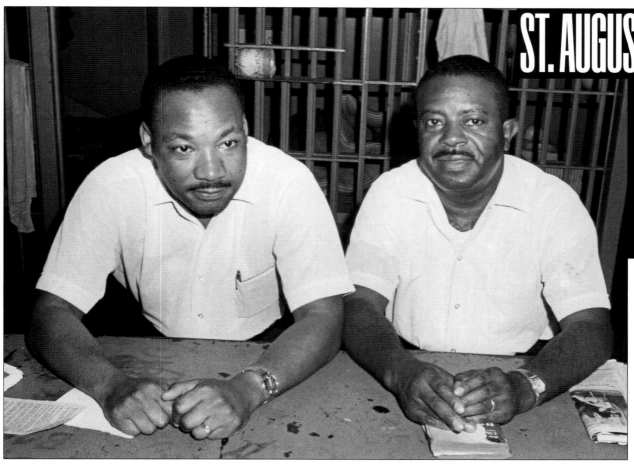

ST. AUGUSTINE, 1964

Arrested for trespassing as they tried to integrate restaurants in St. Augustine, Florida, King and Abernathy are held in the St. John's County Jail. King, by this time quite knowledgeable, opined, "This is one of the nicest jails I've ever been in."

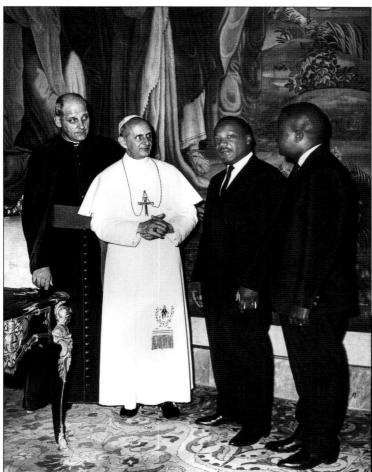

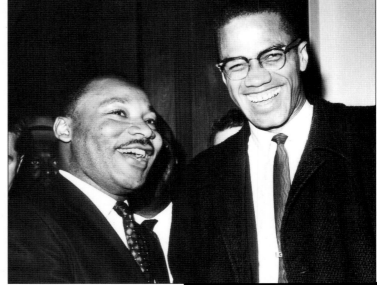

VATICAN, 1964

Baptist ministers King and Abernathy have a private audience with Pope Paul IV at the Vatican. The pontiff promises that he will issue a statement on interracial relations.

WASHINGTON, 1964

By happenstance, King and Malcolm X meet face-to-face for the first and, regrettably, only time in Washington. They usually disagreed, but now they both speak out against a possible filibuster on the Civil Rights Act of 1964.

WATTS, 1965

Angry Watts residents heckle King, who is trying to restore calm. They are questioning his grasp of their grievances. King had canceled a scheduled vacation in Puerto Rico to travel to Los Angeles in the wake of the devastating Watts riot.

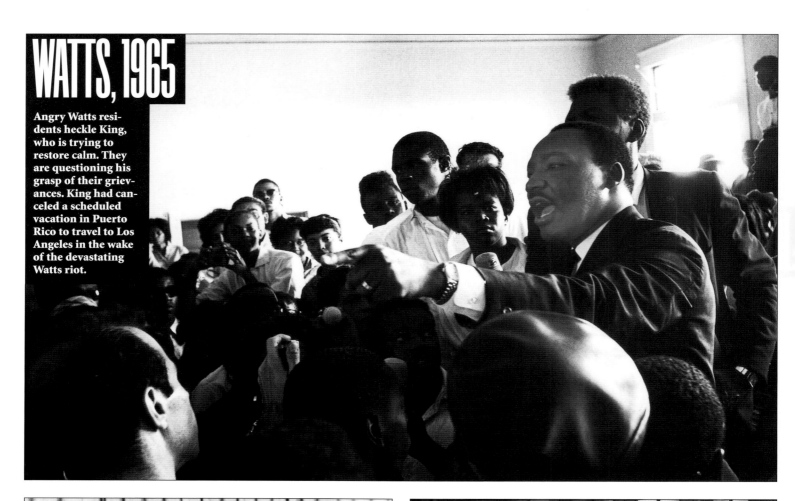

DETROIT, 1964

Teamsters union president Jimmy Hoffa supports King's civil rights work with a $25,000 check. King accepts the donation at the Detroit funeral parlor where he is paying his respects to the slain white Selma marcher Viola Liuzzo.

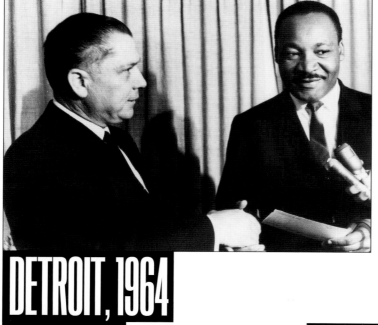

NEW YORK, 1965

Sammy Davis, Jr., an enthusiastic supporter, shares a laugh with King, who has come backstage to the star's dressing room to congratulate Davis after seeing him in *Golden Boy*.

MISSISSIPPI, 1966

UNITED NATIONS, 1966

Senator Edward Kennedy of Massachusetts and Martin Luther King chat at a SCLC banquet in Jackson, Mississippi, in August 1966. Probably no one else in the Senate was more sympathetic to King's goals.

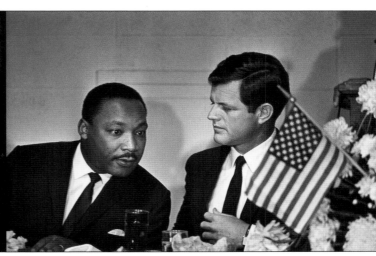

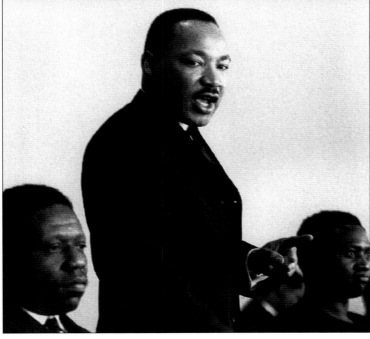

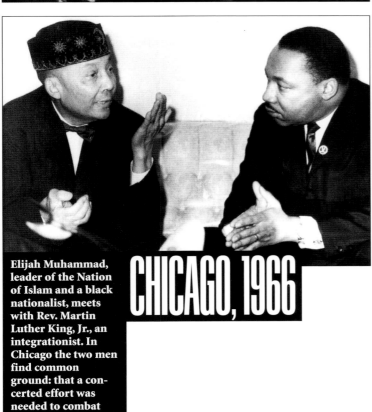

CHICAGO, 1966

Elijah Muhammad, leader of the Nation of Islam and a black nationalist, meets with Rev. Martin Luther King, Jr., an integrationist. In Chicago the two men find common ground: that a concerted effort was needed to combat slum conditions.

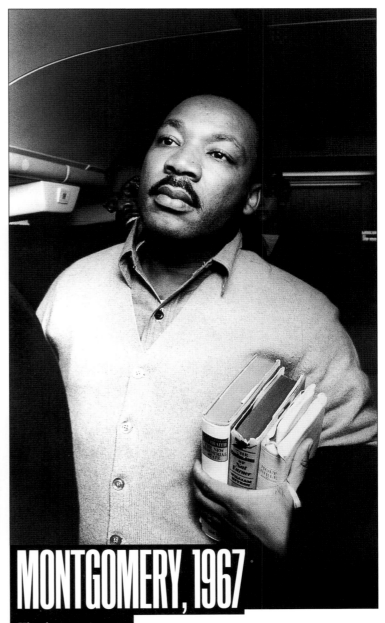

MONTGOMERY, 1967

King is en route to Montgomery to serve a short sentence for a conviction dating back to Birmingham. He is armed with books, one of which is the Bible.

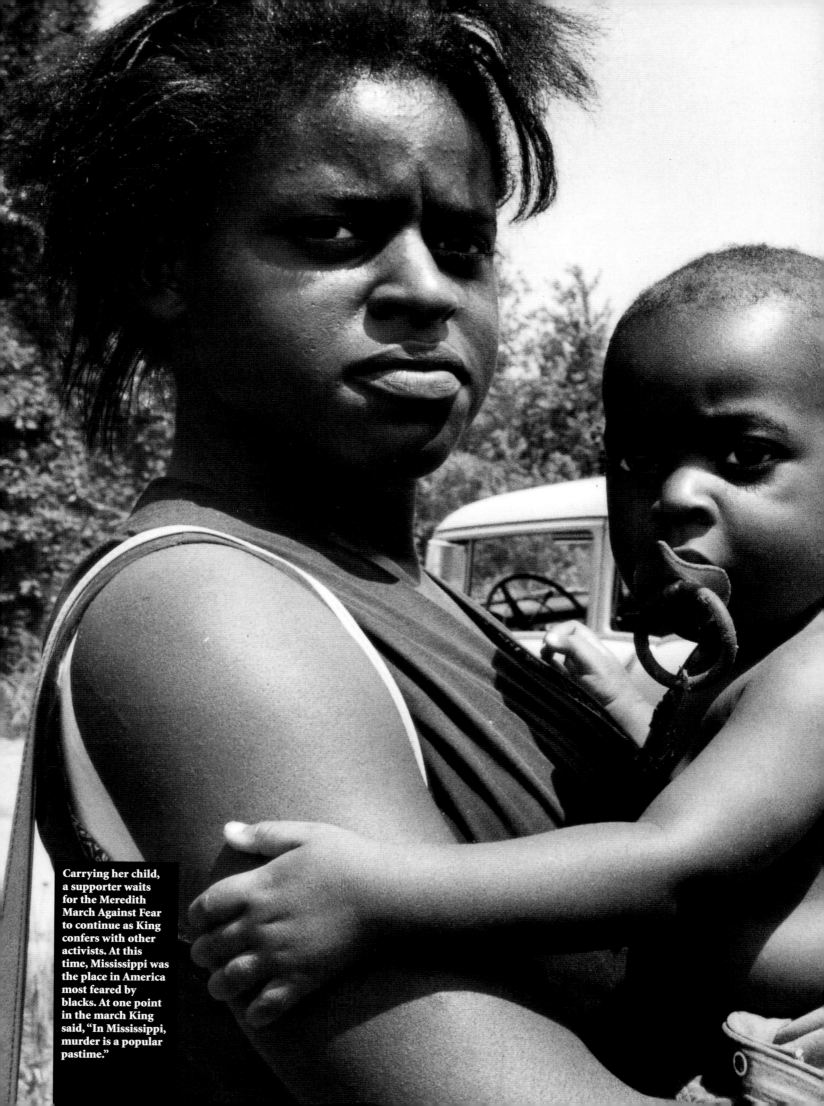

Carrying her child, a supporter waits for the Meredith March Against Fear to continue as King confers with other activists. At this time, Mississippi was the place in America most feared by blacks. At one point in the march King said, "In Mississippi, murder is a popular pastime."

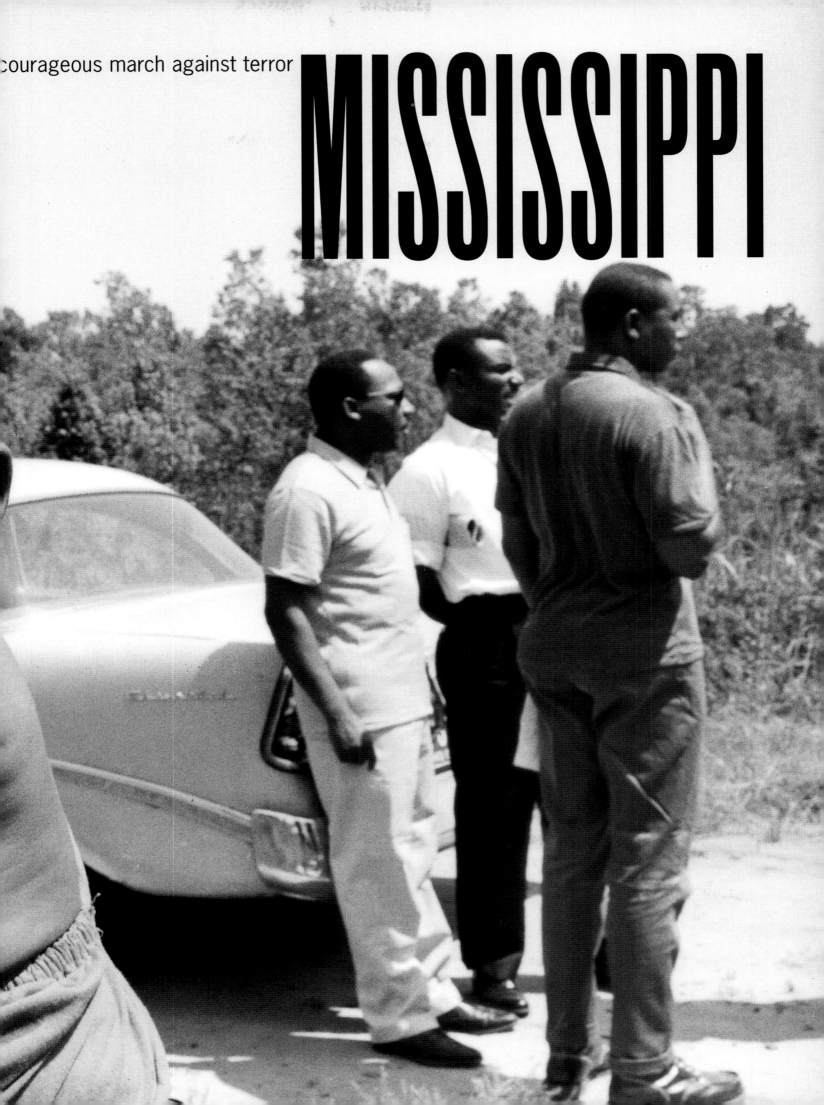

courageous march against terror

MISSISSIPPI

MISSISSIPPI

I've decided that I'm going to do battle for my philosophy.... I can't make myself believe that God wants me to hate. I'm tired of violence…and I'm not going to let my oppressor dictate to me what method I must use.

~MARTIN LUTHER KING, JR.,
MISSISSIPPI, 1966

Selma's interracial "coalition of conscience," which in King's philosophy was the first step toward realizing the "beloved community," began to fray fifteen months later in Mississippi on a lonely stretch of Highway 51. There James Meredith, who in 1962 had integrated the University of Mississippi, was shot in the back as he and four friends conducted a personal march that began in Memphis, Tennessee. After hearing the news, King went immediately from Atlanta to Meredith's side at Municipal Hospital in Memphis. He was joined by Floyd McKissick of CORE and SNCC's new chairman, Stokely Carmichael. They convinced Meredith to let them continue his march so that Mississippians would know threats of death would not stop or slow down the progress of black freedom.

On June 8, they began at the site where Meredith was shot. State police reluctantly served as their protection. While King may have been wary in 1966 of potential white assassins like the one who felled Meredith, and while he was acutely conscious of J. Edgar Hoover's relentless efforts to discredit him after he received the Nobel Prize, he was completely unprepared for those on the march who were determined to wrest leadership of the movement away from him. As they traipsed two hundred miles through the heat for three weeks and registered five hundred blacks in Grenada, he heard the voices of those who rejected nonviolence. He learned that Carmichael, founder of the Lowndes County Freedom Party (which used the figure of a leaping black panther as its symbol), was eager to expel "white phonies and liberals" from the struggle. Some

Speaking at an evening rally in Greenwood, Mississippi, Stokely Carmichael calls for "black power." His cry, so different from King's "freedom now," created a division between SNCC and SCLC during the march.

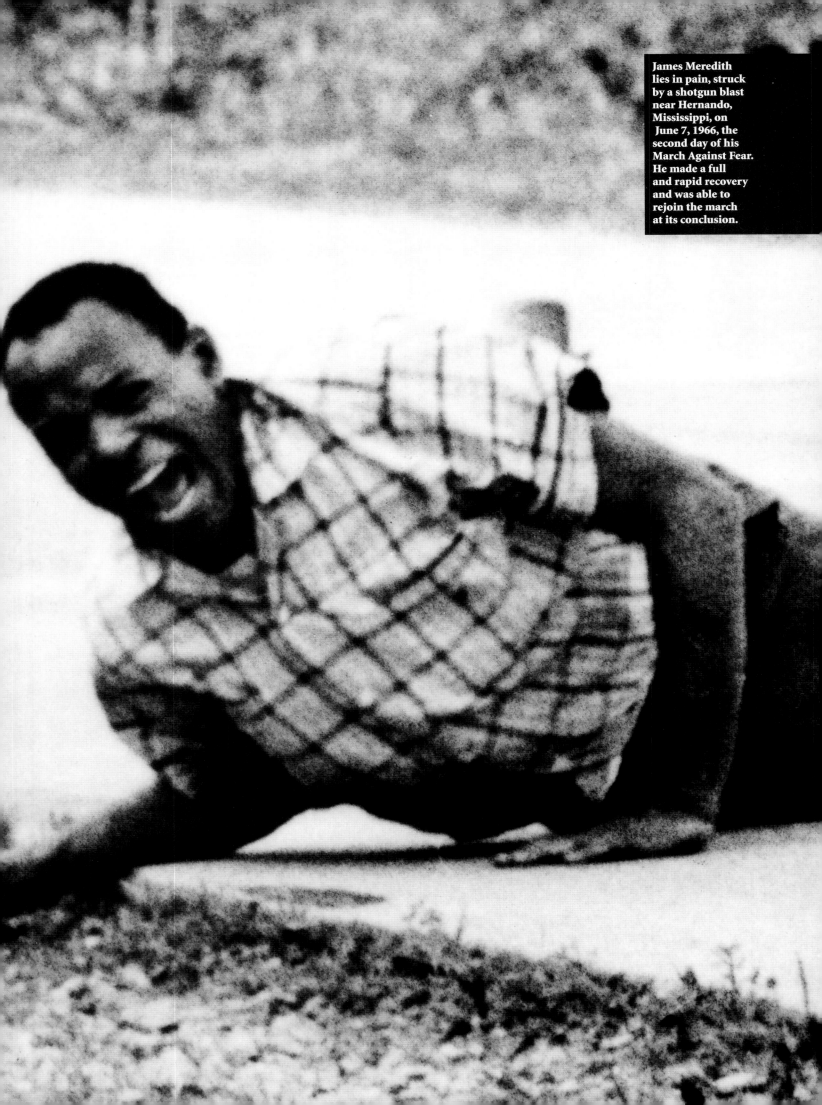

James Meredith lies in pain, struck by a shotgun blast near Hernando, Mississippi, on June 7, 1966, the second day of his March Against Fear. He made a full and rapid recovery and was able to rejoin the march at its conclusion.

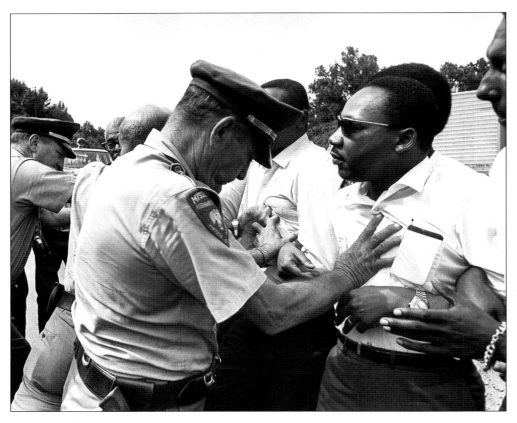

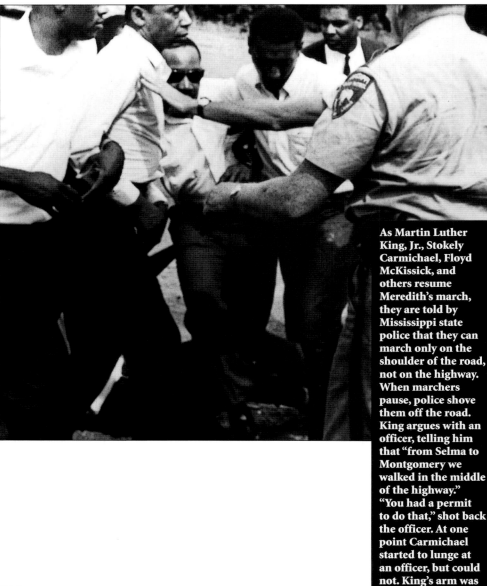

As Martin Luther King, Jr., Stokely Carmichael, Floyd McKissick, and others resume Meredith's march, they are told by Mississippi state police that they can march only on the shoulder of the road, not on the highway. When marchers pause, police shove them off the road. King argues with an officer, telling him that "from Selma to Montgomery we walked in the middle of the highway." "You had a permit to do that," shot back the officer. At one point Carmichael started to lunge at an officer, but could not. King's arm was locked in his.

marchers, King saw, would not sing the stanza "Black and white together" when he led them in "We Shall Overcome." More startling to King, some said they preferred the words "We Shall Overrun."

At night, King, whose unitive vision and Christian values were under attack, argued with Carmichael and McKissick over the very moral premises that had made the revolution begun in Montgomery and carried through to Selma something special in American history, as Gandhi's approach had been in India: justice achieved through love, not hate; social evolution accelerated by peaceful protest, not fratricide. His appeal fell on deaf ears. McKissick dismissed nonviolence as no longer practical; Carmichael held out for an all-black march. Their positions so disturbed Roy Wilkins and Whitney Young, who were also present, that they decided on principle to bail out of the march. King threatened to do so, too, and at that point the young militants agreed to follow his direction for the remainder of the James Meredith March Against Fear.

When the marchers reached Greenwood, where SNCC had been active since 1964, Carmichael declared during a mass meeting in a city park, "What we need is black power," and for the first time that hypnotic, Nietzschean phrase—so similar to the fascist cry for "white power"—entered into the lexicon of the civil rights movement, changing its character forever. From the first, its potential misuse troubled King, though he unequivocally supported black economic and political power, black pride, and the nurturing of black culture. But in the slogan he sniffed danger; indeed, it contained the repudiation of all he had achieved, all he stood and fought for, all he envisioned when he said, "We are all caught in an inescapable network of mutuality, tied in a single garment of destiny. Whatever affects one directly, affects all indirectly." For five hours he pleaded to no avail with the young militants to abandon it, caught between the Scylla of integration and Charybdis of racial separatism, the two dominant, undying antinomies of black thought since the nineteenth century. That ancient ideological divide only

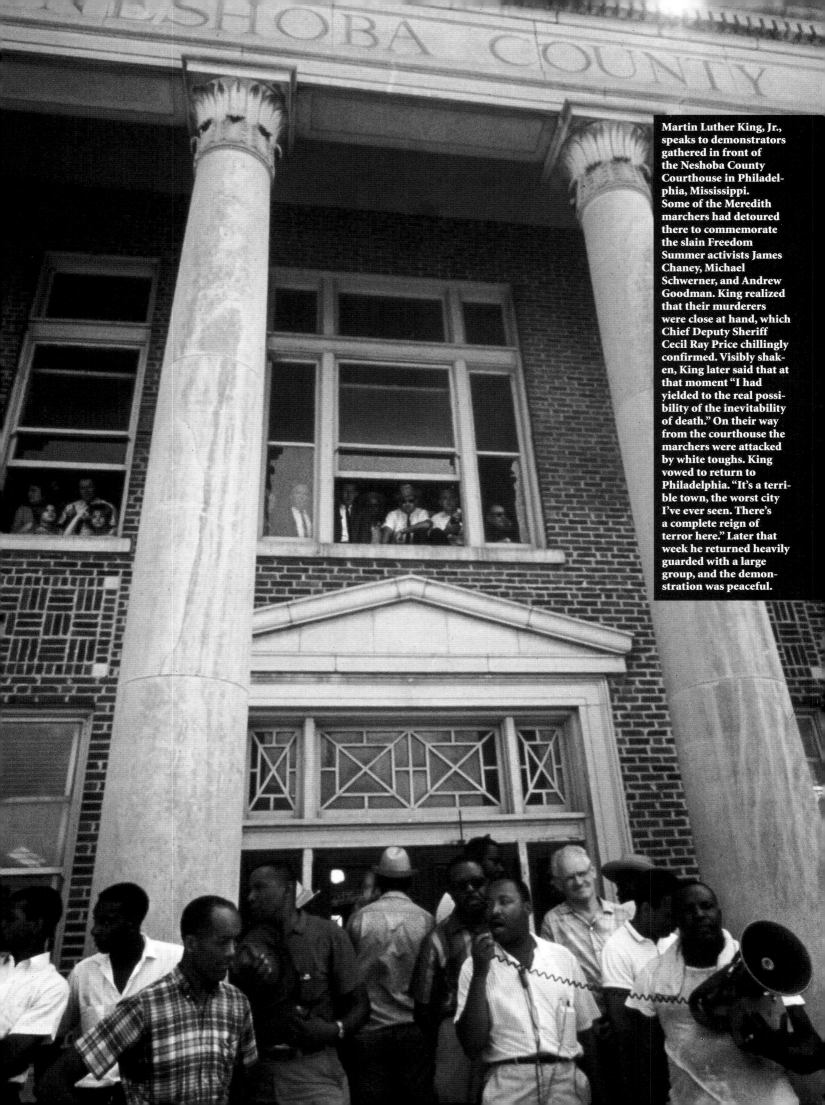

Martin Luther King, Jr., speaks to demonstrators gathered in front of the Neshoba County Courthouse in Philadelphia, Mississippi. Some of the Meredith marchers had detoured there to commemorate the slain Freedom Summer activists James Chaney, Michael Schwerner, and Andrew Goodman. King realized that their murderers were close at hand, which Chief Deputy Sheriff Cecil Ray Price chillingly confirmed. Visibly shaken, King later said that at that moment "I had yielded to the real possibility of the inevitability of death." On their way from the courthouse the marchers were attacked by white toughs. King vowed to return to Philadelphia. "It's a terrible town, the worst city I've ever seen. There's a complete reign of terror here." Later that week he returned heavily guarded with a large group, and the demonstration was peaceful.

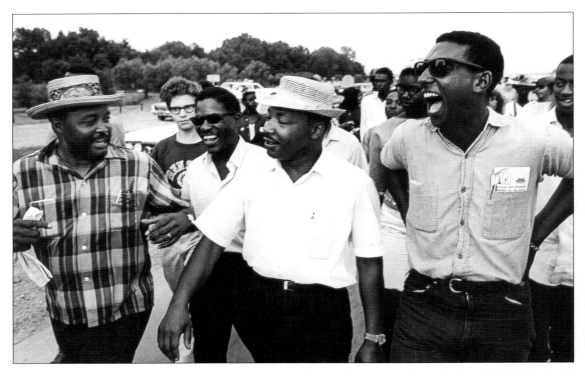

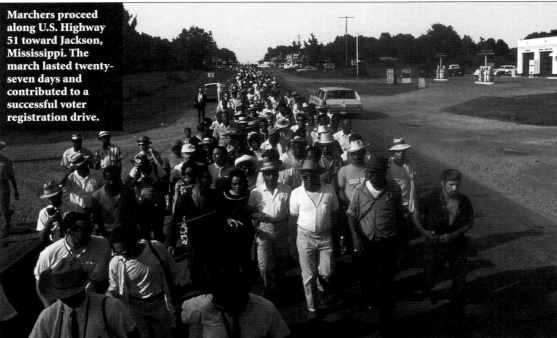

Marchers proceed along U.S. Highway 51 toward Jackson, Mississippi. The march lasted twenty-seven days and contributed to a successful voter registration drive.

widened as the march moved on and Carmichael's factions urged crowds to chant "black power!" competing in volume and vision with King's followers shouting, "freedom now!"

"Martin," Carmichael finally confessed, "I deliberately decided to raise this issue on the march in order to give it a national forum, and force you to take a stand for black power." To which King said, laughing, "I've been used before. One more time won't hurt." (But surely it must have hurt.)

More trouble awaited King up the road in Philadelphia, Mississippi, where

Goodman, Chaney, and Schwerner had been murdered, and the two policemen implicated in their deaths (Sheriff Lawrence Rainey and Deputy Cecil Ray Price) were free and still on duty. As he spoke at a memorial for the slain civil rights activists, a white mob attacked the marchers while the state troopers ordered to protect them simply watched. Things began to unravel quickly: Bone-weary marchers were attacked at their campsite. Then on June 23 in Canton, officials rejected their request to camp in a black elementary-school yard. When they tried to bivouac anyway, police smothered the

area with tear gas and tore so viciously into the marchers, forcing them to seek refuge in a black church, that those who remembered Selma declared this assault worse than Bloody Sunday. Twice King telegrammed the White House, demanding the federal government intervene. Twice he got no reply from President Johnson, who, King now suspected, remained silent because of King's recent opposition to the Vietnam War.

And SNCC was now in control of the march. Its members banned the NAACP from a final gathering in Jackson at the state capitol, and refused to return with

King and a contingent of three hundred to Philadelphia, where he had had one of the most harrowing experiences of his life. He and Abernathy had prayed on the courthouse steps for Schwerner, Goodman, and Chaney. King had said, sotto voce, "I believe the murderers are somewhere around me at this moment," and from behind him he had heard someone say, "You're damn right, they're right behind you."

After that chilling incident, from which King had been doubtful he'd escape alive, he moved on to march from Tougaloo College to the state capitol in Jackson. The crowd that day was at fifteen thousand, and James Meredith joined them, along with King's wife and his two oldest children. On the surface they could celebrate the largest gathering of blacks in Mississippi's history and the completion of Meredith's journey. But beneath the festive atmosphere in the capital the movement had been irreparably fractured and Carmichael elevated to the status of Malcolm X's heir.

And King? The apostle of peaceful protest had yet to face new dangers, dilemmas, and disappointments in the nation's most segregated northern city.

King looks warily past CORE's McKissick at Stokely Carmichael, concerned by the divisive effect of Carmichael's cry for black power. Despite the battle of slogans, the march began to loosen the grip of terror that had made Mississippi notorious.

King shoots pool with Chicago teenagers trying to gain their trust and support for his non-violent campaign against segregation in the North. He was trounced badly in a game at this time, and he realized that disuse had eroded his old pool-shark skills.

CHICAGO

Going north, King is stymied

CHICAGO

I've been in many demonstrations all across the South, but I can say that I have never seen, even in Mississippi and Alabama, mobs as hostile and as hate-filled as I've seen in Chicago.

~MARTIN LUTHER KING, JR.,
CHICAGO, 1966

Activist Al Raby, above right, invited King to the city, where King found the difficulties he encountered daunting. He saw that segregation created a dual school system, a dual economy, and a dual housing market. His goal was "to transform this duality into a oneness."

Here the enemy was not only the redneck, sometimes it was the black face. It was all those forces that represented the self-interest in perpetuating the evil machine.

~JESSE JACKSON

How strange that Chicago, the country's "Second City," could be Albany all over again, especially after the stunning conquest in Selma.

One might think, looking at King's inaugural campaign in the North, that the lessons of his victories in three Alabama cities had been forgotten. Or perhaps it was simply the fact that those southern lessons—and Gandhian satya-graha (soul force)—couldn't be easily grafted onto big-shouldered, hog-butchering, industrialized Bigger Thomas country. As I described in my fourth novel, *Dreamer,* in 1966 Chicago was an ethnically balkanized city with a murder rate of slightly more than two people per day (so I learned when working as a *Chicago Tribune* intern in the late 1960s). It was the home of Elijah Muhammad's Nation of Islam and young militant blacks (some in gangs like the Cobras, Vice Lords, and Black Stone Rangers) for whom nonviolence in the face of white racism was perceived as unacceptable, if not downright unmanly—youths inspired by Stokely Carmichael's chant of "black power" the month before during the Mississippi march. It was a city where Negroes earned an average of $4,700 yearly and some black families were crammed ten to a flat—for the privilege of such claustrophobic lodgings slum-lords charged them $90 per month. Blacks were squeezed into 10 percent of the city, with only 4 percent living in the suburbs, where homes ran as high as $15,000. No, this was worlds away from Alabama. Among its most notable former residents was Al Capone. Politically, it was the fiefdom of Mayor Richard "Boss"

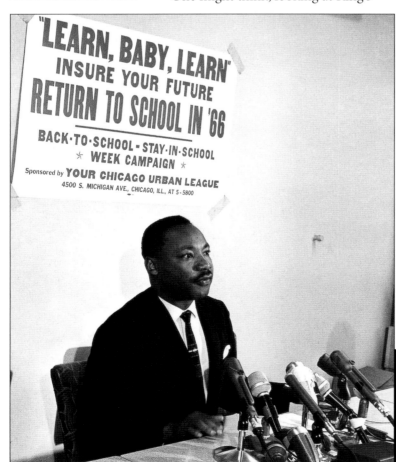

At a press conference, King criticizes Chicago's sub-standard black schools and proposes education as a tool for attacking poverty.

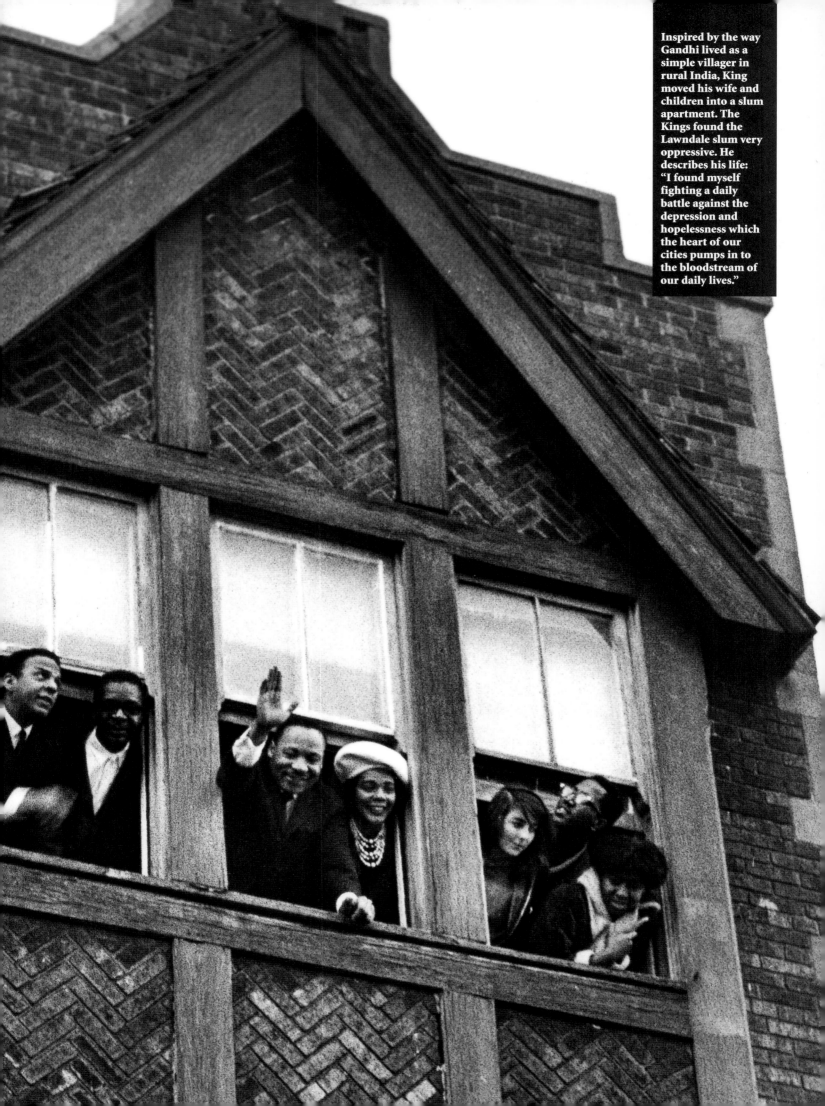

Inspired by the way Gandhi lived as a simple villager in rural India, King moved his wife and children into a slum apartment. The Kings found the Lawndale slum very oppressive. He describes his life: "I found myself fighting a daily battle against the depression and hopelessness which the heart of our cities pumps in to the bloodstream of our daily lives."

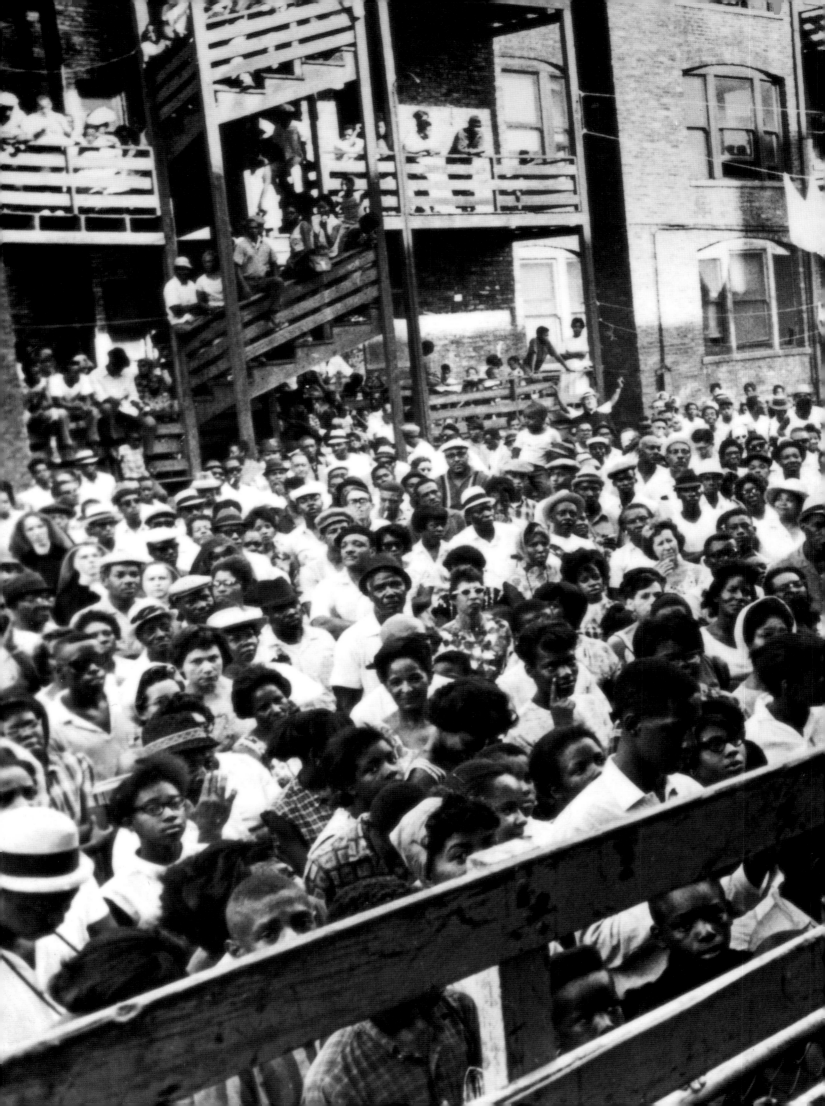

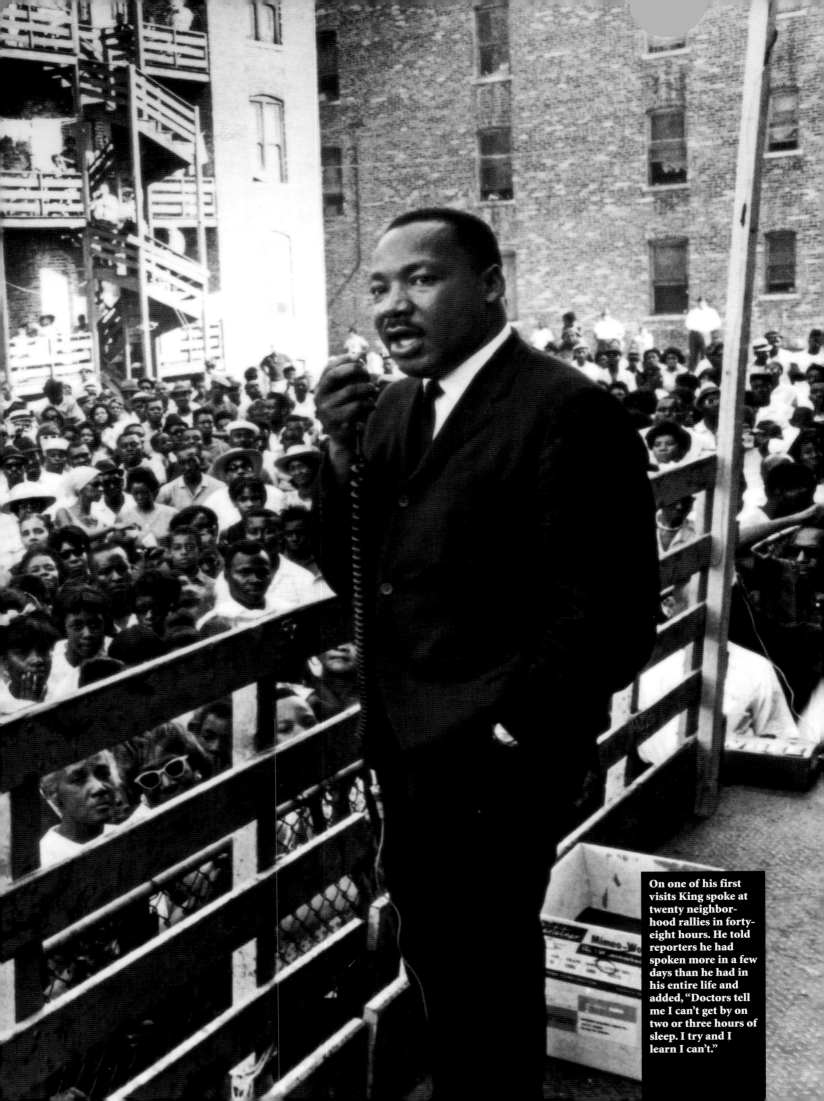

On one of his first visits King spoke at twenty neighborhood rallies in forty-eight hours. He told reporters he had spoken more in a few days than he had in his entire life and added, "Doctors tell me I can't get by on two or three hours of sleep. I try and I learn I can't."

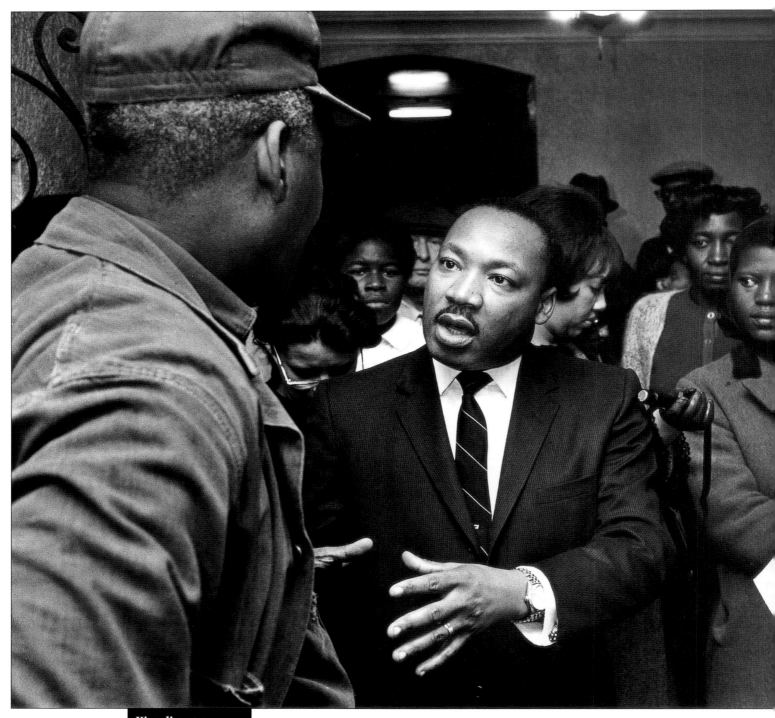

Daley, who cheered King's successes in the South but was not about to acknowledge severe racial problems in his own bailiwick, oh no; and it was the home for blacks more intimately familiar with (and beholden to) the Daley Machine and ward politics than King.

Who, as in Albany, arrived in Chicago in January 1966 without crisply defined goals or an original script sensitive to this city's unique spirit and complex history. Here the villains were not rural buffoons like Connor and Clark. They were abstract, faceless institutions: banks, real-estate agents, insurance companies, and

white landlords barely better off than their black tenants. To demonstrate the plight of the city's poor, the SCLC (headed in Chicago by Jesse Jackson) and the Coordinating Council of Community Organizations (CCCO) leased for King and his family a Lawndale flat at 1550 South Hamlin Street, a place so unpleasant his wife sighed, "There's nothing green in sight." As the campaign drew on, King saw in his children the gradual toll that can be taken by slums and concrete and de facto segregation.

For good reason the Chicago campaign is only briefly sketched in many

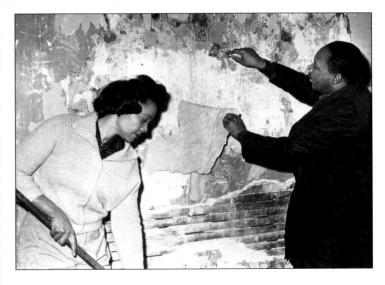

Calling attention to the abysmal living conditions of Chicago's poor and making a constructive effort to improve them, King and his wife join a group of activists in cleaning up a building in a west side ghetto. As they began to help tenants, King's apartment became an unofficial clearinghouse for complaints and remedies, and it fostered the Movement to End Slums, which helped with repairs and assisted rent strikes against slumlords.

movement histories. On July 1 King addressed an audience of thirty-five thousand at Soldier Field, then led them to City Hall where, like his namesake Martin Luther four centuries earlier, he fastened his demands for the poor on the door—a list that included public school integration, increasing the budget for schools, expanding mass transit, building cheap public housing, and support for black banks. But a few days later, when police turned off the fire hydrants black kids played in to escape the withering Midwestern heat, the city erupted in a riot, leaving two dead and hundreds in

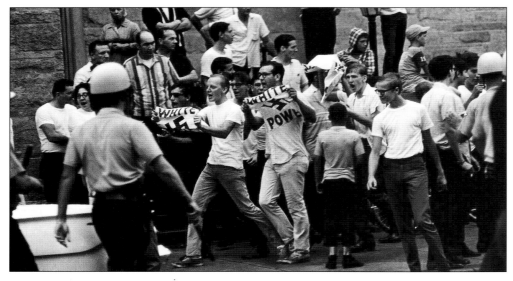

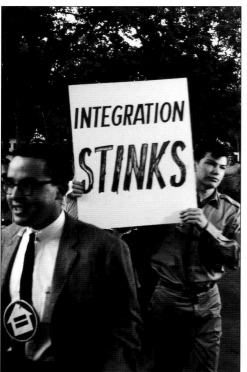

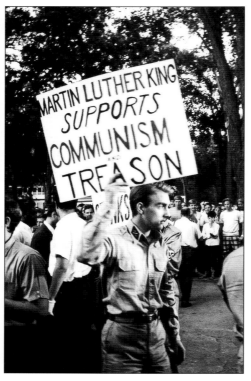

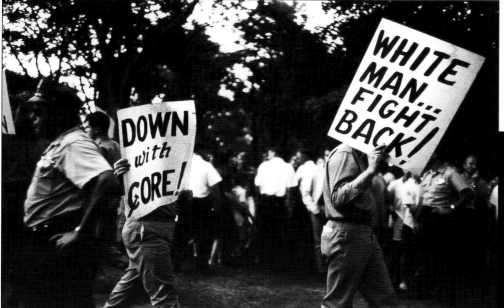

detention. The National Guard was called in, and King spent three hellish nights rushing from one burning slum to another, pleading with young rioters to stop.

Undaunted, he continued the marches through white neighborhoods, populated by Polish, German, and Italian residents who constantly fought among themselves but bonded long enough (urged to do so by George Lincoln Rockwell, head of the American Nazi Party) to pour from their homes, hysterically screaming venomous racial obscenities at the marchers. Gun sales soared in Slavic neighborhoods. During one such trek of six hundred people from Marquette Park, with gang members recruited as nonviolent marshals, King was struck in the head by a rock and barely missed a knife thrown in his direction.

Cicero was long known as a no-man's land for the black. Indeed, when I was growing up in Evanston, Illinois, it was commonly understood that it was prudent for a black person to gas up before entering Cicero, then pray the car did not break down before the town's last street was in the rearview mirror. King and the other leaders declared they would march there. Cook County Sheriff Richard Ogilvie rightly called this idea "suicide." King refused to back down. That meant Mayor Daley had to come to the conference table to avoid a bloodbath. The meeting took place at the Palmer House. Among its participants were members of the Chicago Real Estate Board, the Housing Authority, SCLC, Archbishop John Cody, and business leaders. In the Summit Agreement they hammered out promises for the city to promote fair housing practices, encourage legislation, and make color-blind bank loans.

As King and his followers march into a white neighborhood, youths scream at them and hold up racist signs. Such hostility in the North shocked King. He observed, "Swastikas blossomed in Chicago's parks like misbegotten weeds." Yet he continued to believe that most whites favored integration.

236 —

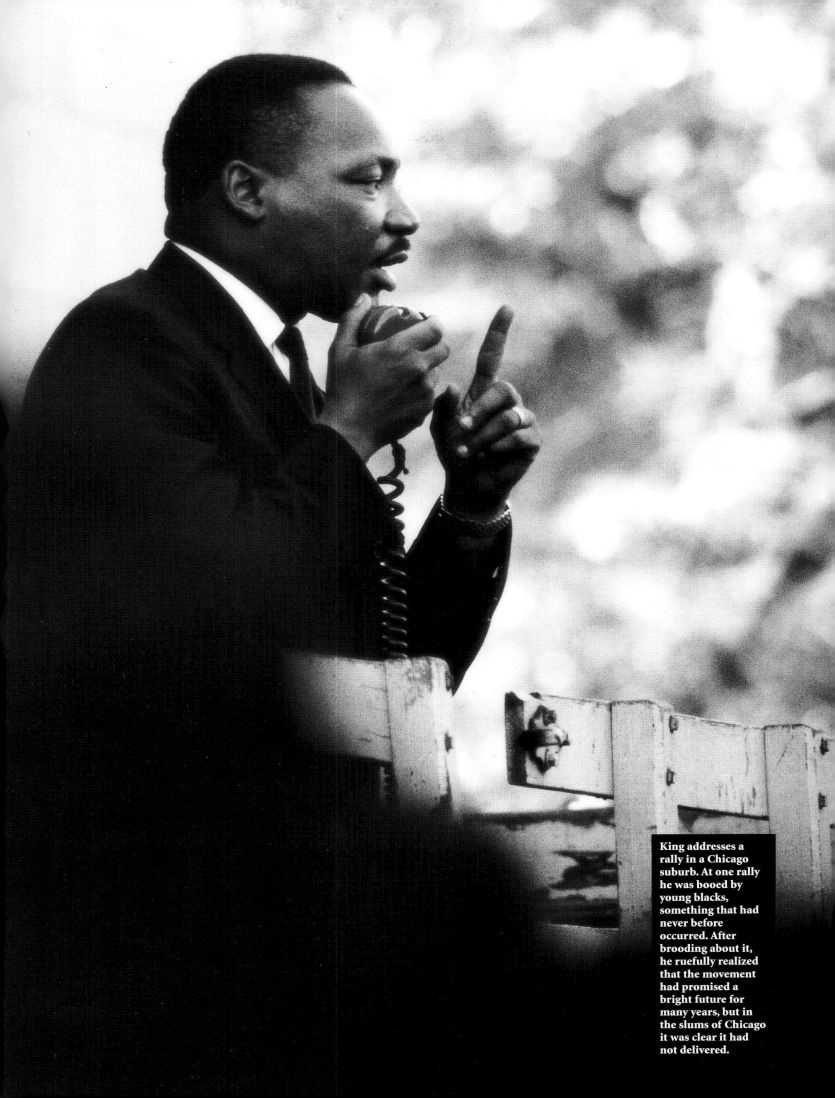

King addresses a
rally in a Chicago
suburb. At one rally
he was booed by
young blacks,
something that had
never before
occurred. After
brooding about it,
he ruefully realized
that the movement
had promised a
bright future for
many years, but in
the slums of Chicago
it was clear it had
not delivered.

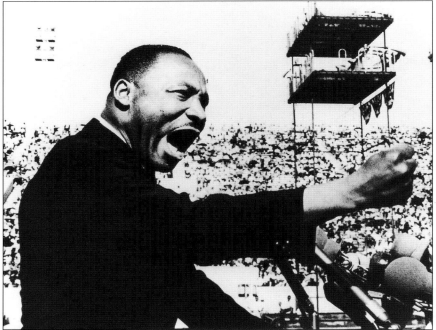

For some members of SNCC and CORE the agreement was a sellout. It had no guarantees, no schedule, nothing but good intentions. Without King's endorsement, CORE sent two hundred protesters into lily-white Cicero in September, protected by National Guardsmen. The violence was severe, and the marchers were forced to fall back to Lawndale.

"Morally," King said at a west side church after the Summit Agreement, "we ought to have what we say in the slogan 'freedom now.' But it doesn't all come now. That's a sad fact of life you will have to live with." Seeds that would require years to grow were at least planted during the Chicago campaign, activism that blossomed into a local chapter of Operation Breadbasket, directed by Jesse Jackson, then Operation PUSH (People United to Save Humanity).

Chicago signaled yet another, perhaps more troubling (for King) change in the racial temperature of the times. The Zeitgeist of black activism was clearly moving away from nonviolent civil disobedience and brotherhood. (King was booed by some blacks in Chicago.) Perhaps King, even he, sensed that the hour for his idealistic, morally demanding philosophy of reconciliation and redemption and personal transcendence was over, and that the new, reactionary winds of social change would never blow Gandhian or Galilean notes again in his lifetime.

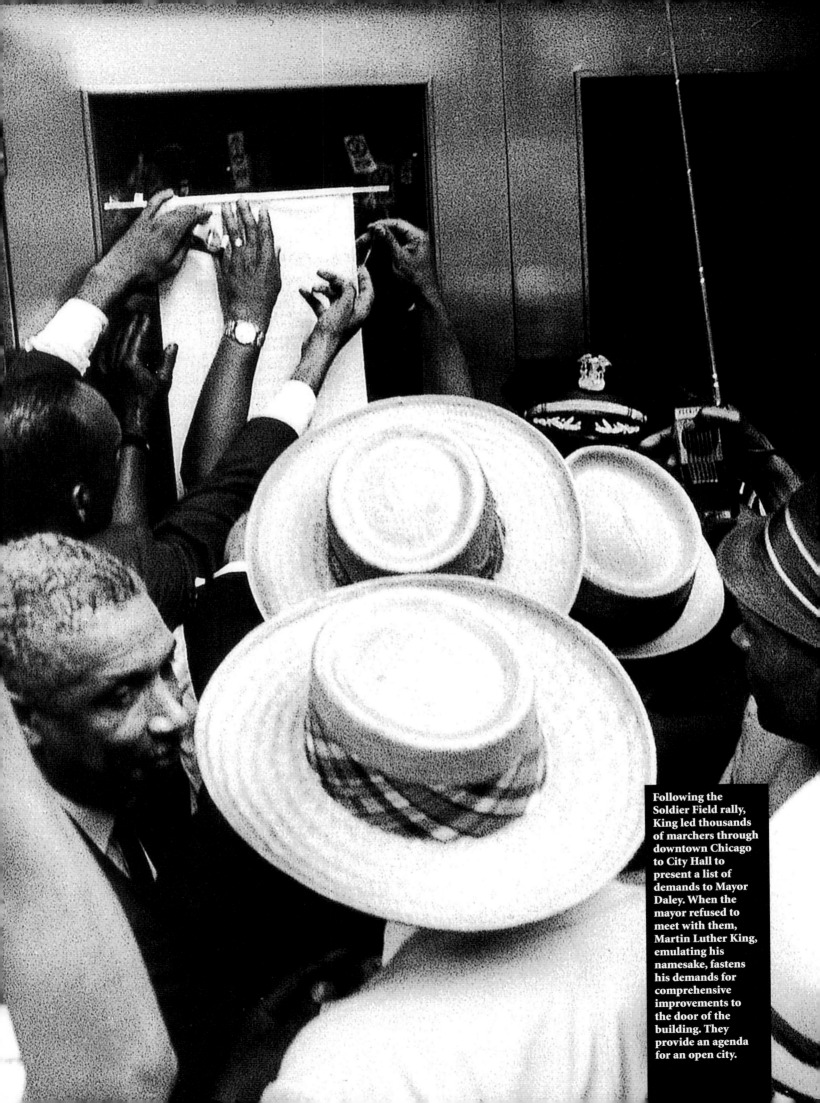

Following the Soldier Field rally, King led thousands of marchers through downtown Chicago to City Hall to present a list of demands to Mayor Daley. When the mayor refused to meet with them, Martin Luther King, emulating his namesake, fastens his demands for comprehensive improvements to the door of the building. They provide an agenda for an open city.

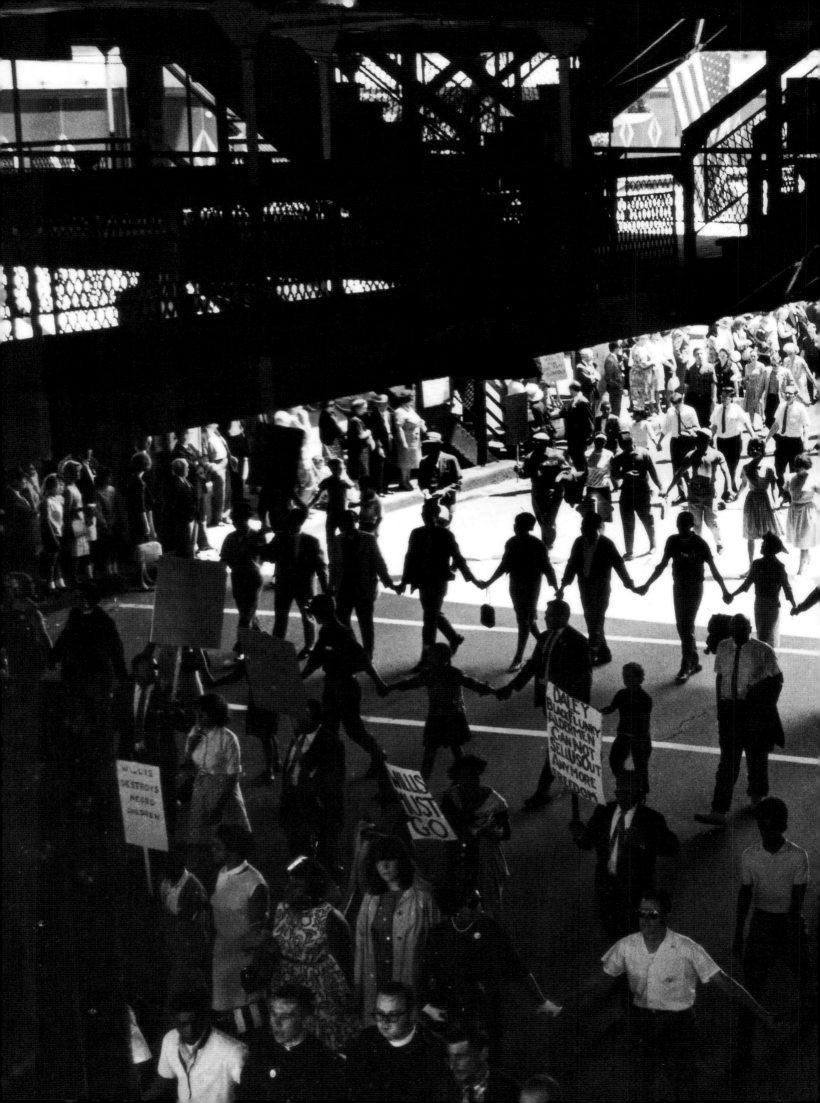

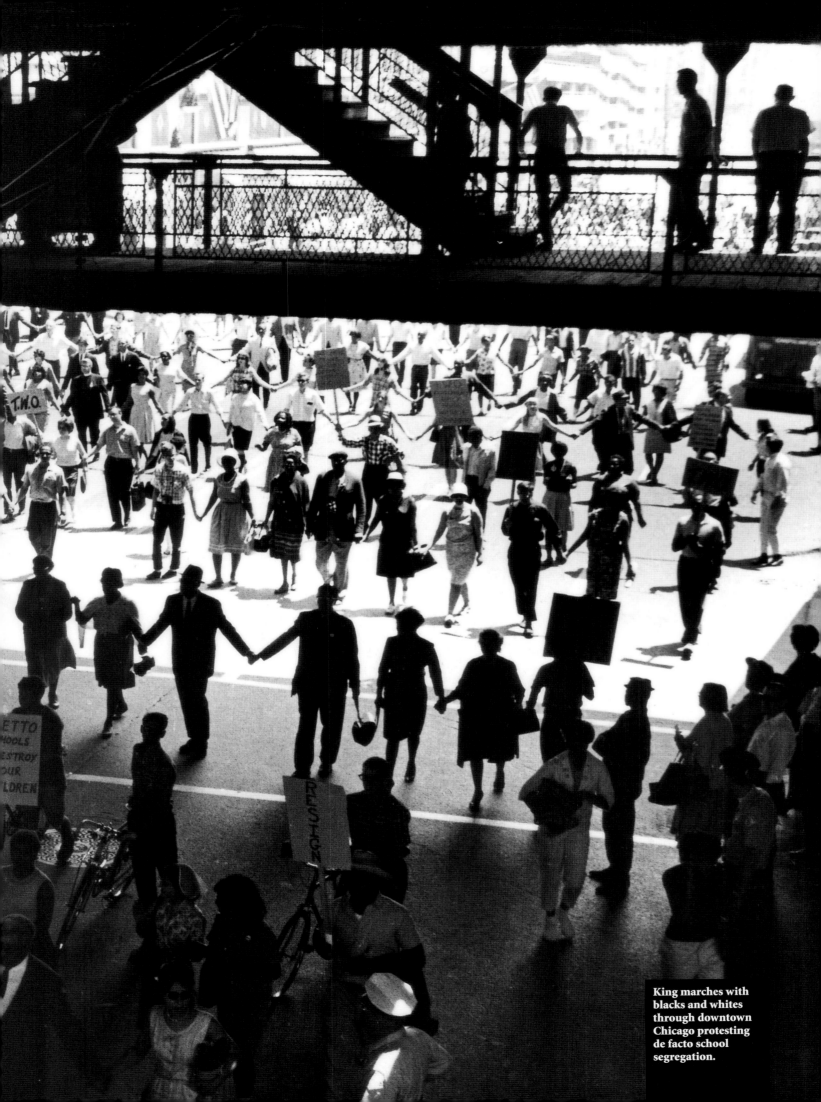

King marches with blacks and whites through downtown Chicago protesting de facto school segregation.

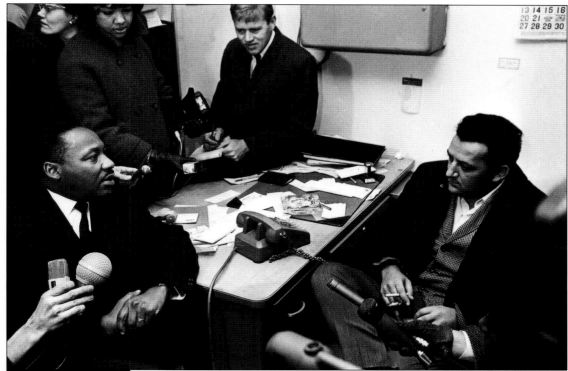

As part of his campaign, King met with real-estate and city officials, including the mayor, to discuss remedying slum conditions.

Rev. Jesse Jackson worked closely with King during the Chicago campaign. Jackson, still a divinity student in 1965, began building support among that city's ministers for the Chicago campaign. Jackson also set up a Chicago branch of Operation Breadbasket, an SCLC program that used negotiations and boycotts to encourage businesses, especially those with black customers, to hire black employees.

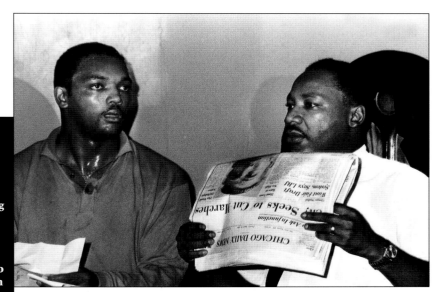

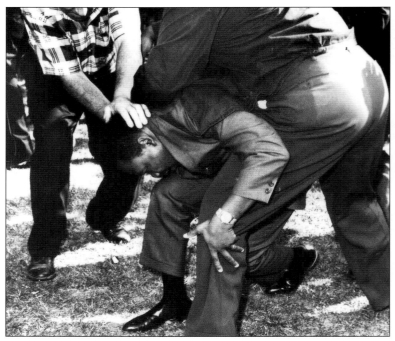

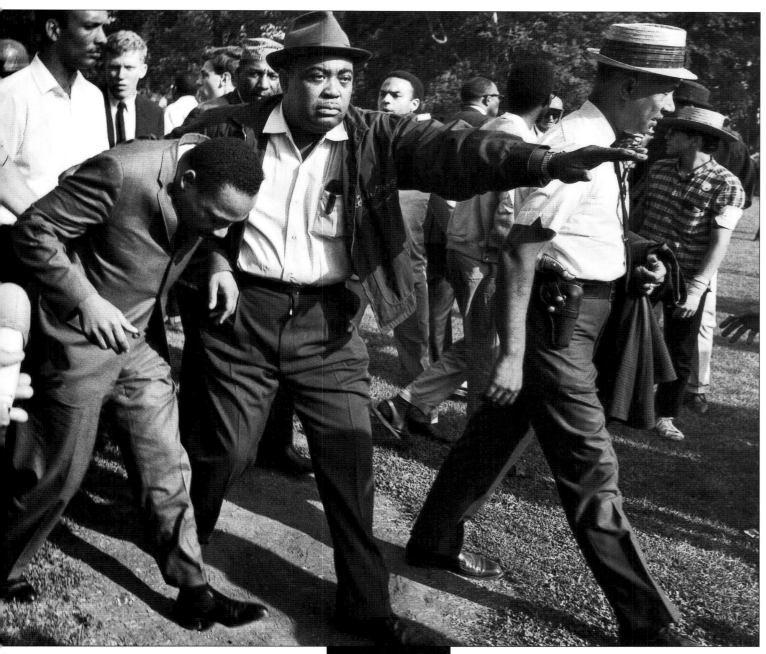

King begins leading a march from Marquette Park to a rally at a real-estate office in that all-white enclave. Seconds later he is struck on the right temple by a rock, falls to his knees, and is immediately surrounded by aides who attempt to shield him from a second barrage of rocks, bottles, and firecrackers. King quickly gathers his wits, and the march resumes.

PEACE MOVEMENT

Anguished by the horror of Vietnam

King addresses the largest peace demonstration in history at the United Nations Plaza in New York City on April 15, 1967. Although he had been critical of the Vietnam War for more than a year, this was his most public break with the policies of the Johnson administration. The Spring Mobilization to End the War in Vietnam started in Central Park and concluded in front of the United Nations Building. The theme of King's speech was caught in his final words: "Stop the bombing. Stop the bombing."

247

PEACE MOVEMENT

If America's soul becomes totally poisoned, part of the autopsy must read "Vietnam."

~Martin Luther King, Jr., 1967

On April 4, 1967—exactly one year to the day before his death—King delivered his first speech against the Vietnam War at New York's Riverside Church.

"Somehow, this madness must cease," he said, explaining that not only was the war diverting America's resources from ending poverty and injustice at home (to say nothing of perpetuating injustice in Vietnam), it was sending young black men "eight thousand miles away to guarantee liberties in Southeast Asia which they had not found in southwest Georgia and East Harlem." As a Christian minister, and as a recipient of the Nobel Peace Prize, King felt compelled to break his silence against America's adventurism in Vietnam and to counsel young men that "if you feel in your heart that this war is wrong…don't go and fight in it. Follow the path of Jesus Christ."

He was the first internationally celebrated American to join the antiwar movement. The backlash against his position, from whites and blacks, brought King to tears when nearly every major American newspaper and magazine condemned him for advocating a fusion of the civil rights and peace movements.

Yet others—students and young people in particular—saw the wisdom in King's prescient, principled stance. Some prayed that he and Dr. Benjamin Spock would run on a third-party presidential ticket. This King declined to do, though he continued to use every pulpit and podium to speak against the war and disregarded the hostility he received. "If you have never found something so dear and so precious to you that you will die for it," he told his congregation at Ebenezer, "then you aren't fit to live."

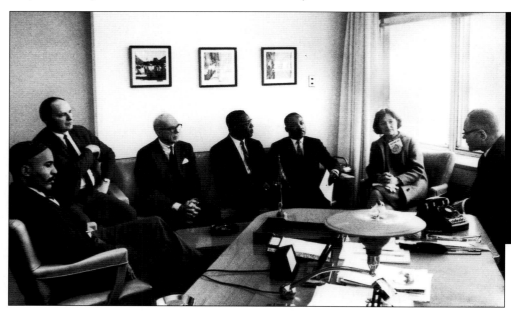

Following the demonstration outside the United Nations, King, along with other protest leaders, meets with Undersecretary Ralph Bunche in his UN office. Bunche was publicly critical of King's antiwar views, but told him privately that he entirely agreed with his position.

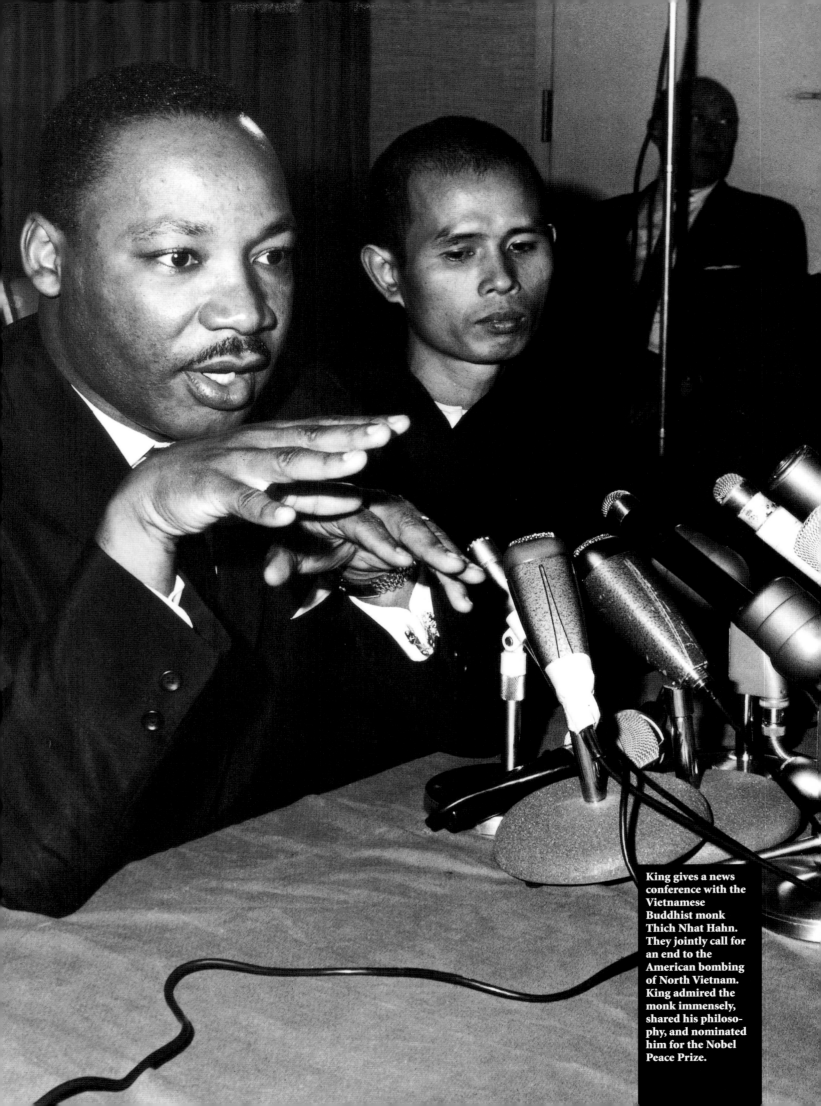

King gives a news conference with the Vietnamese Buddhist monk Thich Nhat Hahn. They jointly call for an end to the American bombing of North Vietnam. King admired the monk immensely, shared his philosophy, and nominated him for the Nobel Peace Prize.

On March 25, 1967, King joins with world-renowned pediatrician and peace activist Benjamin Spock to lead an antiwar march of about five thousand demonstrators through downtown Chicago. At a peace rally later that day at the Coliseum, King railed against the Vietnam War, saying that the conduct of the United States government leaves America "standing before the world glutted by our own barbarity."

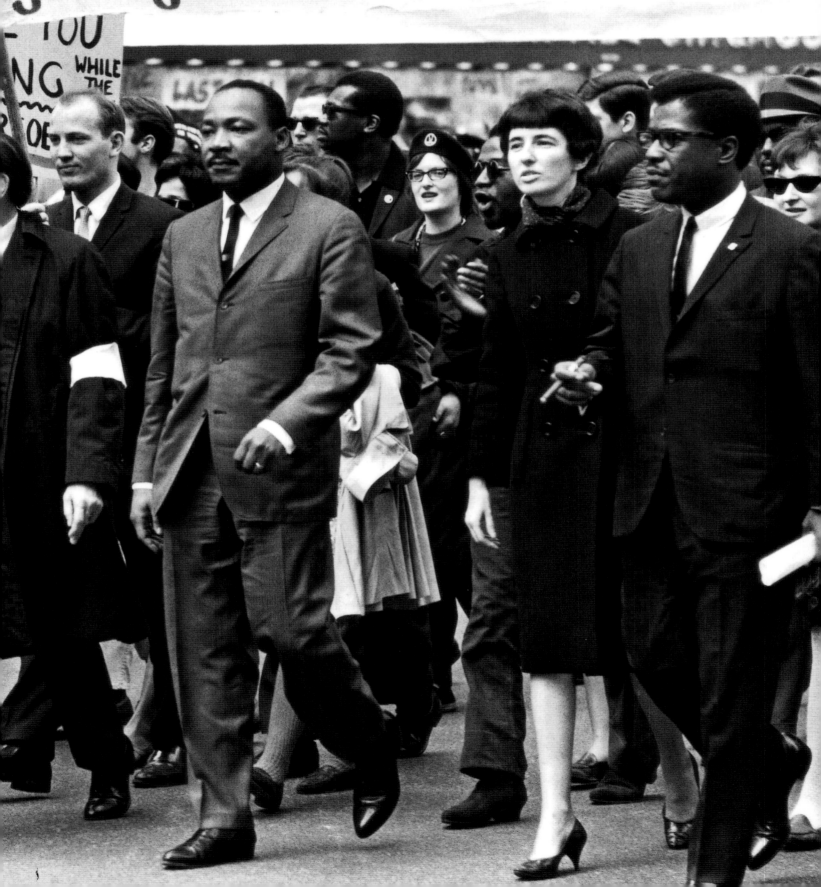

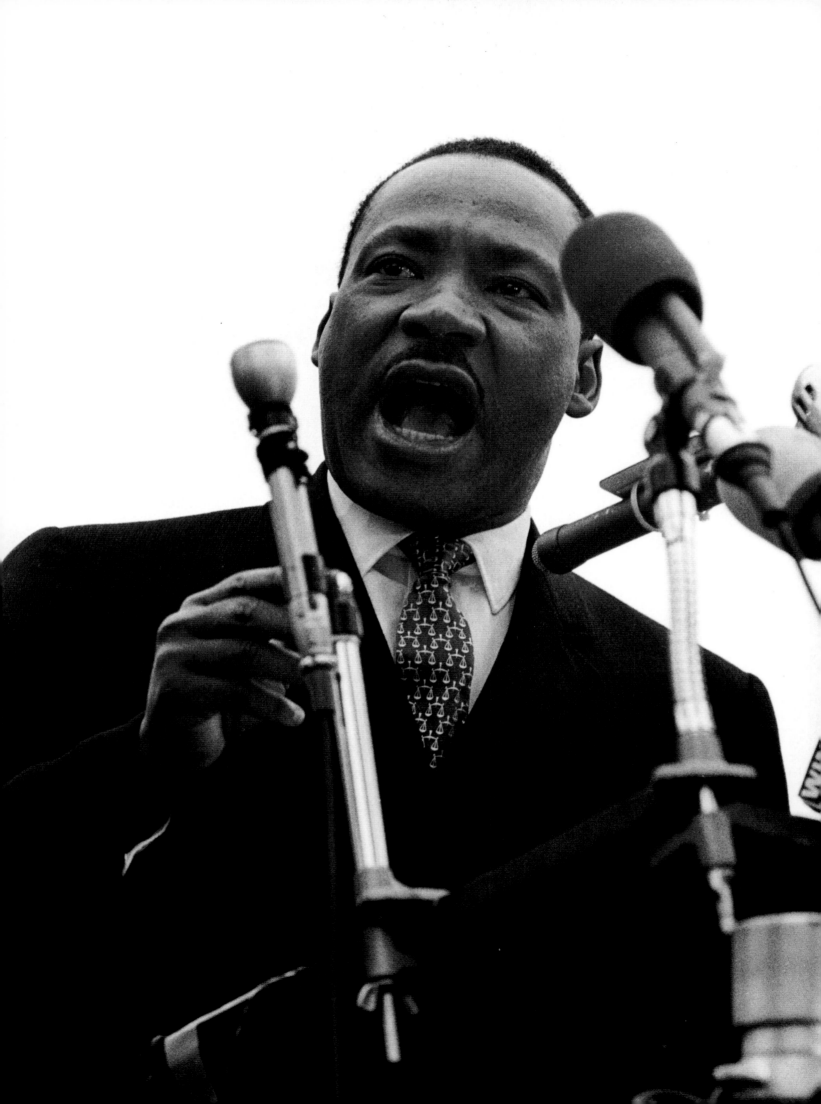

The previous year in Mississippi, Stokely Carmichael and King had had serious differences about black power. Now Carmichael, who speaks after King, warmly embraces him. They are unified by their opposition to the war.

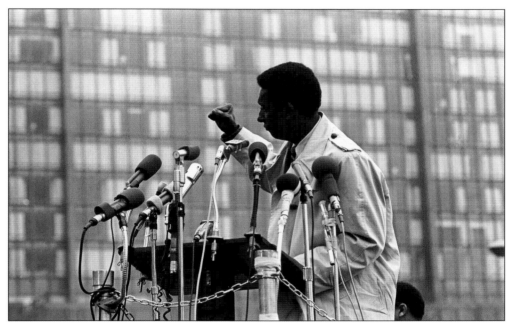

King speaks before as many of the one hundred twenty-five thousand marchers as can fit into the United Nations Plaza. He calls for negotiations with the North Vietnamese and an end to the bombing, and goes on to say, "Everyone has a duty to be in both the civil rights and the peace movements."

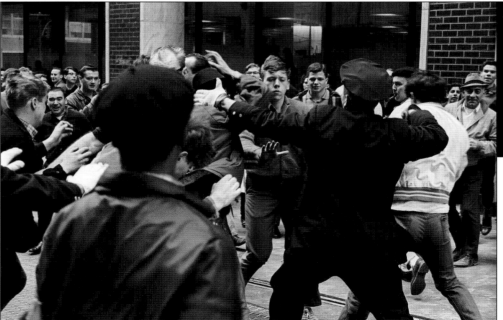

Not far from the speakers' platform, a fight breaks out between pro- and antiwar demonstrators, and the police attempt to break it up. The scuffle indicates how conflicted the country is about the war.

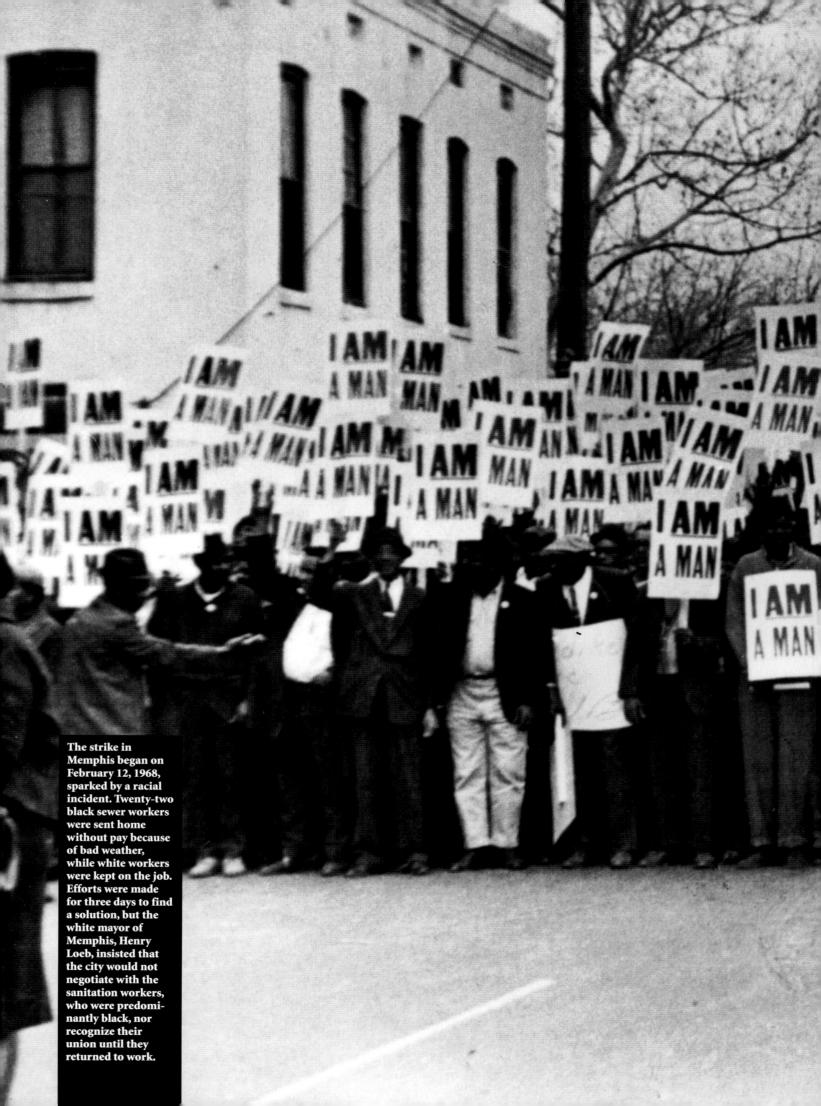

The strike in Memphis began on February 12, 1968, sparked by a racial incident. Twenty-two black sewer workers were sent home without pay because of bad weather, while white workers were kept on the job. Efforts were made for three days to find a solution, but the white mayor of Memphis, Henry Loeb, insisted that the city would not negotiate with the sanitation workers, who were predominantly black, nor recognize their union until they returned to work.

Martyred as he works for the least of us

MEMPHIS

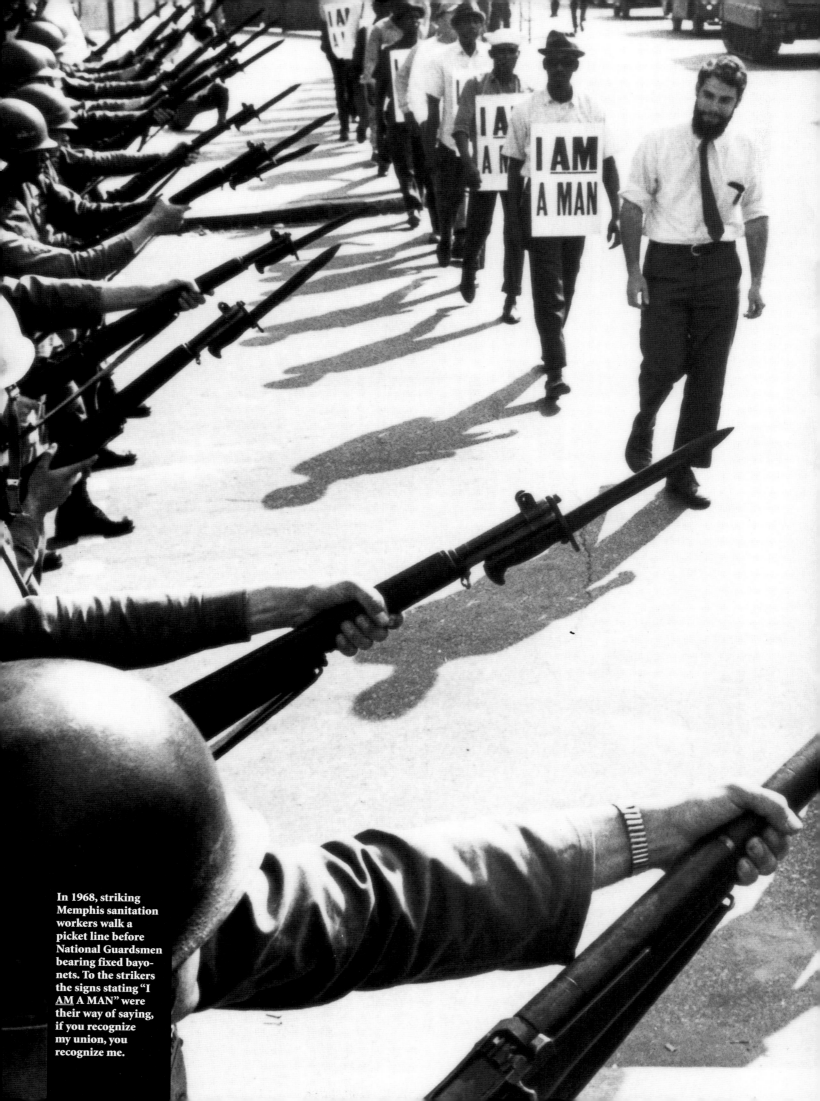

In 1968, striking Memphis sanitation workers walk a picket line before National Guardsmen bearing fixed bayonets. To the strikers the signs stating "I AM A MAN" were their way of saying, if you recognize my union, you recognize me.

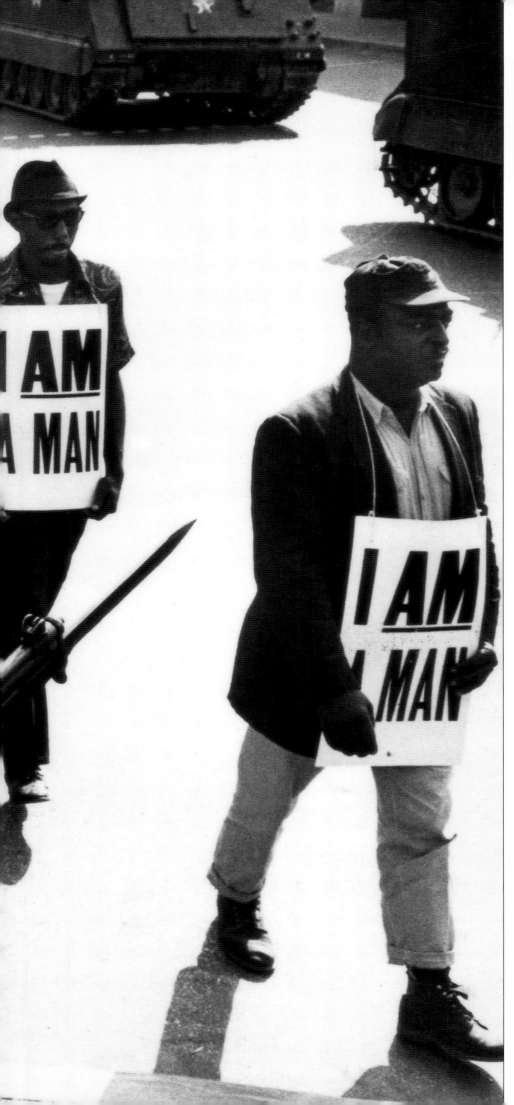

MEMPHIS

Like anybody I would like to live a long life…

~MARTIN LUTHER KING, JR.,
MEMPHIS, APRIL 3, 1968

The penultimate chapter of King's life, set in Memphis, will always be tinctured with mystery, ringed by ambiguity and rumor. However, what we do know is this:

In February 1968, King was immersed in organizing his Poor People's Campaign, scheduled for late April when he planned to bring three thousand of America's impoverished from all backgrounds and races to the nation's capital. This would have begun, one realizes in retrospect, the third phase of his evolution—from a civil rights activist in the fifties to an antiwar proponent of peace after his Nobel Prize, and finally to his championing a Bill of Rights for the Disadvantaged and A. Philip Randolph's Freedom Budget, a domestic Marshall Plan that might correct the evils of capitalism, which as early as 1951 King believed had outlived its usefulness. But in Memphis, thirteen hundred black sanitation workers had formed a union. The city refused to recognize it and also rejected their demands for a 10-percent wage increase and benefits. On the twelfth, the workers went on strike. Their grievances were real, involving racial discrimination. They were skirmishing with the police. The city brought forth an injunction to halt demonstrations. The Memphis protesters needed a high-profile champion, and King's old friend James Lawson asked him to support their efforts by delivering a speech.

King, as his close aides remarked, always had a problem with saying "no."

Thus, on March 18, he spoke to an enthusiastic crowd of seventeen thousand at the Mason Temple. He felt their

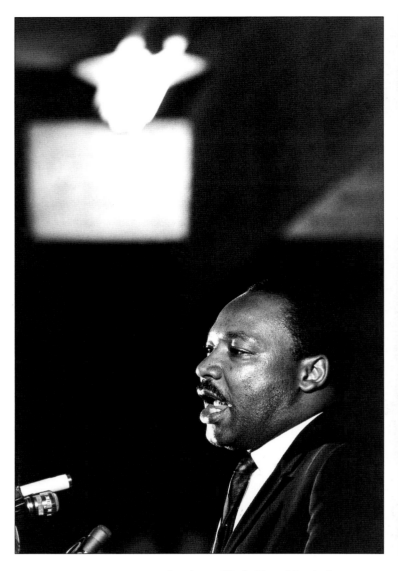
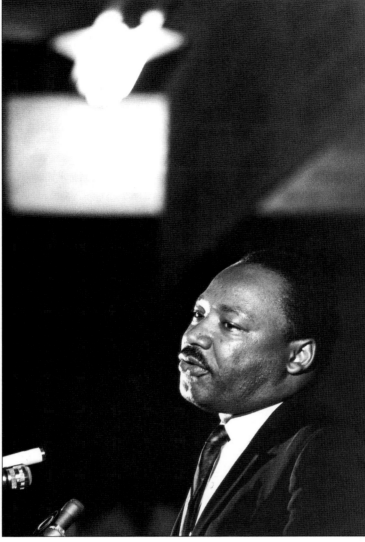

eenthusiasm. He believed in their cause, which combined the objectives of both the unions and black people. And didn't the plight of these sanitation workers—the lowest of the low among workers—complement the point he planned to make with the Poor People's Campaign? That night he promised if they marched, if they supported the garbagemen and their families, he would lead them.

In what should have been a triumphant overture or trial run for his April offensive in Washington, D.C., King joined six thousand Tennesseans, who started out from the Clayborn Temple. He noticed a group of young people toward the end, holding up "Black Power Is Here" signs. That made him edgy. Many of these militant youths called themselves the Invaders and were inspired by H. "Rap" Brown's call for violent revolution. On they marched for three blocks. Then: He heard young blacks in the rear looting. Breaking win-

dows. The march deteriorated into chaos, with the Invaders battling jackbooted police in downtown Memphis. Two hundred eighty were arrested, sixty-two wounded, and one 16-year-old boy killed. As a distraught and tired King assessed the dimensions of this new disaster from the Rivermont Hotel, he knew beyond all doubt he had to return to Memphis and lead a successful, nonviolent march. To clean this up. To make things right. If he did not, his critics would have a field day, declaring that if King could not contain violence during a demonstration in Memphis, how in heaven's name could he expect to do so in the nation's capital?

He set the date: April 8. As with all his campaigns before, Memphis city officials secured an injunction barring the demonstration. And as usual King ignored it.

He returned to Memphis on April 3, checking into room 306 at the black-owned Lorraine Motel. That night he was

Martin Luther King, Jr., makes his last appearance on the public stage, speaking once again on behalf of the sanitation workers and their demand for jus treatment. Before two thousand supporters at the Mason Temple in Memphis on Wednesday, April 3, he makes his chillingly prophetic "I Have Been to the Mountaintop" speech.

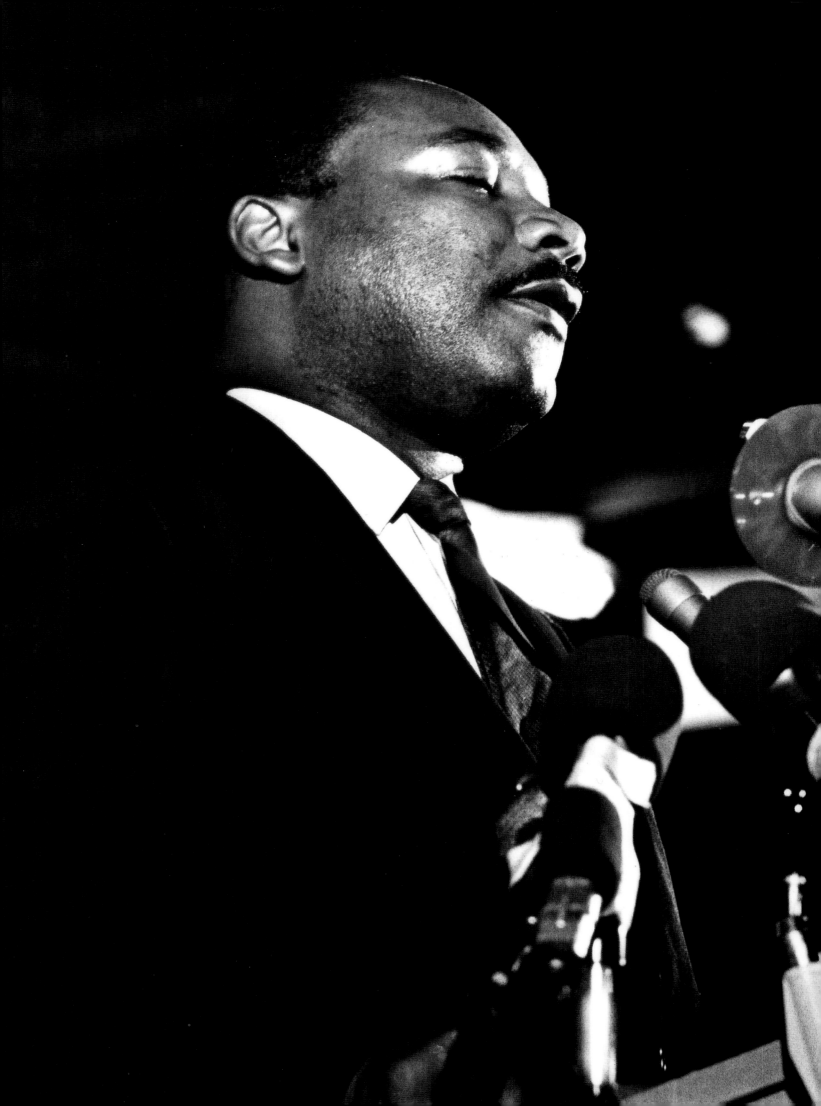

scheduled to speak at the Mason Temple, but he was exhausted and instead sent Abernathy to address the crowd of two thousand. As it turned out, they wanted King. No one else. So he struggled out of his pajamas, dressed, and was driven to the temple in pounding rain with Andrew Young and Jesse Jackson. In that place, on that night, he delivered his last and most haunting speech:

"I've seen the promised land," he said. "And I may not get there with you. But I want you to know tonight that we, as a people, will get to the promised land." He concluded, "And I'm happy tonight. I'm not worried about anything....Mine eyes have seen the glory of the coming of the Lord."

When he was finished, he seemed to fall, emptied, toward Abernathy, who rushed with outstretched arms to embrace and steady him.

King spent the next day (Thursday) conferring in a second-floor room at the Lorraine Motel with those whom we today might call his trusted, nonviolent "samurai." In late afternoon, he began preparing to travel with his aides to Rev. Samuel Kyle's house for dinner. He stepped outside to the balcony, and spoke to members of their group gathered down below in the parking lot. At that moment a metal-jacketed 30.-06 bullet brought down the most influential American citizen in the second half of the twentieth century: the black man who became the complex symbol for the far-reaching movement that realized the Founders' unfulfilled promises in that first revolution in 1776, completed the unfinished business of the Civil War, inspired freedom fighters in South Africa and Czechoslovakia in 1989, and provided in its methods and strategies the impetus for women's rights in the seventies and gay rights in the eighties and nineties.

At St. Joseph's Hospital he was pronounced dead at 7:05 P.M. He was only thirty-nine years old.

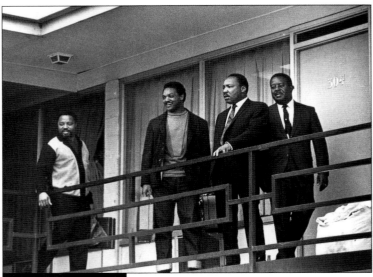

On Wednesday, Hosea Williams, Jesse Jackson, Martin Luther King, Jr., and Ralph Abernathy gather on the balcony of the Lorraine Motel while taking a break during their planning for a march in support of the sanitation men.

Shocked and bewildered as their leader lies in a pool of blood, King's aides point in the direction of the assassin's bullet.

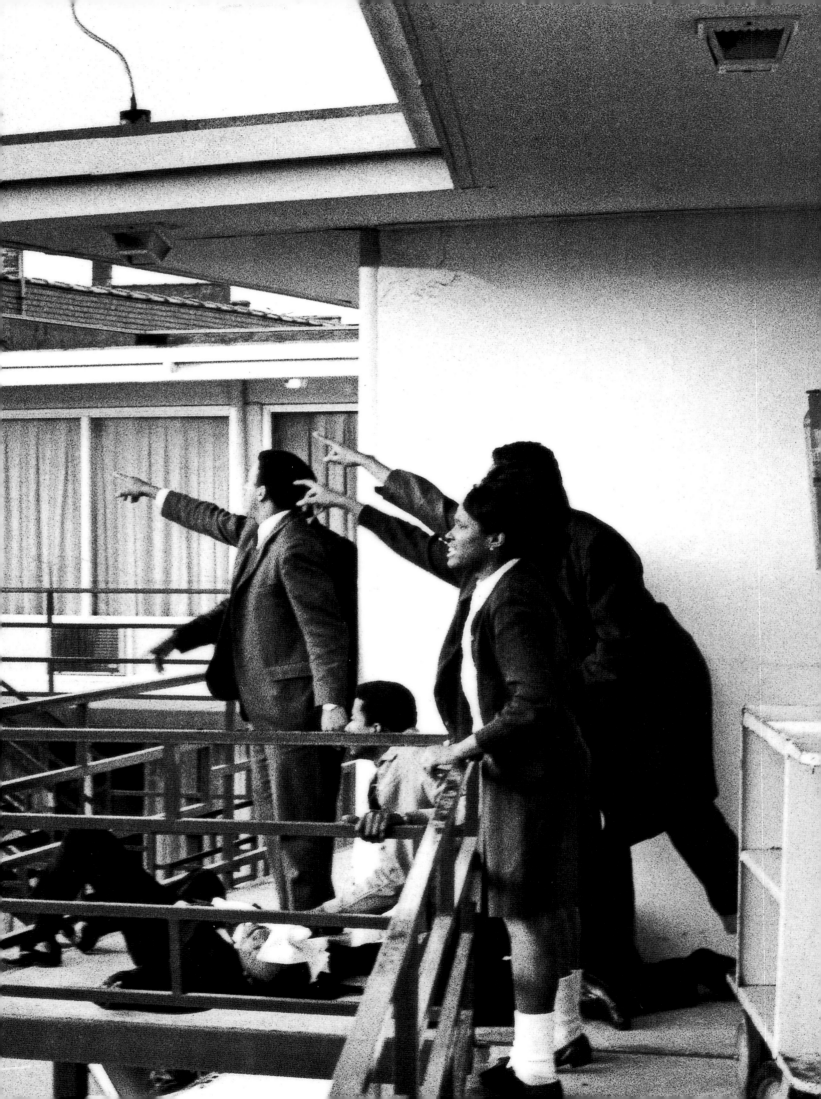

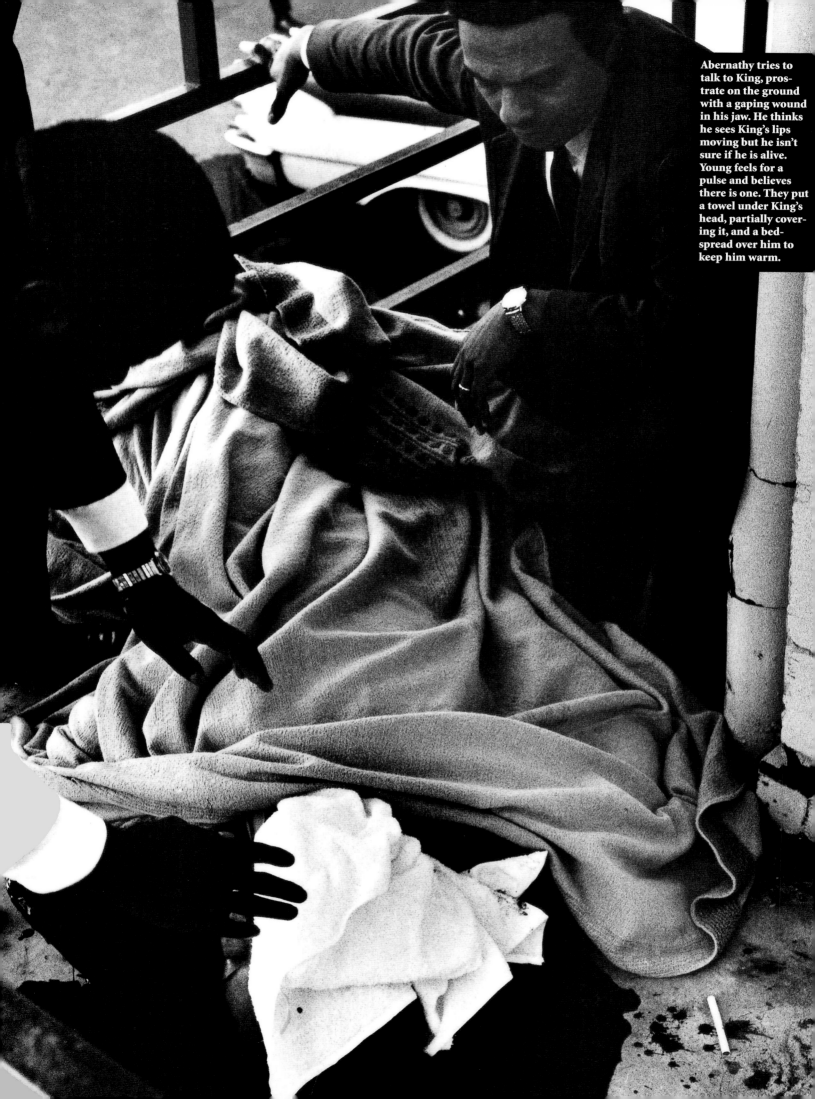

Abernathy tries to talk to King, prostrate on the ground with a gaping wound in his jaw. He thinks he sees King's lips moving but he isn't sure if he is alive. Young feels for a pulse and believes there is one. They put a towel under King's head, partially covering it, and a bedspread over him to keep him warm.

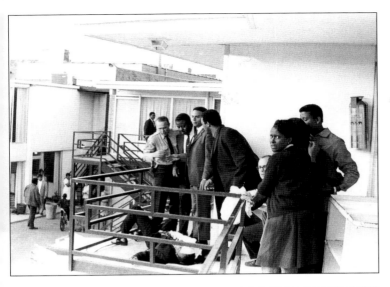

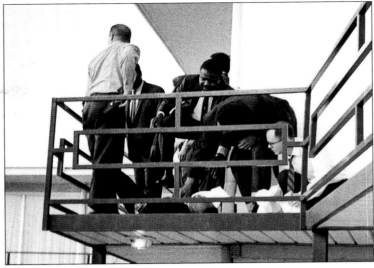

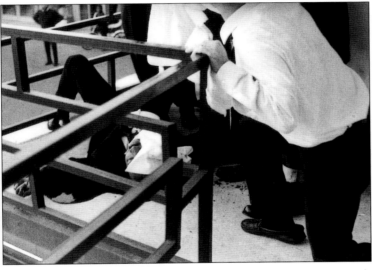

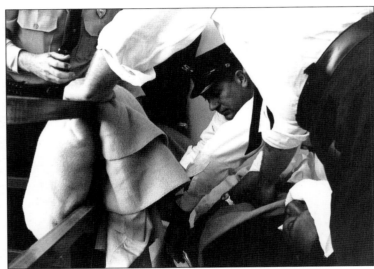

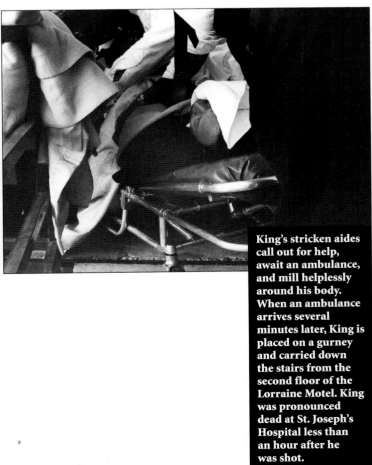

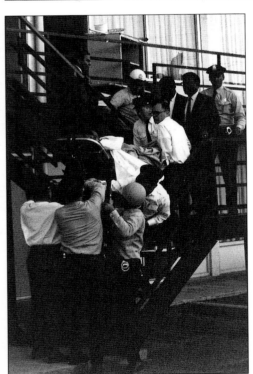

King's stricken aides call out for help, await an ambulance, and mill helplessly around his body. When an ambulance arrives several minutes later, King is placed on a gurney and carried down the stairs from the second floor of the Lorraine Motel. King was pronounced dead at St. Joseph's Hospital less than an hour after he was shot.

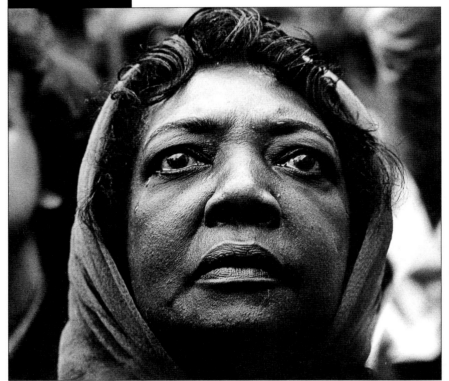

A woman attending the memorial service looks up at Mrs. King and weeps.

A wreath on the door marks the room where King stayed at the Lorraine Motel, which later became a civil rights museum.

King's assassination ignites rioting in cities across the country. Mrs. King and her family come to Memphis and hold a memorial service guarded by armed troops. She grips the hand of a consoling mourner.

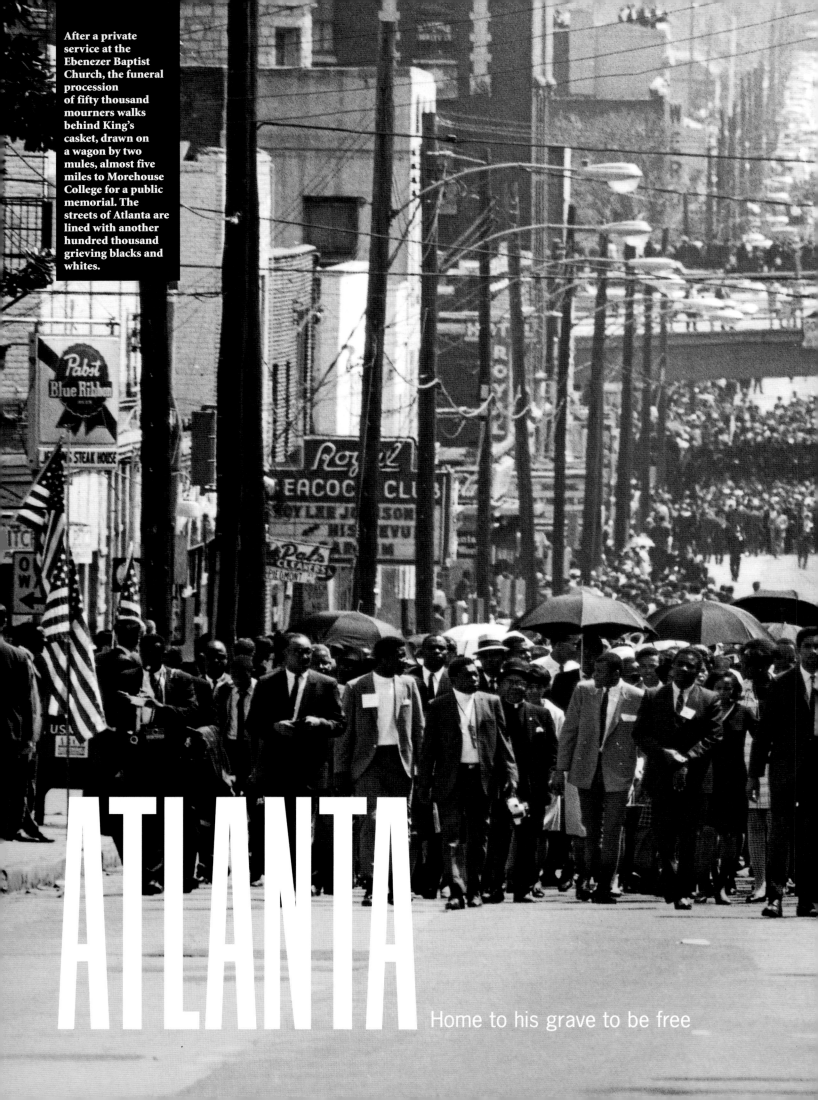

After a private service at the Ebenezer Baptist Church, the funeral procession of fifty thousand mourners walks behind King's casket, drawn on a wagon by two mules, almost five miles to Morehouse College for a public memorial. The streets of Atlanta are lined with another hundred thousand grieving blacks and whites.

ATLANTA

Home to his grave to be free

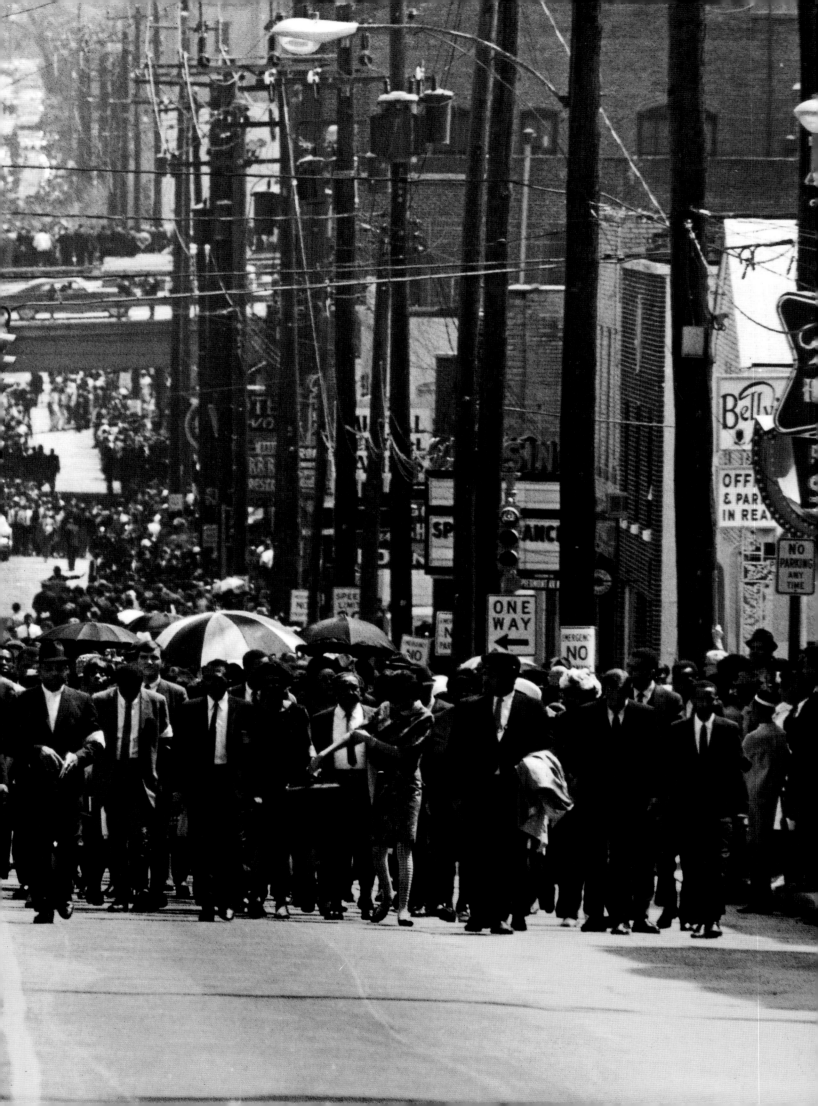

ATLANTA

And I guess one of the great agonies of life is that we are constantly trying to finish that which is unfinishable.

~MARTIN LUTHER KING, JR.,
"UNFULFILLED DREAMS," 1968

Senator Robert Kennedy and his wife attended the funeral and consoled the widow. Kennedy did not always see eye to eye with King, but by the time he ran for president he was equally impatient with the war and with poverty. No stranger to tragedy—he had lost two brothers and a sister—in just two months he, too, would be slain in his bid for the presidency.

Ironically—and tragically—on the day America's greatest advocate for peace was murdered, rioting and looting occurred in more than one hundred cities. That violence lasted for ten days. Before it ended forty-six people died, twenty-six hundred were injured, and another twenty-one hundred were arrested. The parallel with Gandhi's death was plain, and in one prescient speech, "Unfulfilled Dreams," King had mused soberly on the realization that "Gandhi had to face the fact that he was assassinated and died with a broken heart, because the nation that he wanted to unite ended up divided …"

So was America in 1968. So it is today.

Sixty thousand people gathered around Ebenezer Baptist Church for King's funeral five days after James Earl Ray's 760 Remington Gamemaster cut him down. Inside, celebrities, dignitaries, and politicians crowded the pews. A choir sang King's favorite hymns, "When I Survey the Wondrous Cross" and "In Christ There Is No East Nor West." Perhaps the high point of that day came when Abernathy played a recording of King's beautiful sermon, "The Drum Major Instinct," the essence of which is contained in the words, "There is, deep down within all of us, an instinct. It's a kind of drum major instinct—a desire to be first.…We all want to be important, to surpass others, to achieve distinction, to lead the parade.…Don't give it up." He continued, "Keep feeling the need for being first. But I want you to be first in love. I want you to be first in moral excellence. I want you to be first in generosity. That's what I want you to do.…"

Pallbearers loaded King's bier onto a flatbed wagon pulled by two mules, a symbol of the Poor People's campaign that had consumed his final days. Next: the wagon followed by fifty thousand mourners made the slow, long trek across Atlanta to Morehouse College, where one of King's earliest teachers, Rev. Benjamin Mays, delivered his eulogy.

Since the death of this great man whole libraries have been devoted to examining his life and enduring legacy. But no one spoke more beautifully about the essence of Martin Luther King, Jr.'s, life than King himself when, in

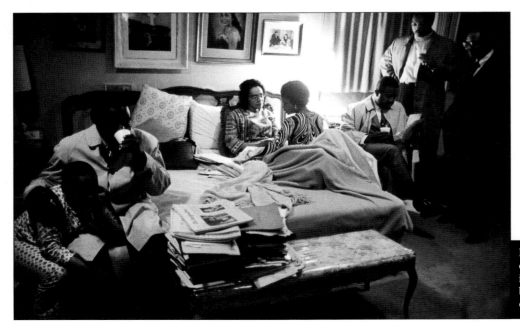

Family members and close friends gather in Mrs. King's bedroom to comfort one another.

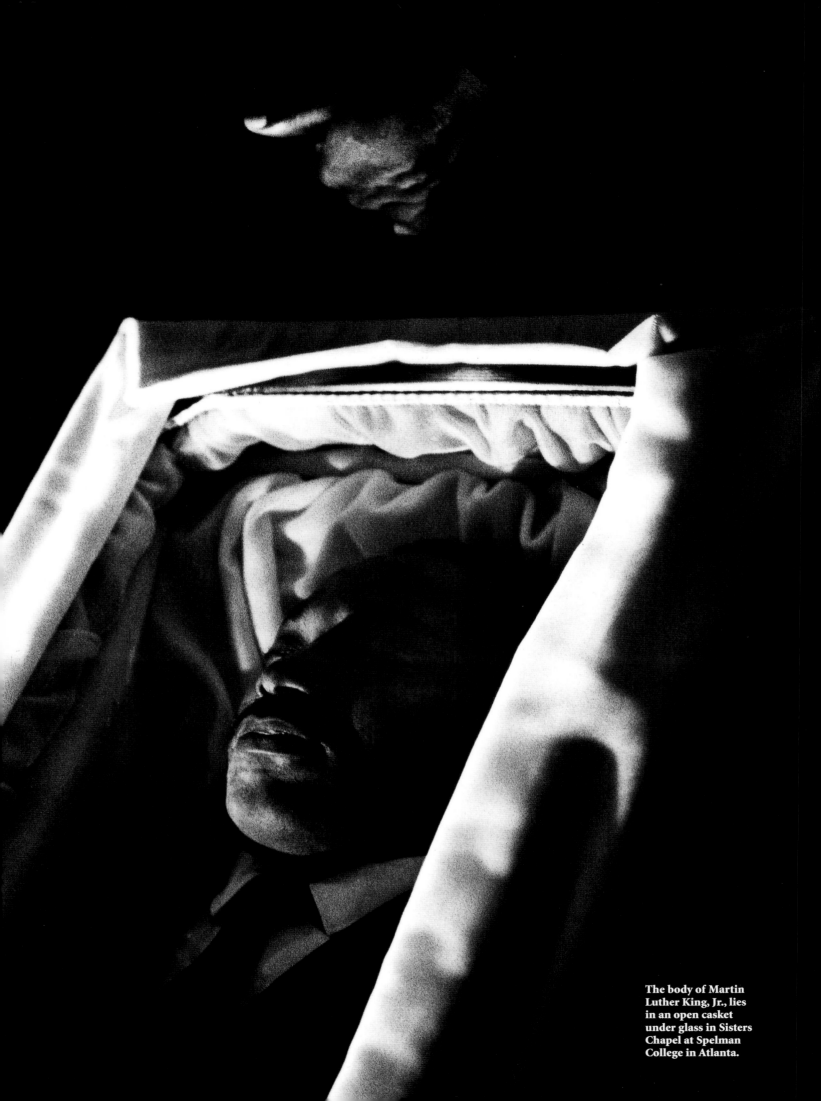

The body of Martin Luther King, Jr., lies in an open casket under glass in Sisters Chapel at Spelman College in Atlanta.

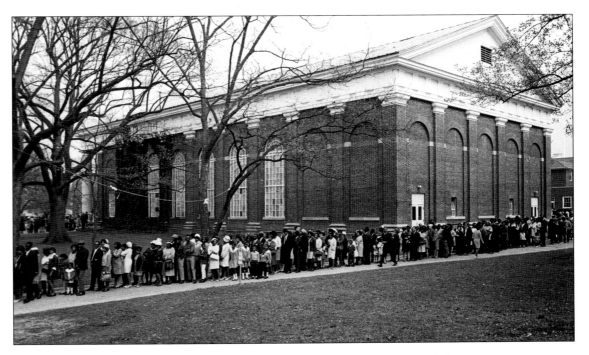

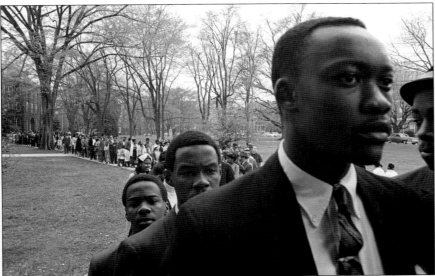

Before King's funeral, mourners bid him farewell on the campus of Spelman College. A line of mourners stretches as far as the eye can see, waiting to pay homage to their leader, teacher, pastor, neighbor, voice, revolutionary, friend, hero, and dreamer.

"Unfulfilled Dreams," he said, "Get somebody to be able to say about you, 'He may not have reached the highest heights, he may not have realized all his dreams, but he tried.' Isn't that a wonderful thing for somebody to say about you?"

We can say all that about Martin Luther King, Jr. And we can add that the vindication of his social and philosophical vision, as a Socratic gadfly of the state, is evident in the fact that thirty-two years after his death an agency of the federal government he so consistently challenged has approved a site for his memorial on the hallowed ground of the National Mall alongside monuments to America's most revered presidents; that he is a candidate put forward to the Vatican as a martyr for the Christian faith; that a national holiday bears his name; that King County in Seattle, Washington, has been renamed after him (and no longer for Vice President William Rufus DeVane King); and that streets, buildings, and community centers from coast to coast across this vast continent, which he traversed, calling his fellow citizens to a higher ethical standard, honor his name and image. If he did not reach the political and social Promised Land he inspired us to believe in, Martin Luther King, Jr., most certainly showed us the way.

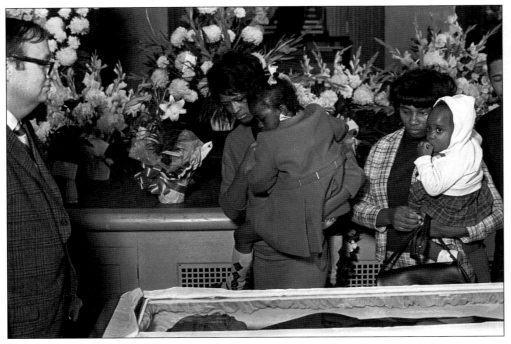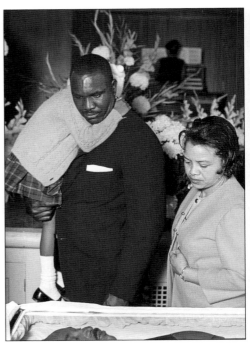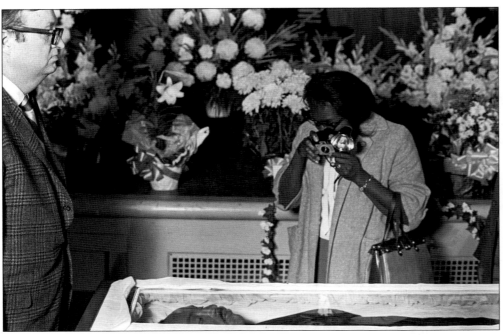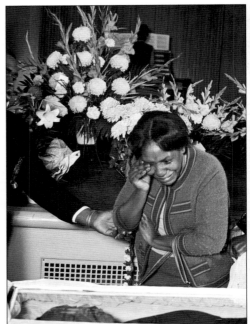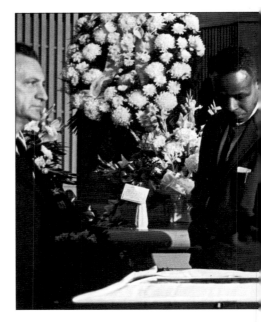

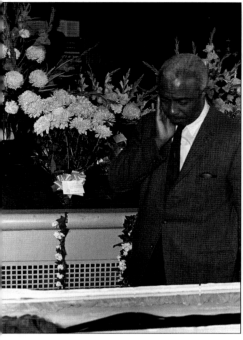

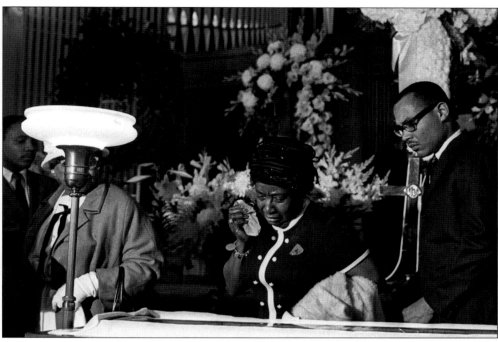

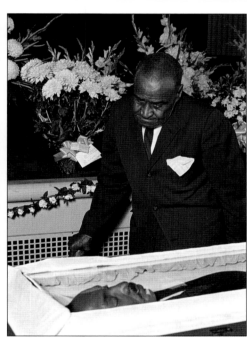

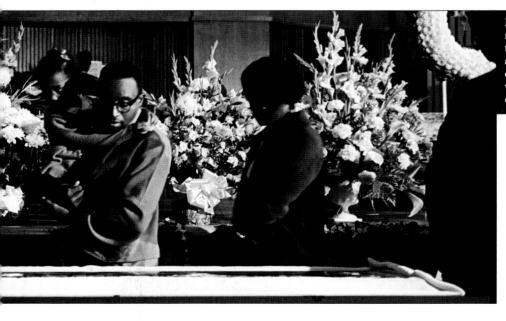

Mourners from near and far pay their respects and say farewell, each in their own way, to their great champion.

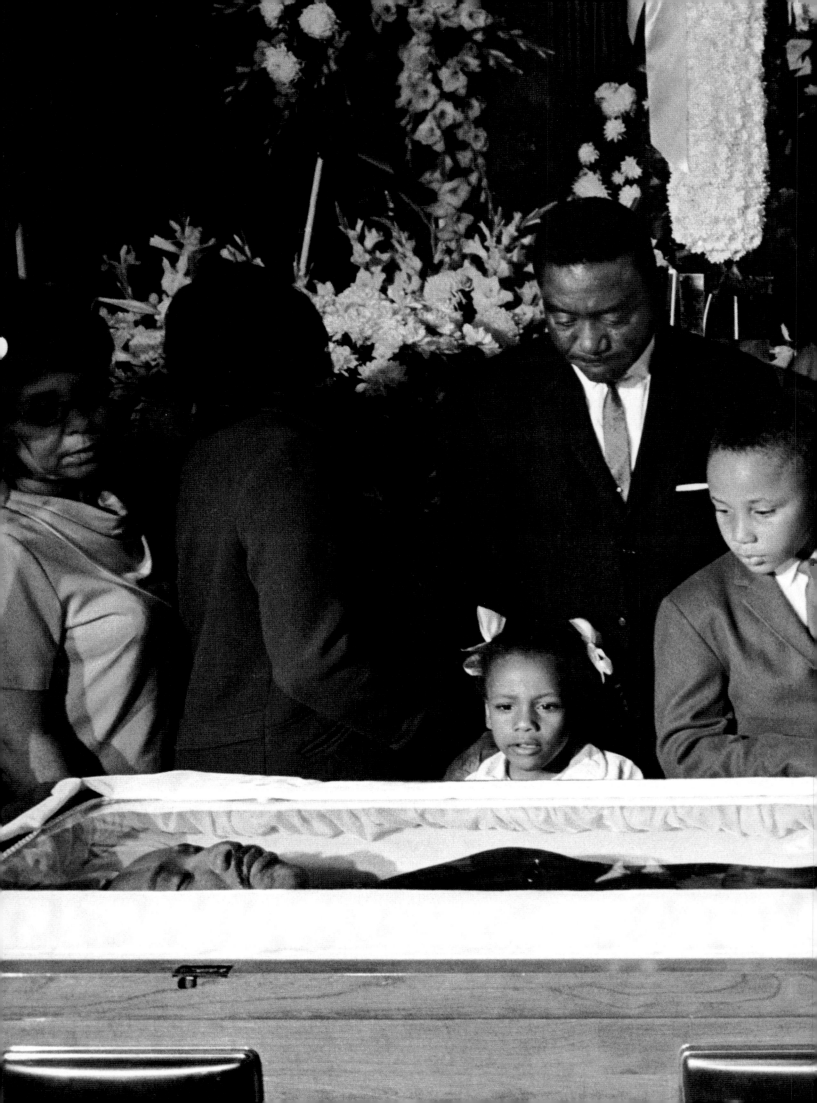

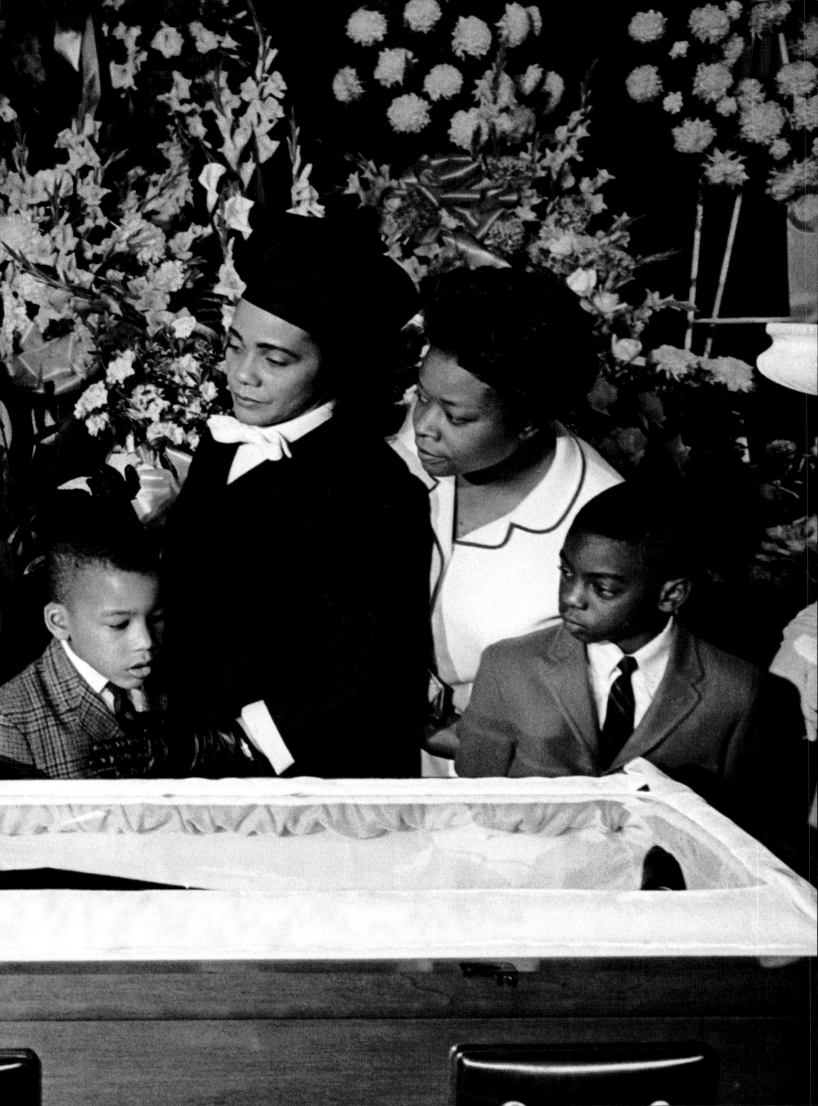

The day of the funeral begins with a private service at Ebenezer Baptist Church for family, friends, and public figures. The church was so crowded that the family, who arrived last, had to struggle to enter the church. Poignantly, and eerily, at the beginning of the service a recording was played of a sermon King gave with his ideas for his own funeral. His recorded voice said, "If any of you are around when I have to meet my day…I'd like someone to mention…that I tried to be right on the war question… that I did try to feed the hungry… to clothe those who were naked…to visit those who were in prison…to love and serve humanity."

During the service the great jazz musician and bop innovator Dizzie Gillespie wails a final tribute on his flugelhorn to his fallen fellow revolutionary.

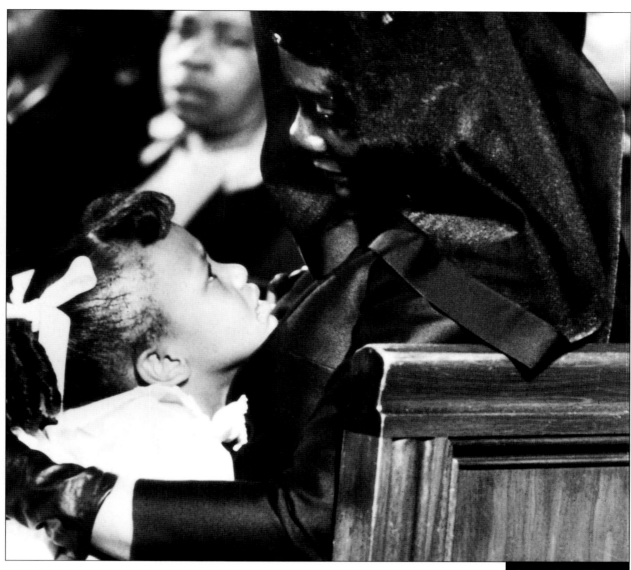

Coretta Scott King comforts her daughter Bernice during the service.

Mrs. Christine Farris grieves the loss of her brother. Beside her stands Rev. King, Sr., inconsolable.

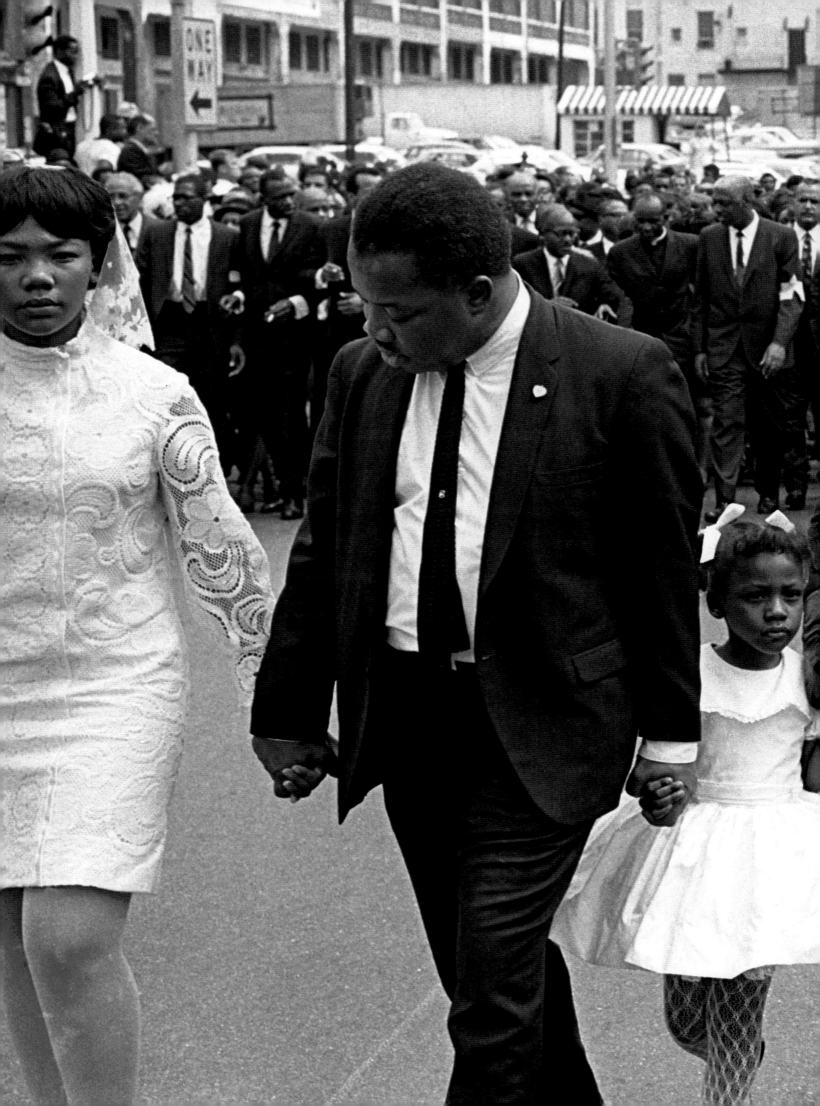

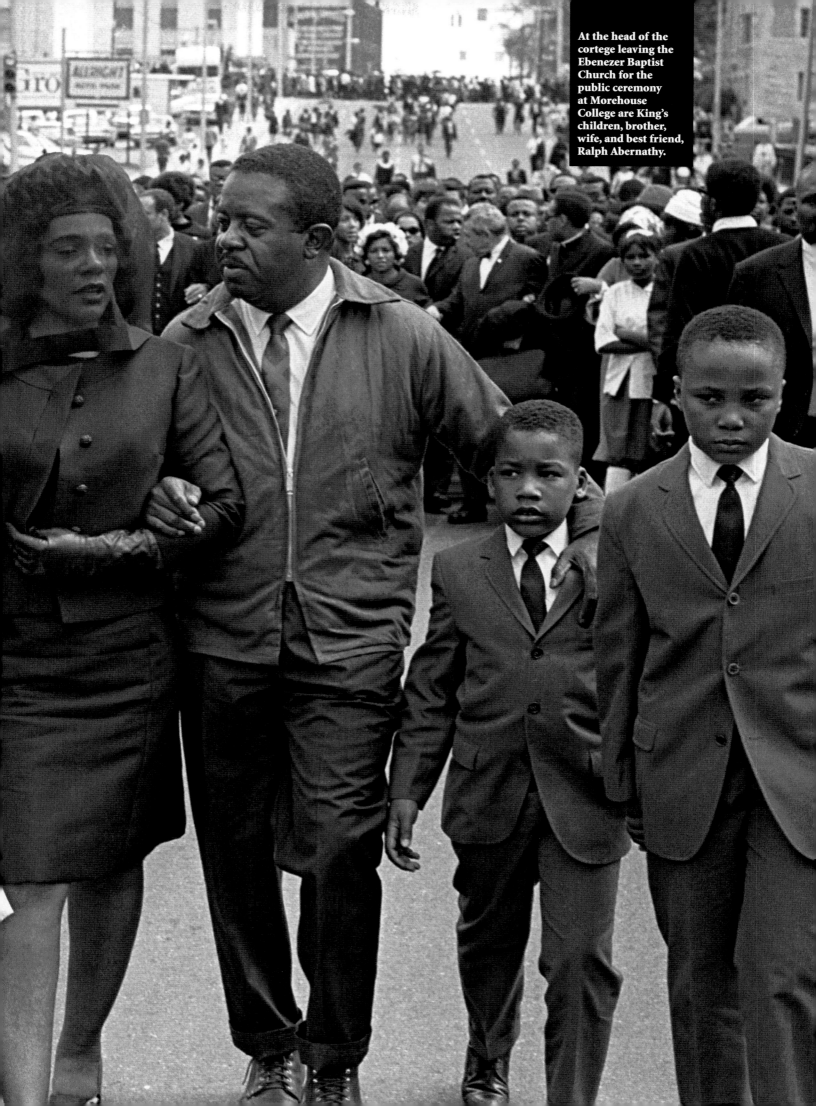

At the head of the cortege leaving the Ebenezer Baptist Church for the public ceremony at Morehouse College are King's children, brother, wife, and best friend, Ralph Abernathy.

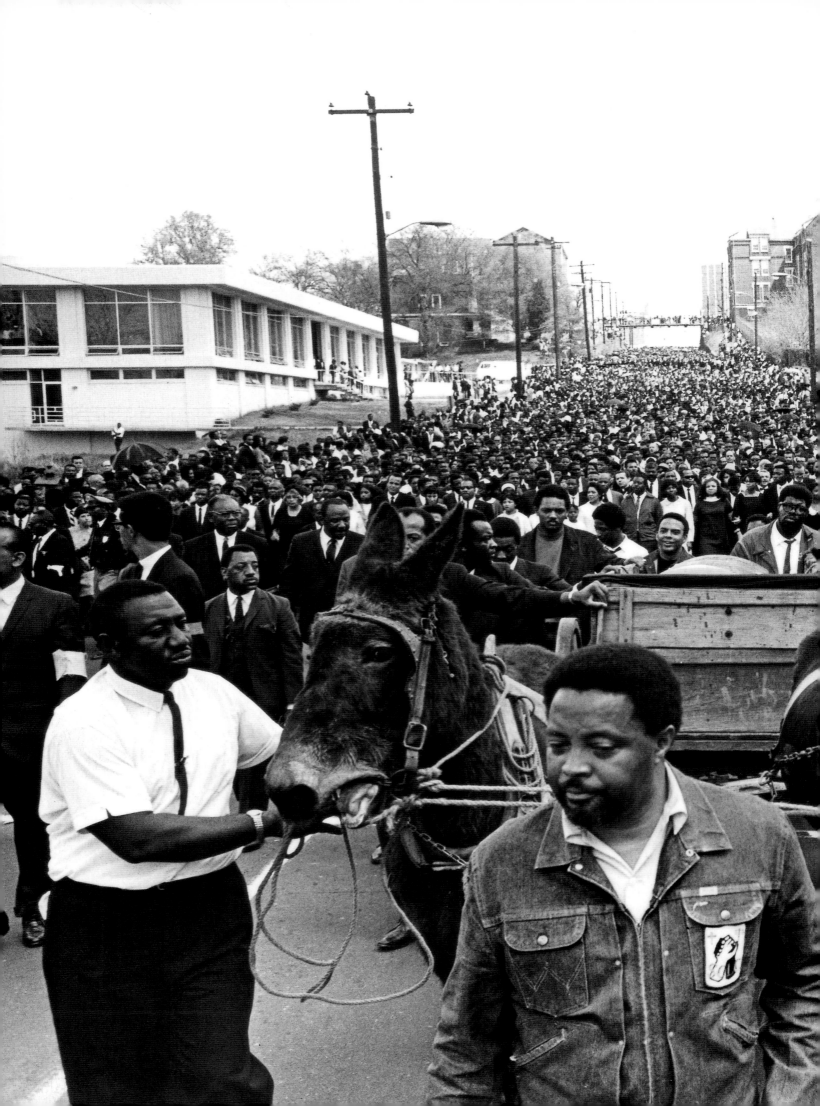

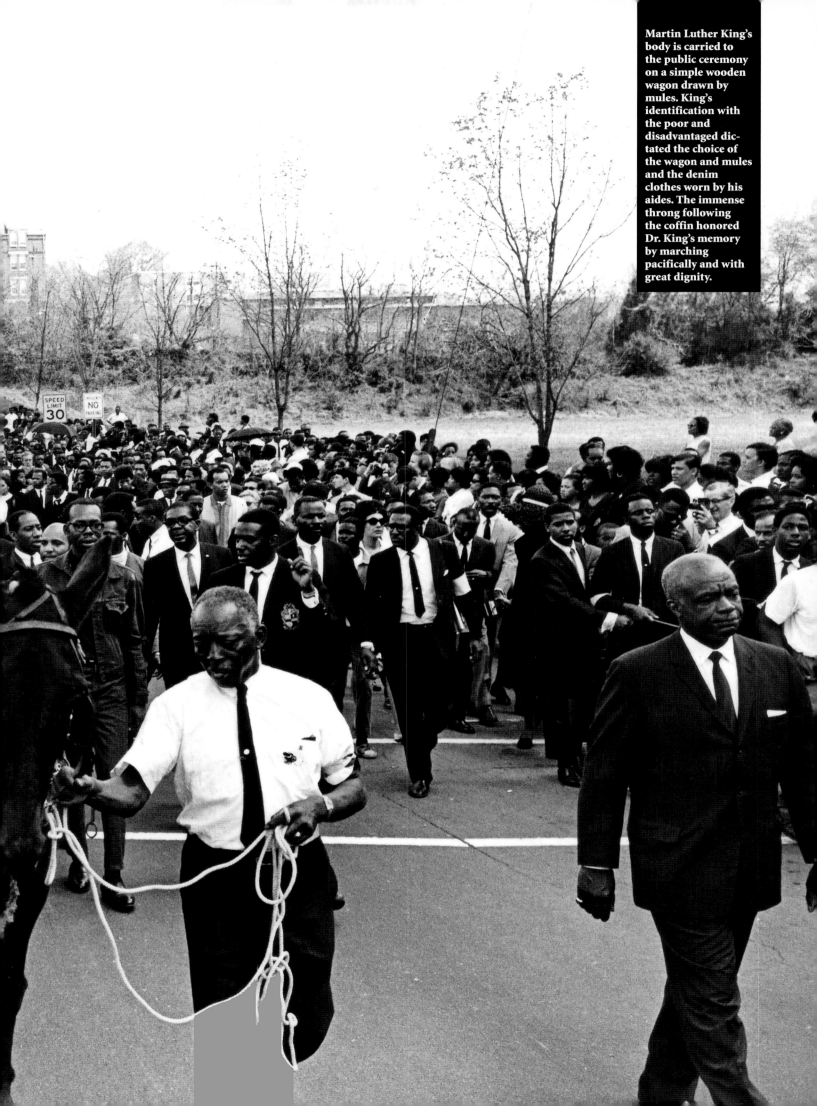

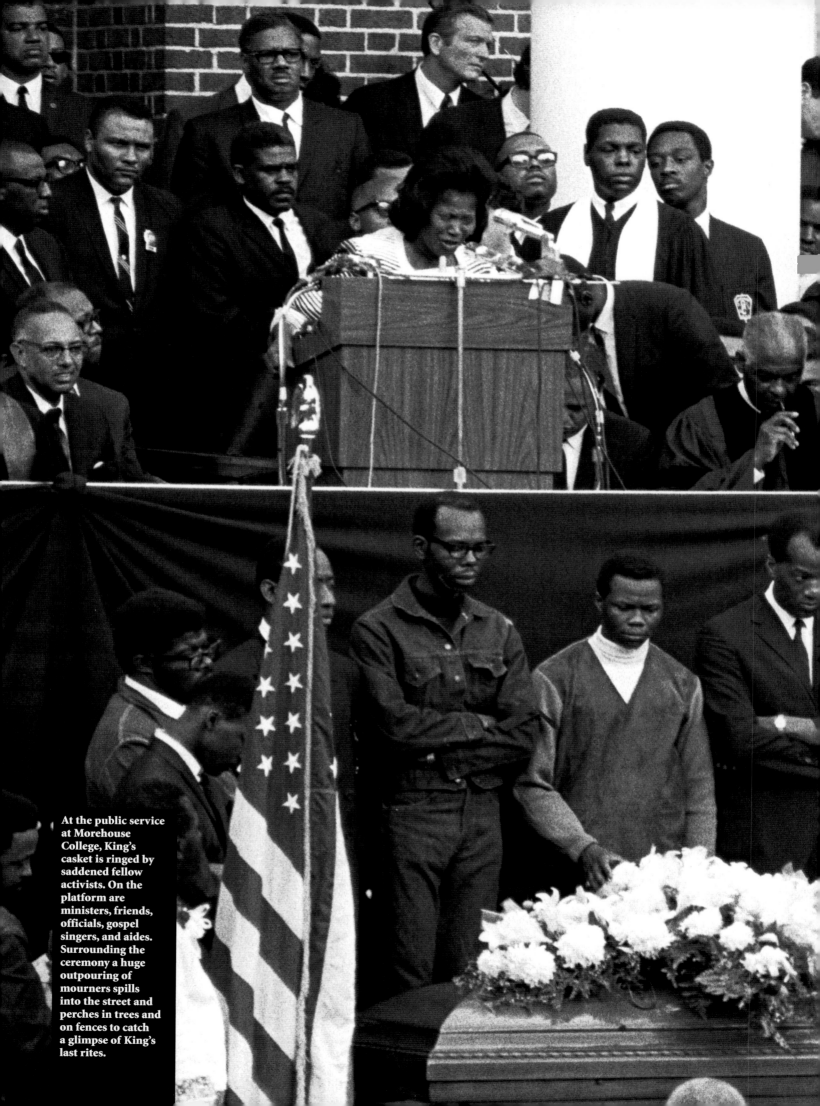

At the public service at Morehouse College, King's casket is ringed by saddened fellow activists. On the platform are ministers, friends, officials, gospel singers, and aides. Surrounding the ceremony a huge outpouring of mourners spills into the street and perches in trees and on fences to catch a glimpse of King's last rites.

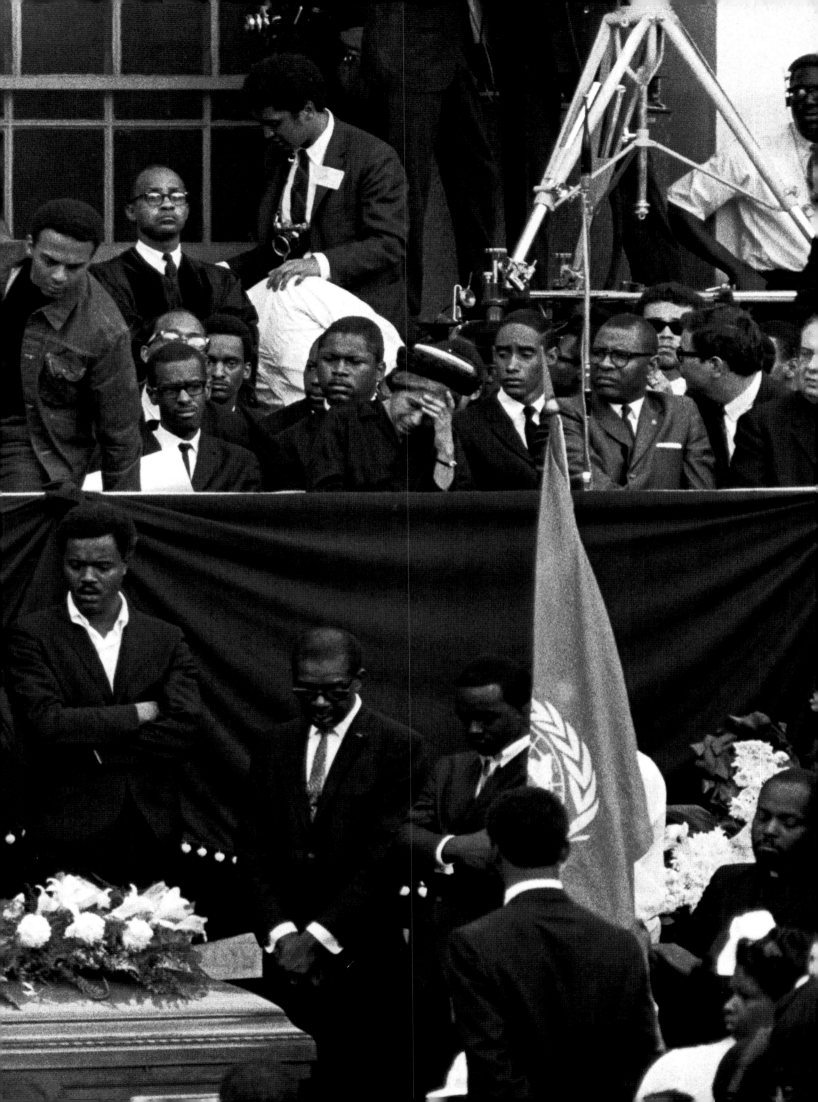

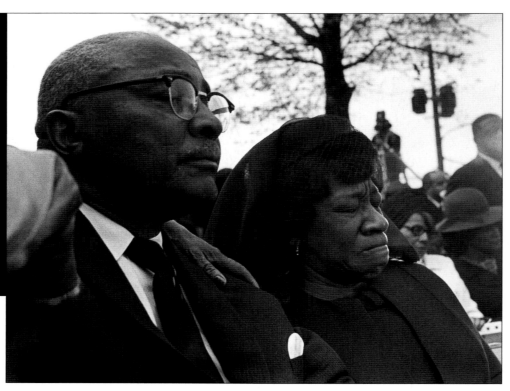

Dr. King's father and mother struggle to maintain composure as they sit at the gravesite as he is buried. Initially King was taken in a hearse for burial to South View Cemetery about four miles from Morehouse College. Later Coretta had his body moved, and he was reburied on the grounds of the newly created Martin Luther King, Jr., Center for Nonviolent Social Change in Atlanta.

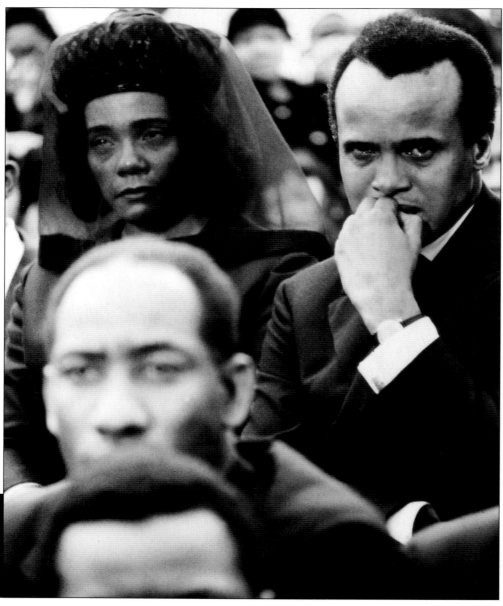

Coretta King and Harry Belafonte, their faces swollen by tears, lament the loss of a husband and a friend as King is interred.

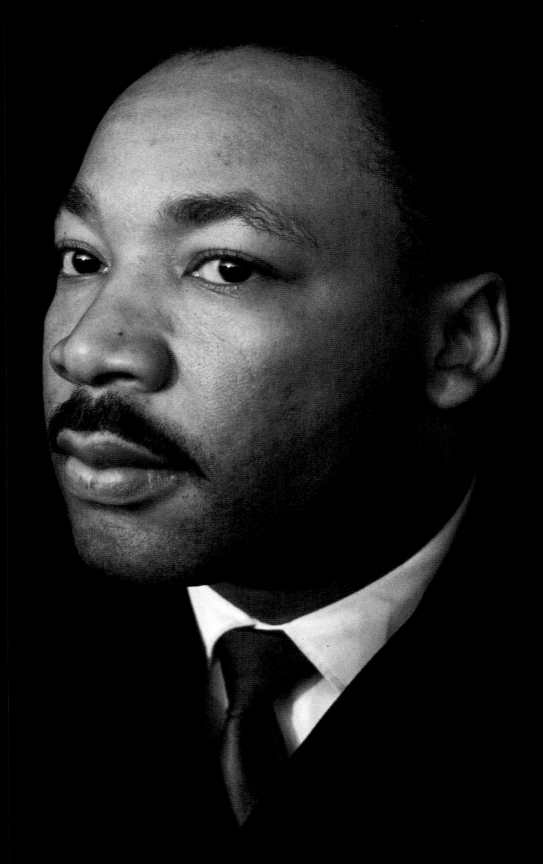

"I want you to say that I tried to love and serve humanity....say that I was a drum major for justice; say that I was a drum major for peace; I was a drum major for righteousness.... I just want to leave a committed life behind."

ACKNOWLEDGMENTS

First, I wish to thank photographer Bob Adelman for giving me the great privilege of writing the text for these outstanding images of America's greatest civil rights leader. Of special importance among the texts from which I drew in narrating this history are Stephen B. Oates's *Let the Trumpet Sound;* volumes 1, 2, 3 of *The Papers of Martin Luther King, Jr.,* edited by Clayborne Carson; Coretta Scott King's *My Life with Martin Luther King, Jr.;* Clayborne Carson's *The Autobiography of Martin Luther King, Jr.;* James M. Washington's *The Essential Writings and Speeches of Martin Luther King, Jr.,* and *I Have a Dream: Writings and Speeches That Changed the World;* Flip Schulke's *Martin Luther King, Jr.: A Documentary—Montgomery to Memphis* (text by Penelope McPhee); David J. Garrow's *Bearing the Cross;* Juan Williams's *Eyes on the Prize;* Taylor Branch's *Parting the Waters* and *Pillar of Fire;* King's own *Strength to Love;* Clayborne Carson's *A Knock at Midnight;* Theodore Pappas's *Plagiarism and the Culture War: The Writings of Martin Luther King, Jr., and Other Prominent Americans;* Aldon D. Morris's *The Origins of the Civil Rights Movement;* John A. Garraty's *The American Nation, A History of the United States;* and Bob Adelman's article from *Ebony,* "Birth of a Voter."

~ *Charles Johnson*
Seattle, July 2000

Photographs were crucial in advancing and recording Dr. King's lifelong struggle for equality and justice for all Americans. More than thirty years have passed since his assassination. Long overdue is a comprehensive and intricate photographic portrait, a close look at the hero who led the great movement that helped bridge the gap between American ideals and practices. As an activist photographer during the days of the civil rights movement, I found that Dr. King unforgettably voiced my aspirations. He showed all of us how grievous wrongs could begin to be righted by imaginatively and righteously employing our rich tradition of peaceful protest. Only the most profound moral and religious dedication could have given Dr. King the fortitude to endure the terror and attacks that were his almost daily lot. Going through the book, keep in mind that many civil rights photographers shared Dr. King's idealism, did their work aware that a camera wasn't much protection, and that quite a number were jailed or hurt. One died.

King's story needed to be told as well as seen, and we are blessed to have the American master Charles Johnson, whose radiant intelligence, vigorous prose, and passionate empathy for King's quest and vision illuminate these pages.

Designers' designers, Will Hopkins and Mary K. Baumann are our fellow authors. On display in every layout is their passion and gift for finding and weaving strong journalistic images into coherent and graphically elegant tales. Having worked with for Will almost forty years, I can only marvel at his continuing virtuosity. Will Hopkins wishes to acknowledge the profound influence made on his life and his work by Dr.

Anna M. P. Strong, principal for more than thirty years of the Robert R. Moton High School in Marianna, Arkansas. Design associate Nadira Vlaun worked with Will and Mary K., as did Jennifer Dixon, who expertly coordinated a multitude of editorial and production details.

We are all indebted to Mary Beth Brewer whose sure touch not only orchestrated the words, but she also did historical and picture research, checked facts, and kept a bewildering amount of information accessible and divergent personalities smoothly interacting. Over the far too many years of this book's gestation, she was the centrifugal force that kept KING together. Working with her on the copy were Paula Glatzer, Amy K. Hughes, Laura Morris, and Carolyn Vaughan.

To find the images in the book required searching through more than three hundred thousand photographs, a truly monumental task that led to many discoveries and engaged everyone on the project. From the inception of KING, we have been fortunate to have the distinguished civil rights photography scholar and curator Robert Phelan as a vital contributor. His knowledge of the period's history and many of the most important collections of photography from that era helped to shape the book's direction. Based on his photographic and historical research, and fifteen years of work in the field, he wrote invaluable outlines and texts that helped organize the picture sequences and formed the basis for the text and captions of the book.

Our search for photographs took us to all corners of the country. Individual photographers and friends were extremely generous in opening their files. I'd like to express my gratitude to my pal, John Loengard, and to James Karales, Flip Schulke, Charles Moore, Bob Fitch, Dan Budnik, Ben Fernandez, Leonard Freed, Matt Herron, Jay Leviton, Robert Sengstacke, and Ernest Withers. Two great photographers, Dan Weiner and Paul Schutzer, are fortunate in having widows, Sandra Weiner and Bernice Schutzer, so devoted to their historic work.

Many photo agencies were most generous in sharing their time and detailed knowledge of their archives. I would like to especially thank Patricia Lantis at TimePix for her wise counsel and enthusiastic cooperation and for giving us access to her great treasure-house of pictures. Paula Vogel at AP/Wide World Photos was equally generous with her rich archive and passed on much useful information. Robert Brenne at Corbis was unfailingly helpful. Gary Truman, a true pro, was always cooperative and made working at the Flip Schulke Archive a breeze. At my agency, Magnum Photos, I'd like to particularly thank Arianna Rinaldo for her help now and in the past, as well as Natasha O'Connor and Jessica Murray. They are all superb professionals. Woody Camp at Woodfin Camp remains the gold standard in his field. Ben Chapnick and Richard Serviss at Black Star were of great assistance and very resourceful dealing with our numerous requests. Kathi Doak and Racquel Figueroa at the Time-Life picture collection graciously allowed us to conduct extensive, original picture research. We are greatly in their debt. At TimePix, Tom Gilbert, Laura Giammarco, Adam Sall, and Stephen Smelz generously extended themselves and did a superb job, as did Tom Stone at LIFE's photo lab. The cooperation of Eric Young at Archive Photos, Tony Decaneas at Panopticon Gallery, and Hermene Hartmann who represents the John Tweedle Photography Collection was invaluable.

My assistant, the photographer Christopher Cataldo, intelligently organized and transferred my archive into digital formats with great patience and sensitivity. John Horan's prudent advice helped us with some thorny issues, and Kenneth Norwick's recommendations were practical and wise.

That paladin of picture book publishing, Christopher Sweet, immediately realized that KING was an essential book, one that had to be done, and I am indebted to him for all his sound suggestions and generous support. Michelle Li at Viking Studio has amiably dispatched all difficulties with effortless efficiency.

Personal heroes of mine from those terrifying and exhilarating movement days who contributed to the book are Dave Dennis, Marvin Rich, Mary Hamilton, Andy Young, and my best man and great friend, Rudy Lombard.

~Bob Adelman
Miami Beach, August 2000

PHOTOGRAPHY CREDITS

Our best efforts have been used to obtain proper copyright clearance and credit for each of the images in this book. If an unavoidable and inadvertent credit error has occurred it will be corrected in future editions. Photographers hold copyrights to their works.

BOB ADELMAN: 108 top right, center right, bottom right; 119 top, bottom; 121 bottom left; 122 top left, bottom left, bottom right; 122–123 top; 123 bottom; 124–125; 126–127; 126 bottom; 127 bottom; 128–129; 130–131 top; 130 bottom; 131 bottom; 132 top left, bottom left; 132–133; 140–141; 142 all; 143; 146 top; 148–149; 151 all; 152–153; 183 all; 184 top; 186–187 all; 188–189; 189; 192 bottom left, bottom right; 193; 195 top right, bottom right; 198 bottom left, bottom right; 201 top left, top right; 202–203; 204 top; 210; 211 all; 246–247; 252; 253 all; 264 top left, bottom left; 264–265; 266–267; 268 top; 271 top, bottom; 272–273 all; 274–275; 278–279; 280–281; 282–283; 285.

AP/WORLD WIDE PHOTOS: 12–13; 31; 74 top; 75 bottom; 88 top; 91 bottom; 99; 102 top left; 102–103; 105; 109; 116 top left; 116–117; 135 top right; 137 top right; 138–139; 155 bottom right; 160 top left, bottom left; 160–161; 168–169 all; 170–171; 172 top, bottom; 176–177; 182; 204; 215 bottom left; 216 top left, bottom left; 217 bottom right; 218 bottom right; 219 top right, bottom left; 222–223; 224 top; 230 bottom; 234–235; 235 top right, bottom right; 236 top; 238–239; 242–243; 243 top right, bottom right; 248 bottom left; 248–249; 250–251; 258 left, right; 260 left; 276–277 top.

ARCHIVE PHOTOS: 155; 215 bottom right; 216 bottom right.

DAN BUDNIK/WOODFIN CAMP AND ASSOCIATES: 1; 199 bottom left; 200.

CORNELL CAPA/MAGNUM PHOTOS: 276–277 bottom.

HENRI CARTIER-BRESSON/MAGNUM PHOTOS: 63; 72 top left, bottom.

CORBIS/BETTMANN–UPI: 21 bottom; 30; 32–33; 55; 56 top; 57 top; 58–59; 59 bottom; 60–61; 75 top; 78–79; 96 bottom; 96–97; 118; 120; 156–157; 158; 163 bottom right; 166; 167; 173 top, bottom; 174–175; 192 top; 196–197; 204–205; 214–215; 217 top, bottom left; 218 top, bottom left; 220–221; 224 bottom; 226–227; 230–231; 244–245 all; 256–257; 259; 277 bottom right.

CORBIS/BETTMANN–DAILY MIRROR: 59 top.

DON CRAVENS/LIFE/TIMEPIX: 12; 22 left; 26 bottom; 27 bottom; 32 top, bottom; 108 bottom.

FRANK DANDRIGE/LIFE/TIMEPIX: 136.

ALFRED EISENSTAEDT/LIFE/TIMEPIX: 215 top right.

BENEDICT J. FERNANDEZ: 8–9.

BOB FITCH: 73 bottom; 206 top left, bottom left;

206–207; 208–209; 212–213; 222 bottom left; 226 top left; 228–229; 268 bottom; 269; 270; 277 top right; 284 top.

LEONARD FREED/MAGNUM PHOTOS: 162–163.

BOB HENRIQUES/MAGNUM PHOTOS: 46.

MATT HERRON/TAKE STOCK: 137 bottom right.

JAMES KARALES: 64 top, bottom; 64–65; 66–67; 70 top; 76 top; 106–107; 110 top left, bottom left; 110–111; 112–113; 114 top left, bottom left; 114–115; 164–165; 190–191; 194–195; 198–199; 201 bottom.

MARK KAUFFMAN/LIFE/TIMEPIX: 214 left.

JAY LEVITON: 68–69; 159; 163 top right.

JOHN LOENGARD/LIFE/TIMEPIX: 216 top right; 219 center left.

JOSEPH LOUW/LIFE/TIMEPIX: 260–261; 262; 263 all.

JAMES MAHAN/LIFE/TIMEPIX: 144–145; 154–155.

ROGER MALLOCH/BLACK STAR: 230 top; 236 center left, center right, bottom; 237.

BURTON MCNEELY/LIFE/TIMEPIX: 138 top left, center left, bottom left.

CHARLES MOORE/BLACK STAR: 34–35 all; 62; 121 top, bottom right; 122 center left; 134–135; 178 top left, bottom left; 178–179; 184 bottom; 184–185; 199 bottom right.

NEW YORK DAILY NEWS: 54.

A. Y. OWEN/LIFE/TIMEPIX: 80 top; 84–85 all; 86 bottom left.

PAUL ROBERTSON/LIFE/TIMEPIX: 18–19.

FLIP SCHULKE: 69 top right, bottom right; 70 bottom; 72–73 top; 76 bottom; 77; 150–151; 180–181 all; 219 bottom right; 225; 226 bottom left; 284 bottom.

PAUL SCHUTZER/LIFE/TIMEPIX: 5; 6–7; 36–37; 38; 39; 40–41; 42 all; 43; 44; 45; 47; 48–49; 50–51; 80 bottom; 82–83; 83 top right, bottom right; 86 top left, center left, center right; 86–87; 88–89; 90 top, bottom; 91 top; 92–93; 146 center left; 146–147.

ROBERT SENGSTACKE: 240–241.

JOHN TWEEDLE: 232–233; 238 top.

DON UHRBROCK/LIFE/TIMEPIX: 52–53; 56 bottom; 57 bottom; 71; 74 bottom; 81; 94–95; 96 top; 98 top, bottom; 100–101; 101 top, bottom; 104.

DAN WEINER: 10–11; 14–15; 16–17; 20 top, bottom; 21 top; 22–23; 24–25; 26 top; 27 top; 28–29.

ERNEST WITHERS: 254–255.